THE COLLECTOR OF LIVES

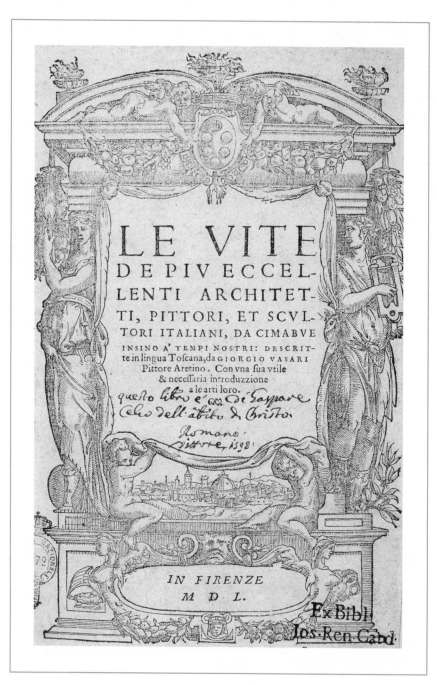

LE VITE

DE PIV ECCEL-
LENTI ARCHITET-
TI, PITTORI, ET SCVL-
TORI ITALIANI, DA CIMABVE

INSINO A' TEMPI NOSTRI: DESCRIT-
te in lingua Toscana, da GIORGIO VASARI
Pittore Aretino. Con vna sua vtile
& necessaria introduzzione
a le arti loro.

*questo libro e' ∞ di Gaspare
Celio dell' abito d Christo.
Romano.
pittore, 1598*

IN FIRENZE
M D L.

THE COLLECTOR OF LIVES

*Giorgio Vasari and the
Invention of Art*

INGRID ROWLAND
and
NOAH CHARNEY

W. W. NORTON & COMPANY
Independent Publishers Since 1923
New York | London

Manufacturing by LSC Communications, Harrisonburg
Book design by Lovedog Studio
Production manager: Julia Druskin

Library of Congress Cataloging-in-Publication Data

Names: Rowland, Ingrid D. (Ingrid Drake), author. | Charney, Noah, author.
Title: The collector of lives : Giorgio Vasari and the invention of art /
Ingrid Rowland and Noah Charney.
Description: First edition. | New York : W.W. Norton & Company, 2017. |
Includes bibliographical references and index.
Identifiers: LCCN 2017026667 | ISBN 9780393241310 (hardcover)
Subjects: LCSH: Vasari, Giorgio, 1511–1574. | Artists—Italy—Biography. |
Biographers—Italy—Biography. | Renaissance—Italy.
Classification: LCC N7483.V37 R69 2017 | DDC 709.2 [B]—dc23
LC record available at https://lccn.loc.gov/2017026667

W. W. Norton & Company, Inc., 500 Fifth Avenue, New York, N.Y. 10110
www.wwnorton.com

W. W. Norton & Company Ltd., 15 Carlisle Street, London W1D 3BS

1 2 3 4 5 6 7 8 9 0

To Izabella,
whose smile is a masterpiece.

Contents

PART THREE

Key Members of the Medici Family

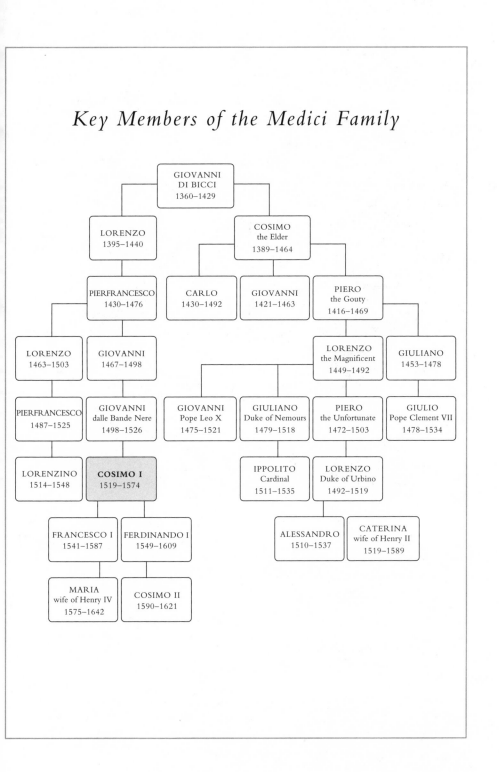

Key Locations for Vasari's Life and Work

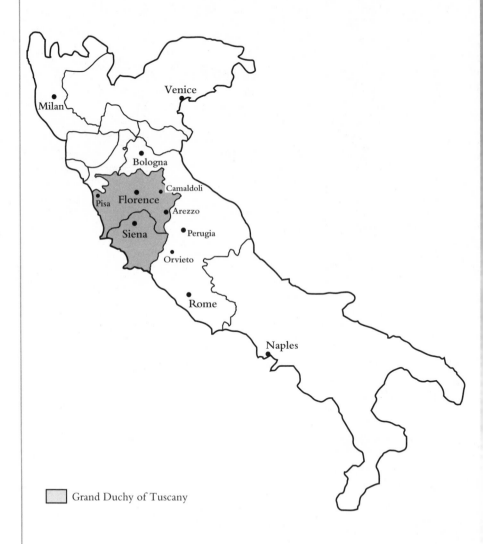

Milan

Venice

Bologna

Camaldoli

Pisa Florence

Arezzo

Siena

Perugia

Orvieto

Rome

Naples

Grand Duchy of Tuscany

Central Florence in the Time of Vasari

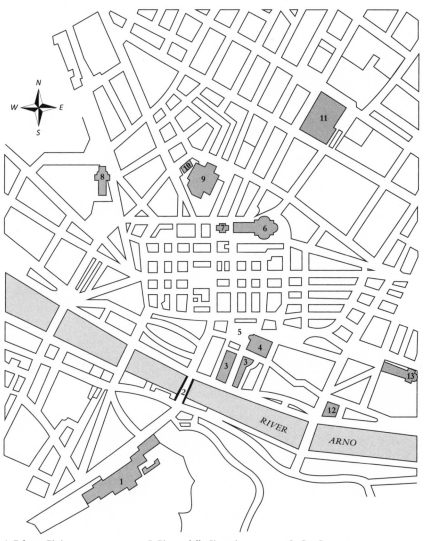

1 Palazzo Pitti
2 Ponte Vecchio
 (Vasari Corridor above it)
3 Uffizi
4 Palazzo Vecchio

5 Piazza della Signoria
6 Santa Maria del Fiore
 (Duomo)
7 Baptistery
8 Santa Maria Novella

9 San Lorenzo
10 Medici Chapel
11 Accademia delle Belli Arti
12 Casa Vasari
13 Santa Croce

INTRODUCTION

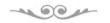

1

THE LOST
LEONARDO

As you step out of the blinding Florentine sunlight and into the terracotta-scented Palazzo Vecchio, it will take a moment for your eyes to adjust. But when they do, and the Sala dei Cinquecento leaps into clarity, you may be surprised to find yourself surrounded by giants. The soaring walls of this vast meeting hall (12,750 square feet, the size of three basketball courts) are painted with larger-than-life-size frescoes of riding and ranting warriors. Four enormous battle scenes show the military triumphs of the Medici family, painted in 1563 by Giorgio Vasari. His soldiers bulge out of skin-tight armor as they assault a fortified city by lamplight.

The Mannerist style of painting, with its steroid-popping musculature and neon armor-clad warriors, is not everyone's cup of tea. Even fellow Mannerists mocked each other: The great sculptor Benvenuto Cellini got it just about right when he said that Baccio Bandinelli's *Hercules* looked "like a sack full of melons." Based on a technique developed by the followers of Michelangelo in sixteenth-century Florence, with its intentional contortions and refusal to adhere to the laws of physics and anatomy, Mannerist paintings look to many like piles of bodybuilders in Day-Glo spandex engaged in an overzealous round of Twister. Yet the colossal frescoes that cover the walls of the Sala dei Cinquecento are undoubtedly awe inspiring, considered masterworks of sixteenth-century painting.

They are also intriguing for another reason. Buried beneath one of

the four frescoed walls may lie a treasure that, in the imagination of the general public, is of far greater importance—one that, should it still exist, has not been seen for five centuries. Hiding behind Vasari's fresco could be a lost painting by Leonardo da Vinci, one that tells the tale of a battle between two of the greatest painters of Renaissance Italy and hinges on a mystery sparked by another masterwork by Giorgio Vasari, a book titled *Lives of the Most Excellent Painters, Sculptors, and Architects.*

Of the lost Leonardo, the known facts are these. In the sixteenth century, the Sala dei Cinquecento, with its theatrically tall ceilings, functioned as the reception room used by the Medicis when hosting visiting dignitaries whom they wished to awe. In 1505, during a brief period when the Medici family was expelled from Florence, Leonardo began a monumental wall painting (54 × 21 feet in size) in the sala, the *Battle of Anghiari*: a torqued melee of riders and swordsmen. The Florentines also commissioned Michelangelo to paint a second battle scene on the room's opposite wall, the *Battle of Cascina*. Michelangelo made a preparatory sketch, but never executed the fresco, for he felt that Leonardo's side of the room had better light, and that he would be at a disadvantage in this intentional duel between the city's two leading living artists. Leonardo began his side, but never finished. His partial *Battle of Anghiari* is known only by a number of copies and an engraving. The most famous copy of the work was painted by Rubens around 1604, but the Flemish painter had to use the engraving as his model, because the original had been covered over four decades earlier, by none other than Vasari. There is no indication in Leonardo's *Life* that he ever made a complete cartoon for the *Battle of Anghiari*, only the design for one section, the "Battle for the Standard," that was copied several times by contemporary artists. Clearly their copies were made from the cartoon, not the fresco. It seems that Leonardo painted only a small portion of one wall, but the beauty and dynamism of his embattled warriors made the unfinished work a point of pilgrimage for artists who traveled to Florence.

That Leonardo gave up on what seemed like a promising project was indicative of his particular brand of genius. The notoriously impatient artist rarely completed anything—he wrote that one of his regrets was the fact that he never once finished a single painting. He was exaggerating, but not by much. According to Leonardo's own notes, a portentous disaster struck when he was just at the start of painting his Florentine battle scene. His diary, dated 6 June 1505, reads, "Just as I lowered the brush, the weather changed for the worse and the bell started to toll . . . the cartoon was torn, water poured down and . . . it rained very heavily until nightfall and the day was as night." Our best guess is that melodramatic weather, as well as Leonardo's habit of rarely finishing anything, led to his deserting the commission.

There are only twenty-two extant paintings by Leonardo, and eight more that are mentioned in archival documents and primary sources but have never been found. Should this unfinished battle scene resurface, it would become the twenty-third.

WHAT WE KNOW OF LEONARDO'S life and stories, we have learned largely from Vasari. In 1550, half a century after Leonardo halted production on the *Battle of Anghiari*, Giorgio Vasari published the first edition of *The Lives of Most Excellent Painters, Sculptors, and Architects* (often called *Lives of the Artists* or just *Lives* as a shorthand), a group biography of the leading Renaissance artists, many of whom he knew personally.

Whether or not you've studied art history, you may have heard some of Vasari's stories—part historical urban legend, part morality tale, his great collective biography spun visual aphorisms that endure to this day. Brunelleschi won the commission to construct the dome of Florence cathedral by balancing an egg on a slab of marble—something none of the other, competing architects could imagine doing. Andrea del Verrocchio assigned his teenage pupil, a

kid named Leonardo da Vinci, to paint a single figure in his *Baptism of Christ*, but this one figure was deemed so superior to those painted by the master that Verrocchio gave up painting forever and reverted to sculpture. The mysterious painter Giorgione decided to die for love, rather than live without his sweetheart, snuggling with her in bed as she succumbed to the plague, knowing that he, too, would contract it and die shortly thereafter. And then there's the dirty joke Vasari made at the expense of his own sister, the one that made Pietro Aretino, Titian's best friend, laugh so hard that he had a stroke and died.

Spanning three centuries and the length of Italy, with side trips across Europe, Vasari's biographies range widely in their length and depth, but their progession outlines the trajectory of Renaissance art and architecture from the crude energy of the early fourteenth century to the refined professionalism of the late sixteenth. Each artist's life presents a small-scale history of personal development within the larger scheme of general artistic progress, and wherever he can Vasari provides examples of each artist's work as evidence to confirm his story, arranged in chronological order.

None of these elements should be taken for granted. The idea of a new entity called "art" was one of the great collective inventions of the working people commemorated in these biographies, along with the idea that they themselves, as creators of art, had become something more than craftsmen; they became thinkers as well as makers. The idea of steady, positive progress also identifies Vasari clearly as a man of his own era. Ancient writers complained that the world had declined from a lost golden age, but the *Lives* end with a golden age of art ushered in by Michelangelo and secured for the future by the training program of the Florentine Accademia del Disegno (Academy of Design or Drawing), founded by Vasari himself. Vasari had good reason for his confidence: by the time he put the finishing touches on his second edition, Italian artists dominated a profession that had expanded its range of influence across continents. And by putting the works of his subjects into chronological order, Vasari stressed their

capacity for personal and professional development, through experimentation with new techniques and new styles.

Each *Life* begins by identifying the artist's region and family. Talent could emerge anywhere, and at any level of society, from a humble Tuscan shepherd boy like Giotto to the mellifluously named Milanese noblewoman Sofonisba Anguissola. But talent could thrive only through rigorous training and tireless application—this is Giorgio Vasari the workingman speaking, but also Giorgio Vasari the Tuscan, inspired by his native region's traditional work ethic and its treasury of wise sayings for every occasion. The most remarkable aspect of these *Lives* is also the aspect that makes them hardest to read: the chronological lists of each artist's work, testimony to Vasari's talent for organization and his pioneering scholarship in a brand-new field, but not enthralling literature. And so, in among the lists, the author adds the comments that give the *Lives* their enduring spice: his own opinions about good artistic practice and wise living, and—following the lead of ancient biographers—juicy bits of gossip.

Some of the more important *Lives* also serve an additional purpose, or illustrate an additional point. Giotto is the great pioneer of art's rebirth. Leonardo da Vinci had trouble finishing what he started, a common problem for artists (and everyone else). His example shows that talent is not enough to build a career: persistence counts too. Piero di Cosimo plays the role of the eccentric artist, surviving on hard-boiled eggs and painting wild fantasies. The *Life* of Raphael provides an opportunity for Vasari to show his prowess at an ancient literary form: ekphrasis, describing a picture in words. Michelangelo embodies both a perfect artist and a perfect human being (never mind that in real life he could be irascible and stingy), though Vasari also records some of his idol's peculiarities, like the dog-skin boots that he wore night and day until they became glued to his own skin.

These are among the funny, poignant, and memorable stories told in Giorgio Vasari's *Lives*. No wonder that for five centuries they have provided the standard primary source text for almost all of the world's

art history courses, from basic introductions to postgraduate levels. Vasari has been called the "father of art history." He is credited with being the first author to consider artistic movements, the chain of influence from master to pupil, the link between an artist's personal biography, beliefs, and artistic creation. His methodology effectively established the way we study art history today, and cemented the primacy of Florentine Renaissance art in the popular imagination. You don't need to have read the *Lives* in order to know many of Vasari's stories and ideas—the way you think of art is largely due to Vasari, whether or not you realize it, and whether or not you've actually read his book. That book also influenced the way we think of history more broadly, the way museums are curated and objects displayed, how biography is written (and read), and how we look to the personal history of famous historical figures to understand why they behaved as they did, why they made decisions that shifted our world.

Since its publication, Vasari's *Lives* has been fundamental to the way we see and study art. Still read by every student of European art history around the world, and still the primary source for scholars of Renaissance art and thought, *Lives* has had a profound effect on how we analyze and define art. Its influence has been consistent for nearly five centuries. Not only is it a point of departure for all other authors writing on art; the book has also colored how the general public approaches different artists—our own idolatry of Leonardo, Raphael, and Michelangelo follows directly upon Vasari's effusive praise of them. By exploring who Vasari was, how he wrote his book, and what influence it has had on how we perceive art, then, we can also explore the significant questions of what art is, why it is so important to the human species, and how we have interacted with it.

While Vasari was the most prominent and successful artist in Italy during the middle to late sixteenth century, he was also something of a groupie. He idolized his peers, particularly Michelangelo. Yet as he assembled the anecdotes that populate his *Lives*, Vasari also carried out an extraordinarily successful career as a practicing artist and architect.

He collected drawings avidly and was instrumental in establishing drawings as a significant art form. Before his time, artists viewed their sketches as preparatory material, not fit for display and generally discarded. The elderly Michelangelo, when he realized that he was near death, frantically burned as many of his own drawings as he could, in order to erase evidence of how hard he had worked to prepare his paintings and sculptures—he hoped that posterity would believe that his finished creations emerged spontaneously, as a product of his genius, not of his diligent preparation. It was only thanks to Vasari's physical intervention, wresting reams of drawings from Michelangelo's hands as he stood before an open fire, that a reasonable number of those drawings survives. A few years back, a Michelangelo drawing sold for thirteen million pounds—that price, the way we value drawings, and Michelangelo, and a drawing by Michelangelo, are all a direct legacy of Vasari's interventions and influence. Vasari kept several large-format books, called his *Libri dei Disegni* (Books of Drawings), which functioned as collectors' albums, filled with drawings by the artists he admired. These books are unfortunately lost, but they testify to his loving admiration of Tuscan artists above all, especially Michelangelo and Leonardo.

Thus when the Medici hired Giorgio Vasari to redecorate the Sala dei Cinquecento, they presented him with a major dilemma. His own admiration for these artists would have caused him serious reservations about destroying work by either man, even a painting only partly finished. Would such a serious painter and collector willingly destroy Leonardo's *Battle of Anghiari*? It seems more likely that when he was entrusted with remodeling the sala and painting it with his own frescoes in 1563, Vasari would have done anything he could to preserve Leonardo's fresco.

The Medici family was in exile when Leonardo painted his *Battle*. The Medici returned to Florence, and to their Palazzo Vecchio, in 1512 to find the unfinished painting on the wall, a painful reminder of their temporary exile. Had the Leonardo been completed, it might

have been a different story—the Medici admired his work and might, indeed, have allowed it to remain. But Leonardo had tried an experimental undercoating for the fresco, mixed with wax, that caused the colors to run before they had a chance to dry. A dilapidated monument to their exile was not what the Medici wanted to advertise when they met foreign dignitaries in the Sala dei Cinquecento, and so, some fifty years after the family's return to power, Duke Cosimo de' Medici commissioned Giorgio Vasari to repaint the sala with battle scenes of great Florentine (that is, Medici) victories.

Vasari fulfilled his commission, and the sala now shines with his frescoed battle scenes. But the question remains: what happened to Leonardo's *Battle of Anghiari*? The answer lies in Vasari's own biography, the story and content of his *Lives*, and the clue to an art historical treasure hunt that Vasari himself painted onto the wall: the only two words that appear in his sprawling frescoes.

Cerca trova.

Seek and you shall find.

MAURIZIO SERACINI LEANS IN to examine a detail of the fresco that covers the enormous Hall of Five Hundred in Florence's Palazzo Vecchio. The sixty-seven-year-old engineer, in an immaculate lab coat, has been staring at the same spot for the better part of an hour.

Cerca trova. Seracini believes this to be a clue. Vasari's fresco, he says, is covering up the lost Leonardo.

This theory hasn't made Seracini popular among art historians, many of whom claim he intends to damage, or even destroy, Vasari's work to get at the Leonardo—if, indeed, the Leonardo is even there. "Not only do I not understand and resent this animosity," he says; "I would like to say that historians have not produced a document stating it is *not* there."

With hidden messages, lost treasures, clues about Leonardo, and a modern melodrama in an ancient palace, this may all seem like an

excerpt from *The Da Vinci Code*. Perhaps it should—throughout the questionable scholarship and fantasy in that novel, at least one character in it is real. Seracini actually appears in the story, described as an "art diagnostician" who was determined to make public his discovery of a ruined temple in the background of Leonardo's *Adoration of the Magi*, a detail that later painters had covered up in order "to subvert Da Vinci's true intentions. . . . Whatever the true nature of the under-drawing, it had yet to be made public."

But Seracini is a scientist to the end, never satisfied with anything but hard data (he has never read *The Da Vinci Code*). He has made public his discoveries and the scientific data and images to back them up, and he leaves the analysis and interpretation to art historians.

Despite his successes with other works by Leonardo, and with scores of monuments and paintings throughout Italy, Seracini was drawn to his revolutionary field by the very mystery he's currently trying to solve. In 1975, Seracini and his colleagues noticed a tiny bit of text hidden within Vasari's frescoes in the Sala dei Cinquecento. Throughout the entire room, one frescoed wall of which is 177 feet long, Vasari had painted exactly two words.

Cerca trova.

Seek and you shall find.

Years later, Seracini would be summoned by the Italian Ministry of Culture to supervise the search for Leonardo's lost *Battle of Anghiari*. An elegant gentleman with a cupola of white hair and the passion and drive of a man half his age, Seracini now is an art detective leading a team of scientists and art historians in the search for the lost Leonardo, which could be the single most important discovery in the art world of the twenty-first century. Seracini has been called the "real Indiana Jones" and the tracker of a "real-life *Da Vinci Code*." He has been lauded by art historians and by the World Science Festival as a "cultural heritage engineer," a title that did not exist before him. He established a new field, one in which art historical mysteries are solved through advanced forensic scientific investigation. He has studied

over twenty-five hundred artworks and monuments by means of new technologies, many of which he himself adapted and developed.

Through his use of advanced technology, Seracini represents a new generation of art historian, inheriting the mantle of Giorgio Vasari but relying on an entirely different arsenal. Whereas Vasari studied artists and art through word of mouth, anecdotes, and found letters and documents, Seracini uses hi-tech gadgetry. And it is through this gadgetry, along with some old-fashioned detective work, that Seracini looks poised to solve a mystery planted by Vasari centuries ago.

Cerca trova.

Seracini and many leading Leonardo scholars believe this to be a valid clue from Vasari, indicating that he somehow preserved Leonardo's painting, while still fulfilling his commission—and that Leonardo's *fresco secco*, dry fresco, is hidden beneath a false wall on which Vasari painted his own frescoes.

In 2006, Seracini announced that he had discovered a 1.5-inch hollow gap behind Vasari's frescoed wall and the outer wall of the sala. This double wall, which Vasari must have built when he painted his frescoes, is unheard of, and has no architectural or structural rationale. Further, the gap is behind only one of Vasari's four frescoed walls—the one with the words *Cerca trova* written on it, the one on which Leonardo is thought to have painted.

Seracini has been stuck in a tangle of red tape, the infamous Italian bureaucracy that causes speeding ideas to grind to a halt. But in 2011 the National Geographic Society announced that it would cofund the search for the lost fresco, and permission was granted to begin in 2012.

What Seracini found over the following few months led to wild enthusiasm, but also to tremendous anger within the art history community. On 12 March 2012, Seracini and his team announced that they had located a paint sample on the hidden wall, by drilling through the Vasari fresco. The black paint sample matched the chemical composition of paints used in other known Leonardo paintings, including the *Mona Lisa*. It is now clear that something is back there,

buried beneath the Vasari. The hunt has led to a real buried treasure. But the question is whether what will be found is worth destroying a portion of another masterpiece, the Vasari fresco.

At least, that's how it was presented by the world media at the time. The truth is more complicated, and more intriguing. And in order to find the Leonardo, to solve the puzzle, to unbury the treasure, we need to understand Giorgio Vasari.

2

HOW TO READ
VASARI'S *LIVES*

V ASARI'S LIFE AND HIS *LIVES* ARE AN IDEAL LENS
through which to examine the history of how humans have
thought about art: from the Chauvet cave paintings and Plato's parable
of the cave to the twentieth and twenty-first centuries, when art has
become a urinal turned on its side and a stuffed shark in formalde-
hyde. We will examine the life and times of Vasari, who lived at the
heart of the sixteenth-century art world, as well as the contents and
legacy of his most enduring and influential creation—perhaps ironi-
cally not a work of art in the traditional sense, but a book.

The Lives of the Most Eminent Painters, Sculptors, and Architects is a
group biography of Renaissance artists, almost exclusively Italian, first
published in 1550, researched and written by Vasari in collaboration
with his scholarly friend Vincenzo Borghini and a host of local infor-
mants. It traces what Vasari terms the rebirth (*rinascita*) of art, after it
had fallen "into extreme ruin" with the destruction of ancient Rome,
through three distinct periods of continuous development, culminat-
ing in the art of Michelangelo. The massive work is divided into three
parts, each roughly corresponding to a century, and for each part
there is a hero who is both an all-around artist and, importantly,
a Tuscan: Giotto di Bondone (1266/7–1337), Filippo Brunelleschi
(1377–1446), and Michelangelo Buonarroti (1475–1564). One recent
scholar describes Vasari's biographies as "an amalgam of facts, shrewd
analysis, and purposeful fiction . . . a carefully plotted construction

and part of the writer's larger conception of the progressive ascent of art from its humble beginnings in the age of Giotto and *i primi lumi* ["the first lights," Vasari's phrase] to its effulgent maturation in the age of the 'divine' Michelangelo and Vasari himself."[1] The biographies of other artists are built around the concept that art evolved and improved from Giotto, who "breathed life back into art and brought it to the point where it could be called good,"[2] to its "perfection," "more heavenly than earthly,"[3] in the work of Michelangelo. Any artist who did not fit this agenda was sidelined, ignored, or undermined.

As Vasari tells us in his "Preface to the Entire Work," his concept of art's continuous development mirrors the human experience: "this art, and others, like the human body, is born, grows, ages, and dies." He begins his tale of art's "progress from its rebirth to the perfection to which it has risen in our own times" in the thirteenth century, with the Florentine painter Bencivieni di Pepo (before 1251–after 1302), nicknamed Cimabue, "Bullheaded," for his proud temper.[4] Cimabue's most famous pupils were Duccio di Buoninsegna (a painter from Siena, the inveterate rival of Florence) and the Florentine Giotto, who quickly emerges as the main protagonist of the first part of *Lives*, both because of his innovations as an artist and because of his versatility in all three of the arts on which Vasari chooses to concentrate: painting, sculpture, and architecture. From Giotto, we move into the second part of *Lives*, roughly covering the fifteenth century, in which the protagonists are Donatello in sculpture, Masaccio in painting, and Brunelleschi in architecture, with Brunelleschi, who was also a sculptor, taking on the dominant role. Perugino is the last artist to appear in the second part of *Lives*, and Vasari presents him in a light of unfulfilled potential—potential that would soon be fulfilled by Raphael, Perugino's most famous pupil, and one of the three luminaries of the third part of *Lives*. This final section focuses on Vasari's own era, the first half of the sixteenth century, with Raphael, Leonardo, and, above all, Michelangelo as its heroes. The book's guiding theme

from beginning to end is the supremacy of Florentine art, exemplified in Michelangelo, "a spirit universally able to demonstrate singlehandedly, in every art and every profession, what perfection is."[5]

Vasari wrote with a more specific agenda than his stated aim to "delight and instruct" his readers.[6] When he published his first edition of the *Lives* in 1550, he hoped to found a school for the arts in Florence. By the time his second edition came out, in 1568, the state-sponsored Accademia del Disegno had been a reality for five years, the subject of its own chapter in the *Lives*, and the chief impetus for revising his colossal text. Vasari believed that good art depended on good teaching as well as native genius, and hence his book might even be helpful "if ever (God forbid), art should fall into the same disorder and ruin" as it did after the fall of Rome. "Then," he continues, "these efforts of mine might be able to keep her alive, or at least encourage superior talents to provide her with better help."

Many would agree with Vasari's opinions about art, even today, but his eagerness to promote his city, Florence, the style of art he taught in his academy, and his friend Michelangelo means that many wonderful artists are either sidelined in the *Lives* (Dürer, van Eyck), undercut (Perugino, Duccio), wholly ignored (Fouquet, Sluter), or vilified (Bandinelli, Andrea del Castagno), simply because they failed to fit his stylistic or geographic requirements. Furthermore, his creative urges extended beyond art to literature—a good deal of what we read in Vasari is either carefully manipulated fact or pure fiction.

Lives is standard reading for any student of art history or Renaissance studies (in the United States alone there are around half a million college students who take a basic course and encounter Vasari's writing, if not his art). But it is one of those books that many dip into, but few read cover to cover. The format—short biographies ranging in length from a handful of pages to around thirty, and a series of essays on various artistic techniques—is designed for dipping; Vasari's ideal readers were busy people. Depending on the printing and language (*Lives* is now available in every major language around the

globe), the 1550 edition runs a little under four hundred pages, but the expanded 1568 edition, which includes more artists and conveys a more finely calculated message, nearly doubled in length. Because the book marks such an important milestone in the story of how humans have thought about art, it deserves our close attention—indeed our careful scrutiny—because vivid, memorable, important, and enduring as it is, Vasari wrote with an agenda, and much of his information is wrong, sometimes by his own deliberate choice.

Vasari's *Lives* has been called "the Bible of Italian Renaissance— if not all—art history."[7] But the great Italian art historian Roberto Longhi warned us, "Bisogna sapere *come* leggere Vasari." One must know *how* to read Vasari. The blank space between the inked letters contains a world of information, if only we know *how* to reach it. Above all, reading Vasari not only provides a portrait of the subjects of the various biographies, and of the time in which the book was written, but also offers up a hidden portrait of the author himself.

The old fifteenth-century patriarch Cosimo de' Medici once said, "Every painter paints himself."[8] At its most basic, the phrase suggests that art is not objective, but the subjective interpretation of an idea, a scene, a moment, a vision, a portrait, absorbed by the artist, considered and digested, before it is projected into a work of art. The opinion of the artist emerges in the artwork, whether or not the artist consciously inserts it. Therefore, when we see a portrait of another Cosimo de' Medici, the sixteenth-century duke of Tuscany, for example, painted by his court portraitist, Giorgio Vasari, we see two people, and three interpretations, on one panel. We see Cosimo as interpreted by Cosimo himself (as he would like to be portrayed for posterity), and as Vasari both sees him and considers how to portray him (fulfilling the commission and satisfying the patron, but nevertheless painting the work "his way"). We also see, however, an "invisible" portrait of the artist himself, Giorgio Vasari, just as a novel by Hemingway may be about Kilimanjaro or the Soča Front or nightlife in Paris and Spain, but literary critics can read the author's life into his

text. Just as "every painter paints himself," we can also say that "every author writes his autobiography," and this is particularly true when a painter writes of painters—there is as much Vasari in each of the *Lives* as there is true history of the artist portrayed.

The idea of who Vasari might be has shifted over the years, from a diligent biographer to a sly fabricator to a visionary historian.[9] The art historians Paul Barolsky and Andrew Ladis are among the modern scholars who first saw *Lives* not as an accumulation of short, loosely linked biographies but as a long, cohesive, literary work. Barolsky's witty studies of Vasari demonstrate that the artist-biographer was not just a compiler but a clever author in the proper sense of the word: aware of historical context, literary structure, thematic aims, the skilled use of anecdotes (whether fictional or factual, and whether Vasari knew if they were fictional or factual) to convey character. But we must keep in mind that all of Vasari's stories were filtered by Vasari. He acted as researcher, but also interpreter of facts, tales, and suppositions, rumors, accusations, and (very occasionally) documented evidence. He does not cite the sources of his "facts" very often, and so we are left to guess at them or simply accept his word. He often uses the phrase *scrivono alcuni*, or "some write," which covers up his sources, but is meant to lend credence to his stories.

He wrote, thought, and lived with his own agenda. As Andrew Ladis notes, Vasari makes Michelangelo "the triumphant savior of the arts, a figure of light, but in his way stand those less gifted, less gracious, and less good. These beings of shadow and darkness make Michelangelo's achievement all the greater in the end."[10]

The 1550 edition of *Lives* is far shorter and less "worked" than the sprawling, 1568 edition. We might be tempted, then, to conclude that the 1550 edition is more reliable historically, but the situation is more complex than that. The 1568 edition includes some new material (including biographies of Titian and the Flemish painters) along with carefully refined revisions that focus the text more sharply on Florence, its artistic traditions, and the potential of the Accademia

del Disegno to perpetuate the supreme excellence of Florentine art, but the real difference between the editions lies in the expanded, solidified narrative that makes the *Lives* of 1568 a much more polished work of literature.

In the interests of furthering his master narrative, Vasari sometimes alters the facts. Yet if his stories are not always wholly true, they are still worth our attention. We should understand that they derive from some core of information that Vasari believed was fact, and were then mined, hammered, and polished, filtered through the author's personal opinion, literary verve, patriotism, the theoretical program for his artistic academy, and the aesthetic demands imposed by a carefully sculpted book.

For example, Vasari's decision to diminish the reputation and production of the wonderful painter Perugino has both an artistic basis in Perugino's relatively static style and a literary basis: for it allows the writer to create a tale of artistic progress that begins with Perugino, reaches a crescendo with Raphael, and culminates in his hero, Michelangelo.

Likewise, the idea that art steadily improved from Cimabue to Michelangelo is reductive. The abstract scheme developed in the sixteenth century no longer matches the opinions of contemporary art historians and critics. Cumulative improvement makes for a fluid narrative, but we would no longer say that Giotto is "better" than Cimabue, that Raphael is "better" than Perugino, or that Cellini is "better" than Donatello. They worked in different ways, in different times. Vasari, however, believed that art had never been better than in his own day, and loved to write in those terms. He declared that Giotto eclipsed his master, Cimabue (who may not even have been his master): "Really, Giotto overshadowed his fame just as a great light dims the splendor of much lesser one." An eloquent statement, to be sure, but it can only be one man's opinion.

Some viewers (especially in Siena) prefer Duccio to Giotto or even to Raphael, and some regard Cellini as a sculptor superior to Donatello

(though almost everyone would rather have Cellini on their side in a fistfight). Different eras have had different expectations, preferences, and styles. The only cumulative experience that we can agree upon about early modern art in Italy is a general tendency toward naturalism, through the advent of foreshortening and single vanishing point perspective, techniques that guided avant-garde Italian artists in the fifteenth century. Vasari's literary plot devices, juxtaposing one artist as categorically "better" than another, and contrasting "good" artists (in all senses of the word) with "bad," are just that—literary devices to make a better story out of history.

Though Vasari knew many of the artists about whom he wrote, the majority lived a generation or so before him. He carried out his research by every means he could imagine: gathering spoken tales and conducting interviews, through scatterings of archival material, through occasional references in printed books (from the likes of Boccaccio and Petrarch), but, most of all, by examining the surviving works of art that acted as a legacy for their creators. How Vasari read those artworks colored how he would write about the artists.

Vasari states, however, that he aimed to do more than just catalog his subjects: he also meant to interpret their significance, as people and as artists. In this, we might consider that Vasari approached writing his biographies as he would have approached painting a portrait. Sixteenth-century portraiture was not intended to be an exact replica of the subject; artists resorted to a great deal of artifice and flattery. Portraits of marriageable young ladies, like Raphael's *Lady with a Unicorn*, were commissioned to be sent to a betrothed husband, who otherwise might not see his future wife before the wedding day. There was every incentive to "airbrush" the portrait into something as flattering as possible. This sometimes caused its own problems—Henry VIII was thoroughly disappointed when he saw Anne of Cleves, misled by the over-flattering portrait that had been sent ahead of the bride. Likewise, attributes were often added to portraits to convey an idea rather than represent factual reality. The insertion of a dog in a

portrait was a symbol of loyalty, an attribute of the subject, not neces-
sarily an indication that the subject actually owned a pet. A scattering
of oranges on the windowsill in Jan van Eyck's *Arnolfini Portrait* is a
symbol of the subject's wealth (oranges being imported to Bruges at
great expense from Spain), not evidence that members of the Arnol-
fini family were in the habit of storing their fruit by the window, or
even that they had a taste for citrus.

Conventional wisdom holds that a great portrait should reveal a
hidden secret about its subject that its subject would prefer to remain
secret. That is, the portraitist can see the truth, but is obliged by his
commission to present a strategically chosen version of that truth, in
order to preserve a flattering view of the subject for posterity. Por-
traitists could sometimes surreptitiously insert hidden messages con-
veying insights that a subject might prefer not to record—like letting
a telltale wisp of real hair emerge from beneath the Roman emperor
Domitian's sheepskin toupee, as happens in the splendid bust in the
Toledo Museum of Art, or letting the raw ambition of the sixteenth-
century writer Pietro Bembo show on his lean, hungry face, as Lucas
Cranach did in his painted portrait—but an artist has to work these
suggestions in so subtly that the subject will ultimately be pleased
with the portrait, and pay for it.

In dealing with the *Lives*, then, we should approach Vasari's writ-
ten "portraits" just as we might approach his painted ones: they are
based on truth, as Vasari understood it, but ornamented and shaped
into a work of art that at once conveyed his subject, but also presented
his artful interpretation of it. We should read Vasari's texts as literary
creations, based on oral and written traditions, about the adventures
of real artists.

But his desire to make a moral out of the lives he documented
meant that he sometimes made villains out of artists who did not
deserve such a reputation. As the Vasari biographer Andrew Ladis
notes, "For Vasari, as for any author, the dark side was an abiding
natural force and essential to his scheme, because history without

error could hardly hold interest, much less be true. Or, to quote Mae West, 'Virtue has its own reward, but no sale at the box office.'"[11]

Vasari's juxtaposition of good versus flawed artists is perhaps most evident in the duel he constructed between the talented but sinful Fra Filippo Lippi, and the idealized, saintly Fra Angelico (officially designated "blessed" by Pope John Paul II in 1982, the first step toward canonization).[12] Lippi's sin was using "carnal" figures as his models for holy figures, like his mistress, the former nun Lucrezia Buti, who often provided his model for the Virgin Mary, with their son Filippino Lippi standing in for the Christ Child.

Vasari's stories tend to endure, even when scholarship overturns them.

PART ONE

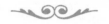

3

FROM POTTERS
TO PAINTERS

Vasari's Forebears and First Teachers

G IORGIO VASARI WAS A MAN OF CAREFULLY CULTIVATED modesty, a rarity among his peers. After devoting hundreds of pages to the lives of others, he added a short account of himself to the very end of the second edition of his *Lives* (1568), just before his concluding afterword, "The Author to the Creators of Drawing." In effect, this brief autobiography establishes his own credentials as a "creator of drawing" before he formally thanks his fellow practitioners for all the help and encouragement they have given him in his massive effort as a chronicler of their profession. Given the stature of these fellow "creators," Michelangelo chief among them, Vasari makes only the briefest of claims about his own achievement:

Because, up to this point, I have discussed other people's works with all the diligence and sincerity my wit has been able to muster, I also want, at the end of these labors of mine, to gather together and present to the world those works that the divine Goodness has granted me to execute, for even if these are not as perfect as I would like, anyone who wants to examine them with an unbiased eye will see that I have worked them with study, care, and loving effort, and hence if they are not worthy of praise, they at least can be excused; besides, they are on public display and visible, so they can hardly be hidden away.[1]

By 1568, the places where these works were "on public display" were impressive and prominent by any standards. There was the gigantic assembly hall of Florence called the Sala dei Cinquecento; the audience hall of the Vatican Palace known as the Royal Hall, or Sala Regia; the walls of the papal chancellery in the center of Rome; and the cityscape of Florence itself, with the Uffizi Palace (which he designed) and the winding "secret" private corridor that connected the Palazzo della Signoria to the grand duke's residence on the other side of the Arno River. Giorgio Vasari was an exceedingly important man, but wise enough, and sensitive enough, to minimize that importance in speaking about himself to others.

That reticence came from his own particular social position. In a society that was still feudal in many respects, Giorgio Vasari came from the middle class in a region of Italy, Tuscany, which was highly urbanized and devoted to commerce. Urbanization had favored the development of a middle class in the first place, and it also favored the upward mobility of individuals. By a combination of talent, luck, and hard work, Vasari came into contact with the highest tiers of contemporary society, where he moved easily, displaying a variety of qualities: he was witty, educated, hardworking, and efficient, and he knew when to keep quiet. He was both an outsider and an insider: a middle-class artisan among aristocrats, a native of Arezzo among Florentines, an artist among writers, a writer among artists, a courtier among guildsmen, a guildsman among courtiers, a complex man with a unique range of skills, who has only begun to be appreciated at the level his accomplishments deserve.

Within one tradition, however, Giorgio Vasari was an insider through and through: art—by which, for reasons we shall see, he basically meant painting. Until very recent times, when child labor laws went into effect, Italian artists and craftsmen began practicing their skills in childhood; this is one of the chief reasons for their extraordinary proficiency as adults. Professions ran in families; thus boys learned from their fathers or joined another studio as appren-

tices, often as early as the age of seven or eight. Because girls stayed at home, it is not surprising to find that the women artists who practiced in the Renaissance are few and far between, and almost always came from artistic families. Giorgio Vasari was typical in his history: he came from a family of Tuscan craftsmen who enhanced their positions through education, taking advantage of the improving social status afforded to artists in the region over the course of the fifteenth century.

While Vasari created many important works of art himself, it is ironic that his compelling judgments about the work of his friend Michelangelo, or that of Bronzino, his predecessor as court painter to the Medici, have established the works of those artists as superior to his own. In fact, Vasari's greatest legacy to the world of art, and indeed to Renaissance history and visual culture more broadly, comes not from his artistic practice (although he was a superb architect) but from his writing: as he gathered materials and composed biographies of the artists he regarded as important, he also invented a new way of studying—and perhaps of creating—art. In this effort, he had no rivals and his achievement is unsurpassed. Vasari was also one of the first people to collect drawings as an important medium in themselves, rather than as a disposable preparation for paintings, sculpture, architecture, or metalwork. He collected drawings because, as he knew at first hand, they documented the creative process of his fellow artists, allowing him to compare their styles directly with one another—activities that lie at the heart of what art historians, curators, and art dealers do for a living. Vasari's biographies stem from the idea that we can better understand art if we understand the lives of the people who created that art, an idea that can be applied usefully to most fields of historical study and that helped shape the way modern biography is written, relating accomplishments to personal background, examined through the prism of life story.

This consummate biographer, however, has attracted relatively little attention from biographers, and much of the scant attention is

surprisingly negative. Writing in 1911, the British architect Robert Carden began his *Life of Giorgio Vasari* by begging his readers' pardon for taking up his subject at all: "It may be urged by those who are acquainted with the works executed by Giorgio Vasari, both in architecture and painting, that they are not such as to merit the serious labor involved by an extended biography. . . ."[2]

The often grumpy Carden then reminded readers that Vasari was a biographer, as well as a painter and architect. And indeed *The Lives of the Most Eminent Painters, Sculptors, and Architects*, first published in 1550 and revised in 1568, has never gone out of style. More recently, scholars have also come to appreciate Vasari's contributions to the visual arts; but few of them will entirely disagree with Carden's sense that the excellent Giorgio fell somewhat short of titanic greatness. Line up a row of Vasari paintings beside the work of his contemporaries (Michelangelo, Bronzino, Pontormo, Parmigianino, Tintoretto, Andrea del Sarto), and he looks more like a follower than a trendsetter, an excellent, but perhaps not a superlative, craftsman. But he was not so much a follower as a synthesizer; deliberately, he evoked the styles of other painters to show that in his adopted city, Florence, and at his time, the mid–sixteenth century, the arts had reached a pinnacle that still left room for individuality. His citations from his fellow artists followed the self-description of the ancient Greek poet Pindar, who said that like a bee, he gathered honey from many flowers.[3] Perhaps no one has understood Vasari better than the brilliant, opinionated historian Eric Cochrane, whose *Florence in the Forgotten Centuries* remains one of the best (and best-written) books ever published on the city. To Cochrane, Vasari's driving ambition was "to cover the world with objects of beauty."[4]

If Vasari's idea of beauty is not entirely in line with contemporary taste, that is partly his own doing. His biographies created an elite among artists, skimming over, or simply ignoring, the thousands of minor local craftsmen (and the occasional woman) who supplied humble parish churches with their altarpieces, decorated the living

rooms of provincial burghers, and adorned the castle walls of minor nobility with frescoes and panel paintings, while stocking their gardens with sculpture. He would never dare to compare himself to his hero Michelangelo, and he presents a convincing argument why this should be so—so convincing, in fact, that we continue to believe him. As a writer, on the other hand, Vasari was unquestionably a genius. A bestseller in its own day, his book has never lost its popularity or diminished in influence. And why would it? Giorgio Vasari was a witty, thoughtful, amusing chronicler (and often a loyal friend) of the artists who, over the course of two centuries, had turned Italy into a thriving center for every kind of visual medium. At the same time, he was also a perceptive and influential critic, whose ideas in many ways have continued to shape the way we who come after him have looked at Renaissance art, history, and culture.

ALTHOUGH WE ASSOCIATE VASARI with Florence, the capital city in which he spent most of his career, he was actually born 45 miles to the south, in Arezzo, an ancient Etruscan city with its own illustrious heritage. This is where his great-grandfather Lazzaro, to whom Giorgio devotes a chapter of the *Lives*, came to settle with his family in 1427. Lazzaro Vasari worked both as a potter (*vasaro*) and as a maker of the fancy painted saddles and harnesses called barding, first in nearby Cortona and then in Arezzo.

Both crafts required skill at ornamental painting, and Lazzaro, according to his great-grandson, showed a special talent for working at this miniature scale: "And because in his day it was the custom to paint the bardings of horses with various kinds of designs and battle scenes appropriate to the owners, Lazzaro became a first-rate master of this art, especially because his specialty was making the small graceful figures that fit particularly well into this kind of setting."[5]

In Arezzo, his great-grandson reports, Lazzaro also began to take on more ambitious work as a painter, encouraged by his friend and

mentor, Piero della Francesca. One of the works that Giorgio ascribes to his great-grandfather, a fresco of Saint Vincent Ferrer in the church of San Domenico in Arezzo, still shows the influence of Piero in its clean lines and stately posture. Giorgio writes that "only the slightest difference could be recognized between them."[6] This was a great compliment, because Piero was the star around Arezzo and, as an apt mathematician as well as artist, is often credited with being the first painter to fully embrace mathematically accurate perspective. To this day, art historical tourists can follow "the Piero trail," visiting the master's works in situ, all within a few dozen miles of one another, passing from San Sepolcro (where Piero was born) to Monterchi to Arezzo, where his fresco cycle behind the altar in the church of San Francesco, *The Legend of the True Cross* (completed circa 1466), is the jewel of the city's abundant artworks, as it was during Giorgio's lifetime.[7] And Giorgio duly notes how Great-Grandfather Lazzaro adapted Piero's advances in emotive painting: "because he took great delight in certain natural situations, full of emotion, in which he expressed crying, laughing, shouting, fear, trembling, and the like, for the most part his paintings are full of this kind of invention."[8]

It was not always easy for Giorgio Vasari to discover exactly what Lazzaro had painted, and where. Modern art historians go to old bureaucratic archives in search of original contracts (surprisingly, these have survived in Italy in great numbers). So did Giorgio, but he also had the great advantage of gathering information from living people. He personally knew many of the artists he researched, or sought out their friends, colleagues, and relatives, penning many a letter to request biographical information. He ended up with scores of anecdotes of varying degrees of accuracy and separation from the artists themselves. For artists long deceased, like his great-grandfather, he gathered notes based on the patchy memories of kinsmen. Here, for example, is how he connected Lazzaro with the fresco of Saint Vincent Ferrer:

In this work, although there is no signature, the recollections of some of the older members of our family and the Vasari coat of arms lead us to believe firmly [in his authorship.] Without doubt there would have been some record [of his presence] in that convent, but because of the soldiers who have come through many times, the inscriptions and everything else have gone bad.[9]

Giorgio relied heavily on oral history in his research, which means that his *Lives* is adorned with memorable stories, by definition—the stories that those he interviewed remembered most clearly. Because his research ultimately told him so little about Lazzaro Vasari, Giorgio Vasari took special pains to explain why he mentioned the painter at all:

The pleasure is truly great for those who discover that among their ancestors and their own family there has been someone who achieves distinction in some profession, whether arms or literature or painting, or any other noble occupation. . . . I know how great this pleasure can be, because I have discovered that among my own ancestors Lazzaro Vasari was a famous painter.[10]

Thus this small-scale story provides useful clues to how Vasari approaches, researches, and narrates his other, more richly documented *Lives*. In the first place, he presents painting as a noble occupation, fully on a level with what his contemporaries regarded as the most prestigious careers of all: soldiery and literature. Secondly, he uses oral histories and visual clues in the artworks themselves to supplement the written sources on which his era, no less than ours, relied for factual information. He composes his accounts, finally, with an abundant dose of human sympathy and with a conviction that these stories will provide his readers with inspiring patterns of virtuous (and sometimes of not-so-virtuous) behavior.

Vasari's interest in history also ran in the family, along with its artistic inclinations. Lazzaro Vasari's son Giorgio, our Giorgio's grandfather, turned back to the family profession of pottery, but he did so in a thoroughly Renaissance manner. The driving force behind Renaissance art was its conscious revival of classical antiquity. Arezzo was one of the great ceramic centers of the ancient world, especially in Roman times, when it produced industrial quantities of a distinctive red embossed pottery called Arretine ware or *terra sigillata* (embossed ceramic). Examples of these popular vessels can be found in archaeological sites all over the Roman Empire, from Britain to India, and they still pop up in profusion from the ground in Arezzo itself.[11] In Etruscan times, some two millennia prior to the Renaissance and several centuries before the dominance of ancient Rome, local potters produced a burnished black ware called *bucchero* and traded with Greek merchants for the glossy black sheen and fine-grained fabric of Athenian ceramics.[12] Giorgio Vasari the Elder, as we shall see, was clearly familiar with both kinds of ceramic, the red and the black.

Giorgio Vasari the Elder consciously modeled his own work on these ancient examples, proving to his contemporaries that he was no illiterate craftsman, but rather an educated, historically informed professional. He enhanced the potter's craft by studying ancient examples, re-creating ancient methods (presumably combining them with more contemporary techniques), and carrying out his chosen occupation with an acute awareness of its important role in local history. This is the way his grandson describes him:

> he paid close attention to the ancient earthenware vessels of Arezzo, and . . . rediscovered the means of creating the red and black colors of the pottery that the ancient citizens of Arezzo worked all the way back to the times of [the Etruscan] King Porsenna. And because he was an industrious person, he made large pots on the wheel, one and a half braccia high, which can still be seen at home.[13]

A *braccio*, or an "arm" (the plural is *braccia*), was the preferred Italian Renaissance measure of length (0.6 meters, two feet), and a jar one and a half *braccia* high is a considerable feat of craftsmanship. But Giorgio Vasari the potter had cultural ambitions for his work, too. In producing ceramics inspired by the ancient Etruscans, he paid his own homage to the Renaissance ideal of combining the elegance of ancient art and literature with Christian revelation and modern technology.

Vasari's *Lives* of the Renaissance greats Donatello and Brunelleschi tell of their several-year sojourn together in Rome, where they studied and sketched ruined ancient buildings (especially Brunelleschi, the architect) and damaged statues (especially Donatello, the sculptor) to learn how these works had been created. The two friends came back to Florence armed with inspiration, but, more importantly, with "new" techniques borrowed from antiquity. Donatello taught himself the "lost wax method" of bronze casting, a means of making a hollow bronze sculpture by pouring the molten bronze as the filling in a "sandwich" of two layers of baked terracotta, and by recovering the ability to work on a large scale he established the tradition of the monumental bronze statue in the Renaissance. Brunelleschi took advantage of the peeled plaster, stripped-away marble façades and damaged husks of ancient Roman buildings, which had survived fires, earthquakes, and invaders, not to mention centuries of deterioration and looting by the local populace to reuse building materials, to learn the engineering tricks by which the Romans had been able to build on such a magnificent scale. He parlayed this knowledge into the dome of the cathedral of Florence (the interior of which Vasari would paint, in his last major project), bringing to the fifteenth century a dome on a scale that had not been seen since the time of the Roman Empire.

In this way, artists were among the earliest "archaeologists," although they would not have identified themselves as such. Instead, they explored ancient ruins to learn how past masters created, built,

and lived, with an eye toward adopting those methods in contemporary works, using erudition and tradition to spark their own creativity. Italians have always thrilled at their own legacies, proudly proclaiming the superior virtues of their own cities, tracing their origins back to ancient Greece (as in Naples) and imperial Rome. But Arezzo, as one of the largest Etruscan cities, was proud of an ancient heritage that stretched back to the days before Rome dominated the Italian peninsula.

So when Vasari takes the time to explain how Giorgio the Elder sought out and studied ancient Etruscan ceramics, developed his own collection of them, and used them as inspiration for his own pottery, he is praising his grandfather not only as a patriot but also as an intellectual and an artist—no mere skilled craftsman.

Throughout the Middle Ages, the names of specific artists were largely considered irrelevant and were rarely noted for posterity. A painter or sculptor, even a master mason, was perhaps paid better than a cobbler or a carpenter, but was not considered as belonging to a higher social caste. It was only in the fifteenth century in northern Europe (at the court of the duke of Burgundy, where Jan van Eyck balanced personal elegance, education, and charm with artistic ability to become a friend and valued member of the Burgundian court, even undertaking secret missions for the duke) and in sixteenth-century Italy with Leonardo and Raphael, the latter only one generation older than Vasari, that painters, sculptors and architects began to separate themselves from other craftsmen and obtain a higher social standing. Vasari's own career at the heart of the Florentine court and the papacy would do much to promote the status of artists, but nothing did more for that cause than his *Lives*, which singled out three "major" art forms—painting, sculpture, and architecture—as activities of the highest social and cultural significance. Had he included cobblers, then shoes might have been displayed today alongside oil paintings and marble statuary in our national galleries.

ALL KNOWN HUMAN CIVILIZATIONS, from prehistory to the present, have produced images, both two-dimensional paintings and three-dimensional sculptures.[14] Functional objects—vases, ceramics, textiles, armor, weaponry, religious statuary—were fashioned with care and often decorated. Yet these objects were largely regarded as the product of craftsmen, not artists in our modern sense (both the Greek term *techne* and its Latin equivalent *ars* convey "the ability to do something specific," a sort of mastery, not creative genius), even if they were lovely to behold, and even if they were more beautiful than functional.[15] As Salvatore Settis notes, "Classical civilizations, although certainly not shying away from judgments about quality and value, never raised the barriers familiar to us between what deserves to be called art and what does not."[16]

Up to Vasari's era, artists were still largely regarded as skilled manual workers. Normally, the objects they created were far more important than the reputation, identity, or genius of the creator. In Vasari's own time, and through his own efforts, this system of values shifted to create a still-vibrant cult of the creative artist, and the artistic biographies of his *Lives* helped document and cement the change. As the *Lives* themselves show, the shift from craft to art had already begun centuries before Vasari's birth. But when Francis I, the king of France, could write to Leonardo, Raphael, Michelangelo, and other Italian artists he admired, and humbly request something, *anything*, by their hand, it marked a drastic change from old ways of thinking. Because Francis admired these artists as ingenious, talented people, he cared more about their authorship than about the works themselves. He tried to persuade his favorite artists to move to Paris and work at his court, effectively collecting people, as well as their creations (and he succeeded in recruiting Leonardo, Benvenuto Cellini, and Rosso Fiorentino, among others, though Raphael and Michelangelo turned him down).[17]

The cult of artistic personality has reached new extremes in our own day, with developments like conceptual art. When an ordinary person breaks a vase, it still counts as an accident, but if the Chinese artist Ai Weiwei breaks a vase, the action is called art, and the shattered mess is worth a fortune. Through Vasari, we will see how this shift began to take place. The "invention of art" was really the "invention" of the artist.

This is why Vasari feels that it is important to demonstrate the erudition of his ancestor:

> They say that when he was out looking for vases in a place where he thought the ancients might have worked, he found . . . three arches from the ancient kilns three *braccia* underground, with many broken vases of that ware scattered around the place, as well as four whole vases, which he gave as a gift to Lorenzo de' Medici on introduction by the bishop; and this was the initial reason for the service he maintained ever after with that most fortunate house. Giorgio worked with great skill in bas-relief, as can be seen from some heads by his hand in his house.[18]

The gift of four Arretine vases to Lorenzo de' Medici was an event of crucial importance in the elder Giorgio's life, as we can tell from the fact that the contact between this humble, if learned, potter and a head of state had to be mediated by the bishop of Arezzo. For patriotic reasons, Lorenzo created the world's first collection of Etruscan antiquities, thereby driving a forceful distinction, historical, ethnic, and cultural, between his native Tuscany and his most powerful neighbors: Milan, with its ties to the Lombard invaders who overran Italy in the sixth century AD, and Rome, where the popes traced their authority back to the ancient empire.[19] The Etruscans had been a powerful, highly cultured civilization when Rome was a village of huts, and Milan had yet to exist; hence Lorenzo, like every Tuscan up to the present day, was only too happy to remind the world of this

fact. Crowned by the diplomatic and professional success of dealing with such an enlightened ruler, the elder Giorgio Vasari died in 1484, at the age of sixty-eight.[20]

His grandson, our Giorgio Vasari, was born more than a quarter century later, on 30 July 1511, to Antonio Vasari and his wife, Maddalena Tacci. The household was full of children; with his typical dry Tuscan humor, Giorgio would later declare, in a letter, that his father "would have a child from my mother every nine months."[21]

Families were large in those days for good reason. Many children never lived to adulthood. An estimated 17.8 percent of Tuscan babies died in their first year of life, in part because wealthier families put their infants out to poor wet nurses rather than keeping them at home, so that the mothers themselves could become pregnant again.[22] Childhood diseases carried off many of those who survived their infancy. Health problems that we now regard as treatable subjected Renaissance men, women, and children to lifelong misery—sinusitis, headaches, pneumonia, broken bones, skin disease, injuries, diabetes, cancer (named "the crab" for its ability to tear the flesh like a pair of crustacean claws). Our Giorgio, for example, suffered severe bouts of epistaxis (nosebleeds) that left him weak and made his parents fear for his life. According to his contemporary Benvenuto Cellini (a brilliant artist and writer, and very much a rival), "Little Georgie the Potter from Arezzo, a painter . . . had a dry eczema, which he always used his hands to scratch." (Cellini's exact term is "a mild dry leprosy.")[23] On one occasion, Cellini claims, "when he was sharing a bed with a good apprentice of mine named Manno, thinking that he was scratching himself, he practically skinned one of Manno's legs with his filthy little hands, and those fingernails he never trimmed. Manno wanted to kill him."[24] Given the hostility that Cellini obviously bears his poor itchy competitor, Giorgetto Vasellario, "Little Georgie the Potter," the story of his attack on Manno should probably be taken with a grain (or perhaps a bushel) of salt.[25]

Vasari himself tells how one of his great-uncles, the prominent

painter Luca Signorelli, tried to cure his childhood nosebleeds with an old home remedy: "And because he had heard, and it was the truth, that at that age my nose bled so copiously that I sometimes collapsed, he held a piece of red jasper to my neck with infinite tenderness."[26]

Signorelli was Lazzaro Vasari's nephew, a native, like Lazzaro himself, of Cortona and, like Lazzaro, a follower of the local legend Piero della Francesca. In the *Life* of Luca, Giorgio reports that "in his youth [Signorelli] made a great effort to imitate his master, and indeed to surpass him."[27]

From Piero, Luca Signorelli acquired a crisp, clear painting style and a fascination with optical effects. He employed perspective and foreshortening, the technical innovations at the heart of avant-garde art in the second half of the fifteenth century. Painterly perspective involved creating an illusion of depth in inherently two-dimensional paintings by making figures and forms that are meant to be more distant smaller than those meant to be in the foreground of the work. Imagine standing in an orchard, with one apple tree just a few feet in front of you, and another some forty yards into the distance. Although logic tells us that both trees are about the same size, the tree forty yards off appears smaller to our eye than the one right in front of us. Italian painters and sculptors began trying to reproduce this visual illusion in the fifteenth century, whereas past artists had been content for their figures and forms to float on the painted ground, with background shown in a flattened perspective, like two-dimensional theatrical "flats."

Some artists reveled in the science of art. Piero della Francesca wrote three advanced treatises on mathematics and geometry around 1480, Albrecht Dürer published two books on geometry and three-dimensional perspective in art in the 1520s, and the Renaissance architect Leon Battista Alberti wrote *On Painting* (1435), which was the first of the great Renaissance publications to teach artists the illusionistic secret of accurate perspective.[28] Items such as the camera obscura, which could project images of three-dimensional objects,

and therefore effectively allow artists to trace outlines, had been written about as early as the eleventh century in Islamic circles, in Abu Ali al-Hasan ibn al-Haytham's *Book of Optics* (1021), which was Alberti's primary influence. At least sixty-one manuscripts written between 1000 and 1425 have been discovered that discuss optics and optical instruments. But it was in the mid-fifteenth century that mathematics and optics would be applied to painting, predominantly by artists in Italy.[29]

After his return from Rome, around 1413, Brunelleschi made a public demonstration of perspective with his painting the Baptistery of Florence, which he displayed in the doorway to the cathedral, directly opposite the Baptistery itself. He then poked a pinhole through his painting and set up a mirror in front of it, facing the viewer and the painting. This allowed a viewer to look through the pinhole and compare Brunelleschi's perceptively accurate painting of the Baptistery (in the mirror) with the real Baptistery across the way. Our Giorgio tells the story in his *Life* of Brunelleschi, and is often cited as the point of origin of interest in perspective among the leading artists of Florence, including Donatello, Masaccio, Paolo Uccello, and Piero.[30]

Foreshortening was a similar innovation driven by a desire for naturalism (painting that is more like nature, what the eye sees) and by an interest in the mathematics behind art. Reproducing the illusion of depth in a single object, larger nearer to the viewer and receding as it extends farther back, is a component of graphical perspective.

These techniques are on display in an early work of Signorelli's in Arezzo (1474), the Accolti Chapel in the church of San Francesco, which was likewise the showcase for Piero's monumental fresco cycle, *The Legend of the True Cross*. Giorgio Vasari knew his great-uncle's painting intimately:

> In this fresco there is a Saint Michael weighing souls, marvelous, and in this figure you can see Luca's mastery in the splendor of

the armor, the reflections, and in short, in the whole work; he put a balance in [the saint's] hands, where the nudes, one rising, one sinking, are presented beautifully in foreshortening.[31]

Sadly, the fresco has deteriorated, and the image of Saint Michael that Vasari describes no longer exists.

Vasari learned to read and write at his local parish school in Arezzo, under the guidance of Giovanni Lappoli, a distinguished local teacher and writer with the curious nickname of Pollastra, "the Young Hen." Pollastra would become a lifelong friend who also did Vasari a magnificent favor by asking his great-uncle Luca Signorelli to encourage the boy's artistic talents:

> Because [Luca] stayed with the Vasari household, where I was a little boy of eight, I remember that good old man, who was entirely impeccable and gracious, having heard from my elementary schoolteacher that I did nothing in school but doodle—I remember, I say, that turning to my father, Antonio, he said, "Antonio, if you mean to keep Giorgino in line, make sure that by all means he learns to draw, because even if he pays attention to literature, drawing, for him as for all gentlemen, cannot be anything but useful, honorable, and helpful." Then he turned to me—I was standing right opposite him—and said, "Learn, little kinsman." He said a number of other things about me, but I will not repeat them because I know how very far I am from living up to that excellent old man's opinion of me.[32]

"Giorgino" was wise enough to take his great-uncle's advice. He began to spend his leisure time sketching inside Arezzo's churches, where he was lucky enough to see some of the greatest paintings of the fifteenth century, as well as some splendid examples of medieval Romanesque architecture. Of the paintings, none were more glorious than frescoes of Piero della Francesca's *Legend of the True Cross*, in the

church of San Francesco, the same place where he admired his great-
grandfather's image of the archangel Michael:

> But for creative power and technical ability nothing surpasses
> [Piero's] having painted a night scene with an angel in foreshort-
> ening . . . who with his own light illuminates the tent of Con-
> stantine, the soldiers and all the surroundings, [executed] with
> great discretion: for in this darkness, Piero shows how important
> it is to imitate real things, and derive them from personal experi-
> ence. By having done this so well, he has given modern painters
> good reason to follow him and to reach that supreme degree of
> accomplishment which we see today.[33]

In San Francesco, the young Vasari could also see a new stained
glass rose window installed by another of his mentors, a friendly
Frenchman named Guillaume de Marcillat. In Arezzo, people called
this talented craftsman Guglielmo da Marcilla, the name by which
Vasari refers to him in his *Life*.[34] The people of Arezzo came to know
"Guglielmo" extremely well. For more than ten years, from 1518
until his death in 1529, Marcillat set up shop in Arezzo. He was
already well established as the most important maker of stained glass
in the Italian Renaissance as well as a painter of considerable skill; one
of his panel paintings survives in Berlin.[35] His relationship with the
city was exceptionally warm:

> Because of his long residence and the affection he bore for the
> city of Arezzo, it can be said that he chose it as his homeland, and
> everyone considered him and called him an Aretino. And truly,
> one of the benefits that can be obtained from excellence is this:
> a man may come from a distant foreign region or a barbarous
> and unknown nation, but if virtue adorns his soul and his hands
> perform some clever operation, no sooner will he arrive in any
> city where he sets foot, and demonstrate his skill than his excel-

lent work will pass by word of mouth and make him a name in a short time, and his qualities will be greatly prized and honored.[36]

Vasari not only dedicated a *Life* to Guillaume de Marcillat but also honored him with a poem, an indication of the lofty respect he felt for this Frenchman turned fellow citizen. The sestina revolves around the word that ends every line: *bello*, which can mean either "beauty" or "beautiful" and therefore makes translation virtually impossible without somewhat unwieldy repetition:

In this body the most surpassing beauty's
A beauteous eye, beauty beyond all beauty;
So in Arezzo's church the greatest beauty
Is in its windows, every other beauty
Is lesser; time itself acquires such beauty
That beauty can attain no greater beauty.[37]

Much is made, throughout Vasari's *Lives*, and indeed the history of art, of the chronology of influence, chronicling which young artist studied under, or worked alongside, which master. This is important for several reasons, both artistic and art historical. Precious little is known about most artists in the past. Those who were linked to aristocratic courts tended to leave behind more records, as did the unfortunates who got into legal trouble. Court documents—in both senses of the term, for law courts and princely ones—are more likely to provide details and survive the centuries, carefully preserved in archives. Artists as influential as Hieronymus Bosch, Rogier van der Weyden, and Giorgione have largely incomplete biographies, for the simple fact that whatever documents might have been written during their lives, describing their activities (usually the most important life events, like birth, death, marriage, or prestigious commissions), have not survived. Nevertheless, an analysis of influence in terms of style, seeing the hand of Piero in Luca Signorelli's paintings, for example, can help

reconstruct the life of Luca, because making a Piero-like painting allows us to conclude that he studied under Piero. Young artists were taught to work in the style of their master, to the point that their work might be indistinguishable, creating a chain of influence that can be traced stylistically, if not through surviving documentation.

Along with his artistic gifts to Arezzo, Guillaume de Marcillat gave a very personal, marvelous gift to the young Giorgio Vasari, that of a master to a pupil. In an aside to his *Life* of Francesco Salviati, Giorgio declares that it was Marcillat who first taught him to draw.[38] By the terms *disegno* and *disegnare*, Vasari meant not simply sketching, or recording what he saw, but drawing as a way of measuring and composing. In his world, *disegno*, which still means both "drawing" and "design" in Italian, was the fundamental step in the education of an artist. There was no greater legacy that Marcillat could have passed on to his ambitious young friend.

4

FROM AREZZO
TO FLORENCE

*D*ISEGNO MAY HAVE STOOD AT THE HEART OF THE TUSCAN
artistic tradition, but such rigorous emphasis on drawing was
not a universal practice in Europe, or even in Italy; it was distinctly
local, essential in Tuscany and Rome, but much less so in Venice.
For a foreigner like Guillaume de Marcillat, working in Italy meant
adopting a whole new way of thinking about the very basis of artis-
tic technique. When he came to Rome at about the time of Gior-
gio Vasari's birth (1511), he found that colleagues like Raphael and
Michelangelo put their hands to paint only after an intensive period
of drawing, beginning with quick, sketchy figure studies, proceeding
to more polished intermediate, midscale designs, and culminating in
full-size paper patterns for frescoed walls. By outlining the figures
of these huge preparatory drawings, "cartoons," with a series of pin-
pricks and then blowing ash through the pinholes, a fresco painter
could transfer drawn designs directly onto walls. The results of this
concentrated attention to drawing—including the Raphael rooms
in the Vatican and the Sistine Chapel ceiling—inspired Marcillat to
adjust his own working methods, again with impressive results. As
Vasari would write years later,

> When he first arrived in Rome, even though he was experienced
> in other things, Guglielmo did not have much *disegno*: but once

he understood the need for it, despite his being well on in years, he gave himself over to drawing and studying, and thus, bit by bit he improved it . . . his [later] works are much different and better than the first ones.[1]

Michelangelo was passionate about the importance of *disegno*: in the margin of one of his own drawings, he wrote these instructions to one of his pupils: "Draw, Antonio, draw, Antonio, draw, don't waste time."[2] In the general remarks that preface his *Lives*, Vasari emphasizes that *disegno* is more than a practical skill; it is a philosophy:

> This *disegno*, when it brings forth a creative idea from our critical faculty, requires a hand ready and able, thanks to years of study and practice, to draw and to express well whatever thing Nature has created, with a pen, a stylus, a charcoal stick, a pencil. . . .[3]

The idea was that sufficient training, from an early age, would make skillful drawing automatic, the way a heart surgeon, after decades of bypass surgeries, can perform the intricate movements required with a natural, unstudied ease. After practicing *disegno* long enough, one can just think up an image or idea, and it will flow forth from one's pen. Vasari continues,

> For when the intellect sends forth its concepts clearly and with judgment, those concepts will make hands that have exercised *disegno* for many years understand both the perfection and excellence of the arts and the expertise of the artist.[4]

As Vasari himself reports, Marcillat initiated his formal instruction as an artist: "after I had drawn all the good paintings there are in the churches of Arezzo, the first principles were taught to me with some order by Guglielmo of Marzilla, a Frenchman."[5]

"First principles" and "order" were terms with precise meanings in the early sixteenth century: "first principles" were the basic terms and techniques of draftsmanship and composition, like "line," "figure," "shadow," and "perspective." "Order" meant putting those first principles into some kind of a meaningful sequence, to produce a set of instructions or a point of view: in this case, "some order" probably means that Marcillat supplied guidelines about how to look at and think about art, guidelines important enough and clear enough for a ten-year-old boy to grasp. Guillaume de Marcillat taught him *disegno* in the most literal sense: drawing with a pen or a stick of charcoal on paper, taking care to waste neither the paper, which was expensive, nor his time. Only the more advanced apprentices were allowed to work with color. This is how Giorgio Vasari envisioned an ideal education in *disegno*:

> Now, whoever wants to learn how to express the ideas of the spirit and any other thing whatsoever in *disegno* will need, once he has accustomed his hand a bit, to practice drawing figures in three dimensions, of marble, or stone, or the cast of a person or an ancient statue, or else terracotta models, either nude or draped in clay-stiffened rags that can serve as draperies and clothing; for all these things, motionless and devoid of feeling, are extremely handy, being immobile, for the person drawing them, something that does not occur with living, moving things. When he has had good practice in drawing such things and gained a surer hand, then let him begin to draw natural things, taking every possible care to have a good, secure technique, because the things that come from nature are truly those that bring honor to the person who has made such effort . . . from her creations we learn perfectly, whereas we never learn enough from the creations of art. And take this as a firm principle: that the practice obtained by many years of studious drawing . . . is the real light of *disegno*, and what makes people outstanding in their field.[6]

In 1524, Marcillat's precocious pupil, Giorgio di Antonio Vasari, moved on from Arezzo to an apprenticeship in Florence. It was a natural step for a boy who showed unusual artistic talent, but it was not a step that anyone could take for granted. It meant pulling out every connection the Vasari family had forged with the Medici since that crucial moment in 1474 when Lazzaro Vasari made his gift of four Arretine vases to Lorenzo the Magnificent. Every link helped, from the web of Vasari relatives in Cortona to Giorgio's teacher Pollastra, a longtime supporter of the house of Medici. So, however, did the poise young Giorgio showed when called upon to perform for a visiting cardinal:

> In the year 1523, when Silvio Passerini, cardinal of Cortona, passed through Arezzo as a legate of Pope Clement VII, Antonio Vasari, who was related to him, sent his eldest son, Giorgio, to pay homage to the cardinal. When he saw that this boy, no more than nine years old, had been so well instructed in his letters (by the diligence of Messer Antonio Saccone and Messer Giovanni Pollastra, an excellent poet of Arezzo) that he knew a great deal of Virgil's *Aeneid* by heart, he wanted to hear him recite it; and when he saw that [Giorgio] had learned to draw from Messer Guglielmo da Marzilla, he ordered that Antonio himself should bring the boy to Florence.[7]

An order from Cardinal Passerini was not to be taken lightly. His position as papal legate to Florence was among the most powerful in Italy, for he also acted as tutor for the Medici family's two heirs apparent, Ippolito and Alessandro de' Medici, both of whom were exact contemporaries of Giorgio Vasari (Alessandro was born in 1510, Ippolito in 1511). Both boys traced their lineage directly back to Lorenzo the Magnificent, although they were "natural" sons, born outside of marriage, and therefore in a somewhat precarious social position. As descendants of Lorenzo, they had a right to live in the

grand Palazzo Medici on the Via Larga, together with a third young legitimate Medici descendant, Caterina, born in 1519. In the sumptuous palazzo designed to hold a deathless dynasty, the three children on whom the future of that dynasty relied lived as wards of the Medici entourage, virtual orphans with an illustrious lineage, limited rights, and a highly uncertain future.

It was not even clear how exactly they were related to each other. Caterina was a real orphan of known descent. Her grandfather Piero had been Il Magnifico's eldest son, who sired her father, "Lorenzino," duke of Urbino. Lorenzino and his French wife, Madeleine de la Tour d'Auvergne, produced Caterina in 1519, the year that Lorenzino died, ravaged by syphilis.[8] Eventually she would become queen of France and import the Italian Renaissance to the French, who, at that period, were still inspired by their own great Gothic heritage in the arts.

In theory, at least, Alessandro de' Medici was Caterina's half brother. He was a "natural" son of her father, Lorenzino.[9] Alessandro's dark coloring suggests that his mother may have been of African descent, and he was called "il Moro," which in Italian could mean either a person with dark hair or, specifically, a Moor.[10] His black hair may well have come from his father's side as well, for a persistent rumor held that Alessandro was really the son of darkly handsome cardinal Giulio de' Medici, the future Pope Clement VII, and was therefore called "moro" in the follicular sense.

Ippolito de' Medici, one year older than Alessandro, was the child of Lorenzo the Magnificent's youngest son, Giuliano, duke of Nemours, who never married and died in 1516.[11] His patrician lover had been married to someone else at the time of Ippolito's birth, and so the boy was quickly absorbed into the Medici clan. Just before his election as pope, between 1521 and 1524, Cardinal Giulio de' Medici (the possible real father of Alessandro) ordered Michelangelo to immortalize his two recently deceased relatives, Lorenzino and Giuliano, in marble. There, in the New Sacristy of the Florentine church of San Lorenzo, in full military gear, accompanied by the

personifications of Dawn, Dusk, Day, and Night, they look far more impressive in art than they ever did in life. Alessandro and Ippolito must have been brought in to admire them often.

Lorenzo the Magnificent's middle son, Giovanni de' Medici, had gone into the Church, the customary career choice for second sons in Renaissance Italy, although most of these second sons were not made cardinal at the age of fourteen! In 1513, the precocious Cardinal Giovanni was elected pope at the equally precocious age of thirty-seven, taking the name Leo X. In that same year, with the new pope's backing, Giuliano, Ippolito's father, retook Florence for the Medici family from a short-lived republican government, thereby forging a potent link between the Tuscan city and Rome, reinforced by a host of financial ties between the Papal Curia and the Medici bank, the source of the family's prodigious wealth and power. In 1517, Leo created a large number of new cardinals, including Silvio Passerini of Cortona and his own cousin Giulio de' Medici (the son of Lorenzo the Magnificent's brother, Giuliano de' Medici, a handsome youth who had fallen victim to an assassin in 1478, and would have been Pope Leo's uncle had he lived).[12] Cardinal Giulio inherited something of his father's dark good looks (though not, apparently, Giuliano's athletic build—he was decidedly pear-shaped), and all of his taste for literature and the arts. In 1523, two years after Pope Leo's death and after the brief reign of a dour Dutchman, Adrian VI, Cardinal Giulio ascended the papal throne in his own right as Clement VII, the second Medici pope in rapid succession (there would eventually be four of them). At the moment of Vasari's arrival at the Medici court, therefore, the connections between Florence and Rome were closer than ever, and the position of the Medici family was consolidated in both cities, not to mention in most of the rest of Tuscany. These labyrinthine political machinations provide the backdrop to Vasari's story, the chessboard on which he would play out his life and work, influential and close to those in power, though never wielding it himself.

Up until his election as pope, Cardinal Giulio had been the de

facto head of government in Florence; now, however, with the onset of new responsibilities (including a revolt of German Catholics against papal authority, led by Martin Luther), he was compelled, as Pope Clement, to delegate his authority. To ensure a continuous Medici grip on Florence, Clement vested supreme authority over the city in his twelve-year-old (probable) son Alessandro and his eleven-year-old nephew Ippolito—under the fatherly guidance of their tutor, Cardinal Silvio Passerini, and another, more distantly related, middle-aged member of the family, the capable Ottaviano de' Medici, who lived just up the street from the great Palazzo Medici in a palazzo on Piazza San Marco. Thus Cardinal Passerini's trip through Arezzo en route to Florence turns out to have been an extremely important occasion for the cardinal himself, as well as for the young Giorgio Vasari; it marked Passerini's own accession to genuine political power over a large part of Tuscany. And given the ages of his two charges, eleven and twelve, it is clear that in commanding Antonio Vasari to bring Giorgio to Florence, he meant for this talented boy from Arezzo—his own relative, after all—to keep company with the two Medici boys and hold them, as much as possible, on a path of industrious work habits and a spirit of public service. Unfortunately, Alessandro, in particular, did not provide promising material.

If Florence had been the supreme Medici stronghold in the early sixteenth century, within Vasari's own lifetime their fiefdom would come to include all of Tuscany. Whenever a Medici family member sat on the papal throne in Rome, the rest of the clan could count on added wealth and favors, but they were never so rash as to trust Fortune entirely. Italy in the fifteenth and sixteenth centuries was in fact a cluster of gauntlet-fisted city-states that would unite as the nation-state of Italy only in 1861. Feudal dynasties, headed by warlords, governed cities and territories, often well into the seventeenth century: the Gonzaga family in Mantua, the d'Este in Ferrara, the Sforza and the Visconti in Milan, the Malatesta in Rimini, the Montefeltro in Urbino, the Doria in Genoa, the Medici in Florence, the Petrucci in

Siena, the Vitelli in Città di Castello, the Monaldeschi and Farnese in Orvieto. These dynastic families waged war on each other, intermarried, formed alliances among themselves, with the great monarchies of France and Spain, and with the Holy Roman Emperor. Because soldiering, *il mestiere delle armi*, stood as the highest calling of an aristocrat, Renaissance Italy suffered from an excess of warlords, who often commissioned wonderful art, but whose real effect on society was almost entirely detrimental.

The Medici had begun to make the transition from bankers to warlords in the fifteenth century and, for their arrogance, were finally exiled from Florence between 1504 and 1513. By 1523, however, thanks to Popes Leo X and Clement VII, Florence and the Medici had once again become inseparable. This time, however, they recognized as a dynasty how closely their fortunes were tied to the Church and to Rome, a city that Leo and Clement had pointedly worked to style in public sermons, art, music, and literature as the universal capital of Christendom.

By this time in the early sixteenth century, Florence, under the Medici, had been an influential and powerful center for culture for more than a century. But the city, with an improbable abundance of talented creators—artists, writers, thinkers—still huddled within city walls that surrounded what was not much larger than a substantial village. The population in 1500 was just around 60,000, tiny considering its influence. The city today covers thirty-nine square miles, but in those days it was far more compact. It is thanks to the wealth and good taste of its Medici patrons that Florence became a magnet for the most talented artists of Italy and, indeed, Europe. But wandering its streets even today, when its population has risen to some 300,000 full-time residents (and millions of tourists each year), one can feel just how small the city really is. This compact size has been an important element of Florentine patriotic pride, symbolized by its favorite biblical hero, David, whose many statues (like those by Donatello, Verrocchio, and, of course, Michelangelo) warned visiting dignitaries

that the little city was ready, like David, to take on any neighboring Goliaths with big ideas. And like David, the Medici were shrewd political operators. Having regained power, with a pair of back-to-back popes to fill the family coffers and boost patronage, they could genuinely consider themselves not only masters of Tuscany but players on a European-wide stage.

Thus the Medici and their counselors had begun to think about their dominion differently than they had in the fifteenth century: on a scale closer to that of a nation-state and in a perspective that included the broad sweep of human history. Similar ideas about politics were also occurring to one of the men that Duke Giuliano de' Medici had driven out of Florence in 1513: Niccolò Machiavelli, a former member of the city government who now lived in exile just outside Florence in his villa at San Casciano and spent his time reading and writing. This was the world into which Giorgio Vasari entered in 1524, an extraordinarily fortunate young man, but also a young man prepared to work as hard as he could to merit his social promotion.

Because he was neither a pageboy nor an aristocrat, and therefore not someone who could be appropriately housed in the Palazzo Medici on Via Larga, young Vasari was housed with a well-to-do Florentine family closely allied with the Medici, the Vespucci (the same family as Amerigo Vespucci, after whom America is named):

> There he was put in the house of Messer Niccolò Vespucci Knight of Rhodes, which was on one rampart of the Ponte Vecchio above the church of the Sepulchre, and he was set up with Michelangelo Buonarroti. . . . [I]n the meantime, Vasari did not leave off studying literature, and by order of the cardinal he spent two hours a day with Ippolito and Alessandro de' Medici being tutored by Pierio Valeriano, their teacher and an excellent man.[13]

The Hospital of the Holy Sepulchre, where young Vasari resided, was an imposing fourteenth-century structure built at the entrance

to the Ponte Vecchio on the "other" side of the Arno River[14] by the Knights Hospitallers of Saint John of Jerusalem and Rhodes, a crusading order of celibate warrior-doctors soon to be known as the Knights of Malta.[15] Niccolò Vespucci and his companions had taken monastic vows and observed celibacy; in effect, then, young Giorgio was living in a very high-class dormitory, dividing the rest of his day between Michelangelo's workshop and the classroom he shared with Ippolito and Alessandro de' Medici. Although Michelangelo owned houses on Via Mozza, near the present-day Casa Buonarroti in the Santa Croce neighborhood, he spent much of his time on the other side of Florence, in the Palazzo Medici and the Medici church of San Lorenzo. The lessons with Ippolito and Alessandro de' Medici took place in the Palazzo Medici on Via Larga. An average day in the life of Giorgio Vasari, therefore, took him on a brisk and scenic walk right through the center of Florence, from Oltrarno to Via Larga, and it is unlikely that he ever grew tired of it.

It is hard to imagine two more enthralling teachers than the pair who instructed Giorgio Vasari in art and literature. Pierio Valeriano is less well known today than Michelangelo, but in his own day he was an exceedingly popular writer, famous for his wit and his erudition.[16] He must have warmed to the young man from Arezzo, because Valeriano, too, came from humble beginnings—born Giampietro Valeriano Bolzani, a native of the Italian Alpine town of Belluno, he had learned to read only at the age of fifteen. He made up quickly for lost time, earning a degree at the University of Padua before heading south to Rome in 1509, where he joined the household of Cardinal Giovanni de' Medici, the future Leo X. Pierio Valeriano was the literary name he assumed in Rome, his given name Pietro transformed to look suggestively like Pieria, the Greek homeland of the Muses (this is the region north of Athens that contains Mount Helicon and the fabled Vale of Tempe).

Valeriano's most ambitious work was a thousand-page study of Egyptian hieroglyphs, *Hieroglyphica; or, Commentaries on the Sacred Let-*

ters of the Egyptians, the first book of its kind, complete with a dictionary of contemporary Renaissance symbols, the hieroglyphs of the modern age.[17] Shapes, symbols, and words fascinated Valeriano, perhaps unsurprisingly for someone who had learned to "decode" the shapes of the alphabet so late in life. He also took up the recondite Late Antique art of composing "concrete" or "pattern poetry," in which the words of the poem on the page form a shape that evokes the poem's content: his 1549 poem "Pierus," for example, is written in the shape of a pear, playing on his given name Pietro, his literary name Pierio, and the Latin word for pear, *pirus*, and paying homage to the Late Antique poet Optatian, who specialized in these playful combinations of verse and geometry.[18]

Valeriano also wrote a series of biographies entitled *On the Ill Fortune of Learned Men* (*De Literatorum Infelicitate*).[19] All of these efforts, however, were still in the future when he settled in Florence in 1523 to teach the Medici boys and their young companion from Arezzo the fine points of eloquence in Latin and the Tuscan vernacular. Like his contemporaries, Valeriano was deeply involved in what was called "the language question," *la questione della lingua*: could the vernacular achieve the same degree of solemnity, elegance, and expressiveness as classical Latin? In Florence, the answer was always destined to be yes, because Renaissance Florentines (and their descendants to this day, who feel they speak the purest and most elegant Italian) believed that their vernacular language, and their distinctive pronunciation of it, derived directly from Etruscan rather than from Latin (once again in competition to boast the oldest founding myth), and because Dante, the great Florentine poet, had written the *Divine Comedy* in Tuscan vernacular.[20]

The fact that Vasari was "set up" immediately with Michelangelo testifies to his artistic skill; there was no more exacting master in Florence, and none more famous. No recommendation could possibly have substituted for competence, and no doting father or cardinal in the family would have tried to commend the young Vasari to Michel-

angelo's studio if he had not been up to the assignment. At fifty-one, Michelangelo was still able to hew marble more swiftly than any other sculptor, but, in true Florentine tradition, he started every project with a *disegno* ("draw, Antonio, draw, Antonio, draw").

In Michelangelo's day, the process of painting or sculpting was divided into two stages: *invenzione* and *disegno*, two terms that Vasari frequently employed. *Invenzione* refers to the concept of a work that the artist has in mind before proceeding to create the physical object, involving theoretical knowledge of how to make something new, intriguing, provocative, and appealing. *Disegno* literally means a "drawing" or "design" and depends on the artist's physical ability to execute the concept, the *invenzione*. Paolo Uccello, for example, excelled in *invenzione* and perspective, but his deficiencies in *disegno*, "execution," make his work perhaps more interesting than beautiful. Vasari, typically, tells us that Paolo loved birds and hated cheese, but then "Uccello" means "bird" in Italian.

Vasari's description of his apprenticeship with Michelangelo is as brief as the apprenticeship itself: it lasted only a few months, and then Pope Clement summoned Michelangelo to Rome. That season was long enough, however, for Vasari to have earned his teacher's favor, and Michelangelo personally arranged for his young apprentice to move to the workshop of Andrea del Sarto in 1525.[21]

Since his return from France in 1520, Andrea del Sarto had run one of the larger painters' workshops in Florence from his stately house (still standing) on the corner of the present-day Via Gino Capponi and Via Giuseppe Giusti. A number of artists had settled in the area around the basilica of the Santissima Annunziata, which housed the official Florentine artists' guild (in those days still part of the pharmacists' and doctors' guild), making for a constant interchange among masters and their apprentices (as well as lively doses of gossip). By shifting from Michelangelo's studio to Andrea's, Vasari received a solid grounding in what would become his primary métier—painting.

In a Florentine painter's studio like that of Andrea del Sarto, scents

of linseed oil, sweat, and sawdust would have greeted the visitor outside the door. Ideally, the large windows would face south to catch the best possible light, and the studio had to be tall enough, and wide enough, to accommodate altarpieces of all sizes. Sawdust, scattered on the floor, absorbed splatters and facilitated cleaning, as apprentices like Vasari, aged eight to eighteen, mingled with older paid assistants, bustling around the space, sweating profusely into grimy leather smocks, laughing, cursing, mopping, grinding pigments, creating an atmosphere that was surprisingly lively and social. The Romantic image of a lone artist painting in a garret did not apply to sixteenth-century Italy, or anywhere else in Europe—in Wittenberg, Lucas Cranach, a contemporary of Andrea del Sarto and Raphael, ran a veritable factory.

Wooden panels, expensively and carefully prepared by specialist carpenters from aged, tempered pear or similar woods that resist insects and warping, would have been stacked in a corner. These carefully planed boards could be very expensive indeed, especially when several of them were joined together to prepare a single large surface. The panels were prepped for painting by adding a grounding of gesso, a messy, sticky mix of chalk and rendered animal connective tissue (rabbit skin was popular), boiled at around 140 degrees Fahrenheit. For paintings on canvas, rather than wooden panels, gesso is an absolute necessity because the linseed oil binder for oil paints is mildly acidic and could eat through canvas over time.

In addition to a ready supply of panels, another corner of the studio would have bristled with rolls of hemp canvas, which apprentices nailed to wooden frames, called stretchers, to make taut supports for painting. After the gesso, the panels and canvases, collectively known as supports, were ready to receive a base coat, applied by yet another apprentice. For landscapes, the preferred base layer was brown; for seascapes, blue; and for portraits, an olive green, at least in Italy, to subtly bring out the olive tone of the Mediterranean complexion. Titian, however, favored red underpainting, giving his faces and

plump cherubim a lively, bright tone. Only after these sublayers had dried was the support ready for the actual, detailed painting.

In another corner, arrayed with pots of precious pigments in jewel-like colors, the younger apprentices would have prepared paints by hand, according to the preferred recipe of the master—tubes of pre-mixed paint were not invented until the nineteenth century. In earlier times, each artist purchased pigments (often at great expense), mixing and grinding them in the studio to produce a totally individual choice of color palette. While making black from charcoal is fairly straight-forward, other colors were harder to come by. Reddish browns came from mineral pigments. The colors we know as raw or burnt sienna and raw or burnt umber hailed from the regions of Siena and Umbria; Tuscan painters knew them well). The priciest pigment of all was a cobalt blue made from the semiprecious stone lapis lazuli, mined in the area that is now Afghanistan and transported to Europe down the long and perilous Silk Road. In the Middle Ages, lapis lazuli cost more by weight than saffron or gold and, for this reason, was usually reserved for the garment of the Virgin Mary. Unlike cheaper copper sulfate blue, which tended to turn bright green, the ultramarine blue of lapis lazuli never turned—it was true blue, worth its high price.

Andrea del Sarto sometimes used a striking red to paint garments, a color born of the pigment called vermilion. This was bad news for the apprentices who had to grind it—it is actually a toxic mercury compound, made from powdered cinnabar. Another option for red pigment was carmine red lake, produced by extracting carminic acid from the powdered bodies of the cochineal, a type of scale insect. This recipe for making paint and food coloring from crushed bugs has been in use since the time of the ancient Egyptians and can still be found today.

Much of a sixteenth-century studio space would have been taken up with paintings that were waiting to dry. If an artist worked in egg-based tempera (quite literally an egg cracked open, the yolk used as a binder to stick the pigments onto the support), then drying was

relatively quick. The medium was essentially opaque: each layer of paint completely covered whatever lay beneath it. Oil paint used the same pigments as tempera, but bound them with linseed or nut oils rather than egg yolk. This produced slow-drying, luminous colors that could be thinned to become a nearly transparent glaze, so that artists could attain more precise detail and build up layers of color to dazzling effect. Central Italian painters from the Middle Ages to the sixteenth century worked primarily with egg-based tempera paint on wooden panels or, for walls and ceilings, in fresco, which was pigment diluted with water and applied to wet plaster. The painters of Venice and northern Europe, on the other hand, often used glistening, slow-drying oil-based paint on wood or canvas, and by the early sixteenth century most painters throughout Europe preferred oil.

Smelling of oils and sawdust, a large studio like Andrea del Sarto's would have included many active painting projects at various stages of completion at any given time, because each layer of oil paint had to dry completely before a new layer could be applied. This process could take months. A few of the panels would be actively painted in any given day, while a score or more might be drying, waiting for the moment when the next layer could be added. Years might pass from the moment of a commission to the handover of the finished product, but actual, active painting would have amounted to a matter of weeks.

Depending on local regulations of the guild of painters, a sort of union that kept track of those who practiced their craft (and usually called the Guild of Saint Luke, for Luke is the patron saint of painters, said to have painted an icon of the Virgin Mary from life), a master artist could have a specific maximum number of apprentices and assistants. Too many, and it diluted the output of the studio, the assumption being that a master could not possibly supervise a studio that was too expansive. Regulations such as these were often circumvented—Rubens had over thirty people working for him at one point, when the Antwerp guild maximum was fourteen. Yet Vasari profiled only the masters, while overlooking the team that collaborated on their

masterpieces. Writers and artists of the Romantic era embellished Vasari's Renaissance stories of lonely, forlorn, melancholic geniuses, basing their fantasies on figures like the morose Heracleitus in the foreground of Raphael's *School of Athens* (a portrait of Michelangelo).[22]

Assistants, moreover, were future masters in the making. Young Vasari assisted a series of artists, including Andrea del Sarto, before becoming the leading artist of Italy. Rubens's most famous pupil was Antony van Dyck, who passed from creating works by "Rubens" to works in his own right. In some cases, the pupil outshone the master. Fewer people have heard the name of Giuseppe Cesari, called the Cavaliere d'Arpino, than that of his most famous assistant, Caravaggio, briefly responsible for painting still-life details and architectural backdrops to the cavaliere's competent but conventional paintings. And it is Vasari who enshrined the famous story of Verrocchio's *Baptism of Christ*, in which his young pupil Leonardo da Vinci painted a single figure in the group. The angel he painted was so much better than the rest of the painting that Verrocchio decided it was time to retire from painting and stick to his specialty—sculpture.

Apprentices were indentured to members of a trade, as early as the age of eight. They would sign contracts with the master, who agreed to feed, house, and train them, in exchange for their labor until a specified age, usually sixteen or eighteen. At that point, trained apprentices could stay on or move to the studio of another master for a salary, or they could prepare a "master piece," a single work that was exemplary of what the young artist was capable, which was submitted to the local painter's guild. On the basis of that work, the guild would determine whether the trainee was sufficiently skillful to become an independent master, and therefore run his own studio and accept commissions himself.

Although Vasari respected Andrea's accomplishments as a painter, he had absorbed Michelangelo's rigorous work habits and found the del Sarto studio decidedly less stimulating. Andrea was a henpecked husband, whose beautiful wife, Lucrezia, modeled for many of his

Madonnas, but kept the artist and his workshop on a tight leash. As Vasari would later write, "Had Andrea had a slightly more courageous and assertive spirit to match his profound intelligence and judgment in this art, he would have been, beyond any doubt, unequaled."[23]

Life as an apprentice meant long days in tight studio spaces crowded in with a dozen other pupils and assistants. Commissioning a work by Andrea del Sarto did not mean that the master would do all the painting himself. The more one paid (or the more prestigious the patron), the greater the master's hands-on involvement. In most cases, he would design the work, supervise its execution, and personally handle the hands and faces, considered the two most difficult tasks. But backgrounds, still-life elements, architecture, draperies, furniture, and the like would almost certainly be painted by paid assistants or indentured apprentices learning the trade. (Raphael was an exception; in some of his later paintings, he has clearly done the background and left the main figures to trusted collaborators like Giulio Romano.)

Regardless of the quality of an artist's work, or his patience and ability at instruction, there was a social dynamic to the situation, to be either enjoyed or endured.

> Andrea had an endless number of pupils, but not all of them made the same course of study under his tutelage, because there were some who spent a great deal of time with him and others who spent little, not because of any fault of Andrea's, but because of his wife, who vexed them constantly by showing respect for no one and imperiously giving orders.[24]

Vasari was one of the artists who could put up with Lucrezia for only a short time. Shortly afterwards, Ippolito de' Medici, his patron and classmate, arranged to move him from del Sarto's studio to that of the sculptor Baccio Bandinelli, a Medici favorite. Vasari's closest friend among Andrea's pupils, the promising Francesco Salviati, moved as well.

It is impossible to understand Bandinelli's success in his own day by looking only at his sculpture; what brought him commissions was his ability at *disegno*. His preparatory drawings are exquisite, some of the best in the business. Vasari, however, quickly came to despise him; his *Life* of Bandinelli is so virulent that he dared not publish it in 1550 when the artist was still alive, as the sculptor might have sued him for libel—or sought him out, sword in hand. In 1568, with Bandinelli dead and buried, Vasari unleashed the venom he had harbored for decades.

What earned Giorgio's ire above all seems to have been what he saw as Bandinelli's dishonesty. Among other misdeeds, he accuses Baccio of entering the Palazzo della Signoria with a skeleton key in 1512, taking Michelangelo's cartoon for the *Battle of Cascina* and ripping it to pieces.

Nor was he the only contemporary to accuse Bandinelli of underhanded methods. A letter from Baldassare Turini (the Tuscan bishop who managed Medici properties in Rome) to Cardinal Cybo warns that "Signor Bandinelli":

has known how to deal with all of you in such a way that he has eaten up all the money available for these tombs [the tombs of the Medici popes in the Roman church of Santa Maria Sopra Minerva], and it's a disgrace to have promised him 600 scudi for a relief that for 300 scudi could have been made more beautifully than he did; and likewise they promised him 300 scudi for a small relief that could have been done better for 150 scudi. . . . And if your Reverence could see his greed and his eagerness to eat up all this money, and the fuss he makes about providing these figures and reliefs, good or bad as they may be, you wouldn't believe it. And it has been and will be a disgrace if Your Most Reverend Lordships accept the fact of his treating you in this fashion. . . . [H]e is so presumptuous and such a liar that he'll let you think

what he wants you to think, and in everything he'll tell lies and lie through his throat.[25]

These are strong words; accusing another man of "lying through his throat" was the ritual phrase that signaled the challenge to a duel. In a second letter, this one to none other than Cosimo de' Medici, Bandinelli's patron, Turini writes that the sculptor is "so bad-natured, and so greedy, that [he] thinks more about the four cents he might earn from one of his works than he does of a hundred Dukes."[26]

Vasari and most of the other artists at the Florentine court regarded Bandinelli as a shameless flatterer, his lucrative commissions and honors the reward for obsequious fawning rather than for artistic talent. (An unfair condemnation: Bandinelli, as noted above, was a superlative draftsman—even Vasari has to concede that he was a "gran disegnatore."[27] As Leonard Barkan has noted, the beauty of his drawings held out the promise of equally beautiful statues that never quite lived up to the grace and elegance of their *disegni*.)[28]

Bandinelli was also genuinely loyal. At considerable personal risk, he maintained his support for the Medici during their exile from Florence, and it is not surprising that they rewarded his fidelity when they returned to power. Nor is it surprising that the viper's nest of artists around the Medici court, from Michelangelo to Cellini to Vasari, subjected their rival to vicious attack. Of Bandinelli's *Hercules and Cacus*, which stood before the Palazzo Vecchio opposite Michelangelo's *David* (removed in 1873 and replaced now by a replica), Cellini famously said, "If you shaved off Hercules's hair, there wouldn't be enough head left to put his brain in."[29] As for the hero's face, "you can't tell whether it belongs to a man or to a cross between a lion and an ox." The rippling muscles of his chest "aren't drawn from a man, they're drawn from a sack of melons that's been stood up against a wall." Cocky Cellini then went on to reprimand Bandinelli for "impatiently" interrupting him before he could begin to mock the second figure in the sculpture group, Cacus.

Vasari's vicious portrayal of Bandinelli destroyed the poor man's reputation. So devastating was the former assistant's campaign against his deceased master and later rival that even expert art historians, centuries later, have passed him by: thus Frederick Hartt's influential 1976 textbook, *Art: A History of Painting, Sculpture, and Architecture* (its Vasarian origins declared in its title), completely omits Bandinelli from the history of Italian Renaissance art. Yet the sculptor was a major presence in Medici Florence, from his *Hercules and Cacus* in front of the Florentine city hall, to his *Adam* and *Eve* from the Medici collection (now in the Bargello Museum), to his own tomb in the church of the Santissima Annunziata.

Andrew Ladis shows how Vasari mounts his case against Bandinelli by creating a negative mood:

> Although filled with verifiable facts about a person whom the author knew all too well, Vasari's "life" of Bandinelli so effectively envelops the historical person in the rhetoric of invective as to deprive him of sympathy and thereby take him hostage forever, making of him an extraordinary literary construction, a villain worthy of Michelangelo, and a persona in whom art and biography converge.[30]

Vasari was clearly dismayed by the popularity, at least among the Medici, of *Hercules and Cacus*, which prompted Cosimo to name Bandinelli his official court sculptor. To Giorgio's mind, the placing of *Hercules and Cacus* beside Michelangelo's *David* in 1534 was an act of artistic hubris, made worse because the stone itself originally had been reserved for Michelangelo's use, nearly twenty years before. Yet Vasari had to tread carefully with his criticisms, condemning Bandinelli without offending Cosimo, their joint patron, whereas the swashbuckling Cellini, self-confident to a fault and with the barrel-chested swagger of a Renaissance Ernest Hemingway, spoke his mind without inhibition (and sometimes paid the price of his candor).

Vasari, a more careful soul, chooses instead to damn *Hercules and Cacus* with faint praise, which Andrew Ladis calls "velvet strangulation":[31]

Once the work was finally unveiled, those qualified to judge it have always held it as both difficult and very well conceived, carefully executed in each of its parts, and the figure of Cacus extremely well placed. In truth, of course, Michelangelo's David draws the praise away from Baccio's Hercules, because there it stands right alongside, the most beautiful giant ever made, all grace and goodness, whereas Baccio's style is entirely different. But really, taking the Hercules of Baccio on its own terms, one can only praise it highly, all the more after having seen how many later sculptors have tried to make large statues and none has arrived at Baccio's level, who, if he had received as much grace and skill from nature as he invested of his own labor and concentration, he would have been entirely perfect in the art of sculpture.[32]

Vasari has offered up another story, unsubstantiated elsewhere and highly improbable, that blames Bandinelli for vandalizing Michelangelo's cartoon for the *Battle of Cascina* in the Sala dei Cinquecento in the Palazzo Vecchio. Stealing and destroying what was officially the property of Bandinelli's masters, the Medici, would have been a dreadful crime and cannot be accepted as plausible. But Vasari would like us to believe that Bandinelli's destruction of the cartoon was common knowledge in Florence:

Without knowing the reason for [his action], some said that Baccio had torn it apart to have some pieces handy for his own purposes. Some surmised that he wanted to deprive young people of that opportunity in case they should benefit from it and make a reputation as artists. Some said that his affection for Leonardo

da Vinci moved him to do it, because Buonarroti's cartoon had greatly reduced Leonardo's reputation, and some, perhaps with better understanding, attributed the cause to the hatred he bore for Michelangelo, as the rest of his life would show. The loss of this cartoon was not a small one for the city, and Baccio incurred immense blame for it, with everyone calling him envious and malicious.[33]

Like a wily lawyer, or the Roman biographer Suetonius, Vasari distracts from the implausibility of his story by listing all the reasons why "some said" that Bandinelli might have committed his act of vandalism.

Vasari may have decried envy as "most criminal" ("sceleratissima invidia"), but he was no stranger to the sentiment. Bandinelli had been awarded two honors that Giorgio had good reason to covet: a Knighthood of Saint Peter, conferred by the pope, and a Knighthood of Saint James, from the Holy Roman Emperor, an honor that came with a massive gold chain to wear around his neck—and Bandinelli wore it always. In addition, Baccio had received constant Medici support and patronage, from Lorenzo to Pope Leo X to Duke Cosimo. According to another unconfirmed anecdote in Vasari's biography of Bandinelli, the Medici pope Clement VII had commissioned statues for the top of Castel Sant'Angelo, where we now see Cornelius Verschaffelt's enormous eighteenth-century archangel Michael: they would have included allegorical personifications of the Seven Sins ranged beneath a giant sculpture of Michael, vanquisher of sin and evil. Only Verschaffelt's winged Michael stands there today, Michel Angelo triumphant over what Bandinelli was meant to have created, the embodiment of his own sins.

Fortunately for Vasari, his service in Bandinelli's studio ended after only a few months, in the spring of 1527. An invading army was bearing down on Italy, led by the lantern-jawed Holy Roman Emperor Charles V.

PLUNDER
AND PLAGUE

W ARFARE IN RENAISSANCE ITALY WAS WAGED LARGELY
by hired armies rather by than citizen militias. The cap-
tains of these mercenary troops, called condottieri (from *condotta*, a
contract), were often feudal lords from minor cities. They fought on
horseback in heavy armor for sums of money that would have been
impossible to earn without resorting to battle, for which they were
paid by their patrons, and plunder, which supplemented salaries and
substituted for them, if the patron was slow to pay. Frequently, these
men became generous patrons of art as well as masters of destruction:
Federico da Montefeltro, Count of Urbino, besieged Volterra in 1472
on behalf of Lorenzo de' Medici; for his brutal victory, Federico
earned the title of duke and money to lavish on his palace, his art col-
lection, and his library. Federico's archenemy, Sigismondo Pandolfo
Malatesta of Rimini, spent the fortune he earned from soldiering
on art, architecture, and manuscripts of startling originality; he also
designed his own fortresses, state-of-the-art in the mid-fifteenth cen-
tury, using star shapes with tight angled walls rather than squares or
circular walls to give advantage to cannon warfare.

It may not seem obvious that men of war should also be patrons of
the arts. But as heads of state, they were wise enough to know that
admiration cemented their authority more effectively than fear. A
court full of interesting, creative individuals to praise them in poems,
treatises, paintings, and madrigals brought a prestige more lasting

than battle. Machiavelli praised Lorenzo il Magnifico as "the greatest patron of literature and art that any prince has ever been," and others followed his example. There were also religious motives—paying for expensive altarpieces or decorative chapels was a sign of pious devotion that might speed the way to Heaven after death. Churches and their visitors reaped the benefits.

Though a military career was considered the highest calling of the aristocracy, leading an army was an art form, and not everyone was cut out for it. French and English kings traditionally led their own armies, but they were also killed and imprisoned on too many occasions. Italian city-states relied on condottieri regularly to preserve the safety of their prince or duke, but also for a logistical reason. France and England had entire nations from which to draw their armies, whereas city-states like Florence had limited populations. With some 60,000 people in Florence circa 1500 (more than half women, children, elderly, or infirm) the Medici would have been hard-pressed to recruit an army of a useful size, much less one to match the 34,000 soldiers paid to fight in Charles V's army. They used their wealth, therefore, to buy foreign soldiers, rather than recruit from their own ranks.

The Medici family did produce one illustrious warlord, Giovanni delle Bande Nere, who fought on behalf of the two Medici popes Leo X and Clement VII and fathered Vasari's patron Cosimo I. But they largely relied on foreign muscle-for-hire, like the English adventurer Sir John Hawkwood, who took advantage of a pause in the Hundred Years' War to earn a fortune in Italy in the 1360s (his memory is preserved in a tomb in the cathedral of Florence, painted by Paolo Uccello). Other famous condottieri eventually struck out on their own. Francesco Sforza translated his military success into seizing the rule of Milan and starting his own dynasty.

Mercenaries were both expensive and dangerous; if no one paid them, they seized their provisions—food, horses, weapons, and lodging—by force. Because they worked for hire, they switched sides

without hesitation. Machiavelli objected to them strenuously, because of their greed, their violence, and their utter lack of loyalty, let alone civic sense.[1] There would be no more lurid illustration of all these disadvantages than the Sack of Rome, the event that also ended Giorgio Vasari's apprenticeship with Baccio Bandinelli.

Ever since the fall of the Roman Empire in AD 410, the Italian peninsula, with its small, contentious city-states, had been a fertile breeding ground for mercenaries and a tempting target for larger European powers. France and Spain had been fighting to control parts of Italy since the Crusades, along with the loose, shifting federation known as the Holy Roman Empire (which Voltaire famously disdained as "neither holy, nor Roman, nor an Empire").[2] The pace of these incursions accelerated in the fifteenth century, spurred by the increasing strength of the French and Spanish nation-states. In 1442, King Alfonso of Aragon conquered Naples and, with it, the southern regions of Italy, wresting them from French control. In 1494, King Charles VIII of France descended into Italy with an army that succeeded in reaching Naples from the north (the Borgia pope, Alexander VI, bribed them to leave Rome alone), but the French troops withdrew as quickly as they had come. In 1499, the French returned to Italy under Louis XII, this time taking Milan and Genoa. From 1509 to 1512, Louis and Holy Roman Emperor Maximilian I, a Habsburg, mounted a joint, multipronged attack on Venice, laying siege to every Italian settlement they met on the way and declaring war on the Papal States for good measure. This conflict, the War of the League of Cambrai, was settled by mutual accord in 1512, but when Maximilian's son Charles V acceded to control over Spain, Burgundy, and Austria in 1519, a wave of conflicts with France broke out on Italian soil.

Florence and the Medici traditionally sided with France, and so they did when hostilities broke out in 1521. But Charles V, far more than his predecessors, turned out to be a formidable general and statesman. City by city, he began to conquer Italy for Spain and the

Holy Roman Empire, and his decisive victory over France at Pavia in 1525, on his twenty-fifth birthday, brought him the French king, Francis I, as prisoner.

In 1526, France, the Vatican, Milan, and Venice struck a new alliance to drive Charles V out of Italy. Instead, Charles took Milan, Genoa switched sides to join the Holy Roman Empire, and the most promising of the league's condottieri, the Medici family's own Giovanni delle Bande Nere, was killed, wastefully, in a minor skirmish south of Milan.

Yet success came at a steep price. By the autumn of 1526, Charles could no longer pay his 34,000 imperial troops, and so he dismissed them, confident that they would make their way back home over the Alps. But the imperial army had other ideas. As a paid force, it had loyalty to nothing but money, and so the soldiers forced their field commander, Charles III de Bourbon, to target the richest city in the vicinity, where their missing pay could be extracted in the form of loot: Rome. Pope Clement VII, in traditional Medici fashion, had sided with France; the imperial forces were eager, therefore, to put him in his place. Some 14,000 of them, moreover, were Swiss Lutherans, keen to punish the Eternal City for its stubborn adherence to old-line Catholicism. Fed on contemporary caricatures of fat, greedy popes and priests, they imagined that Rome must be as rich as El Dorado. Home, as they all knew, was not—poverty is what had driven most of them into soldiering in the first place.

By April, the mutinous troops were camped in Arezzo. They had bypassed Florence as they moved south from Milan—there was no point in wasting their energies on so potent an enemy before reaching their destination. Vasari must have felt relatively safe, with protectors like Ippolito de' Medici and Cardinal Passerini, the two most powerful men in the city.

Contemporaries describe the Sack of Rome as a surprise, but the surprise lay in its sacrilege, not in its swiftness. It took two weeks for the duke and his horde of 34,000 soldiers to reach the Eternal City

from their camp at Arezzo, just 130 miles away. They left on April 20, and reached the walls of Rome on May 5, cruelly subjecting the smaller cities in their path— Acquapendente, Viterbo, Ronciglione— to sword and fire. On May 6, they prepared to enter Rome itself.

The reluctant leader of the mercenaries, Charles de Bourbon, was killed in the first assault—Vasari's rival Benvenuto Cellini claimed to have shot the fatal cannonball from the Vatican fort at Castel Sant'Angelo. That left the soldiers of the leaderless army free to rampage through the city unchecked, and they did, their brutality fired by religious hatred. The descriptions of the damage are horrific: people slaughtered in the streets, palazzi and churches looted, libraries torn to shreds, hostages seized for ransom. All but forty-two of the Swiss Guard were slain on the steps of St. Peter's Basilica, as they tried to bar the entrance and allow Pope Clement VII to escape—the only time men in the fabled papal bodyguard have been required to lay down their lives to save their pontiff in their five hundred years of existence. Clement scurried down the covered passage that leads from the Vatican Palace to the protective walls of Castel Sant'Angelo, a formidable series of rings of ancient Roman concrete originally built to house the tomb of Emperor Hadrian, which had evolved into a nearly impregnable fortress. As the chaos roiled and Rome smoldered below, Clement became a prisoner. The mercenaries were unable to extract him, but he was unable to move. He tried once to escape disguised as a charcoal burner, but his well-tended hands, insufficiently stained with coal, and his distinctive pear shape gave him away.

In Florence, a network of informers tracked every movement of the imperial army. Eventually, the troops would move north again, and with Rome hobbled, there was no longer any reason for them to fear the Florentine defenses. A terrified Ippolito de' Medici, flanked as always by Cardinal Passerini, summoned the league's most able condottiere, Francesco Maria della Rovere, duke of Urbino, to discuss a counterattack. Nominally in the pay of Venice, della Rovere could have helped to stop the imperial troops at any point along their

long march south. But with no personal reason to do so, and without an official *condotta* (marching orders from the city he then served), he bided his time—Venice, after all, was not in danger. He was no fan of the Medici; Pope Leo X had deposed him as duke of Urbino in 1516 and passed the title on to Lorenzino de' Medici, the father of Alessandro de' Medici, Vasari's classmate. Della Rovere had returned to Urbino only after Pope Leo's death in 1521. But now that Venice was in league with Florence against the army of Charles V, he was spurred into action.

Rather than station the duke's own mercenary troops in Florence itself (it was mid-May, and Rome had been under siege for more than a week), Cardinal Passerini and Ippolito rode out to meet della Rovere on neutral ground, beyond the city walls. It was not a good moment for the Medici. In Rome, Pope Clement had cut a cowardly figure. Seventeen-year-old Ippolito ruled the city through a guardian. Teenage lords were not unknown in recent Italian history: both Federico da Montefeltro and Sigismondo Malatesta, for example, took full charge of their city-states at fifteen, and della Rovere himself had taken over Urbino at eighteen, but these men were made of tougher stuff than the handsome, languid Ippolito, whose most notable activity seems to have been courting, inconveniently, Alessandro de' Medici's sister Caterina, his niece and the future queen of France.

With Ippolito de' Medici and Cardinal Passerini out of the city, a group of Florentine citizens seized the government offices in the Palazzo della Signoria, proclaimed a revival of republican government, and condemned the Medici to exile. But with a famous mercenary captain and his army at their disposal, Ippolito and Passerini had no intention of backing down: bolstered by Francesco Maria della Rovere, they shifted targets and leveled an attack against their own city, bullying their way at last into the very heart of Florence.

Vasari was there to witness the ensuing melee, though it would not take long for the mercenary army to subdue the citizen revolutionaries. Della Rovere's troops, Ippolito, and Cardinal Passerini

were able to retake city hall after the first day of skirmishing. But the story Vasari tells about this historic moment, in his *Life* of Francesco Salviati, is more about saving a Florentine icon than an account of the military machinations inside the city:

> When the Medici had been expelled from Florence in 1527, in the struggle for the Palazzo della Signoria, a bench was thrown from above onto the people fighting in front of the entrance; but as fate would have it, [the bench] struck an arm of Michelangelo's marble David that stands above the balustrade next to the door, and broke it into three pieces.[3]

This is the famous *David*, Michelangelo's colossal sculpture of the biblical hero who symbolized the city. It had been displayed, along with a marvelous array of other statues, in the Piazza della Signoria since June 1504. The statue was originally destined for a perch high up on the façade of the cathedral of Florence, one of a series of Old Testament prophets to be sculpted by leading artists. Today, at ground level, the proportions look somewhat off: the head and right hand appear oversize when we view the sculpture on its low plinth in the Accademia gallery, but had it been displayed on high, viewed from below at an angle, the proportions would have looked correct. The project for the series of sculptures was never completed, and in Vasari's time the statue was instead stationed on a plinth in front of the Palazzo Vecchio.

MICHELANGELO WAS NOT ONLY Vasari's heroic model of the consummate artist. He was also a cherished friend, and thus the *Life* of Michelangelo, an exceptionally long biography in the collection, presents details that make the real man come alive to readers: the classical rhetorical technique of ekphrasis, description, combined with gossip to forge an irresistible combination. What also emerges is a life

filled with trauma, the brutal side of Florentine society and the competitive all-male world of the artistic world's studio system.

Because Michelangelo's family belonged to minor nobility, he was sent to grammar school as a boy rather than apprenticed in an artist's workshop. Being an artist, even at the end of the fifteenth century, was not quite an occupation for gentlemen:

> He spent all the time he could drawing in secret, and for this he was scolded and sometimes beaten by his father and his other relatives, perhaps because they thought that paying attention to skills unknown to them might be beneath the dignity of their ancient house.[4]

Finally, in 1488, his father relented and apprenticed Michelangelo with Domenico Ghirlandaio; Vasari's researches fished the actual contract out of the Florentine archives. The young pupil's progress within the studio was predictably swift, and one day, as a fellow apprentice copied some figures of the master, Michelangelo could restrain himself no longer:

> Michelangelo took that paper, and with a wider pen he redrew one of the female figures, giving her new contours so that she would be perfect, and it is a marvelous thing to see the difference between the two styles, and the excellence and judgment of so spirited a youth, so bold that he dared to correct the work of his master. Today I have that piece of paper, which I keep as if it were a holy relic . . . and in 1550, when he was in Rome, Giorgio showed it to Michelangelo who recognized it and was touched to see it again, remarking modestly that he knew more about that art when he was a young boy than he did now as an old man.[5]

Talented, aristocratic, and well-mannered, Michelangelo quickly achieved a reputation in the city, and as his fame increased, Giorgio

reports, so did the jealousy of his contemporaries. Lorenzo de' Medici invited him to draw the ancient sculptures in the Medici collection and dine with the family's extensive entourage, a rare privilege that Michelangelo never forgot—later he would remind everyone in Rome about those glory days in the late 1480s and early 1490s. One day (out of jealousy, Vasari claims), his friend and fellow apprentice Pietro Torrigiano punched him in the nose, so hard that "it marked him for life" and earned Torrigiano banishment from Florence. Like Giotto and Brunelleschi, Michelangelo would go through life as an ugly man with a beautiful spirit.

Jealousy would mark much of Michelangelo's career, and Giorgio, a victim of jealousy himself, empathized completely. Among the different branches of art, sculpture was the least esteemed, because sculptors struggled and sweated and covered themselves in dust. Their hands were the hands of manual laborers, and Michelangelo's hands at the end of his career were painfully crabbed with arthritis.

But what Michelangelo could do with stone transcended the physical world and took art into the realm of pure spirit, just as the philosopher Marsilio Ficino used to declare at Lorenzo de' Medici's gatherings. With his *Pietà* in Rome (1499) and his *David* in Florence (1504), he established a reputation for supreme mastery that has persisted to the present day.

Success hardly stopped the critics. Some complained that the Virgin Mary in Michelangelo's *Pietà* of 1499 was too young. At such temerity, Vasari snapped: "And although some dolts say that he made Our Lady too young, don't they realize that virgin persons who have been uncontaminated preserve themselves and keep the freshness of their face for a long time, without any blemish, and that those afflicted as Christ was do the opposite?"[6] The essence of Michelangelo's art was the transformation of pain and effort into works of tragic beauty. His final sculpture, the *Rondanini Pietà* in Milan, concentrates all the sorrow of a small, sturdy Virgin Mary into the muscular arm that supports the huge bulk of her dead son, implacable in its strength.

Michelangelo's *David* is that much more miraculous because the enormous block of marble from which it is carved was begun by another artist, who had abandoned the project. The block had been standing in the cathedral yard ever since, thin, heavily worked, and battered by the elements. It would have presented a daunting challenge to any sculptor, but Michelangelo turned the challenge into a triumph of stone carving. Vasari likewise bemoaned the fact that the colossal marble block for Ammannati's *Neptune* statue in the Piazza della Signoria was not given instead to a finer sculptor, like Michelangelo. Locals joked, "Oh, Ammannati, what a beautiful piece of marble you ruined!"

Vasari lingers over *David*, and with good reason: in his opinion, and that of many Florentines, this was the greatest sculpture ever made (and many a visitor to Florence will agree to this day). He also relays a funny story regarding unwanted (and unnecessary) criticism by the man who commissioned the statue in 1504. Piero Soderini, the leader of republican Florence during the brief period of Medici exile, suggested to Michelangelo that the figure's nose looked a bit too big. Obediently, Michelangelo climbed up his ladder to the head of the statue and touched his chisel to the nose. Pretending to tap away at the marble, he let some marble powder drop from his hand, enough to convince Soderini that he had chipped away a bit of stone. A delighted Soderini promptly complimented the artist on this vast improvement to the nose, which in fact had not been changed a bit.

Michelangelo's stratagem is one that Machiavelli recommends in *The Prince* and Baldassare Castiglione in *The Courtier*: if you can make a patron think that your ideas are his, he will champion them enthusiastically. Vasari's anecdote adds a play on words to the story: in Italian, "pulling my nose" means the same as "pulling my leg" in English. Whether the incident ever really happened is anyone's guess. The point is to show how Michelangelo could combine perfect diplomacy with perfect devotion to art.

As the gleaming symbol of Florence, *David* marked one of the key

episodes in the life of Vasari's artistic hero, and hence in the overall progression of the *Lives*. Our author therefore weaves himself into the story of *David* by describing how he personally saved the statue during the uprising of 1527:

> When those three pieces lay on the ground for three days without anyone's picking them up, Francesco [Salviati, Vasari's close friend] went to the Ponte Vecchio to find Giorgio, and told him his plan. Young as they were, they went into the piazza, and in among the soldiers of the guard, without any regard for danger, they picked up the pieces of that arm, and brought them to the house of Francesco's father. . . .[7]

The story is more than a tale of boyish courage—it has unmistakably biblical overtones. If the *David*'s arm had really fallen from the height Vasari claims, it would have shattered into a hundred pieces, not three. As for lying on the ground for three days, sixteenth-century readers would instantly have recognized a certain similarity with the story of Jesus, sealed in his tomb on Good Friday and risen from the dead on Easter Sunday. In effect, Giorgio and Salviati enter the scene like a *deus ex machina* to resurrect and make whole the statue that represents the very incarnation of the Florentine spirit. In his *Florentine Histories*, their friend Benedetto Varchi makes the struggle for Palazzo della Signoria less violent than Vasari's account suggests, but there is a larger point to this story: protecting works of art is a heroic, holy enterprise.

If *David* and the young artists who saved his arm were probably never in mortal danger during the uprising of 1527, the situation for Ippolito de' Medici and Cardinal Passerini was truly perilous. Their position in Florence now depended on Francesco Maria della Rovere, duke of Urbino, a formidable mercenary captain as well as feudal lord. But della Rovere had been hired to defend Rome, not Florence. When he departed with his army on May 17, the Florentine rebels

reclaimed their city and exiled the Medici again. This time, Ippolito, Alessandro, and Cardinal Passerini, along with their closest relatives, dared not return.

The duke of Urbino and his troops reached the northern outskirts of Rome on June 1, but it was clear that he could do little to extract the imperial army. After three weeks rampaging through the city, the soldiers were dispersed and out of control; there was no way to corral them onto a battlefield, and a building-by-building street fight in the ruins of Rome was out of the question. Five days after della Rovere's arrival, on June 6, Clement VII surrendered, paid a ransom of 400,000 ducats in exchange for his life and the withdrawal of the imperial soldiers, and was further obliged to turn over a series of papal landholdings to Charles V and to Venice (in compensation for the loan of della Rovere's services). Despite this treaty, and Clement's return, many of the imperial troops remained in Rome for another seven months, misbehaving, plundering on a smaller scale, and otherwise enjoying their role as unstoppable bullies, before they withdrew north. Clement could do nothing but watch in horror.

Giorgio Vasari's father reacted to these events as any good father would: he dragged his son back home. For Giorgio, leaving Florence meant enduring an exile as bitter (or so it felt) as that of his former classmates Ippolito and Alessandro de' Medici. Above all, he missed his Florentine friend Francesco Salviati—Giorgio wrote that they "loved one another as brothers."[8]

6

ARTIST VERSUS ARTIST

Demonic Beetles and Morality Tales

FRIENDSHIP SEPARATED BY EXILE, WHETHER BY LEGAL OR parental decree, was difficult to bear, though Vasari's time away from Florence and his close friend Salviati would be brief. Another famous exiled friendship would feature in his *Life* of Giotto: the traumatic moment when the poet Dante was forced to part from his dear friend, the protagonist of part one of Vasari's *Lives*. He describes Dante as "Giotto's contemporary and great friend, and no less famous a poet than Giotto was a painter" (although Dante would not compose his *Divine Comedy* until he left Florence).[1] The painter's portrait of his poetic friend is still preserved in the Bargello Museum in Florence. Giotto is one of the three principal figures in Vasari's work, and the exemplar of the best of the earliest period of Renaissance art in Tuscany. He is depicted as clever, talented, and cocksure—with a sly sense of humor, as in this famous anecdote, about "Giotto's O":

> Pope Benedict XI of Treviso sent a courtier of his to Tuscany to see what kind of a man Giotto was and what his work was like, with the idea that he might make some pictures in St. Peter's. This courtier . . . went one morning to Giotto's studio when he was working, revealed the Pope's thoughts about employing him, and finally requested a bit of drawing to send back to His Holiness. Giotto, an extremely courteous man, took a sheet of paper, dipped a brush in red paint, and propped his arm against

his side to create a compass. Rotating his hand, he made a circle so uniform in curvature and profile that it was a marvel to see. Having done this, with a smirk he said to the courtier, "Here is the drawing." Feeling tricked, the courtier asked, "Am I going to get something else too?" Giotto replied, "This is more than enough. Send it along with the others and you'll see whether it's recognized for what it is."[2]

Among the thousand-and-one tales spun by Vasari in his *Lives*, the story of Giotto's O is one of the best known. Seemingly simple, the account can be deconstructed in surprisingly complex ways. The red O, empty as it may look, turns out to be packed with meaning beyond the essential fact that Giotto's ten-second painting did, as he predicted, win him the commission in Rome.

Vasari portrays Giotto as a cool, gracious, but subtly disdainful figure, fully aware of his own genius. As a Florentine, and hence the citizen of a free republic, he is ready to stand his ground against any member of a feudal court, and it is this freedom that enables him, with one flawless stroke of his brush in 1304, to usher in modern art, not only for his own time but also for ours.

According to Vasari, Giotto was born to a peasant villager near Florence. At the age of ten, he tended the family sheep and passed the time drawing with chalk on a rock or with a stick in the earth. One day, the *Life* of Giotto tells us, the great painter Cimabue happened to stroll past while the boy was using a pointed stone to draw a sheep on a flat stone. Cimabue saw such talent in the image that he invited Giotto to move to Florence as his apprentice. Like many of Vasari's origin stories, this one probably never happened, but its memorable details serve their literary purpose all the same, by framing Giotto's biography between tales of his genius.

Giotto's O also serves a higher literary purpose: it represents a triumph of *ingegno*, wit, over manual skill. The very idea of choosing to draw a perfect circle provides a greater demonstration of the artist's

competence than making the drawing itself, although the drawing, too, is a masterpiece. The circle is also a test of the pope's *ingegno*, to "see whether it's recognized for what it is."

The courtier is skeptical, but Giotto, as stubborn as he is genteel, will not be moved:

> The legate, seeing that he could not obtain another drawing, took his leave of Giotto with great dissatisfaction, afraid that he had been hoodwinked. Still, when he handed the Pope the other drawings [he had collected] and the names of their makers, he also passed along Giotto's, recounting how the artist had made his circle without moving his hands and without the aid of a compass. Thus the Pope and the connoisseurs among the courtiers recognized how greatly Giotto exceeded all the other painters of his time in excellence. When this story began to spread, it gave rise to a proverb we still use to describe thickheaded people: "You're rounder than Giotto's O." The proverb is fine not only because of the story behind it but especially for its meaning, which plays on its ambiguity, because in Tuscany, "round" (*tondo*) describes not only a perfect circle but also a slow, dull wit (*ingegno*).[3]

The art historian Andrew Ladis describes Giotto's O as "a pun so elegant as to be silent, so cunning as to leave the victim oblivious, so satisfying as to reward the reader with the compliment of sophistication."[4] Vasari enjoys the way that Giotto's clever roundel comes to refer to ordinary blockheads. He would probably appreciate the fact that English uses both "dense" and "empty-headed" to denote stupidity.

The idea that only the wise and worldly will "get" Giotto's art did not begin with Vasari. Petrarch declared that one of Giotto's *Madonna* paintings inspired awe in the intelligent viewers, while sailing over the heads of the ignorant.[5] This attitude toward Giotto's art, and indeed art in general, has come down to modernity as a combination

of elitism with rewarding the informed—members of the general public today may be concerned that they won't "get" art, and therefore avoid engaging with it as a preemptive defense mechanism. The fact that some of those who take the time to engage and to study it do "get" it, at least to some extent, heightens the general idea that art is "only for the elite," though this is also a notion that the art world seems to enjoy cultivating. As the story about Giotto shows, exclusivity was already a concern of art viewers circa 1300, and remains so to this day.

A fourteenth-century commentator on Dante's *Divine Comedy*, Benvenuto da Imola, reports that Dante once asked Giotto how he could have painted such beautiful figures, but fathered such ugly children. The painter replied, in Latin, "quia pingo de die, sed fingo de nocte" ("because I paint by day and 'sculpt' by night").[6] It's a good joke. Vasari, too, loves to play word games. The multiple meanings of *tondo* fit so perfectly with the story of Giotto's O that the whole tale sounds suspicious—too artful for reality. Scholars have noted that this tale, and so many of Vasari's anecdotes, are reminiscent of the yarns told by the *novellieri*, the early modern writers of jaunty, saucy, humorous, and cagily moral tales, such as Boccaccio (with whom Vasari was evidently familiar and who praised Giotto, writing, "Our Giotto, to whom in his era Apelles was not superior") and Chaucer, who visited Italy and was inspired by Italian authors.[7] Ancient Roman authors like Pliny the Elder regarded Apelles, the court painter to Alexander the Great, as the greatest artist of ancient Greece. Indeed, Pliny's way of writing about Apelles furnished a model for Vasari's writing about contemporary greats. He adapts one Pliny's best-known anecdotes about two other great Greek painters, Parrhasius and Zeuxis, for his *Life* of Giotto.

> It is said that when Giotto was still a boy working with Cimabue, he once painted a fly on the nose of one of Cimabue's figures, so lifelike that when the master returned to resume his work, he

tried more than once to swat it away with his hand, thinking that it was real, before he realized his mistake.[8]

This is another one of the stories in *Lives* that we cannot be expected to believe as fact. It is rather a trope, a standard tale used by many authors, from antiquity to the present, to demonstrate the illusionistic powers of great artists. It is telling that the story is told only in the 1568 edition of *Lives*, and that it comes not chronologically but at the very end of the chapter on Giotto, as if to underscore the artist's greatness (at the expense of his master, Cimabue, whose more medieval Byzantine style Vasari disliked and considered old-fashioned).

The original anecdote from Pliny's *Natural History* describes a contest between two famous painters of ancient Greece:

Parrhasius is reported to have entered a competition with Zeuxis, and when [Zeuxis] painted grapes so successfully that birds flew down to the panel, [Parrhasius] painted a linen drape, portrayed so truthfully that Zeuxis, puffed up with pride about the birds' judgment, demanded imperiously that [Parrhasius] lift the drape and reveal his picture. But when [Zeuxis] understood his mistake, he conceded the victory to Parrhasius with sincere deference, because he may have fooled the birds himself, but Parrhasius had fooled a fellow artist. It is said that later Zeuxis painted a boy carrying grapes, and when the birds flew to that, too, with the same sincerity he angrily addressed his work and said, "I painted the grapes better than I painted the boy, because if I had painted him right, the birds should have been afraid."[9]

Vasari's contemporaries would have recognized these references. Educated readers of his *Lives* would have read Pliny for themselves, and any half-educated artist would at least have heard the story of Zeuxis and the grapes.

Are we meant, then, to believe that the story of Giotto's O is true?

Historians have been unable either to confirm or to deny it, though *something* won Giotto prestigious commissions with the pope, later with the king of Naples, as well as his famous work at the Arena Chapel in Padua. This last work ranks among the most important fresco cycles of the Renaissance, showing a heretofore unseen level of theological complexity in its biblical scenes, as well as technical excellence in naturalism and emotion. Vasari himself probably believed the anecdote, because he received it from Petrarch, and Petrarch was a revered authority. But true or not, Vasari's story was undeniably influential in perpetuating the cult of Giotto, justifying his position as the figure who launched the rebirth of the arts, a fitting anchor for the first section of the *Lives*.

Just as Pliny juxtaposed two rival artists to demonstrate the superiority of one over the other, so too did Vasari, though he often elevated the competition to a Zoroastrian struggle of good against sin, or occasionally downright evil. Among the numerous juxtapositions found in *Lives* (Domenico Veneziano against the murderous Andrea Castagno, Michelangelo against the duplicitous Baccio Bandinelli) perhaps the most memorable, for its vivid imagery and humor, is that of the brilliant Giotto contrasted against the talented, but lazy and misguided, Buonamico Buffalmacco.

> To begin with the pranks he did when he was still a boy, when Buffalmacco was an apprentice with Andrea [Tafi], the master had the habit on long nights to get up before daybreak to work, and he roused the apprentices too. This annoyed Buonamico, who was forced to awaken from his soundest sleep, and he began thinking about ways to discourage Andrea from getting up to work before dawn. So when he found thirty cockroaches all together in a seldom-swept cellar he fastened candles to the back of each one, and at the hour when Andrea normally awoke, he inserted the cockroaches, one by one, through a crack in the door to Andrea's bedroom. When Andrea awoke, at just the time when he normally called out to Buffalmacco, and saw those tiny lights, he began to

tremble with fear, and like the old man he was, he began com-
mending himself to God and praying and singing psalms in total
panic, and finally, putting his head under the covers, he never
called Buffalmacco the rest of the night; instead he huddled like
that, trembling from fear, until morning. The next morning, when
he finally got up, he asked Buonamico if he had seen the same
thousand and more demons. Buffalmacco said no, he'd kept his
eyes shut and wondered why he hadn't received his wake-up call.[10]

Buonamico Buffalmacco's *Life* is the second-longest in the first part
of Vasari's *Lives*, second only to Giotto's, for Buffalmacco was a well-
known figure. Together with two other artists, the crafty Bruno and
gullible Calandrino, he features in four outrageous stories from Boc-
caccio's *Decameron* (VIII, 3 and 6; IX, 3 and 5). Bruno and Buffal-
macco successfully convince Calandrino that he is invisible, feed him
a medieval truth serum while stealing his pig, make him believe that
he is pregnant, and finally induce him to mix love potions, until he
is discovered by his wife and promptly pummeled. The comical trio
became stock figures of later Renaissance literature, and Vasari prob-
ably knew all their adventures well.

In Buffalmacco, therefore, Vasari had a well-known figure through
whom he could make a didactic moral point, while adding to the
endless story of Buffalmacco's pranks, a favorite theme of Tuscan
humor.[11] As a painter, Buffalmacco was superbly talented, although
what was considered his best-known work in Vasari's day, the fresco
of the suicide of Judas in a chapel of the Badia of Florence, has now
been re-attributed to another painter, Nardo di Cione.[12] Today schol-
ars believe that he was largely responsible for the fresco cycle in the
Campo Santo in Pisa, which was almost completely destroyed by an
errant bomb during the Second World War.

On a literary plane, however, Buffalmacco serves as the perfect foil
for more serious-minded artists—he becomes, for Vasari, an example
of how *not* to lead one's life, how to fail to become a true artist.[13] His

talent without diligence leads not just to unfulfilled potential but also to a sort of damnation, for to the diligent Giorgio it was a sin to waste one's God-given potential. Born with some of Giotto's talent, Buffalmacco squandered it (though he certainly makes readers laugh in reading about his antics. Had he lived in the later twentieth century, he could have made a career as a conceptual artist).

Vasari's Buffalmacco is smart, but he does not use that strength wisely. A man with limited mathematical abilities commissioned Buffalmacco to paint Saint Christopher in a church, instructing that the saint be twelve *braccia* high (about twenty-four feet). When Buffalmacco stepped into the church, he quickly realized that the entire church was not nine *braccia* high or nine *braccia* long. In order to fulfill his commission, he did the only thing he could: he painted Saint Christopher lying down, wrapped around the church interior. When the commissioner viewed the fresco, he did not see what he had had in mind and refused to pay. But Buffalmacco brought him to court, and won, successfully arguing that he had fulfilled his commission to the letter (or perhaps to the *braccio*).

The final tale of Buffalmacco's wicked wit is an act of illusionism:

I'll just say this [writes Vasari], that when he'd painted a fresco at Calcinaia [a village near Pisa] of Our Lady with her Son embracing her, the man who commissioned the painting gave him fine words rather than his payment. Now Buonamico, who wasn't used to being hoodwinked, decided to get revenge. And so one morning when he went to Calcinaia, he turned the Christ Child he had painted in the Virgin's arms into a bear cub, using water colors without any glue or tempera. Not long afterwards the farmer who had commissioned the painting saw what had happened, and went to see Buonamico in near desperation, begging him to remove the bear cub and make another Christ Child as he had done before—this time the farmer was willing to pay. And when Buonamico had done this carefully, he was paid for both

the first job and the second without delay. A wet sponge was all it took to make everything right.

Buffalmacco's name indicates his personality. *Buffone* is the term for someone who is silly, a jester. *Macco* is related to the word *macchia*, meaning a stain (the word *macco* also means bean soup). Vasari enjoys name games in a way that we might call Dickensian, but which he himself would have thought of as Boccaccian. Names are initial identifiers of character. Raffaello Santi (Raphael) has a surname that means "saints," and he is portrayed as saintly. Raphael's contemporary Giovannantonio da Vercelli, nicknamed "Sodoma," is shown as a sinner. Whether people live up to their names, or are led to make real what their names suggest, Buonamico Buffalmacco, whose full name we might translate as Goodfriend Sillystain (or Sillysoup), could hardly have turned out otherwise than he did. Giotto, on the other hand, has a name that immediately brings to mind the story of his O, with a pair of nice round O's at the heart of his name, which may also be a shortened form for Angelotto—"little Angelo." Vasari contrasts the two, but their competition was already a stock theme in earlier centuries. There is a poem about Giotto's O by the fifteenth-century poet Burchiello, in which he writes, "Al tuo goffo buffon daro del macco" (I'll give some fava bean soup, *macco*, to your clumsy buffoon, *goffo buffon*). *Buffon* and *macco*—the reference to Buffalmacco is unmistakable, and it is no coincidence that the poem about Giotto's triumph contains the name of his antithesis.

And now, a word on naughty monkeys.

These creatures appear in Vasari's *Lives* with greater frequency than you might think; monkeys, imported at great expense, were exotic pets guaranteed to amuse their keepers. Vasari's *Life* of Buffalmacco tells about an incident in Arezzo, where the historical figure Bishop Guido had commissioned Buffalmacco to paint frescoes in the episcopal palace. The bishop's pet monkey found this whole painting business fascinating and watched Buffalmacco at work. "This animal, who

sometimes perched on the scaffolding to watch Buffalmacco work, had observed everything, and never took his eyes off the painter when he mixed the colors, handled jars, beat eggs to make tempera—in short, every sort of activity, the monkey watched."[14] Monkey see, monkey do. When Buffalmacco left for the night, the monkey took over, repainting the chapel. One joke would have been for Buffalmacco to return the next morning to find his frescoes completed, and better than he could have done, but that is not Vasari's punch line. Instead, the monkey's wild daubs are seen as vandalism. The bishop is informed, and he orders an armed guard to stand watch in the chapel and to "mercilessly slice to ribbons" whoever the vandal might prove to be.

It was not unusual for the simpler members of a congregation to vandalize portions of frescoes that depicted the "villains" of medieval and Renaissance Europe: demons, despots, Judas, and Jews.[15] The devilish embodiment of Injustice in Ambrogio Lorenzetti's fresco cycle in the Sala della Pace at the Palazzo Pubblico in Siena is scarred by scratches made by centuries of visitors. The faces of the abusers of Christ in Andrea Castagno's *Flagellation* fresco, in the cloister of Santa Croce in Florence, are scraped away. The bizarre monstrosity in Giotto's Arena Chapel in Padua, the allegorical personification of Envy, with a serpent slithering out of its hair and biting it in the face, has been scarred by graffiti cuts across its neck, the body of the serpent, its cheek and its eyes.

It was, however highly irregular for monkeys to vandalize paintings, even those depicting Judas.

The monkey in Buffalmacco's tale, now with a taste for painting, heads back to the church, despite having been encumbered with a wooden weight that was meant to keep him from scampering off. He gets back to work. The guards and Buffalmacco rush to the scene and burst out laughing, when they see the culprit painting away.

The best line in the story is given to Buffalmacco, who goes to the bishop and says, "My Lord, you wish the painting to be done in one way, but your monkey wants it done in another."

Buffalmacco's fresco cycle for the Badia in Florence provides Vasari the occasion to level a stern assessment of the painter's career:

> He made the Passion of Christ with inventive, beautiful gestures, portraying the greatest humility and gentleness in Christ as he washes the feet of his disciples, and arrogance and cruelty in the Jews when they turn him over to Herod; but he revealed his creativity and mastery most of all in the Pilate he painted in prison, and in Judas hanging from a tree. From this it is easy to believe what has been said of this pleasing painter, namely that when he applied himself and really worked, which rarely happened, he was the equal of any painter of his era.

The juxtaposition of this judgment with the figures of Pilate and Judas suggests that Vasari may regard Buffalmacco's lack of diligence as a sin in the truest sense. The *Life* also links him to an unfortunate disaster that took place in Florence on May Day of 1305:

> Buonamico . . . found himself charged, among many others, with directing the May Day festival that the San Frediano neighborhood celebrates on board a series of boats, and when the Carraia Bridge, which was made of wood in those days, collapsed because it was overloaded with festivalgoers, he didn't perish there, like so many others, because he was out getting supplies at the precise moment when the bridge fell in, right on the painting of the Inferno that hung above the boats.

Buffalmacco was at most about fifteen at the time and can hardly be blamed for the disaster, but Vasari manages to insinuate a degree of responsibility all the same. The *Life* of this fun-loving, slightly lazy painter serves above all as a powerful literary antithesis, casting the heroic Giotto in an ever more saintly light.

7

THE OPPORTUNITIES OF WAR

WAR PROVIDED SOME ARTISTS AND ARCHITECTS WITH new opportunities, shifting them into the roles now taken by industrial engineers: designing fortresses, cannons, powder horns, guns, siege engines, or reinforced bastions. Michelangelo and Benvenuto Cellini both worked on the fortifications at Castel Sant'Angelo in Rome, as had Leone Battista Alberti a century before them. Leonardo may be the best-known artist to have dabbled in military engineering, but he was by no means the most successful; in the first half of the sixteenth century, that distinction went to the Sangallo family of Florence and Baldassare Peruzzi of Siena, whose designs for city walls and fortresses squarely faced the challenges presented by the rapid development of gunpowder artillery in those same decades.

Giorgio Vasari's years as an architect were still well ahead of him in 1527; that profession was reserved, by and large, for mature men. At sixteen, without any direct experience in warfare, and with his patrons newly expelled from Florence, Vasari had little to offer as a potential military engineer. His Sienese contemporary Vannoccio Biringucci was a different story: the son of the chief contractor of the Siena cathedral, Vannoccio had grown up making fireworks and forging armor with his father. Vasari praised Biringucci's pioneering book on metallurgy and fireworks, *De la Pirotecnia* of 1540, but Vannoccio does not appear on the roster of artists in his *Lives*. By Vasari's

standards, and perhaps by ours as well, Biringucci was and remained a craftsman, rather than an artist.[1]

Giorgio returned to Arezzo in the autumn of 1527, to find that his father had perished of the plague. The disease had reappeared in Italy in 1522, but the Sack of Rome turned it into a rampant problem. The sheer number of victims slain by the imperial troops (14,000 by one count) meant that unburied corpses lay everywhere, breeding infection, flies, and rats, whose fleas carried bubonic plague. Fleeing refugees did the rest. From Arezzo, Vasari was sent by his uncle out to the family properties in the countryside, where living conditions were less cramped and contagion posed less of a danger. Far from the complex, carefully organized artistic world of Florence, Giorgio sought work as an independent artist, learning by doing, taking on projects that would never have been possible for a young apprentice in Florence itself.

If war sometimes presented artists with new opportunities, the plague did the opposite: it shut down all the familiar rhythms of life. The tiny bacilli of *Yersinia pestis*, the plague germ, were invisible before the invention of high-powered microscopes, and neither contagion itself nor the role of rats in the transmission of the disease were understood as yet. Still, denizens of Renaissance Italy perceived that in times of plague, sick people tended to make other people sick as well. In Florence, which remained an exceptionally well-organized city, despite its political turmoil, seven-eighths of the shops closed as a precaution, while the few that remained open passed goods to customers through an iron grate, forbidding them to come inside. Customers placed their coins in a bowl rather than in the shopkeeper's hand, and the bowl's contents were then tipped into a jar of water to wash away potential contaminants.[2] Those unfortunate Florentines who were compelled to strike out into the city streets did so only by night, often holding a ball or bundle of aromatic herbs up to their noses as a filter against "bad air" (typical ingredients included parsley, sage, rosemary, thyme, and aromatic flowers). At home, they would

drink or douse themselves with a potion of boiled nettles, thought to ward off evil. Some of the same precautions were observed in the countryside. High death tolls, restricted travel, and civic quarantines led to further problems even when the plague itself subsided: 1528 would bring famine to much of Italy.[3]

To Giorgio Vasari, on the other hand, 1528 brought the first glimmers of professional success. A famous Florentine painter, Rosso Fiorentino, spotted one of his easel paintings and decided to make his acquaintance. Although Rosso had earned his own reputation by painting strange, skinny figures in highly artificial poses, what he saw in the young Vasari's work (at least according to Giorgio) was "some good quality derived from nature."

For all the extravagance of his personal style, then, Rosso was a firm believer in the Florentine method of artistic education. Sixteenth-century artists understood the purpose of art to be the imitation of nature. Aristotle himself had said so, and Aristotle was not to be taken lightly, especially in an age that prided itself on having revived the ancient classics. The best way for an artist to understand the workings of nature was, of course, to draw, for Nature herself had laid out the world according to God's supreme *disegno*. (One of the ancient writers who believed in Aristotle's doctrine, the Roman architect Vitruvius, actually assured readers that Nature had drawn the designs of the constellations from nature!) Rosso may have stretched his angular figures to unnatural lengths, but he did so only after acquiring a solid knowledge of how natural proportions worked. What he must have seen in the work of the young Giorgio Vasari was a good grasp of *disegno*, a sense of proportion, and an idea of how colors work on figures, in space, and with each other.

Rosso was also a generous spirit, as Giorgio was to discover shortly after their meeting in Arezzo:

Nor did much time pass until, on his recommendation, Messer Lorenzo Gamurrini ordered me to make him a panel, for which

Rosso provided the drawing and I completed it with all the study, labor, and diligence that I could muster, so that I could learn and begin to make myself a reputation. And if my ability had been equal to my desires, I would have become a reasonable painter, for all that I exerted myself and studied the things that have to do with art; but I found the difficulties to be much greater than I had thought at the outset. Still, without giving up hope, I returned to Florence, where I saw that it would take a long time until I could become established enough to support my three younger sisters and two younger brothers, all entrusted to me by my father, and so I apprenticed myself to a goldsmith.[4]

In the *Life* of his friend Francesco Salviati, Vasari tells us that this sobering recognition of his limitations happened in the workshop of the painter Raffaello da Brescia, where Vasari, Salviati, and a third friend, Nannoccio da San Giorgio, had decided to work together as apprentices: "Giorgio was so encouraged by letters from Francesco, who himself almost died of the plague that he returned to Florence, where with incredible study, for the space of two years, driven by need and by the desire to learn, they made marvelous progress."[5]

Letters were the primary means of communication at this time, and their delivery was surprisingly reliable. A network of post-horses and couriers knit together the entire peninsula and connected Italian merchants to northern Europe. The specialists in this field since at least 1251 had been the Tasso family, of Bergamo in Lombardy. Omodeo, the founder, began with a courier service for the Venetian republic, operating a chain of postal stations between Venice and Milan and between Venice and Rome. In 1460, the Tasso family took exclusive charge of postal service for the Papal States, a monopoly it held until 1539. By that time, it had also branched out to serve the Holy Roman Emperor in Spain, the Low Countries, Germany, and Austria, as well as the duchy of Milan. The German branch of the family went by the name Taxis (from which our modern term "taxi"

is derived) and mustered a fleet of taxicabs as well as post-horses.[6] An efficient postal service would also become an increasing concern of the modernized Tuscan state over the course of the sixteenth century.[7] People also entrusted letters to friends or merchants who were traveling; that was cheaper than the post, but less reliable. And for a quick dispatch, a special courier, a *staffetta*, could be hired at great expense (four ducats between Siena and Rome). A *staffetta* could bring the news from Rome to Venice within a day and a half; when it came to announcing events like the results of a conclave, the expense was worthwhile.

Almost nothing is known about this Raffaello da Brescia, and only a little about his more successful brother, Andrea,[8] though both originally trained as dance masters, before shifting to painting.[9] Vasari does not dedicate a *Life* to either brother, nor indeed mention Andrea at all. But his time in the workshop of Raffaello da Brescia was limited, for in 1529 life in Florence once again became dangerous and complicated.

As soon as the plague struck Rome in 1528, the renegade imperial troops who had sacked the city in 1527 began to wander back north. Although a shaken and humbled Clement VII had paid in June 1527 for a cease-fire (and his life), he had remained a prisoner inside his refuge of Castel Sant'Angelo for another six months, finally escaping, disguised as a peddler (presumably keeping his manicured hands out of sight), to take refuge in Orvieto and Viterbo. In October of 1528, he finally returned to Rome and opened negotiations with his one-time adversary Emperor Charles V. Charles, a fervent Catholic, had been horrified by the sack and was eager to make amends. So Clement asked another favor of Charles: the return of the Medici to Florence. In exchange, the pope was willing to make an extraordinary offer: on Christmas Eve of the year 800, over seven centuries earlier, Pope Leo III had set the crown of Holy Roman Emperor on the head of Charlemagne, Charles the Great, transforming the Frankish king and his army into an instrument for enforcing papal dominion over mat-

ters both sacred and secular. Now, in the summer of 1529, Clement offered to perform the same ritual for Charles V, but in Bologna, sparing the emperor the long journey south to Rome.

Because Charles was so adamantly Catholic, Clement also felt compelled to stiffen his own piety to match. At precisely this delicate moment, King Henry VIII had written him to request an annulment of his twenty-year marriage to Catherine of Aragon. Clement had been inclined to grant the request, but now felt that he could not do so without offending the Holy Roman Emperor. Henry, of course, broke with the Church shortly thereafter.

First, however, Pope Clement and Charles V took action to resolve the problem of Florence. On 24 October 1529, a coalition of papal and imperial troops surrounded the city and began a siege that would last until the following August. Vasari saved his skin by escaping:

> When the battlefield came to Florence in 1529, I left with Manno the goldsmith, my good friend, for Pisa, and there I left off working as a goldsmith and painted. . . . As the war grew day by day, I decided to return to Arezzo, but it was impossible to do so by the usual direct route. Instead, I went over the mountains to Bologna, where I discovered that they were making painted triumphal arches for Charles V, and so at my young age I found work that brought me profit and honor.[10]

His *Life* of Salviati adds a few details: "When 1529 came around, Francesco regretted not having followed Giorgio, who went that year to Pisa with Manno the goldsmith, with whom he stayed for four months. Then Vasari went to Bologna, when Charles V was crowned by Clement VII."[11]

The natural way to return to Arezzo from Pisa was to follow the course of the Arno River, but in 1529 the Arno valley was swarming with troops. Instead, Vasari probably headed home by going inland as far as Pistoia and then climbing north, up and over the Apennines,

to reach the flatlands of the Po valley. Here, he could travel much more quickly and easily over territory that belonged first to the duchy of Modena, then, farther east, to the papal state of Bologna. From Bologna he may have planned to follow the same track that the imperial troops had taken in 1527, crossing the Apennines along ancient Etruscan roads that led directly from Arezzo to Italy's eastern coast. Most people in sixteenth-century Italy traveled distances on the back of a donkey or by foot, and Giorgio probably did the same. Horses were quick but expensive, and much less sure-footed than donkeys on mountain trails. If need be, a relay of post-horses could transmit a message with lightning speed, but the usual pace of travel and communication in those days was much more leisurely (though a letter often reached its destination more quickly in Renaissance Italy than it does today). Vasari might have taken a week or two to reach Bologna.

The phrase that Giorgio uses to describe what kept him in Bologna, translated here as "profit and honor," *utile e onore*, is a classic Tuscan pairing that describes the two goals a right-thinking, hardheaded citizen hoped to achieve in life. *Utile* meant "utility" as well as "profit" or "advantage"—gain that was socially and morally useful, as well as simply profitable. *Onore* meant acquiring an external reputation for honest practice by obeying a strict internal code of honor. In Renaissance Italy, this code combined ancient Roman virtues with the moral teachings of the Bible, drawing from Hebrew wisdom literature and from the Gospels. Thus Jewish merchants observed the same basic tenets as their Christian compatriots, and because both communities had existed under Roman rule, they still subscribed to ancient Roman ideas about maintaining a good public reputation. They were certain, moreover, that God took a fervent interest in their economic well-being. The Tuscan banker Francesco di Marco Datini headed his ledgers "in the name of God and of profit."[12] Another Tuscan merchant, Agostino Chigi, topped his letters with a cross and repeatedly invoked "utile e onore" as he went about amassing the largest fortune of the early sixteenth century.[13]

Doing good and doing well, then, were perfectly compatible in the ethical code that Giorgio Vasari inherited from his family and absorbed from his environment. After all he had seen happening around him, from the chance encounters that advanced his career, to the sudden disasters that could overtake even the most powerful people and the best-fortified cities, he also acquired a sharp instinct for survival.

To improve his own *utile e onore*, Giorgio Vasari stayed in Bologna painting triumphal arches up until the great event for which the arches were being designed, the coronation of Charles V by Pope Clement VII on 24 February 1530. He was surely present in the cavernous medieval basilica of San Petronio, or at least in the gigantic piazza outside. The sight of the two distinctive faces of pope and emperor, in the midst of a sea of gilded bishops, knights in decorative armor and plush doublets, the elite of Europe crowded into and around the basilica, would stand him in good stead in his subsequent career. His painter's eye would have admired the glitter of their entourages, as satins, gems, and armor caught the light and focused the attention of Europe on Charles.

The ceremony began with prayer, after which a sword was presented to Charles, "to serve for the defense of the holy Church"—an ironic assignment with Rome still smoldering from the sack by his army.[14] But the appointment healed, if superficially, the rift between pope and emperor, and Charles was elated to inherit a title that made him the leading monarch of Europe, officially sanctioned by the Church. He now donned the mantle, and indeed some of the crown jewels, that had been carried by Charlemagne, his namesake.

After the ceremony, the crowned emperor would return through the decorated triumphal arches, which symbolically linked the Holy Roman Emperor to the emperors of Roman antiquity. In ancient Rome, a triumph was a ceremonial procession awarded by the Senate to generals who won an outstanding victory in the service of the state (to qualify, the victory had to put the definitive end to a foreign

war).[15] As the conquering general rode on a chariot through the streets of Rome and up the Capitoline Hill to the Temple of Jupiter, his way was marked by temporary wooden arches (a few were later turned into permanent marble structures). The shape of these ceremonial "gates"—a curved Roman arch with thick piers and a crossbeam above, covered in inscriptions and relief sculpture that illustrated the battle scenes and the subjugation of the vanquished, was reminiscent of entrance portals to cities, but with no door or gate to block access: they were an artificial symbol of the army passing through the gates of a defeated city after a siege. An ancient Roman triumph could go on for hours, displaying illustrious prisoners and glittering booty as well as the victorious troops.

Renaissance triumphal processions drew inspiration from the descriptions of ancient historians and remanants of ancient Roman art, including the three surviving marble arches in the Roman Forum (the arches of Constantine, Titus, and Septimius Severus). The arches erected for Charles V in Bologna were proudly antiquarian in their design, a temporary stage set for the pageant of accommodation between the head of a beleaguered Church and a beleaguered head of state, both painfully aware of a widening split between Catholics and Protestants in their respective realms.

A depressingly large amount of the time and energy of Renaissance artists, from van Eyck to Vasari, was dedicated to preparing elaborate decorations for onetime events like weddings, coronations, and triumphal processions, like this spectacle for Charles V. As printing became more and more popular in the course of the sixteenth century, the ephemeral ceremonies could obtain a kind of immortality on large broadsheets or illustrated pamphlets called festival books. Albrecht Dürer's triumphal arch for Charles's father, Emperor Maximilian I, took six years to make (1516–22) and consisted of thirty-six printed sheets designed for pasting to walls and gates—unfortunately, Maximilian had died by the time Dürer completed the massive project.

But perhaps the most curious spectacle of all was the face of

Emperor Charles. Clement VII was a handsome man, with a regal nose and deep-set eyes with a brooding dark complexion (Ippolito de' Medici shared this same attractive look). The pope had grown a beard to mourn the Sack of Rome and never shaved it; fashions were changing to favor beards and short-cropped hair. Charles, on the other hand, suffered badly from the Habsburg family's distinctive underslung jaw. He, too, had grown a beard, but it was to mask this deformity. When the painter Sebastiano del Piombo sketched the two monarchs in conversation, he emphasized the contrast between the elegant pope, whose portrait he had painted several times, and the strange-looking foreigner, with his unfashionable pageboy haircut and his gaping mouth.

In person, however, Charles usually impressed people not for his odd appearance but for his extraordinary charisma. He spoke four languages, rode, fought, and danced with superb ability, and took in the world through eyes that glittered with intelligence. The jaw simply underlined his individuality. It is the eyes that painters have recorded, from Titian to Vasari himself—the eyes and the kingly bearing. Thirty years later, Vasari would decorate a ceiling of the Palazzo Vecchio in Florence with an image of that coronation (the spacious room now serves as the mayor's office). In the midst of a colorful crush of onlookers, Charles kneels before Clement to receive the crown of the Holy Roman Empire. Everyone who saw the painting knew that the man who bent over in humble obeisance would rise to his feet as the mightiest monarch in the European world. He might be bowing before Pope Clement, but he held the fate of the Medici pope in his hands, along with that of much of the rest of Europe.

8

BACK AMONG
THE MEDICI

CHARLES V LEFT BOLOGNA SHORTLY AFTER HIS CORONA-
tion. So did the Medici pope who had crowned him, Clement
VII. With less fanfare, Giorgio Vasari also departed, back to Arezzo
and his family. Work was still available in Bologna, but he was wor-
ried about how his brothers and sisters were faring without their
parents. He may also have sensed that the opportunities in Bolo-
gna, however tempting, would ultimately limit his development as
an artist. As a papal possession in the fertile Po valley, Bologna was
famously prosperous—its nickname was "Bologna la grassa," "fat
Bologna," and one of its most distinctive products is still a sausage
stuffed with cubes of fat (*mortadella di Bologna*, the refined ancestor
of American baloney). But fat Bologna also suffered from the family
feuds and factionalism that were a near-universal curse of Italy's city-
states. Verona had its feuding Montagues and Capulets (Montecchi
and Cappelletti in Italian). In Orvieto, the Monaldeschi fought the
Filippeschi, in Siena it was Petrucci against Bellanti, in Florence, Pazzi
and Strozzi against the Medici. In Bologna, the conflict raged between
the Baglioni family, local warlords, and the succession of popes who
tried to drive the Baglioni out of town. By 1530, decades of civil strife
and external wars had sapped the city's bountiful resources, and it had
drained into something of a cultural backwater. Fifty years hence,
under more peaceful conditions, Bologna would become an impor-
tant artistic center in its own right, but that transformation had yet to

begin. Vasari was astute enough to realize that he might have found work easily in the Po valley, but the real developments in art were happening in Florence and Rome, with Arezzo fortuitously situated in between.

In 1510, at the heart of the High Renaissance, there was a great, four-pointed rivalry among Italian painters. The leaders in the field—Raphael, Michelangelo, and Leonardo—hailed from the belt across central Italy (Leonardo and Michelangelo were Tuscan, Raphael from Le Marche on Italy's east coast). But marvelous things were happening in Venice as well, most notably the buildings of a transplanted Tuscan architect named Jacopo Sansovino, and the career of a painter named Tiziano Vecellio (Titian, as he is called in English). Vasari describes how, aged ten, Titian was sent to live with an uncle in Venice, who set him up as apprentice to Giovanni Bellini, at the time Venice's leading painter. But even though Vasari admired Titian, he would always regard the Venetian tradition as hopelessly deficient in *disegno*.

> And because at that time Gianbellino and the other painters of that country, who made no study of antiquity, were accustomed, in fact did nothing else but to portray whatever thing they were making from life, but with a dry, crude, and labored manner, and thus Titian, too, learned that style, at least for the time being.[1]

Vasari throws in backhanded compliments to the great Titian (though the two were friendly), who would have been so much greater, he sighs, if only he had employed the Tuscan style of focusing on drawing.

> But then, in about the year 1507, Giorgione da Castelfranco, who was not entirely satisfied with that way of working, began to give his works greater softness and higher relief, with a beautiful style, although he still put live and natural things in front of him and tried to portray them as best he could with pigment, dabbing them with raw or gentle hues according to the appear-

ance of the living subject, without making any drawings, in the firm belief that simply painting with the pigments, without any preliminary study on paper, was truly the best way to work and the true meaning of *disegno*; but he failed to notice that [*disegno*] is essential to anyone who wants to arrange compositions well and to adjust their ideas, because first they need to be put on paper in different ways, to see how it all works out together.[2]

Titian, born in Cadore, at the foot of the Alps, took part in the tradition of Venetian painters whom Vasari admired, but viewed as flawed for their lack of interest in *disegno*. He also felt that they neglected Rome, arguing that because they did not study in the ancient capital, they never saw "any works of absolute perfection."

But Titian could not be ignored. His success throughout Europe was indisputable (he was a favorite of the Habsburgs, and there are more of his paintings in Madrid, the Habsburg capital, than in Venice). It is difficult to tell whether Vasari's opposition to the Venetian style was heartfelt or a matter of Tuscan patriotism. He described Titian as "the most excellent of all the others" in his *Life* of the painter, but by "the others" he means the other Venetians, whose work, we hear repeatedly, would have been immeasurably improved had they all studied in Rome and practiced drawing.

In many respects, however, Giorgio Vasari and Tiziano Vecellio understood each other, despite some obvious contrasts: their ages (Titian was twenty years older), their artistic training, their regional loyalties, the way they spoke (Titian with a lilting Venetian cadence, Vasari in precise, complex Tuscan). They shared a close friend in the writer Pietro Aretino, and socialized as friends themselves on the few occasions when work brought them to the same city at the same time. Masters of conversation as well as portraiture, they had both come to serve the most illustrious patrons in Europe, yet they also answered to local markets (Titian may have furnished paintings to the king of Spain and the Holy Roman Emperor, but his most demanding critics

were his fellow Venetians, and some of his best work is to be found in Venice). Both, above all, were shrewd businessmen who also worked exceptionally hard to keep abreast of all their orders. Despite the profound differences in their training, Vasari could not help admiring Titian's skill, and the radical change that came over the Venetian's style as he grew older. And tellingly, the *Life* of Titian focuses on the subjects that may have dominated their own conversations: money and commissions, their professional bread and butter.

The *Life* begins with Titian's birth in the Alpine village of Cadore to the noble Vecelli family. At the age of ten, because of his "lovely spirit and quick wit," young Tiziano was sent to Venice to live with an uncle, who apprenticed him to Giovanni Bellini, the most successful painter of the era (successful enough to merit his own separate *Life* in Vasari's collection), where he met another talented apprentice, Giorgione.

Giorgione was a superb painter, but he too (at least in Vasari's view) was hampered by the wrong kind of training. The teenage Titian, on the other hand, was captivated by Giorgione's style and began to imitate it. He also painted frescoes "of such quality that many experts reckoned that he would develop, as he did, into a most excellent painter."[3]

Vasari's list of Titian's most important works differs somewhat from our own. Like modern critics, he singles out the *Flight into Egypt* of 1506 as an enchanting early work, and for largely the same reasons:

> Our Lady travels to Egypt in the midst of a great forest with some excellent landscapes, for Titian spent many months learning to make such things, and kept some Germans in his house for that purpose, excellent painters of landscapes and greenery. He also put many animals in the forest of that panel, drawn from life, and they are truly natural and almost alive.[4]

But he claims that he can barely make out the great *Assumption of the Virgin*, which Titian painted for the Venetian church of Santa

Maria Gloriosa dei Frari in 1518, a monumental painting that is now regarded as a crucial turning point in the artist's career. The rest of the *Life* is a mostly long list of commissions and payments, a brief description of their meetings in Venice and Rome, and a gossipy assessment of Titian's career by Sebastiano del Piombo, a Venetian painter who moved to Rome in 1511 and fell under the sway of Michelangelo:

> And I remember that Friar Sebastiano del Piombo told me that if Titian had come to Rome at that time and had seen the works of Michelangelo and Raphael and the ancient statues, and had studied *disegno*, he would have made truly stupendous things, and if their grand tradition of *disegno* had underpinned his excellent handling of color, he would have been the greatest and most beautiful imitator of nature in paint.[5]

But what truly fascinated Vasari about the elderly painter (who would outlive his biographer by four years) was the way his style changed in late life:

> His first paintings are executed with a certain delicacy and incredible diligence, and can be viewed either close-up or at a distance, but these latest works are created by big coarse strokes and blotches, so that up close you can see nothing, yet from a distance they seem perfect.[6]

The apparent simplicity of these new paintings, as Vasari well knew, was deceptive. Rather, he declared, "this style is judicious, beautiful, and wonderful because it makes paintings come alive, executed with great artistry, hiding the effort that went into them." As he has begun to realize, Titian has shown him an entirely new concept of painting, and the idea thrills him. The *Life*'s final paragraph is an expression of pure gratitude.

In short, Titian, having adorned Venice, all of Italy, and other parts of the world with first-rate paintings, should be loved and observed by artists, and admired and imitated in many things, as someone who has created—and is still creating—works worthy of infinite praise that will last as long as the memory of illustrious men.[7]

The question of how artists did, or should, go about their craft is one that Vasari deals with in many of the lives in his book, as debates raged through the fifteenth and sixteenth centuries on technique, both theoretical and practical. This loaded opening section to the *Life* of Titian manages simultaneously to praise and undermine Venetian painting, incorrectly considering that the city's distance from Rome meant that artists of the Veneto were not "able to study ancient works" (there were, of course, ancient works scattered throughout a territory that itself once belonged to the Roman Empire), and also setting up a delineation between Venetian-style painting, which Vasari cast as involving the direct application of paint (*colore*) to canvas, as opposed to the "proper" central Italian habit of drawing first and afterwards adding paint.[8] Never mind that Venetian painters did draw, and Giorgione did not invent the mode that Vasari attributes to him in the quotation above. But because Vasari's scheme has such persuasive power, his dichotomous description of Tuscan versus Venetian painting styles has been believed, internalized, and taught for centuries.

THE RETURN TO AREZZO was bittersweet. One of Giorgio's two brothers had died of plague, aged only thirteen. On the other hand, the young artist discovered, to his relief, that his uncle Antonio had managed the family finances with proper Tuscan prudence. As for his artistic career, at nineteen Vasari felt confident about his ability to draw, but considerably less confident about his ability to handle paint. After producing some small oils, he executed several commissions for

the Olivetan friars at San Bernardo in Arezzo, who occupied a spacious fourteenth-century church:

> The Olivetans had me paint some frescoes, namely, the four Evangelists with God the Father on the vault and some other life-size figures, which, as a young, inexpert beginner, I did not execute as well as a more practiced painter would have done, but nonetheless I did the best I could and the result did not displease those Fathers, who made allowances for my youth and my lack of experience. But no sooner had I completed that work than Cardinal Ippolito de' Medici passed through town.[9]

The church and monastery of San Bernardo stood on the western edge of Arezzo, built into the foundations of the city's ancient Roman amphitheater right next to the city walls. The Olivetans' distinctive cloister therefore follows the curvature of the ancient arena. Since 1937 it has housed Arezzo's archaeological museum, with an incomparable collection of local pottery, the very kinds of pottery that Vasari's grandfather collected and imitated with such skill. On 17 January 1944, an Allied bomb aimed at a stretch of railroad fell instead on San Bernardo, virtually destroying the church and badly damaging the monastery. Panel paintings, archaeological artifacts, and some frescoes had already been removed for safekeeping, but Vasari's frescoes perished along with many other treasures. Both church and cloister were reconstructed after the war, but the starkly beautiful whitewashed interior of San Bernardo is a far cry from the colorfully painted space where young Giorgio "did the best I could," amid a riot of frescoes dating back to the fourteenth and fifteenth centuries. As he added his own paintings to the jumble of decorations, the young painter turned an analytical eye to the way in which artistic style had developed over the previous two centuries, evaluating *disegno*, proportion, color, and composition.

The meeting with Ippolito de' Medici was a lucky coincidence.

Pope Clement VII had appointed the young man cardinal in 1529, when he was only eighteen, and immediately handed him several responsible positions within the Church. These responsibilities, as Ippolito well knew, removed him from Florence, where Clement had carefully maneuvered with Charles V to install Alessandro de' Medici as the city's new ruler in 1530. The former classmates and cousins had now become bitter rivals, so much so that Ippolito continued to maintain contact with the republican rebels who had expelled the Medici—that is, Alessandro, himself, and Cardinal Passerini, in 1527. Given the right moment, they could always rebel again.

Cardinal Ippolito must have noticed Giorgio Vasari's increasing maturity as a painter. He also knew all about trying to make a living without a father's protection. As Vasari would write in his *Life* of Francesco Salviati, "When [Cardinal Ippolito] passed through Arezzo, he found Giorgio fatherless and making ends meet as best he could; for which reason, in hopes that [Vasari] might make some progress as an artist and in a desire for his company . . . [the cardinal] ordered that he be sent to Rome."[10]

Joining the Medici entourage in Rome was not simply a matter of charity to an old friend; Ippolito must have seen that Vasari had ambition, talent, and energy and that artistic success would bring credit to them both. With a Medici pope still enthroned in Rome, both the cardinal and the young artist could count on a privileged life in the Eternal City, though for both of these precocious orphans it was a life entirely dependent on the whims and hold on power of a weak pope.

9

ROME AFTER
THE SACK

I N ROME, THE PRICE OF CLEMENT'S WEAKNESS HAD BEEN
ruin. When Vasari arrived in 1531, damage from the sack was still
evident everywhere. The city had been devastated in AD 410 when
Alaric and his band of Visigoths became the first army to invade
Rome in eight centuries, but Alaric's rampage lasted only three days,
with a military technology limited to stone-throwing catapults and
fire arrows, as were the subsequent attacks on the city: in 455 by the
Vandals, 546 by the Ostrogoths, and 1084 by the Normans. Eleven
centuries after Alaric's assault, on the other hand, the mercenar-
ies of Charles V had liberal access to gunpowder and cannon, and
they stayed for a full six months, before hauling their loads of booty
northward.

Both before and after its wrecking by imperial troops, Renaissance
Rome was a very different place from the capital city we experience
today. The population, up to a million in the time of Constantine
(fourth century AD), had dwindled to twenty or thirty thousand in
the aftermath of the Black Death of 1348. As Francis Henry Taylor
wrote, "With the transfer of the capital to Byzantium in 476 AD,
Rome had entered into its thousand years of medieval slumber."[1]
Since the papacy's return to Rome from France in the mid-fifteenth
century, the dilapidated little city of the late Middle Ages had dou-
bled both the number of its inhabitants and the height of its houses,
improved its economy, and developed a thriving construction indus-

try. It had also turned into a distinctly cosmopolitan place, with substantial settlements of French and Spanish churchmen, merchants, craftsmen, and bureaucrats.

Because so many of Rome's residents served the Church, and the Church forbade priests to marry, the ratio between men and women in the city was unnaturally lopsided. Prostitution was rife; in fact, prostitutes made up the largest group of professional women. Still, the requirement that priests maintain celibacy was defined more leniently: Renaissance priests could not marry, but many of them had mistresses and families, like Clement VII's successor, Paul III, who openly acknowledged having both legitimate and illegitimate sons (the legitimate son, Pierluigi, was made legitimate only by a papal decree; the same provision had been extended to the future Clement VII by his cousin Leo X, in order to make him eligible for election as pope).

Romans of all income levels lived among the magnificent ruins of the ancient city, ruins of brick and travertine rather than marble, which had been stripped away by pillagers as booty, or by locals for reuse. With a few exceptions like the Pantheon and the Late Antique basilicas of St. Peter's and St. John Lateran, the brilliant colored stone wall panels and patterned floors of antiquity had long since been hacked from their original locations and transformed into gorgeous inlaid pavements for the city's medieval churches. In such a unique setting, surrounded by gigantic structures in indestructible Roman concrete, the architecture of medieval Rome remained deeply classical in spirit. Attentive artists like Raphael studied every remnant of the past with careful attention. None more so than the pair of closest friends, the leading architect and sculptor of fifteenth-century Italy, Filippo Brunelleschi and Donatello.

GIOTTO ANCHORS THE FIRST SECTION of Vasari's *Lives* by signaling a break with the formal Byzantine artistic tradition, choos-

ing instead to "rely on nature" and drawing from life to create his forms. The next stage in our biographer's large-scale history of art begins with that pair of fifteenth-century Florentine friends, Donato di Niccolò di Betto Bardi and Filippo Brunelleschi, who advance the development of Italian art by adding a new source of inspiration to the contemplation of nature: classical antiquity. The real story, needless to say, is more complicated than this broad outline: Giotto also looked to the ancients for inspiration, and so did his medieval predecessors. Still, Vasari's historical scheme puts huge amounts of information into usable order for his readers, just as it must have done for his students at the Accademia del Disegno.

Like Giotto before them, Donatello and Brunelleschi were born into comfortable circumstances in Florence. Their fathers belonged to two of the city's most important guilds, known as "arts." Brunellesco di Lippo (short for Filippo) was a trained notary, educated in Latin, and Niccolò di Betto Bardi belonged to the Arte di Calimala, the wool finishers. But what Giorgio Vasari, a bundle of ambition in a diminutive body, sees in Filippo Brunelleschi is what he saw in Giotto: a kindred soul.

> Many have been created by nature to be small in stature and appearance, but with a spirit full of such greatness and a heart of such boundless immensity that if they do not undertake things that are difficult, not to say impossible, and finish them to the marvel of all who behold them, [they] will never rest in their lives; and whatever things opportunity puts in their hands, however short and unprepossessing they might be, they transform into lofty renown.[2]

It was this tiny man, his little hands trained to the delicate art of goldsmithing, who created what is still the largest monument in Florence: the dome of its cathedral. Vasari brims over with pride at the achievement:

He was small and skinny, like Giotto, but had so lofty an imagination that you can say that he was granted us by Heaven to give new form to architecture, which had lost its way for centuries. People in those days had spent fortunes on buildings devoid of order, with bad style, wretched design, and bizarre inventions, their charm charmless and their ornamentation even worse. And Heaven decreed that, after Earth had endured so long without an outstanding spirit, divinely inspired, Filippo should leave as his legacy to the world the greatest, most towering structure, and the most beautiful, of all the others built in our modern times, and indeed in antiquity, showing that the skill of Tuscan craftsmen might have been lost, but it was by no means dead.[3]

Vasari does not explicitly mention another quality of Filippo's: his ability to turn defeat into triumph. In 1402, as a goldsmith, he had entered the competition to design new doors for the eleventh-century Florentine Baptistery, but came in second to Lorenzo Ghiberti. To distract himself from his public disappointment, he decided to make a trip to Rome with an ambitious young sculptor of twenty, Donatello Bardi, and for the next two months they studied and sketched the monuments of Rome, great and small. In Vasari's eyes, this educational trip to Rome becomes the essential step in perfecting the education of every Tuscan artist, for only by measuring their ambitions with the ancients could these two modern masters develop their own powers to the fullest—none of their contemporaries shared either their interests or their burning talent. Vasari describes Brunelleschi as "beside himself" with enthusiasm for architecture, but when he returned to Florence in 1404, he worked, like his friend Donatello, as a sculptor. By 1416, he had created a system of linear perspective that allowed painters to create an uncanny illusion of depth in their work, and then, in 1418, well into middle age, he entered the competition to put a roof on the gigantic unfinished cathedral of Florence.

Like Giotto, at least in Vasari's telling of the story, Brunelleschi obtained the commission by a display of unconventional cleverness:

The [other architects] wanted Filippo to describe his intentions in detail and show his own model, as they had shown theirs. He had no desire to do so. Instead he put this challenge to the masters, both Florentines and outsiders: whoever could balance an egg upright on a marble slab should make the cupola, because in this way their ingenuity would be seen by all. An egg was provided, and all these masters tried to make it stand up straight, but none could find the way. When they finally told Filippo to make it stand still, he graciously took the egg, smashed its bottom onto the surface of the marble—and up it stood. When they all protested loudly that they could have done the same thing, he replied, laughing, that then they should also have known how to vault the cupola, with its model and blueprint in front of them. And so it was decided that he should have charge of this project.[4]

Brunelleschi declares that this test will reveal what he calls the architects' *ingegno*, a word that means wit, intelligence, ingenuity, creative power, and genius all rolled together, and in this anecdote Filippo demonstrates every one of these qualities. His *ingegno* is what wins him the commission in the first place, but it is also what enables him to complete it, by taking a trip to Rome and studying the dome of the Pantheon. It is the single-shelled concrete structure of the Pantheon that provides him with a model for putting a roof over the gaping center of the unfinished building. But Brunelleschi's much steeper dome also achieves an impressive effect that the Pantheon does not: its soaring lines became the most prominent element in the Florentine cityscape, and today that dominance is protected by law.

How did Filippo make the transition from goldwork to majestic architecture? By *disegno*. No matter the scale of an artwork, at least in the Tuscan tradition, it needed to display good composition and

harmonious proportion, and the best way to ensure these qualities was to sketch a series of alternatives, refining the design until it was truly graceful. It is an overarching scheme of proportion, from the narrowest molding to the project as a whole, that transformed the Hospital of the Innocents in Florence (1419) from a standard medieval hospital structure to what is usually regarded as the first building of the Italian Renaissance. Like Filippo himself, that one step was small in itself and mighty in its impact. He would go on to create a new architectural style for Florence, a marriage of local Tuscan traditions and the legacy of Rome. He died in 1446, buried in his beloved cathedral, a rare honor for a small man of huge courage, skill, and resilience.

Disegno was also central, in Vasari's eyes, to Donatello's success. Like Brunelleschi, he trained as a goldsmith, but moved on to large-scale sculpture in metal, wood, terracotta, and stone:

> Because of his attention to the art of drawing, he became not only an extraordinary sculptor and a marvelous maker of statues but also an expert in stucco work, a master of perspective, and a highly regarded architect. His works had such grace, line, and excellence that they were held to be more like the excellent works of the ancient Greeks and Romans than the work of any other artist up to his time; with good reason, then, he receives credit as the first to have made good use of narrative in sculpted reliefs. These last he crafted in such a way that, from the reputation he had in this medium, from his ease and mastery, it is clear that he had a true understanding of it, and he made reliefs of extraordinary beauty. As a result, not only has no artist outdone him in this specialty, but also, up to this day, there is no one who has ever been his equal.[5]

Donatello's career took off at virtually the same time as Brunelleschi's in 1417, with his Saint George on the elaborate oratory of St. Michael (Orsanmichele), that peculiar Florentine structure that is

part church and part civic granary. Often he worked together with Brunelleschi, supplying the sculptural ornament to his friend's architecture, in projects that ranged all over the city of Florence, from the Medici stronghold of San Lorenzo to the Franciscan basilica of Santa Croce, the cross-town headquarters of the rival Pazzi clan. For both artists, the key to the innovative designs and techniques was to be found in the work of the ancients, in many ways their closest friends in the art world. They also had each other, just as Giorgio Vasari had his scholarly friend Vincenzo Borghini to share his unusual ambitions and unprecedented plans.

Appropriately, then, Vasari rounds out his *Life* of Donatello with a tribute from Borghini in Greek and Latin, comparing Donatello to Michelangelo, and remarking that either Donatello's spirit inspired Michelangelo or Michelangelo's genius was foreshadowed by Donatello. Beyond doubt, however, both Borghini and Vasari saw a divine hand guiding the development of Italian art.

VASARI WOULD HAVE ARRIVED in Rome, as did all who came from the north, through a gate at what is now the Piazza del Popolo. Immediately inside the gate, the church of Santa Maria del Popolo was built on a site reportedly haunted by the ghost of Emperor Nero, in an attempt to exorcise that malevolent spirit. Giorgio would have turned to cross the Tiber River toward the site of the incomplete, but magnificent, church of St. Peter's, built on a low hill called the Mons Vaticanus, situated on the western bank of the Tiber. The bankers and bureaucrats who worked with the Church clustered their houses and offices just across the river, in the flatlands known as the Campus Martius, the Field of Mars, because it was here that the ancient Romans had assembled their armies in honor of the god of war. The Campus Martius had one great advantage: close proximity to both the river port of Ripetta and the seaport of Ripa Grande; and one great disadvantage: it occupied the floodplain of a temperamental

river. Minor floods occurred every winter, major floods almost once every decade. In high water, the normally muddy streets turned into canals, prisoners in the vile Tor di Nona jail drowned in their riverside cells, basements and ground floors filled with slime and debris. The ground level of Rome rose two entire stories between the time of Julius Caesar in the first century BC and the time of Pope Julius II at the beginning of the sixteenth. This is evident if you walk the city today and look down a good two to three yards into the Forum, the former street level of ancient Rome. It was easier to build on top of a millennium of debris, garbage, and demolished buildings than to sink new foundations through thick layers of rubbish and into the soil of a floodplain. So much of the city had been damaged by the 1527 sack, and its rebuilding was so grand in scale, that most of the city that we see today dates from this reconstruction period, from the 1530s through the early 1600s—this is why the predominant architectural style in contemporary Rome is Baroque (dating from circa 1600). Surviving medieval buildings are few and far between, since they were so badly damaged, destroyed, or built upon.

And yet, the smelly, grimy, low-lying Rome of the 1530s was also a place of dazzling excitement. A succession of popes and their followers had widened the old streets and built huge new palazzi using stone fallen from the Colosseum in long-ago earthquakes. They remodeled tumbledown churches, St. Peter's chief among them, and shaped new styles of painting and sculpture inspired by Raphael and Michelangelo, the brightest stars of art in Rome circa 1510. They were also rivals, competing for prestigious commissions. Raphael was the refined courtier, one of the first Italian artists to be an active member of court, a powerful figure in the service of several popes. He was young, handsome, elegant, and talented, with an alpha personality to match. Michelangelo played the game of courting potential patrons with more reluctance. He was more reclusive, introverted, and could not be bothered with court any more than was necessary. He also had little interest in painting. His passionate

focus was sculpture, followed by poetry and architecture. He produced very few paintings.

The two worked in different styles. Raphael developed what he considered an ideal of beauty (high cheekbones, a high forehead, rosy cheeks, a small pointed nose, slightly protruding chin, large eyes) and reused it for the majority of his figures. His religious paintings were meant as previews on earth of the perfection that must exist in Heaven. A Raphael *Crucifixion*, for example, will base its structure on solid geometry (usually a triangle), with a feeling of balance and peace.

Michelangelo, by contrast, was fascinated with the human body (he examined anatomy up close, dissecting corpses, illegally, in the basement of the Ospedale di Santo Spirito in Florence). His response can be seen in his figures, in the Sistine Chapel ceiling and in his later works, like the *Last Judgment*, a later commission for one of the walls of the Sistine Chapel. He was perfectly aware of the correct anatomy of the human body, and he thought the nude athletic male, as embodied by ancient sculptures in the papal collections, was the ideal of beauty. But he toyed with hyperextending this perfection, intentionally contorting bodies for dramatic effect (in this he may well have been inspired by ancient Etruscan bronzes, which he collected). He added musculature where there was none (his Christ in the *Last Judgment* is so muscle-bound that he has an eight-pack instead of a six-pack) and posed his painted bodies in unnatural ways that were otherworldly in their elegance. He thought the most beautiful form was the *figura serpentinata*, the serpentine or snake-like form, an S shape that he likened to a candle flame flickering in a gentle breeze. And so his paintings are full of eerily muscled figures twisted in S shapes. Yet somehow it works.

The fates would sanctify Raphael but grant Michelangelo the more immediate lasting influence, especially in Tuscany and Rome. Raphael died in 1520, aged just thirty-seven, whereas Michelangelo lived to eighty-nine, dying in 1564. From Raphael's death until the

rise of Caravaggio in 1599, a combination of their styles predominated in central Italy, especially in Florence, adapted by a generation of artists who admired them both. Art historians sometimes call the artists of the mid-sixteenth century Mannerists, from the word *maniera*, a word they themselves used to mean "style"—both Raphael and Michelangelo discussed it at length. Vasari himself popularized the term in his 1568 edition of *Lives*. Encouraged by the patronage of the Florentine state and the papacy, this carefully cultivated *maniera* became a signature style for Italian art.

Rome of the 1530s offered a vibrant artistic environment, and not just in the realms of painting and sculpture. Writers and musicians performed enthusiastically for sophisticated aesthetes and fun-loving crowds, and secular theater in specially designed structures began to emerge as a unique form of entertainment. Rome still suffered grievously from the sack, but its momentum could merely be checked, not stopped. For Giorgio Vasari, it had to be the most exciting city on earth.

The excitement, moreover, was one he could share, because his close friend Francesco Salviati was already in Rome as part of Cardinal Ippolito's entourage. Salviati's *Life* puts the situation charmingly: "Now, when Francesco was there in Rome with no greater desire than to see his friend Giorgio Vasari in the city, he found that Fortune favored his wishes—but she favored Vasari even more."[6] In fact, Giorgio quickly discovered that he was in an awkward position with his old friend:

As soon as Giorgio arrived in Rome, he went to visit Francesco, who told him eagerly how much favor he enjoyed from his lord the cardinal, and that he was in a place where he could give free rein to his desire to study, adding, "Not only am I doing well now, but soon I hope to be doing even better, because you are here in Rome, so that I can think about and discuss art with a friend and peer, but I am also hoping to go into service with Car-

dinal Ippolito de' Medici, and thanks to his generosity and the Pope's favor, I can hope for greater things than I have now; it is bound to happen if that young man they are expecting from out of town doesn't show up." Giorgio, though he knew that he himself was the young man they were expecting, and that the place reserved in the cardinal's entourage was his own, decided to keep [the information] to himself, fearing that perhaps the cardinal had other candidates in reserve, and to avoid saying something that would turn out not to be true.[7]

Spending time among the statues and buildings of Rome was already considered to be a crucial part of a young artist's education, and it would remain so for centuries. Even when the most exciting place in the art world shifted from Rome to Paris, in the nineteenth century, the most sought-after prize for any art student was the Prix de Rome, in which a student had expenses paid to sojourn in Rome, to soak up its majestic cultural past.

Vasari and Salviati's collegial meanderings through Rome recall Donatello and Brunelleschi's time together, sketching the ruined buildings and ancient sculpture. We might imagine the twenty-year-old Vasari, paper spread out on a board, sitting beside the husk of the Baths of Caracalla or the flayed haunches of the Pantheon, silverpoint in his right hand, gripped between the thumb and forefingers. Vasari's love for sketching in Rome would inspire him throughout his life. A few years later, when he lingered in Rome rather than returning to Florence, he wrote to his patron at the time, Ottaviano de' Medici,

> I am resolved to stay constantly among these stones, transformed by the skilled hands of those talents who rendered them more lifelike than Nature herself, when she strives to make them move with every breath. . . . I would rather be dead and buried in Rome than live it up anywhere else, where leisure, laziness, and

inertia rust away the beauty of talents that would have been clear and beautiful, but have instead become dark and gloomy.[8]

Five days after Giorgio's arrival, however, the game was up: the two of them went together to Cardinal Ippolito's residence, the Palazzo del Re, and Giorgio pulled out his letter of recommendation from Arezzo:

> Just then the cardinal himself came in, and Giorgio stepped forward to present the letter and kiss his hands. He was received with joy, and shortly thereafter handed over to the major domo, who gave him lodging and a place at the pageboys' table. It seemed strange to Francesco that Giorgio had said nothing of this, but thought in any case that he must have acted with good intentions. Now that Giorgio had some rooms behind Santo Spirito and near Francesco, the two of them spent that whole winter in each other's company, with great benefit, studying art.[9]

Today, the church of Santo Spirito in Sassia stands almost in the shadow of St. Peter's Basilica, on the Vatican side of the river Tiber. In the early sixteenth century, however, St. Peter's was nothing more than a sprawling construction site. Pope Julius II had laid the cornerstone for a new basilica in 1506, but much of the old church still stood in 1531, a hulking ruin, more than a thousand years old, of brick, travertine, and ancient Roman concrete. Because of this massive project in the making, which took 120 years to complete, the little neighborhood where Vasari and Salviati settled had already started to become an artists' colony, and would remain one for centuries to come.

Vasari would remember this time of his life as a golden age, when he had nothing to do but what he loved best: drawing and studying in the company of other ambitious young artists.

> Thanks to the courtesy of [Cardinal Ippolito], I had the opportunity to spend many months studying *disegno*. And I could truly

say that this opportunity and this period of study were my true and principal master in this art . . . and that an ardent desire to learn and a tireless eagerness to draw day and night never left my heart. In those days the competition of my young companions and peers was also of great help; most of them have turned out to excel greatly in our art.[10]

Vasari and Salviati sketched monuments, buildings, and statues, even sneaking into the papal apartments in the Vatican when the pope was out riding, in order to draw the Raphael and Michelangelo frescoes inside.[11] Sketching by day, the aspiring artists would take turns critiquing each other's work during the candlelit evenings, after supper. They then copied each other's sketches. Vasari also notes that he studied anatomy during this time, not in a classroom but, as he put it in a rather macabre manner, "up in the graveyard." Digging up graves and dissecting corpses was not an acceptable Christian practice, and so this would have been done with shovel, by lamplight. Not a job for the weak of stomach.

With a fatherless family back in Arezzo, Vasari felt the need to provide for his relations and sent most of his earnings to them. He also wrote to influential contacts in hope of obtaining a pension—a permanent salary. Even the most successful artists of the Renaissance sought to secure regular work in the entourages of great men, princes, dukes, and cardinals. As a pensioner, the artist would receive a set sum of money, often supplemented by room and board (sometimes in the palace of the patron), and sometimes his own designated servant. In exchange he—these pensioners were always male—was expected to work regularly for his patron, dedicating his creations to the lord or cardinal (just as Petrarch dedicated his *De Vita Solitaria* to the bishop of Cavaillon, and Albrecht Dürer dedicated his *Life of the Virgin* print series to Emperor Maximilian I). Patrons had the first right to any paintings or sculptures made by the artists in their service. Some stricter relationships, like that between Jan van Eyck and Duke Philip

the Good of Burgundy, specified that the artist could not paint for anyone but his patron without express written permission.[12]

Because of their privileged access to privileged people, artists often participated in court life as agents, sometimes secret, on behalf of their masters. A generation before Vasari, Raphael in Italy and van Eyck in Flanders had served crucial roles in the political maneuverings of their respective courts. Van Eyck sometimes acted as a secret agent on behalf of Duke Philip, undertaking several covert diplomatic missions, much as Peter Paul Rubens would do for Antwerp in the seventeenth century. Thus when Vasari wrote during this period to people like his former patron Niccolò Vespucci, he hoped to obtain a fixed, long-term pension that would allow him peace of mind, a position of some courtly significance, as well as the possibility of gaining extra income from other creative enterprises.

Even without a pension, artists favored by a wealthy patron could do quite well. In his letter to Vespucci, Vasari mentions that, under the protection of Ippolito de' Medici in Rome (but without a proper pension as yet), he has been provided with housing and a manservant, as well as a new set of fine clothes.[13]

Another way to earn a stable income in Rome was to buy a position in the papal administration. A payment to the Apostolic Chamber, the papal financial office, could secure a bureaucratic post as an apostolic abbreviator, drafting documents; or as a scriptor, a letter writer; as a notary; or as a tax collector. Officeholders received small payments for every letter written or contract notarized, and these eventually offset the purchase price of the office itself. Tax collectors could pocket whatever revenue they raised beyond the sum stipulated by the Apostolic Chamber. These positions, in turn, were traded on a local market; Rome's wealthiest residents, merchants, scholars, and clerics alike, hired other subordinates to do the work their offices entailed and traded the offices themselves as if they were stocks and bonds.[14]

One curial position in particular attracted Vasari, and many other

artists, when it came open. It was called *frate del piombo*, the "friar in charge of lead." The friar's job was to affix a special lead seal to papal documents, and stamp it with the pope's coat of arms to guarantee its authenticity—not exactly backbreaking work, but work that entailed following the pope wherever he went. For performing this service, a *frate del piombo* could expect to earn a tidy eight hundred scudi per year, more than twice the salary of a university professor.

Curial positions like this were just what they seem to be: sinecures to be given as a gift to friends. No fewer than four of the artists in the Medici entourage applied to be the "friar of lead." In addition to the young Vasari, only twenty, the sculptor Benvenuto Cellini, eleven years older, also applied—but Clement knew Cellini too well to consider him for the job, "The place you ask for is worth eight hundred scudi a year," the pope informed the sculptor, "so that were I to give it to you, you would never do any work, but spend your days in idleness, pampering your body." To this, the bombastic and witty Cellini replied, "A really good cat mouses better on a full stomach."[15]

A third applicant was Raphael's talented former assistant, forty-three-year-old Giovanni da Udine, but in the end, the office of *frate del piombo* went to the Venetian-born painter Sebastiano Luciani, well into his forties, married, with two children. As the title "friar" implies, becoming the "friar of lead seals" involved taking religious orders, which Sebastiano, chronically short of money, promptly did. Pope Clement also ordered him to pay Giovanni da Udine three hundred scudi a year from his own earnings as a consolation for not becoming *frate del piombo* himself.

Taking orders did not necessarily require a change of lifestyle in Renaissance Italy. A fair number of new clerics remained active men-about-town. From the giddy tone of Sebastiano's 4 December 1531 letter to his friend Pietro Aretino, "scourge of princes" and professional wit, he seems to be taking the position's responsibilities lightly, even though he was a very serious religious painter, who also executed some splendid portraits of Clement VII:

My dearest brother, I believe that you'll marvel at my negligence and that it has been so long since I wrote you. The reason up to now was the lack of any news worth the effort. Now that our Lord has made me a friar, I wouldn't want you to think that friarhood has ruined me, and that I am no longer that same Sebastiano, painter and partygoer, that I have always been; so I'm sorry that I can't be together with my dear friends and companions to enjoy what God and our patron Clement have given me. I doubt that there is any need to tell you the hows and whys . . . suffice it to say that I am the Friar of the Leaden Seal. . . . Tell Sansovino that at Rome we fish for offices, seals, cardinals' hats, and other things, as you know; but in Venice we fish for eels, picarels, and soft-shell crabs. . . . [P]lease give my friarly regards to our dear compadre Titian, and all our friends.[16]

Sebastiano would be known forever afterward as Sebastiano del Piombo, Sebastiano of the Lead Seal.

Vasari never managed to procure a pension during this sojourn in Rome—no surprise given his youth and his modest financial resources—but he had the next best thing: the protection of a solicitous patron, Ippolito de' Medici, the onetime classmate who became a cardinal. However, life as part of the entourage of clerics and politicians was precarious—not only could you fall out of favor but so too could your patron, who might also be sent off on assignment, obliging you either to part ways or uproot and move with him.

So it was for Giorgio. In 1532, Pope Clement dispatched Ippolito off to Buda Castle (not yet Budapest) as papal legate to Hungary, on the front lines of battle against the Turkish sultan, Süleyman the Magnificent.

Vasari passed from Cardinal Ippolito to Pope Clement's major domo, who recommended the young artist to Duke Alessandro, the cardinal's bitter rival. In June of 1532, Duke Alessandro summoned Vasari to Florence. The timing was not ideal for the young artist, who

had begun to find some private commissions in Rome, the first step toward establishing a reputation. In a letter, he wrote, "It's too bad that, now that I'm beginning to make some real progress, he's gone off with his whole court and his army to fight the Turk in Hungary."[17] Vasari had been close to Ippolito for years. Ippolito was in the habit of dropping in on Vasari's studio, to check on his latest drawings and chat. A few months on, with Ippolito still away at war, Vasari wrote to his friend Paolo Giovio, "I am less eager and energetic than I used to be, because I have no reason to produce examples of my work every day, as I did, and no one to encourage me, raise my spirits, and challenge me as Monsignor the cardinal used to do."[18] A physician, and an important intellectual figure in Rome, Florence, and Milan, Giovio was Clement VII's personal doctor. For in 1536, at his villa on Lake Como, Giovio created what he called a *museo*, a gallery featuring portraits of famous men he admired, as well as antiques and objects of interest, including specimens from the New World—America. As we shall see, Giovio shaped both the modern concept of a museum and Vasari's *Lives of the Artists*.

In a marathon effort to finish two particular pictures before he left Rome, Giorgio turned to extreme measures. He described working all day and all night, pulling the sort of "all-nighters" that modern college students (at the same age) do in preparation for exams, keeping his sleep-heavy eyes open by smearing them in lamp oil.[19] Perhaps unsurprisingly, he grew sick with some form of fever, so severely that he thought he might die. He was transported from Rome to Arezzo by litter, what he describes as "a basket." His friend Francesco fared no better, becoming so sick that spring that he "nearly died."

Vasari was sure that the air of Rome had harmed him. It may well have done so, and made Salviati ill as well. What sixteenth-century Italians called bad air, *mal'aria*, was often the mosquito-borne disease we still call malaria, especially virulent in summer and in low-lying, swampy areas, which their neighborhood behind Santo Spirito cer-

tainly was in those days.[20] The pope had his own summer residence, the Villa Belvedere, on a hilltop next to the Vatican Palace, and anyone who could afford to do so fled to the countryside in summer, or at least to the breezy slopes of Rome's proverbial Seven Hills. For Giorgio Vasari, Arezzo, on its Tuscan hillside, was a better place to recover than Florence, another low-lying river port and mother of mosquitoes or, as Vasari would have seen it, of bad air. For the moment, at least, his new patron and old classmate would have to wait.

10

A FLORENTINE
PAINTER

B Y OCTOBER OF 1532, GIORGIO VASARI HAD RECOVERED
enough to move back to Florence, ready to serve once again
under Medici patronage. By an express agreement between Pope
Clement VII and Emperor Charles V in 1530, government of the city-
state had been adjusted to balance Medici rule with the old Florentine
republic. The bargain included putting nineteen-year-old Alessandro
de' Medici in control of Florence, with the promise of marriage to the
emperor's "natural" daughter Margherita. At the same time, however,
some remnants of the old republic were preserved: the chief officer,
called the gonfalonier, or standard-bearer, chosen by lot for a two-
month term, and three senators, elected for terms of three months.
With this small concession to democracy, both Charles and Clement
hoped to contain the threat of another anti-Medicean revolution.
Alessandro returned to Florence from his exile to resume residence in
the Palazzo Medici on 5 July 1531. In April 1532 a new constitution
transformed Florence into a monarchy by making Alessandro perma-
nent gonfalonier of the city and duke of Florence, a hereditary feudal
position awarded by (actually purchased from) Charles V. The young
duke would finally marry Margherita in 1536. These extraordinary
signs of favor for an otherwise unprepossessing youth suggest that
fatherly solicitude counted more with Pope Clement than objective
judgment.

Another crucial element in the bargain over Florence involved

neutralizing Cardinal Ippolito, Duke Alessandro's chief rival for power. Dispatching him to the battlefields of Hungary served two purposes: keeping him away both from Alessandro and from Caterina de' Medici, with whom he had been caught, at least according to the ubiquitous Florentine gossip, in a torrid embrace. The war in Hungary promised to be a titanic clash between the era's two great rulers, two great religions, and two great powers. By sending Ippolito to the front, where Emperor Charles V stood with his troops against Süleyman the Magnificent, Clement was taking the risk, or perhaps betting that the inconvenient cardinal might fall in battle. But part of the greatness of both Charles and Süleyman lay in a willingness to show moderation and mercy, in knowing when to stand and when to draw back. Rather than unleash a cataclysm, both sides decided to allow what became known as the Little Hungarian War fizzle away. Under pressure, moreover, Ippolito moved with a certain diplomatic and, especially, military skill. When Charles withdrew westward in 1533, the cardinal followed, stopping in Venice long enough to have Titian paint his portrait, once in military gear and once in Hungarian dress, his velvet jacket and plumed hat dyed deep cardinal red. Titian may not have drawn as maniacally as Tuscan artists did, but he could handle oil paint with a mastery that astounded his viewers. Up close, the shimmering velvets and wispy plumes of Ippolito's portrait (now in the Florentine Galleria Palatina) look like dabs of paint. Then, at the right distance, they spring into three dimensions, at the same point when the cardinal's wary, ambitious eyes lock onto ours; suddenly, then, we seem to be standing in front of a real person rather than a painted canvas. And that person is no longer a boy; he may be only twenty-one, but he is a mature man.

Wariness must have been an important part of Ippolito's makeup. Born illegitimate, farmed out to a wet nurse, brought up for years as a simple boy named Pasqualino, orphaned at the age of five, then summoned abruptly to Florence to live and study with a relative, Alessandro, whom he quickly learned to despise, he had survived by

paying attention to his surroundings and adapting fast. In 1533, he knew that he was returning to vicious intrigue in Florence, Rome, and all the places in between, and that the pope, despite their family ties, was allied with his rival.

But Duke Alessandro had reason to worry too. He was not a charismatic dynamo like Ippolito, dashing cardinal, and warrior. Alessandro was a duke with clipped wings, set in place by a weak pope and a strong emperor. He did little in office to improve his reputation. The Florentines disliked him intensely, especially after he became their hereditary monarch. Some detractors blamed his weakness of character on his mother's servile status, a criticism that may have had racist overtones, but Alessandro's chief sin was to preside over a monarchy still called, for lack of a better term, the Republic of Florence.[1]

Ippolito enjoyed greater popularity, and in the 1520s it was he who had been treated as the more dominant of the two young Medici. Since that time, his own misfortunes, as Giorgio Vasari well knew, had made him mindful of others, including struggling young artists.

Although Ippolito had commended Vasari directly to Duke Alessandro before leaving for the Hungarian front, Giorgio was actually assigned to the service of Ottaviano de' Medici, fifty-two years old in 1533 and too distantly related to the line of Lorenzo to pose any political threat on his own. Since the 1520s, Ottaviano had taken responsibility for managing many of the Medici family's artistic commissions, which he had done with taste and efficiency. He would have known the young Vasari from their time together in Florence before 1527, and under the new regime, he was the best possible patron to be serving among the Medici clan: mature, knowledgeable, and conveniently removed from the direct line of fire.

By now, Vasari had reached the legal age of twenty-one and could finally enroll in the Florentine painters' guild, the Compagnia dei Pittori Fiorentini, Company of Florentine Painters. This venerable organization, somewhat dilapidated after the wars and coups that had plagued the city without interruption since 1494, functioned both as a

labor union, assuring the rights of painters within the community, and as a regulatory agency: only registered painters could legally set up a workshop in Florence and train apprentices. Once registered, they had a right to the title of *maestro*, "master." Dues were five florins a year, a modest sum in keeping with a profession that was rarely well-paid.

Typically, Vasari was not only interested in joining the guild; he was also fascinated by its history and eventually would take an active part in transforming it from a medieval relic into a prestigious modern organization. He tells of its origins in his *Life* of Jacopo del Casentino, one of the guild's original founders:

> To return to Jacopo . . . in his time, in 1350, the Company and Fraternity of Painters had its beginning, because the masters who were living then, both of the old Byzantine style and the new style of Cimabue, finding themselves in great numbers and considering that in Tuscany, indeed in Florence itself, the art of *disegno* had been reborn, created the said Company under the name and protection of Saint Luke the Evangelist, in order to render praise and thanks to God in their chapel, and also to gather together from time to time and to come to the aid of those who might be needy in soul or body, which is still the practice of many guilds in Florence, but was even more so in those days. Their first chapel was the main chapel of the Hospital of Santa Maria Nuova, which was granted them by the Portinari family. And those who governed the guild with the title of captains numbered six, with two councilors and two chamberlains. . . . When the company had been created, by consent of the captains and the others Jacopo del Casentino made the altarpiece for their chapel, creating a St. Luke who paints the portrait of Our Lady on a panel, and in the predella on one side were the guildsmen and on the other all their wives, all kneeling. From this beginning, whether they met or not, this guild has continued until it was reduced to the conditions in which we find it today.[2]

Modern scholars correct some of Vasari's information. From 1314 onward, painters were admitted to the Arte dei Medici e Speciali, the Physicians' and Apothecaries' Guild, established in 1197 as the sixth of the Arti Maggiori, the Major Guilds of Florence. An eminent logic guided this association: doctors, druggists, and artists all dealt in strange substances, used for medicines or pigments or both. In 1378, the painters split off into their own independent organization. (Meanwhile, sculptors who worked in bronze belonged to the silk workers' guild, other sculptors joined the stonemasons and wood-carvers, and architects were too few to need to benefit from their own structured guild.)

When Giorgio Vasari signed the register of the Company of Florentine Painters, he did so with an acute awareness of his heritage as an artisan and guildsman, for he wrote, "Giorgio d'antonio di maestro Lazzaro Vasari" (Giorgio of Antonio of Master Lazzaro Vasari), invoking both his father and his great-grandfather. This was the community to which he belonged more intimately than to any other.

Vasari's first important commission for the Medici was another exercise in belonging: a posthumous portrait of Lorenzo il Magnifico, Duke Alessandro's (supposed) great-grandfather, and his chief claim to legitimacy as leader of Florence and lord of the Palazzo Medici. The painting was designed for display in the palazzo on Via Larga, though it now hangs, appropriately, in the Uffizi Gallery, Vasari's architectural masterpiece.

Vasari's portrait of Lorenzo is a striking image, and one that was a portrait but necessarily had some "imaginary" components to it, not least the sitter's face, because Lorenzo died in 1492, nearly twenty years before Giorgio's birth. Florentines knew il Magnifico's face from his plaster death mask, and Vasari carefully reproduced the distinctive profile, with its flattened nose and projecting jaw, without attempting to improve upon it. The epiphet "the Magnificent" celebrated Lorenzo's personality and deeds, not his looks. Indeed, Lorenzo was famously ugly, with limp hair and a high, rasping voice, but in his

presence most people quickly forgot everything but his charm and intelligence. Vasari has captured these, too, in Lorenzo's dark eyes and intent expression. He seems to be listening to an empty dramatic mask, and sits in his blue velvet mantle amid grotesque sculpted figures and an antique pitcher, apparently living in another world, a remote world of the imagination.

In self-portraits and portraits, there is a trick to knowing whether the artist used a mirror. Prior to the modern era, just about everyone was right-handed. Dating back to the ancient world, tradition held that lefties were "sinister" (*sinister* means "left" in Latin). The left hand was used for cleaning oneself, never for eating, never for greeting. Those born favoring their left hand were trained to use their right. Therefore, if you see a portrait of someone with his left as the active hand (a painter holding the brush in his left, a soldier with his sword strapped on his right hip, meaning he would draw the sword with his left), then the person has been portrayed with the help of a convex mirror (at this time, flat mirrors were hugely expensive). Looking in the mirror's reflection rather than directly at his subject, an artist could "frame" a sitter within the confines of the mirror, replicating the framing of the painted portrait. So it would not be odd to find a painter sitting beside his subject, sketching while looking not directly at the person being drawn, but instead at their reflection in the convex mirror that sat before them both. This trick does not work for a posthumous portrait, of course, but much of the painting involved in portraits from life might take place without the sitter present.

When an artist would visit a subject to prepare his portrait, he would bring paper on which to draw, but no paints—they were too unwieldy and required the equipment of a studio. (Portable paint boxes were an invention of the nineteenth century.) He would sketch his subject in silverpoint, chalk, or charcoal (the ancestor of graphite pencils) and take notes about color and surroundings, for the surroundings were very rarely specific real locations, but rather idealized spots that would contain symbolic references to the life and works of

the sitter. The actual brushwork would take place back in the studio, based on the sketch and notes taken, and without the sitter's having to sit for hours, if not days, while the paint was applied. A stand-in model might be used—often a member of the studio was drafted when bodies had to be painted.

For "imaginary" scenes, such as biblical and mythological paintings (or a posthumous portrait of a duke), where no living subject was being portrayed, actual models were hired. These models tended to appear in multiple works by any given artist, or during any given period. Bronzino liked to use a striking model with a red beard for all his paintings of Jesus, and we can follow this personage through many paintings by Bronzino and his associates, for the same model worked for other artists as well. Caravaggio used a young friend, possibly his assistant Cecco Boneri, in many paintings and in many forms, from an altar boy to an angel to Cupid to Saint John the Baptist (naked and hugging a goat, odd as that may sound).

In his portrait of Lorenzo, Vasari drew on other images of il Magnifico, and likely had a model stand in to get the figure's positioning right. He chose to surround Lorenzo with an array of arcane-looking objects that are difficult to decode. Fortunately, Vasari himself described their meaning in a letter to Alessandro de' Medici (although not all the details are identical in the finished painting):

> And if Your Excellency is content to have me make a painting with a portrait of Lorenzo the Magnificent, dressed as he used to at home, let's obtain one of the portraits that most resembles him, and from that we'll take the image of his face, and for the rest I thought to use this scheme, if it pleases Your Excellency.
>
> Although you know better than I the actions of this most rare and singular citizen, in this portrait I want to surround him with all the ornaments with which his outstanding qualities framed his life, even if painting him in isolation would still leave him richly decorated in his own right. So I will paint him seated,

dressed in a long scarlet robe lined in white wolfskin, and the right hand will hold a handkerchief that dangles from a broad leather belt in the old style, worn around his middle. To this will be fastened a red velvet purse, and he will lean his right arm on a marble pilaster, that holds up an ancient piece of porphyry, and on this pilaster there will be a head of Falsehood, made of marble, biting its tongue as it is revealed beneath the hand of Lorenzo the Magnificent. The wainscot will be carved with these letters: Sicut maiores mihi ita et ego posteris mea virtute preluxi ("Just as my ancestors shone forth in their virtue so I shone forth for my descendants"). Above this I have made a hideous mask to represent Vice, lying face up, and it will be trampled by a pure vase full of roses and violets with these letters: Virtutum omnium vas ("Vessel of all Virtues"). This vase will have a spout that pours out water separately, and on this [spout] a clean, beautiful mask will be fixed, crowned in laurel, and on its forehead or the spout these letters: "Premium virtutis" ("Virtue's reward"). On the other side there will be a lamp in the ancient style of the same porphyry, with a fantastic pedestal and a bizarre mask on top, where it will be evident that the oil can be put between the horns on its forehead, and with its tongue sticking out of its mouth to act as a wick it will light up, showing that il Magnifico, by his remarkable government, shed light, not only through his eloquence, but in everything, especially his judgment, on his descendants and on this magnificent city.

And in order to satisfy your Excellency, I am sending this letter of mine to Poggio a Caiano, in wherever my poor powers have fallen short in giving you what I can, your most excellent judgment will make up the deficiency. I told Messer Ottaviano de' Medici, to whom I gave this letter, that he should excuse me to you, for not knowing more than a little. And to Your Most Illustrious Excellency I commend myself as best I can from my heart. Florence, *Jan 1533*.[3]

For a master painter of only twenty-two, this is an impressive achievement, as dense with ideas as with images, and impossible to understand without looking closely at every detail. It was exactly the kind of learned painting the Medici prized, and their protégé Paolo Giovio may have helped the young artist draw up the complicated program.

Vasari also painted a portrait of Duke Alessandro himself in shining armor, a resting knight looking out toward Florence, its towers, steeples, and Brunelleschi's dome looming in the distance. The only distinctively modern touch is the rather phallic gun that Alessandro holds in his lap, a hand cannon that would have been exceedingly dangerous to use. Before the widespread use of of rifling (spirals carved inside a gun's barrel, which promote a spin that causes the bullet to fire straighter), early firearms were often inaccurate. Their smooth bores facilitated loading (which was done through the barrel, a fiddly affair of ball, powder, and tampers), but once the powder had been fired, the ball bounced around the sides of the barrel before shooting into the air. Between the gunpowder explosion intentionally set next to the shooter's hand, and the pinball tendencies of the bullet, the weapon was as likely to injure the shooter or his compatriots as it was to hit its target. The hand cannon in Vasari's picture is a beautiful object, certainly, and attests to Alessandro's wealth, warrior spirit, and up-to-date weaponry. But in the early days of firearms, it was sometimes safer to be the target, provided you were a good distance away, than the gunman.

In our present age of omnipresent selfies, several generations into the era of photography, it is easy to lose track of just how important and potentially powerful painted or sculpted portraits could be. Kings of the ancient world understood the value of having citizens who could never see them in person associating a face with the name of their ruler. Although Roman emperors could not be physically present throughout their lands, they could erect semblances of themselves, stand-ins in the form of publicly displayed statues, as a reminder of

their authority. Emperor Augustus, for instance, funded the creation of statues in his likeness—or at least, an idealized version of it. His distinctive jug ears are present, though how much the face resembled his own is uncertain, and the perfectly proportioned, muscled bodies onto which sculpted heads were attached surely came out of a factory-like production line of idealized male trunks onto which any choice of portrait head could be affixed. For private use, Romans kept busts of their deceased family members in their homes, to remember them and honor them.

It stands to reason, then, that Alessandro must have had specific ideas in his wishes for his portraits, projecting the aspects of his personality and power that he felt most important—this would come across not just in his face, body, and costume but also in the background and implements around him, which would be charged with symbolic value that viewers would "read" and understand.

A third project, a copy of Andrea del Sarto's *Sacrifice of Abraham*, shows how eagerly Vasari promoted the work of artists he admired. When he discovered that Andrea's original was no longer in Florence, he reproduced the work from memory, filling out the rest with his own invention. It is not entirely clear whether this was a commissioned painting (as almost all paintings at this time were), or whether Vasari simply undertook the project for himself. Painting on spec or for fun was extremely rare at this time, owing largely to the expense of raw materials: the purchase of well-planed panels and pricey pigments, some of which were imported along the Silk Road, was included in the fee for commissions and could be a significant investment.

Whatever prompted Vasari to get started on the copy after Andrea del Sarto, he was sufficiently pleased with the result to write about it in a letter, dated February 1533, to Antonio de' Medici, another active member of the illustrious family that had taken Vasari under its broad, gilded wing, and who may have commissioned this copy:

And if Your Lordship cannot see the spirit and affection, the fervor and readiness in Abraham that he had to obey God with this sacrifice, painted by me, Your Lordship and Messer Ottaviano will excuse me, for although I know how it ought to be and have not quite expressed it, everything stems from my being young and learning, so that my hands still don't quite obey my intellect, as I have not yet reached the perfection of experience and judgment. But it's very good, and you will have to content yourselves with the fact that this is the best thing I have ever painted up to now in the judgment of many of my friends, and bit by bit I hope to make great progress in everything, so that one day I won't have to make excuses for my work; may it please God to grant me that grace and make you obedient in His holy service, as the story illustrates in the painting I am sending you.[4]

Only a young man could hope with such certainty that one day he would achieve perfection!

In this same year, fourteen-year-old Caterina de' Medici was promised in marriage to Henri, the second son of the king of France, the formidable Francis I. Wellborn Italian girls, unlike their poorer counterparts, often married just after the onset of puberty. Among aristocratic and well-connected families, the union would be carefully arranged. Bridegrooms in Italy were usually seven to ten years older than their brides, although the average age gap between spouses in Renaissance Florence was unusually large, at twelve years.[5] In the Tuscan countryside and among the urban poor, men usually married in their midtwenties, and women at about eighteen, setting up their household with the groom's family.[6] Because upper- and middle-class marriages were so often a business arrangement, it was common for husbands to have affairs, and not necessarily in secret. Women, of course, were not supposed to stray, although they did. Daughters would be married off in order of birth and were expected to be

virgins at least until their engagement. The depth of the dalliance between preteen Caterina and her half brother Ippolito is not known (that it happened at all comes down only through the gossip mill), but no eyebrows were raised when she was betrothed to the man who would become Henry II.

Vasari was asked to paint several portraits of her, including her wedding portrait, none of which survive. Over the course of several sittings, Vasari seems to have developed a crush—or at least a talent for strategic flattery. To a Medici associate in Rome, he wrote,

> Given the kindness this Lady shows all of us, her painted image deserves to stay among us, just as, leaving us, she will remain sculpted within our hearts. I have grown so fond of her, both for her individual virtues and for the affection she bears not only for me but for my whole homeland, that I adore her, if it is permissible to say so, as I do the saints in paradise. Her pleasantness cannot be painted, because otherwise I would gladly commemorate it with my brush.[7]

Caterina's influence on Renaissance history was limited in Italy, but enormous in her adopted land. She has been credited with bringing the Renaissance to France. Montaigne, the great essayist, describes his homeland as an uncultivated quilt of knightly fiefdoms, where people ate rough food with their hands and were more interested in swords than brushes, and who wouldn't know a sole meunière if it flopped off the plate and bit them (though the phrasing he used was slightly more decorous). Caterina's father-in-law and rival of Charles V, Francis I, blazed a trail for French aristocrats, inspiring others to mimic his interest in art. As a passionate Italophile (recall that he collected not only Italian art but Italian artists, like Leonardo da Vinci), he was doubtless delighted to have such a cultivated bride for his son. With her enormous entourage, Caterina brought to France a team of Italian chefs (not to mention maids, gardeners, chaperones, attendants,

priests, and more). The world's first cooking academy, la Compagnia del Paiolo (the Company of the Cauldron) opened in Florence just prior to Caterina's 1533 marriage, and the idea of adding "culinary" to the list of the arts was brand new. The Compagnia promoted experimenting with foods, such as introducing goods imported from the Americas to local cuisine, exotic edibles like corn and tomatoes (which were originally thought to be poisonous). Members of this company may have been among the chefs who moved to France in Caterina's entourage. Perhaps the most tangible positive legacy of Caterina's time in France (the negative legacy being a small matter of the Saint Bartholomew's Day massacre, in which she ordered the murder of thousands of Protestant Huguenots in 1572) was related to food. She is responsible for importing the fork to France. The early, two-pronged variety, used to spear morsels and bring them to the mouth, marked a revolution in Europe, where most meals featured a piece of bread that functioned as an edible plate, a spoon for soup, and a stout knife. Even princes and cardinals ate with their hands. Until, that is, Caterina made forks fashionable and transformed French dining.

As Vasari worked away for Alessandro de' Medici, Cardinal Ippolito plotted with Alessandro's enemies to take Florence for himself. In response, Alessandro frantically fortified the city and its surroundings. The Florentine architect Antonio da Sangallo, an expert designer of modern bastions outfitted for gunpowder artillery, supervised construction of a stout new fort set into the thirteenth-century walls and dedicated to John the Baptist, the city's patron saint. The structure is now called the "lower fort," the Fortezza da Basso, and its 100,000 square meters serve as a convention center. In 1534, when construction began, it was meant to ward off an attack from the most likely direction: the wild hills above the Arno valley to the west of Florence, where rebels gathered in places like Pistoia and made con-

tact with the coast at Pisa. Alessandro did not have enough ready cash to pay for so massive a project and relied instead on loans from his friends, including the banker Filippo Strozzi.

Vasari must have watched the hectic attempts to fortify the city, but did not take part himself. This was no time for a leader to try out young, inexperienced artists in the exacting specifics of military architecture. Just under fifty, Antonio da Sangallo was the greatest expert of his era at designing and building fortifications, often in partnership with his brother, Giovanni Battista. Trained since childhood in his profession (a rarity for architects), he mustered large construction teams with exceptional skill; for that reason, since 1520, he had served as head architect of St. Peter's Basilica in Rome, a position he would hold until his death in 1546. He also designed and built palazzi, churches, fortifications, and the building that housed the papal mint in Rome. Trained as artisans rather than scholars, he and Giovanni Battista worked hard to perfect their understanding of the ancient Roman writer Vitruvius and collaborated with scholars in Rome to promote systematic study of the city's ancient ruins.[8] Vasari already shared Sangallo's ambition to combine technical training with literary study. He would soon display a similar skill at managing large teams of workers. It would be interesting to know whether the two men met at this tense moment in Florentine history.

Whatever private thoughts Giorgio Vasari harbored about the impending duel between his two friends and former schoolmates, Alessandro and Ippolito, he wisely kept them to himself. But he did write to his friend Pietro Aretino in Venice about the ceremonial laying of the cornerstone for the Fortress of St. John, a bastion to defend Florence against fellow Florentines:

I went on the morning of 5 December to see the consecration of His Excellency's castle. . . . Dawn had just broken when I arrived, and just as I arrived before the gate of the castle there appeared a float extraordinary beyond all floats, with an altar on the west-

ern side, covered with gorgeous brocades and other ecclesiasti-
cal trappings, next to which was a bishop's throne . . . [a Mass
follows]. It was time to raise up an Our Father, and already the
captains began to appear, armed with some divine weapons, so
that it seemed to be the triumph of Scipio at the Second Punic
War, and they paraded four by four, spreading out toward the
left, turning their backs to the east. At the tail end were forty
pieces of artillery, each drawn by four oxen, all new, with the
ducal arms and gorgeous fittings, decorated with olive branches,
followed by some carts loaded with cannon balls, with mules in
between bearing barrels of gunpowder and other instruments of
war, which would have terrified Mars himself with their appear-
ance. And there were some pale faces among those who were
prepared to put a bridle on those who had put the bridle on so
many in the past. The Mass finished with a blessing that seemed
to come from Heaven itself.[9]

Though Vasari could not have known it at the time, he was right
about putting bridles on the people who had been accustomed to
impose bridles themselves. Filippo Strozzi, having paid for the For-
tress of St. John, would eventually become a prisoner in its dungeons
and commit suicide in despair within its impregnable walls.

With each new wave of war and political change, artisans like
Vasari could only stand by, aware that their lots would surely change
in the aftermath, either for the better or, more often, for the worse.
Alessandro had taken good care of his old classmate, supplying him
with a monthly salary of six scudi (a generous full-time rate for a
skilled artisan), room and board, and a servant of his own. In addition,
Giorgio was allowed to keep any profits he made from independent
painting projects. The duke also arranged a dowry for Vasari's sister,
now in her teens and of marrying age.

In the upper and middle classes of Renaissance Italy, marriages
were rarely love matches; more often than not, they were business

transactions between family corporations. Fathers and mothers discussed the mutual benefits of a familial alliance, whether political or financial, and the prospective bride and groom had virtually no share in most of these debates (though a sermon of the fifteenth-century preacher Saint Bernardino of Siena commends a tall, beautiful girl who refused to marry a short, ugly man). Vasari corresponded with his uncle and took it upon himself to provide funds for dowries for his three sisters. Cash-poor, he arranged for the Medici family to cover the dowry of his first sister. His second sister, like many second sons and daughters in Italian families, joined a nunnery, which required its own dowry (the nuns were officially brides of Christ), but in this case a monetary payment was waived in exchange for a picture by Vasari's hand.

The feelings of foreboding that he described to Pietro Aretino in his letter were well founded; Giorgio was developing a useful sixth sense about life in a monarch's court, a nascent political savvy that would serve him well throughout his long career. On 25 September 1534, the Medici pope, Clement VII, died. His successor, Paul III, the former Cardinal Alessandro Farnese, was the scion of a powerful Roman family, and an inveterate rival of the Medici. Ippolito, who knew Farnese from Rome, hoped that the new pope would help him seize control of Florence. To this end, he also sent messages to Charles V, complaining of the duke's tyrannical behavior and deficient political skill, along with a donation to Charles's cause, and offered to take over Florence himself. The plan itself was not implausible; Pope Clement had posed the greatest obstacle to Ippolito's political advancement, and now Clement was dead. Ippolito arranged to meet Charles V in Naples, as the emperor returned from a military campaign in Tunis. But on 2 August, the cardinal fell ill as he traveled down the Appian Way, and was forced to stop halfway at the little town of Fondi. Three days later, immediately after drinking a potion of chicken broth, he grew violently worse. Within five days, he was dead. His death was taken as an obvious murder by poison, and the blame fell on Giovan-

nandrea dal Borgo, the seneschal or steward in charge of the daily operations of Ippolito's household. Under torture, Giovannandrea confessed to poisoning his master, but torture is notoriously unreliable as a method for revealing truth. In the heat of August, along a road, the Appian Way, that led through the malarial swamps known as the Pontine Marshes, Ippolito de' Medici may just as easily have died of a combination of malaria and bacterial infection as of poison deliberately administered.

If, on the other hand, Ippolito's steward was in fact guilty, then he must have acted as an agent of Duke Alessandro. Charles V certainly felt that the cardinal had been assassinated, and he summoned Alessandro to face charges in Naples. Despite the emperor's suspicions, Alessandro managed to turn their meeting entirely to his advantage. We have no word-for-word record of what went on between Charles V, his ministers, and Alessandro de' Medici, but the eighteenth-century historian Ludovico Antonio Muratori gives a wry, cynical account of the proceedings:

> Once Alessandro de' Medici, duke of Florence, had arrived in Naples accompanied by three hundred cavalry, all in good order, and made his proper obeisances to the Emperor, the accusations of the Florentine exiles were made known to him. To these he made the reply that seemed most correct to him. Whether it was the money he had applied to the imperial ministers that produced those good effects that it usually does everywhere, or whether it was the fact that the Emperor, finding himself on the verge of yet another Italian war, recognized that it would be more profitable to his interests to have a single ruler in Florence, it is certain that [Charles] pronounced a sentence favorable to the Duke, and recognized him as lord of Florence. Furthermore, he finally gave [Alessandro] his oft-promised natural daughter Margherita in marriage, with certain pledges by which he obtained a goodly sum of money to use in the impending war. He also decreed

that the exiles were permitted to return home, and enjoy rights to their property and offices just as with the other citizens. But most of them felt no desire to return to their fatherland, because of either fear or anger. On the last day of February, the wedding was celebrated with great pomp, and after a few days of honeymooning the Duke returned to Florence triumphant.[10]

Thus ended the potential rule of Ippolito de' Medici, cementing Alessandro de' Medici in his position as hereditary duke of Florence.

Having exonerated Alessandro de' Medici of killing Cardinal Ippolito, Charles V made good on the promised marriage to his daughter Margherita, a strategic alliance of two great dynasties. Though Alessandro might have preferred his half sister, Caterina, taking Margherita's hand was a wise tactical move. The wedding itself took place in Naples, a ceremony by proxy, as dynastic marriages often were; the bride would not reach Florence until the end of May. She and Alessandro had already met when she visited the city in 1533. Normally, the bride's family would have paid the groom a dowry as part of the arrangement, but in this exceptional case, the groom paid his father-in-law 120,000 gold scudi for the honor of marrying a Habsburg, albeit a "natural" Habsburg.[11] This sum equaled the annual state budget of a city like Venice or Florence, but the Holy Roman Emperor would soon squander the piles of gold on another series of wars.

Charles V loved peace, but he saw little of it during his reign. Epileptic and increasingly crippled by gout (exacerbated by a diet that consisted largely of red meat), he lived in the saddle and on the move, with no real home until he retired to a Spanish monastery at the end of his life. With vast domains that stretched across Europe in every direction and extended deep into the New World, the emperor could keep control only by shifting constantly from place to place. French was his mother tongue, but he routinely spoke four languages. He has often been credited (not entirely correctly) with the claim "I speak

Spanish to God, Italian to women, French to men, and German to my horse."[12]

As Charles settled his affairs in Naples, Francis I of France began to move into northern Italy, hoping to capture Milan. Slowly, as was inevitably the case with a large army, Charles headed north to intercept his longtime rival, stopping in Rome on 5 April to a visit his staunch ally Pope Paul III. By the end of the month, the Holy Roman Emperor planned to reach Florence, where his dutiful son-in-law was eager to impress his political savior. As Charles approached, Duke Alessandro transformed the city with elaborate temporary decorations. As in Bologna six years earlier, Giorgio Vasari prepared to create evanescent marvels of wood, plaster, and painted cloth. This time, however, he would not be a simple craftsman laboring in a crowd. Instead, barely twenty-five, newly enrolled in the Company of Florentine Painters, he was made chief artistic adviser to the whole enterprise. The appointment was an extraordinary honor, and it aroused intense jealousy among his colleagues. The Florentine art world was ruthlessly competitive under any form of government, but the ducal courts of Italy, entirely dependent on their monarch's whim, usually brought out the worst in everyone, including the monarch himself.

For Vasari, this moment in April of 1536 was a landmark in his career, and he writes about its twice in his *Lives*: once in connection with the sculptor Niccolò Tribolo, who produced four statues for the event, and more extensively in his own autobiography. In the course of his discussion, he reveals that he had begun to study architecture as well as painting, with his usual diligence. His particular combination of curiosity, hard work, and attention to his patrons' interests, so evident in this account, would stand him in good stead throughout his career. Vasari may not have been the best painter available, but he was certainly one of the most reliable, and for many assignments, especially those on a short deadline, reliability counted as much as, if not more than, genius:

When I saw that the Duke was totally absorbed by fortifications and construction, I began to study architecture, and I spent a great deal of time at it. In the meantime, when the need arose in 1536 to build temporary decorations for Emperor Charles V, in order to keep the project organized, the Duke commanded the three men in charge to keep me at their side to design all the arches and other ornaments that would need to be made for that entrance. . . .

These favors attracted a thousand jealousies, and some twenty men who had been helping me with making the flags and the other work left me in the lurch, lured away by this person or that, until I could no longer hope to complete all these important projects. But I had also begun to see through the evil intentions of people to whom I had always tried to be helpful; and so, partly by working day and night with my own hands, and partly with the help of painters from outside [Florence] who helped me in secret, I kept to myself and tried to overcome these difficulties and jealousies with the artworks themselves.[13]

As Vasari realized, some of the animosity he generated was a matter of local patriotism. Although Arezzo and Florence are less than forty miles apart, they were (and remain) two separate societies. Since the late Middle Ages, Florence had become the leading city in the region of Tuscany, Arezzo a local capital in the system of dependent cities the Florentines called their *Dominio*. To some Florentines, therefore, Vasari was an outsider and something of a provincial, even though he was a fellow Tuscan.

The city of Florence had reason to be proud and to distinguish itself from its neighbors. Its wealth, derived largely from the textile industry (particularly the wool trade), since the thirteenth century had attracted artisans and tradesmen from all over Europe: sculptors from France, fabric merchants from Flanders, Swiss soldiers, Spanish politicians, Balkan courtesans, and at least one English mercenary

captain, Sir John Hawkwood ("Giovanni Acuto" to his Florentine colleagues). For forty years, since 1492, Sephardic Jewish refugees from Spain and Portugal had settled in the area between the cathedral and the Palazzo della Signoria, the site of the ancient forum. Muslim merchants from North Africa and the Levant traded with their European counterparts, both Christians and Jews, and together with Portuguese colleagues dealt in African slaves and the carved elephant tusks called oliphants. African, Berber, and Slavic faces were exotic sights but not unusual on Florentine streets and in Florentine markets.

At the same time, however, Florence, like every other Tuscan city, maintained its purely local loyalties. The city was divided into neighborhoods, *quartieri*, each with its own colors, churches, and patron saints. The *quartieri* clashed officially between Christmas and Lent in football matches. *Calcio Fiorentino*, or Florentine Kickball, is the predecessor to modern soccer (football) and became a regular feature in the fifteenth century. Played on sand (or sand-covered ice) with goals, the game allowed the twenty-seven players per team to use their hands and feet, and violence was not in the least discouraged (though there were referees and linesmen)—it was nearer to rugby than to today's football. It provided a fine opportunity to pick a fight with a *stronzo* (piece of shit) or *coglione* (idiot, though the literal translation would be something like "testicle-head") over wearing the wrong colors in the wrong area of the city or making a comment about a girl from another *quartiere*.

Rivalries existed not only between potential suitors or residents of other cities. Families passed down remembered slights and disagreements through generations, and street fights between clans were not uncommon. The cityscape of Renaissance Florence was dramatically different from what we see today, its roofline spiked with square towers, each one owned by a different wealthy family as a fortified city residence when they were not at their country estates. The need for high-security housing in the city dated back to the civil war between the Guelphs (supporters of the pope) and the Ghibellines (supporters

of the Holy Roman Emperor) that ran, off and on, from the 1120s to the 1320s. In practice, families used the towers as safe havens to retreat from street fighting (or from which to hurl aged produce down upon their enemies). A visit to the Tuscan hilltop town of San Gimignano, where the medieval towers are wonderfully intact, gives a sense, in miniature, of what Florence might have looked like. In the fourteenth century, Lapo da Castiglionchio wrote that Florence had "around 150 towers belonging to private citizens, each around 120 braccia" in height (around 230 feet). Because the towers encouraged violence and un-neighborly activity, their construction was banned as early as the thirteenth century, but they remained a fixture of the cityscape until the nineteenth century, when many were demolished for new construction.

Lives emphasizes the kind of rivalry among artists that Vasari experienced himself in Florence. Federico Zuccaro, a contemporary artist, architect, and writer from Urbino, was a lifelong rival of Vasari's, and the two would clash on multiple occasions, before their legacies would meet in a single great work, Giorgio's last, the painting of the cupola of the cathedral of Florence. Often Vasari describes these contests as contests of good against evil, with opposites at war. If two artists are not literal rivals, then their works can be weighed against one another. We have already seen how Giotto, the upright Florentine who "restored *disegno* to life" contrasts with Buonamico Buffalmacco, the trickster from Arezzo, as famous for his practical jokes as for his frescoes in the Campo Santo of Pisa. Andrea del Castagno's resentment of Domenico Veneziano leads Vasari to begin his joint *Life* of the two artists with a classical contrast between praise and blame:

> Just as the competitive rivalry that seeks, through virtuous practice, to prevail for the sake of glory and honor is a praiseworthy thing, to be prized as necessary and useful to the world, so, in equal measure, if not more, hateful envy deserves blame, for by its intolerance for the honor and esteem of others, it seeks to

kill those it cannot strip of honor, like poor Andrea dal Castagno, whose painting and *disegno*, in truth, were great and excellent, but the rancor and envy he felt toward other painters were even greater, so that he buried and hid the splendor of his virtue beneath the darkness of sin.[14]

If Giovanni Bazzi, nicknamed "Sodoma," is Siena's "bad boy" painter, then Domenico Beccafumi is his saintly opposite, both morally and artistically good. As for Baccio Bandinelli, who dared to challenge that best of all possible artists, Michelangelo, he cannot hope for any role but that of the villain.

In an era when gentlemen carried swords at all times, and used them with disconcerting regularity, these artistic duels take on an inescapably military tone. For Vasari's narrative, the antiheroes of his *Lives* justify and make cosmically right and necessary the arrival of Michelangelo (named after the archangel Michael, the leader of Heaven's army), who fulfills the combined promise of the earlier heroes of Vasari's story (Giotto, Donatello, Masaccio, and Brunelleschi). Sixteenth-century readers were familiar with foreshadowing from both classical and biblical sources. Jesus fulfilled the promise of Old Testament prophets like Moses and David; the emperor Augustus fulfilled the promise of the legendary hero Aeneas; and in the same vein, after 1538, Duke Cosimo would fulfill the promise of the fifteenth-century Cosimo the Elder and his grandson Lorenzo the Magnificent, who never was quite as magnificent in his own time as he was in Duke Cosimo's imagination.

Vasari, as an Aretine with a favored position in Florence, had a clever response to this peculiarly Italian form of animosity. There was no question that he would finish his work, no matter what obstacles his rivals tried to put in his way. There was too much to do for him to succeed alone, but he knew better than to let on that he was struggling. He also knew better than to ask a native Florentine for help—that would only have fueled the gossip. Instead, quietly, he

wrote to a fellow outsider, Raffaello dal Borgo, an artist who lived in the Umbrian town of Borgo San Sepolcro "above the arch of St. Felix in the piazza of the castle"—and not far from Arezzo. Cleverly, then, Vasari used his own local allies to thwart the Florentine cabal. His letter to Raffaello also mentions the task that had engaged him before the emperor announced his plans: decorating Duke Alessandro's bedroom in the Palazzo Medici with scenes from the life of Julius Caesar. The emperor would be staying in the ducal suite for the duration of his visit to Florence, while Duke Alessandro decamped to his guest quarters in the Palazzo Tornabuoni. For a man like Charles V, whose titles included Caesar, the theme was perfect, and Vasari could not postpone this project either. In the end, in place of the unfinished frescoes on two walls, he hung his paper cartoons, the full-size working drawings for the eventual decoration. This assignment in itself shows how highly Duke Alessandro already thought of him:

> While I was finishing the third history painting of Caesar that Duke Alessandro had me paint in his palazzo, an order came from His Excellency [Alessandro] in Naples that the Emperor will be passing through Florence, and so he ordered Luigi Guicciardini, Giovanni Corsi, Palla Rucellai, and Alessandro Corsini to supervise the decorations, installations, and triumphal procession that will honor His Majesty and beautify this magnificent city. He also wrote that these gentlemen should make use of me and my knowledge. I made no delay in supplying them with drawings and ideas. . . .

Vasari continues with his request to Raffaello.

> Now, to explain your opportunity and my need, I would be grateful if, on receiving this, which I have sent via the Duke's horseman, you came here without wasting time searching for

your boots, your sword, your spurs, or your hat—you can get them later.

This all came up when I was busy in the Palazzo della Signoria with a flag bearing all the coats of arms and seals of His Majesty to fly over the keep of the new fort, fifteen braccia high and thirty in length [as a reminder, a *braccio* was around 0.6 meters, or two feet], and around me sixty of the best painters in Florence were at work. We were almost done when an order came in from these lords of the festival to make a full-size façade in the Piazza San Felice, full of columns and arches, pediments, ressauts, and ornaments, a glorious thing. . . . These masters I had assigned to the project refused to do it, intimidated by the amount of work and the short deadline, but because I designed it, Luigi Guicciardini and the others have stuck me with it. So I need help fast. I wouldn't have burdened you with this if these masters, who resent my getting the credit for their work, hadn't conspired against me, thinking, for all I know, that the horse from Arezzo plans to strut around in Florentine lion skin. Now, as a caring friend a needy neighbor, I am calling on your help, which I know will be forthcoming, because I want to show them that I may be beardless and small of stature and very young, but I can and will serve my lord without them, and when they come around looking for work in the future, I can say, "Eh! It can be done without your help." Dear, sweet, excellent Raffaello, don't let down your Giorgio, because you would be doing a cruel thing to our friendship; it would be like having the Borgias' hit man throttle my reputation.[15]

With his Umbrian helper, Vasari finished decorating both Florence and, in cartoons at least, the ducal bedchamber, in time for the emperor's entrance on 29 April 1536. The final push so exhausted him that he wandered off to a local church, stretched out on a bundle of leafy boughs, and promptly fell asleep. Perhaps he snored; in any case, news

of his unceremonious nap reached Alessandro de' Medici, who evidently thought it hysterically funny. Quickly the duke sent servants to rouse Vasari from his sleep and bring the disheveled, bleary-eyed artist into his presence. "Your work, my Giorgio," he supposedly declared, "is the best, most beautiful, best designed, and most swiftly executed of any other master's. . . . Now why are you sleeping when it's time to be awake?"[16]

Though Vasari may sometimes be inclined toward exaggeration and self-flattery, in this case his statement is true: Alessandro not only paid his faithful servant four hundred ducats for the work itself but also assigned him the revenue from fines leveled at artists who failed to fulfill their commissions, a further three hundred ducats a year. At twenty-five, Giorgio Vasari was earning a serious income.[17]

Most of Italy's city-states issued their own currency. Venetian ducats, Florentine florins, Roman scudi (and Spanish crowns) were all gold coins approximately equivalent in value, and merchants often made their calculations on the basis of a fictitious corresponding unit, the *lira*, derived from the Latin word for "pound." (This was also the name of the unit of currency used in modern Italy before the introduction of the euro.) *Soldi* (from Latin *solidi*) also means "money" in current Italian, but in the sixteenth century a silver *soldo* was roughly the Italian equivalent of a shilling in Britain. *Denari* still means "money" in Italian, and derives from the Latin word for ten: *denarii* were basically dimes. There were also small copper coins called *baiocchi*, pennies. The rough breakdown for the currencies in Leonardo's notebooks was 1 Venetian ducat = 6 lire = 120 soldi = 1440 denari. Among the artist's possessions, we find a bed listed at 140 soldi, the cost of a burial and funeral 120, 20 soldi to buy a lock, 18 for paper (it is not listed how much, but paper, made of boiled-down rags in this period, was not cheap), 20 for a pair of glasses, 11 for a haircut, 6 to have his fortune read, 3 to rent a basic room for the night (the same cost as a single fresh melon), 21 for a sword and a knife, 23 to buy a meter of cloth from which clothing could be made, 100 for a linen

doublet, whereas hose (for men, of course) could run him anywhere from 40 to 120 soldi.

The daily salary of an apprentice was 11 soldi, while 1 ducat was ten days' pay for a skilled assistant in the studio of a sixteenth-century Italian artist, making some 350 ducats a year a solid salary. This puts into perspective Vasari's wealth, when he received a years' salary for a single picture—worth 400 pairs of top-of-the-line hose for men, or 16,000 melons.[18]

The comfortable situation, dependent on the state of Florentine politics, lasted less than a year. A scant nine months later, it was Duke Alessandro's turn to be murdered by yet another Medici with ambitions to control Florence for himself, a murder so gruesome that it may have inspired some of the scenes of foul play in Shakespeare and Jonson. It certainly provides some of the most vivid pages in Benedetto Varchi's *History of Florence*, a true crime story made all the more compelling because Varchi claimed to have gotten his information from the assassins themselves.

11

MURDER AND
REDEMPTION

T HE MURDER OF ALESSANDRO DE' MEDICI IS ONE OF THE
greatest and grimmest true crime tales of the Renaissance, and
if it sounds like a scene from a Jacobean revenge tragedy, that is likely
no coincidence. The playwrights of seventeenth-century England
were often inspired by Italian events, and they could invent little more
vivid and vengeful than this blood-covered tale of family betrayal.

The chief perpetrator, Lorenzo de' Medici, was nicknamed
"Lorenzino" (Little Lorenzo) or "Lorenzaccio" (Nasty Lorenzo), to
distinguish him from the other Medici men with the same name:
Duke Alessandro's presumptive father "Little Lorenzo" (Lorenzino),
the duke of Urbino, as well as Lorenzo "of the people" (il Popo-
lano), the second cousin of Lorenzo the Magnificent, and, of course, il
Magnifico himself. Lorenzaccio was Lorenzo il Popolano's grandson,
making him either Duke Alessandro's fifth cousin (if the duke's father
was Lorenzino, duke of Urbino) or, more likely, his second cousin
twice removed (if his father was Clement VII). Born in 1514, Loren-
zaccio was four years younger than his relative, rival, and eventual
victim. He had grown up on a rural Medici property in the mountains
northeast of Florence, along with his second cousin Cosimo and, for
a brief time, the future Duke Alessandro. In 1530, Lorenzaccio went
to Rome, where he amused himself by knocking the heads off the
ancient sculptures on the Arch of Constantine; only the intervention
of Cardinal Ippolito kept him from being killed by Clement VII, who

had decreed that the vandal be hanged by the neck without a trial. At first the pope had looked indulgently on his wayward relative, because of Lorenzaccio's intellectual interests, but after the vandalism he called the youth the "infamy and disgrace of the house of Medici."[1] Varchi reports that he "had a strange lust for glory" and "took his pleasure, especially in love, without regard for sex, age, or social condition; in his heart of hearts, he had no respect for anyone." Physically, he was "a small man, more scrawny than not, and that was why he was called Lorenzino. He never laughed, but snickered. He was more attractive than handsome, with a brown, melancholy face."[2] Hated in Rome, Lorenzaccio returned to Florence as a hanger-on in Duke Alessandro's entourage, cash-poor, dependent, and resentful. The only person who failed to see the seething envy beneath his obsequious manner was Alessandro himself. Benvenuto Cellini, who saw the cousins together, marveled that the duke could be so attached to a person who so evidently despised him.[3] But Lorenzaccio provided useful services, spying on other members of the ducal household and facilitating the duke's frequent forays into Florentine low life. It was this last bond that finally enabled Lorenzaccio de' Medici to set his mortal trap.

Alessandro had fixed his eye on Lorenzaccio's aunt Caterina Ricasoli. On the chill night of 5 January 1537, Lorenzaccio offered his apartment next door to the Palazzo Medici for a first encounter with the lady. A fire was roaring in the fireplace, the bed was ready; Alessandro removed his protective vest of chain mail and his sword belt, settled into a chair, and dozed off. Silently, Lorenzaccio tied the duke's sword tightly to its scabbard, disabling it, and slipped out, ostensibly to pick up his Caterina, but in fact to return with a hired assassin, a local mercenary captain with the picturesque nickname of Scoronconcolo.[4]

Thanks to Benedetto Varchi, we learn that Lorenzino had engaged the services of Scoronconcolo without telling him the name of his victim, but Scoronconcolo swore that he would do the job "even if [the victim] were Christ himself." Lorenzaccio continued:

"Brother, now is the time; I've shut my enemy in my room and he's asleep . . . don't even think about whether he's a friend of the Duke, think about doing your handiwork."

"I'd do that even if it were the Duke himself," Scoronconcolo replied.

And then Lorenzo, after an initial hesitation, lifted the latch. (Varchi is a master at drawing out suspense). "Sir, are you asleep?" he asked, at the same time driving his rapier into his cousin's flank, so deeply that it came out the other side. "This blow alone was mortal," Varchi would write, but Alessandro fought back like a Florentine lion. Brandishing a footstool, he tried to scramble behind the bed, but Scoronconcolo slashed his face with a dagger as Lorenzaccio pushed him down on the bed, covering his mouth to muffle his shouts. Alessandro bit deep into Lorenzaccio's thumb, nearly severing it, and the two wrestled, so closely wrapped around each other that Scoronconcolo could only stand by for fear of wounding the wrong man. Finally the duke began to weaken, and then Scoronconcolo ended the struggle with a thrust to the jugular.

The two assassins covered the body, Lorenzino shoved his injured hand into his glove, locked the door and put the key into his pocket. Then the two of them mounted horses and rode for Venice. They arrived two days later, and this is where Varchi eventually interviewed them.[5]

There was only one flaw in Lorenzaccio's plan. The point of killing Alessandro had been to seize power in Florence himself. But after the horrifically messy murder, without an army to back him and only an assassin for company, he had become a fugitive in the night.

Florence did have its own militia, headed by the mercenary captain Antonio Vitelli, who happened to be back in his native Città di Castello when Lorenzaccio decided to strike. When Duke Alessandro failed to appear on the morning of January 6, another Medici descendant suspected what might be afoot and summoned the troops.

This was forty-six-year-old Cardinal Innocenzo Cybò, a grandson of Lorenzo the Magnificent through his mother, Contessina de' Medici, and already in place as Alessandro's regent whenever the duke was out of Florence. Quickly, Cardinal Cybò also revived the old republican Council of Forty-Eight to govern the city until the situation became clearer. In the meantime, rumors began to fly; Lorenzaccio had been sighted riding like fury with a bloody glove on one hand, ducking into a surgeon's house, and shortly afterward disappearing into the night. The cardinal was not entirely surprised to open the locked door of Lorenzaccio's apartment later in the day and find the body of the late duke swathed in bloody bedclothes.

There was no evident heir to the Medici dominion. Innocenzo Cybò knew he was only a placeholder; although he was a direct descendant of Lorenzo the Magnificent, that descent went through the female line. Alessandro's widow, Margherita (daughter of Charles V), was fifteen, and although she was a fluent speaker of Italian, she was a foreigner in no position to take over the state; instead, she was swept into the safe confines of the Fortress of St. John (in later life, however, this formidable woman would govern several states in her own right). Duke Alessandro's two children were mere toddlers and illegitimate; a third child was still in the womb. Lorenzaccio had destroyed any chances at his own succession by committing the murder without a firm plan for stepping into his victim's place. Running away did not help either. The closest eligible relative seemed to be Lorenzaccio's childhood companion Cosimo de' Medici, who came from the same "Popolano" branch of the family as Duke Alessandro, through a particularly illustrious lineage: his father, Giovanni de' Medici, had been a brilliant mercenary captain, the one person, people believed, who might have been capable, had he lived, of stopping the imperial invasion of 1527. Cosimo was only eighteen, but he had trained with the Florentine militia and the soldiers liked him.

It was those same soldiers who placed Cosimo de' Medici in charge

of the city on 9 January 1538, by barricading Cardinal Cybò and the Council of Forty-Eight into the Palazzo della Signoria, and threatening to throw all forty-nine of them over the battlements, one by one.[6] This subtle political stratagem did the trick, and Cosimo was swiftly "elected" as head of state.

For Vasari, as for many Florentines, this abrupt shift in government held out both confusion and promise. Of his allies among the Medici family, only Ottaviano remained. Alessandro had never been popular with the Florentines, but he had been a generous patron for the rising young artist. Cosimo was an unknown. The events put Vasari into a real spiritual crisis:

> Behold, dear Uncle, the hopes of the material world, the favors of Fortune and the support of trusting in princes and the rewards of all my labors, vanished in a single breath! Behold Duke Alessandro, my lord on earth, dead, gutted like a beast by the cruelty and envy of Lorenzo di Pier Francesco, his cousin! I weep, like many, for their unhappiness, for the court feeds on adulation, seducers, barterers, and pimps, and thus, thanks to them, we get not only the death of this one prince but also of all those who honor worldly goals and make fun of God, and wallow in the misery in which His Excellency found himself tonight, and now all his servants find themselves as well. Certainly I confess that my own arrogance had risen so high because of the favor I had first from Ippolito, Cardinal de' Medici, then from his uncle Clement VII. . . .
>
> Now that death has broken the chains of my servitude to this most illustrious house, I have resolved to separate myself for a time from all courts, of princes of the church and secular princes alike, knowing from these examples that God will have more mercy on me if I wander starving from city to city, making ornaments for this world to the extent that my talent permits

me, confessing His Majesty and standing ready for His holy
service. . . .

In the meantime, pray the Lord to guide me safely [to Arezzo],
because I swear to you that here in Florence we other servants
run the greatest danger. I have retired to my rooms and sent away
all my things among various friends to send past the city gates.
Once I finish a painting of the Last Supper, I will leave it to il
Magnifico Ottaviano as a parting gift; just as Christ in parting
left this memory [of the Eucharist] to his holy apostles, so I leave
this sign of benevolence as my legacy to him, separating from the
court to return to a better life.[7]

In the next few months, Vasari suffered from what he called melan-
choly, and we would call depression. He returned to Arezzo in Febru-
ary, but the affection of his family was hard to bear after the traumas
of Florence. He became a recluse. Unlike most depressed people,
however, he continued to work, compulsively. Free of courtly life, he
was no longer lashed to its machinations: politics, intrigue, etiquette,
gossip. But he was also lonely and confused. Of his state of mind he
would later write,

Look at me, forlorn there in Arezzo, despairing after the death
agonies of Duke Alessandro, shunning human contact, the inti-
macy of family and the warmth of home; out of depression I
closed myself in a room, doing nothing but working, wearing out
my energies, my brain, and myself all at once, not to mention my
mind made melancholy by terrifying visions.[8]

He developed the spiritual side of his character, writing,

Thus while I work, I contemplate this divine mystery: that a
blameless son of God should have died for us so shamefully. I

bear my own affliction with this in mind and content myself with living in peace and poverty, so that I feel a supreme contentment of spirit.[9]

Friends wrote to him regularly, urging him to return to city and court life, but to no avail. To Antonio Serguidi, he wrote,

The love of my mother, and the kindness of Don Antonio my uncle and the sweetness of my sisters and the love this whole city bears me have made me recognize more with every passing day the harsh chains of servitude I had in the court, and its cruelty, its ingratitude and empty hopes, the poison and sickness of its flatteries, in short, all the miseries that are involved with it.

Furthermore, he had been unlucky in his choice of patrons in Florence. "I must be the only person who wants to serve the people who are taken from you by poison or the knife when you most need them."[10]

Instead, he threw himself into his work. To his Florentine friend Baccio Rontini, he wrote, "I would be grateful if when you come you could bring me that book on bones and anatomy that I gave you last year, because I could use it; here I don't have the same access to cadavers as I did there in Florence."[11]

It was his old tutor Giovanni Pollastra who divined the cure both for Giorgio's melancholy and for his spiritual strivings: the mountain sanctuary of Camaldoli, a hermitage in the Tuscan Apennines run by its own order of monks. As worldly a soul as Benedetto Varchi wrote a sonnet in praise of this mountain monastery, some thirty-five miles northeast of Arezzo:

What heart was ever so infirm and weak
That in the alpine quiet of this retreat
Surrounded by a thousand thousand pines

Released forever from all mortal care
It would not pledge its steadfast faith to God?[12]

The mountain air, and the space to think and breathe offered relief to Vasari, who felt better after just a few days. Exhilarated and grateful, he wrote back to Pollastra in Arezzo,

> May you be blessed by God a thousand times, my dear Messer Giovanni, because thanks to you I was guided to the hermitage of Camaldoli, where I could have found no better place to know myself. For along with passing my time in the company of these holy monks, who have improved my health and well-being in two days, and already I can begin to recognize my crazed insanity, and where it was so blindly leading me. Here in this high mountain pass, among these upright pines, I can discern the perfection that is to be had from stillness.[13]

A monastic retreat of this sort refreshed the spirit by taxing the body. The hermitage, like many of its type, consisted of single-occupancy cells divided into three compartments. The bed was a straw pallet without blankets of any sort, so guests were obliged to sleep fully clothed. In the middle of the cell stood a section that might be called a study, containing a desk and a book (usually only one at a time). The rest of the cell functioned as a sitting area and provided the structure's only real comfort. At Camaldoli, a wood-burning fire was kept running at all times, to stave off the cold. This and wooden boards that lined the interior walls of the cell were the only equipment to maintain warmth. A recess in the wall provided a makeshift altar. A single small window let in light, and a small table, in the form of a wooden board, stretched beneath the sill. Food was left on a shelf outside each cell door, silently—no speaking was allowed, apart from prayer in church. The ear would grow accustomed to the song of the wind in the pines, the trickle of water in the fountain, the shuffle

of sandal-clad feet on the paving stones, and the heartfelt, but likely out-of-tune, chants of the brothers during the many church services that dotted the days. The common space, a cloister surrounded by the monks' cells, was always there for strolls and meditation, but nothing that could be called socializing was permitted.

The church at Camaldoli had been built in 1203 and refurbished in 1523, but the soldiers of Charles V sacked it 1527, en route to Rome. During Vasari's visit, the church was still in poor repair, and the Lutheran troops had gleefully stripped it of its artworks. He suggested that he might paint a new altarpiece, in thanks for the hospitality that had so revived him. According to his own account, the monks were hesitant to hire such a young man, so he offered to paint a trial picture, a *Virgin and Child with Saints John the Baptist and Jerome*. The panel took him two months, and won him the commission. The monks, now convinced of his skill, happily engaged him to return after the winter frosts to continue painting their church:

> These holy hermits want me to make the altarpiece for the main altar along with the chapel façade and the rood screen, where there are many ornaments in sculpture and fresco, and also two altarpieces, with the door to the choir in the middle.[14]

If an artist was required to work on-site, the usual condition for working in fresco, his housing and meals would be provided, but they might not always be to his liking. Vasari tells the story about Paolo Uccello that illustrates the point:

> They say that while Paolo was working [at San Miniato], an abbot who was then in that place made him eat almost nothing but cheese, and when this began to bore Paolo, he decided, timid as he was, not to show up for work any more. When the abbot began searching for him, whenever he heard a friar ask after him, he was never at home, and if he ever saw a pair from that order

on the street in Florence, he ran away as fast as he could from them. So two of them, curious, and younger than he, caught up with him one day and asked him why he didn't return to finish the work he'd begun, and why he ran away every time he saw a friar. Paolo answered, "You've ruined me; I not only run from you, I also can't go anywhere that there are carpenters, and all of it's the fault of your abbot, who has put so much cheese into my body by always feeding me cheese omelets and pasta with cheese that I'm afraid, now that I've turned into cheese myself, that I'll be used for glue, and if this goes on any longer, perhaps I won't be Paolo any more, just Cheese." The friars, laughing, left him, and told the abbot everything. The latter made him come back to work, and ordered other food for him than cheese.[15]

Paolo was also a great painter, but thanks to Vasari's vivid anecdote, he tends to be recalled more for his passion for birds (his surname means "bird") and his hatred of cheese than for his professional accomplishments.

We can assume that Giorgio ate better, or at least a more varied diet at this mountain retreat, than Paolo had. His letter from Camaldoli also reveals an increasingly eloquent writer, whose descriptions of the beauty and stillness of his hermitage are among the most moving passages he ever wrote. But the world, and its courts, were not yet done with Giorgio Vasari, however sure he was that he was done with them.

PART TWO

12

THE WANDERING
ARTIST

With surprising skill, eighteen-year-old Duke Cosimo de' Medici began to take a weary Florence in hand, with the help of some seasoned counselors who included Ottaviano de' Medici, now fifty-three. Ottaviano also continued to serve as a point of reference for Giorgio Vasari, although the young artist's recent experiences in Florence and the sanctuary of Camaldoli had soured him on courtly life: "In two months, I experienced how much a gentle quiet and honest solitude can do for one's studies; for I declare that in the noise of the piazza and the courts I realized what a mistake it had been to put my hopes up to then in people, and in the trifles and jabberings of this world."[1]

In cinquecento court life, a form of deceit was fundamental to survival. As the art historian Maurice Brock notes, the attributes of the ideal courtier, famously defined in Baldassare Castiglione's *The Courtier* (1528) as *grazia* (graciousness) and *sprezzatura* (nonchalance), were concerned only with the perception of others. "Courtly life was based on a culture of appearances: however spirited it may appear, the face must remain a mask . . . the vivacity of both courtier and court lady is undoubtedly a question of social veneer." As a survival tactic, interior life had to be kept hidden; for Renaissance Italians, the word *segreto* meant "private." Brock continues, "As Castiglione recommended for the court lady, life in society makes it advisable to change one's persona from time to time, but whatever figure is

chosen, one should never let one's true personality slip out."[2] A line from a poem by Michelangelo elegantly summarizes the necessities of courtly life: "And I bend like a Syrian bow, deceptive and strange."[3] One alters oneself, bending to the necessities of a situation, donning the mask and manner of a different person.

The basic lessons of survival and success at court were likewise written in chapter 23 of Machiavelli's *The Prince*: "In conclusion, it is better for good counsel, no matter its source, to originate from the prince's prudence, rather than having the prince's prudence originate from good advice."

The culture of deceit at court would be the subject of Bronzino's famous *Allegory of Love and Lust*, painted in 1545 when Bronzino was official court portraitist to Cosimo de' Medici and Vasari was in his period of roaming prior to finishing his *Lives*. This painting presents a coded message of how exhausting (and often sad) life was at court, where no one could never really be sure who was a friend and who was only pretending to be one. For a hardworking, well-meaning artist like Vasari, games of masks at court were of no interest, and it is understandable that he would find respite in his work, away from the shell game of courtly life.

Now in a tranquil state of mind, Vasari "went to Florence to see Messer Ottaviano, and it took some doing to keep him from putting me back into service at court, as he had planned. But I won the battle by good arguments, and by my resolve to go back to Rome before I did anything else."[4] Before subsidizing a trip to Rome, however, Ottaviano gave his protégé an assignment in Florence: to copy Raphael's portrait of Pope Leo X and two cardinals, the short-lived Luigi de' Rossi and Giulio de' Medici, the future Clement VII. Ottaviano owned the original, but now Cosimo wanted it for the ducal collection, not as a personal possession but as a treasure of the developing Tuscan state.

Copying famous paintings was a frequent activity for artists in the sixteenth and seventeenth centuries, and not only as a way to refine

their personal technique. In the days before photographic reproduction, copies could make a popular painting available to several patrons, or replace a painting that had to be sold or given away, or re-create an old master long after the old master's career was over. A generation after Raphael's death, Andrea del Sarto was making copies of his paintings; a century later, the copyist would be Peter Paul Rubens. Rubens would also make the only surviving copy of Leonardo's lost *Battle of Anghiari*, demonstrating the value of copies to the historical record. When painters as talented as Andrea or Rubens made a copy, those works became masterpieces in their own right: in effect, they are conversations carried out in pigment—an homage, a learning tool, and a means of competition, demonstrating that the later artist's skill is comparable to that of the great master of the original work. There was a significant difference between copies and forgeries (as we will see in the next chapter), and copying always played a significant role in how artists learned.

Titian provided images of the penitent Mary Magdalene, at least four of them, both nude and clothed. He experimented over and over with variations on *Venus and a Musician*. Caravaggio painted at least two *Lute Players*, maybe three, and two *Conversions of Saint Paul* for the same chapel in Rome. Leonardo, who rarely finished anything, nonetheless completed two versions of his *Virgin of the Rocks*. In some of these cases, like Titian's *Penitent Magdalene*, a painter discovers a successful formula that customers ask him to reproduce—closely, but not exactly. In the case of Caravaggio's *Conversion of Saint Paul*, on the other hand, the original painting proved too complex when it was set in position within its narrow chapel in Rome, and Caravaggio, on his own initiative, replaced the work with a simplified, more dramatic composition. His two versions of the *Supper at Emmaus* (when Jesus returns from the dead and reveals himself to two disciples) are distinct explorations of a single theme, executed several years apart and entirely different in mood, style, and detail. And Vasari's contemporary Bronzino made an exact copy of his *Altarpiece of Eleonora di Toledo*

on panel because a visiting dignitary had so admired the original version in Eleonora's private chapel at the Palazzo Vecchio.

Painters also copied one another, as with Michelangelo's cartoon for the *Battle of Cascina*, the work that catalyzed Baccio Bandinelli's development as a draftsman. Titian copied Raphael, Rubens copied Titian, Delacroix copied Rubens. When the Inghirami family of Volterra was forced to sell Raphael's portrait of their forebear Tommaso Inghirami to cover a gambling debt in the seventeenth century, they ordered a copy from the Medici court artist Giovanni da San Giovanni—and sold that, in turn, to the Boston collector Isabella Stewart Gardner in the late nineteenth century as a product of Raphael's workshop.[5] Before Caravaggio's *Betrayal of Christ* was discovered in a shadowy corner of a Jesuit seminary in Dublin, and cleaned of centuries of grime, it was thought to have been a nineteenth-century copy after a Caravaggio or, at best, a late seventeenth-century copy after Caravaggio, and of middling value. Now, clean and in bright spotlights, it is the centerpiece of Ireland's National Gallery, thought to be one of Caravaggio's greatest works. The value of art depends to a daunting extent on the delicate, subjective matter of perception. Perception had limited the value of Caravaggio's *Betrayal of Christ* and perception made it skyrocket. In the case of the Gardner Museum's portrait of Tommaso Inghirami, a seventeenth-century bill of sale from a remote archive confirms its identity as a work painted in Tuscany in the seventeenth century rather than in Rome, in Raphael's workshop, around 1510. And of course we only know what Leonardo's lost *Battle of Anghiari* might have looked like from a Rubens copy, which was itself based on a print based on the missing original.

VASARI'S PORTRAIT OF LEO X and two cardinals was meant to fill the blank space in Ottaviano's gallery where the original had hung. By February of 1538, the portrait was done, and at last Vasari could go off to Rome. Now, however, he did not travel alone; he was an

established master, and he went with an assistant in tow. He spent the next five months "drawing everything that I hadn't drawn the other times that I was in Rome, and in particular what was in the grottoes underground. And I left behind not one work of architecture or sculpture that I hadn't drawn and measured. I can truly say that I made more than three hundred drawings in that period."[6] To Pietro Aretino, Vasari wrote, "About myself I can tell you that this year . . . all the time I stayed [in Rome] I did nothing but draw, and I stripped her of all her greatest marvels."[7] For artists in Tuscany and Rome, drawing was all—it revealed the secrets of the ancients, perfected technique, and provided the key to greatness. Travel, to Rome above all, provided a requisite pilgrimage for all serious artists, and would remain so until the nineteenth century, when the capital of European art shifted to Paris.

Although Ottaviano de' Medici continued to urge the artist to dispense with his drawings and return to Florence, where Duke Cosimo had set in motion a functional government favorable to the arts, Vasari was determined, at least for the moment, to stay on in Rome. As he wrote to Ottaviano,

> I am resolved to remain among these stones, transformed by the learned hands of those geniuses who made them more lifelike. . . . And because I will be more content to do less but better than to do a great deal and fall short, and put into practice nothing more than my own peace and quiet . . . I have made the decision I have just mentioned to you, preferring to lie dead and buried in Rome rather than enjoy myself and live well somewhere else where leisure, laziness, and inertia rust away the beauty of native wits that could be bright and beautiful, but become dark and shadowy.[8]

Regular commissions in Rome, Camaldoli, and places in between rewarded Vasari's avoidance of court life in Florence. He even man-

aged to work for Cosimo de' Medici without enlisting as a courtier
full-time. In 1539, the duke, barely twenty, married the beautiful
daughter of the Spanish viceroy of Naples, Eleonora di Toledo. Their
wedding took place in Bologna, with the usual swarm of artists called
in to decorate the city with temporary installations. Vasari looked
forward to seeing his good friend Salviati, and spent a month pre-
paring an enormous cartoon, a preparatory sketch, for the occasion,
including three large panel paintings and twenty scenes of the Apoca-
lypse (perhaps an odd theme for a wedding, but the Toledo family
was extremely pious). He brought three assistants to work with him:
Giovanni Battista Cungi, Cristofano Gherardi, and Stefano Veltroni.

As his career progressed, Vasari would be repeatedly mocked for an
overreliance on assistants, but in fact he used them no more than other
masters did. His competitors' complaints really reflect his relentless
(and to them, maddening) ability to finish his projects on time. Guild
statutes licensed a master to sell paintings and to employ both assis-
tants and apprentices in his studio; a large number of assistants was a
sign of success.

With three assistants, Vasari was hardly unusual, but a number of
his detractors called attention to his supposed refusal or inability to
work on his own. In order to urge along his assistants in a large-scale
project for the monastery of San Michele in Bologna, Vasari promised
a pair of scarlet silk leggings to the most diligent of his helpers (this
was high-end male fashion at the time). In the end, he was sufficiently
impressed (or wished to avoid the scenario of Joseph and his coat of
many colors) that he awarded leggings to all three. His massive paint-
ing cycle took eight months to complete, and Vasari was paid two
hundred scudi for it—a relatively small amount, considering the time
it took him. When he next returned to Florence, he painted a *Deposi-
tion* for the church of Santissimi Apostoli, and received three hundred
scudi, this time for a single panel that would have taken him a fraction
of time the cycle took. The cycle, like many of Vasari's works, is sadly

lost. The monastery was suppressed in 1797 and its treasures scattered. Only a few of the paintings still exist.

In Bologna, local painters resented "the little man from Arezzo" (as Vasari was often called) and made him feel unwelcome. He seems to have taken this in stride, seeing the slights more as a sign of jealousy and territoriality than anything more sinister. But once he had made a thorough study of the local painting style, he left for Tuscany: "I returned quickly to Florence, because the Bolognese painters, thinking that I wanted to settle in Bologna and take away their commissions and work, never stopped harassing me. But they bothered themselves more than they bothered me; I just laughed to myself at certain upsets of theirs, and their ways."[9]

It was the fall of 1540, and Giorgio had been wandering, by his own volition, for four years. In Camaldoli, he had met a congenial new patron: forty-nine-year-old Bindo Altoviti, the Rome-born, Rome-based scion of a Florentine banking family staunchly opposed to the Medici. Altoviti had come to Camaldoli on business: his bank had the contract for supplying timber for the construction of St. Peter's Basilica, and the massive pines around the monks' mountain retreat were ideal. Once felled and milled, they were dragged by donkey or ox to the Tiber River, loaded onto barges, and shipped into the heart of Rome. Vasari would certainly have known who Bindo Altoviti was long before meeting him in person; in the late 1520s, he had become the most prominent Tuscan banker in Rome, skillful, cultured, and exceptionally handsome. Raphael had painted Altoviti just after his twentieth birthday, dressed in blue to bring out the color of his eyes and his cascade of golden hair (with a stylish hat to hide the first hints of baldness).

By the time Vasari met him at Camaldoli, Bindo Altoviti had grown a luxuriant beard, its blond turning white. The banker moved between Florence and Rome, agitating for the republican cause in Florence. On the surface, he and Cosimo de' Medici continued to

maintain cordial relations, but in fact the two were busily conspiring against each other. Altoviti could count on the backing of his old friend Pope Paul III, who had awarded him the St. Peter's timber contract, among many others.

From Vasari's standpoint, moreover, Bindo Altoviti was already well established as a connoisseur of art, and that reputation was confirmed when the banker proposed a project that posed a real challenge to an ambitious painter: an altarpiece showing the Immaculate Conception, the idea that the Virgin Mary had been born without sin, a raging controversy in the sixteenth century (it would not be proclaimed a dogma, or fundamental belief, of the Catholic Church until 1854). The Franciscans and the brand-new order called the Jesuits believed; the Dominicans were adamantly opposed. Bindo Altoviti's visit to Camaldoli must have had a strong effect on his own Christian faith, as well as his business interests:

And when [Messer Bindo] saw all the works I had done in that place, and to my good fortune liked them, he decided that I should make an altarpiece for his church of the Holy Apostles in Florence. So, when I had finished the work in Camaldoli with the façade of the chapel in fresco—where I experimented with combining oil paint with fresco and succeeded quite handily—I went to Florence and made the picture. And because I had to prove myself in Florence, never having made a work like that before, what with so many competitors and my desire to make a name for myself, I prepared myself to make my best effort in that work and apply myself to the best of my abilities.

And so in October of 1540 I began Messer Bindo's painting, to make a *storia* that would show the Conception of Our Lady, to match the dedication of the chapel. And because the subject was very difficult for me to handle, Messer Bindo and I decided to ask the opinion of many mutual friends, literary men, and this is how I finally did it.[10]

Giorgio goes on to describe the central figure of the tree trunk with the serpent wound about it, with Adam and Eve tied to its truncated branches, and the Virgin triumphant above. From this anecdote, and from the painting itself, still in its original setting, we can see how much painter and patron must have enjoyed their learned conversations.

At thirty, with this *Immaculate Conception* commission for Altoviti, Giorgio Vasari had come into his own, with a successful practice, regular commissions, a core of dedicated friends stretching from Venice to Rome, and influence both within the ranks of the Medici and among their fiercest opponents. He had found a measure of tranquility in the spiritual retreat at Camaldoli, to which he would return several summers running. He was still several years from embarking on his *Lives*, but he had been collecting information for them, especially in the form of drawings by the artists he admired. These he had begun to keep in a set of folio books, which he called his *Libri dei Disegni* (literally Books of Drawings)—providing him with a resource that was partly a portable archive and partly an illustrated history of art. He received three hundred scudi for one picture with some regularity—a fine sum, when we recall that the salary that he sought so eagerly some years back, the position of *frate del piombo*, paid eight hundred scudi for an entire year.

By now Vasari had also begun to think about settling down. Most adults could not expect to live much beyond fifty-five, and thirty was regarded as a milepost: Dante himself had called thirty the "middle of our life's road." For Vasari, as for many of his male contemporaries, marriage was not an immediate concern—that would come later, and only after vigorous pressure from a cardinal. But finding a husband for his last sister finally relieved him of his duties as a surrogate father for his younger siblings, and like any sensible Tuscan who had "arrived," he had made an investment in property: that house in the good neighborhood of Arezzo, a large, attractive palazzo to renovate and to decorate with his own frescoes, now known as the Casa

Vasari. He wrote, "To unburden myself of every care, first I married off my third sister and bought a house in Arezzo, with enough space for beautiful gardens, in the San Vito neighborhood, in the part of the city with the freshest air."[11] Today, Casa Vasari still lives up to its proud owner's description: it stands high on Arezzo's sloping hillside, and its masonry fence encloses a large garden, with Italian-style ornamental hedges and a marble fountain. As so often in his life, when it came time to choose, Giorgio Vasari chose well.

13

FLORENCE, VENICE, ROME

T HE BAPTISM OF A NEW HEIR WAS A MOMENTOUS OCCA-
sion for Renaissance princes. It offered hope for the continu-
ation of the family line (though health was a precarious thing for
infants and young children prior to the discovery of penicillin), and
that was reason to celebrate. Cosimo de' Medici and Eleonora di Tole-
do's first son, Francesco, was born on 23 March 1541 (their daughter
Maria had been born in April 1540). Emperor Charles V was asked to
serve as godfather. The baptism was scheduled for 1 August, a special
date in the duke's personal history and a public holiday for Florence:
for on that day in 1537 Cosimo had defeated an army of republican
opponents (among them Bindo Altoviti's son, Giovanni Battista) at
Montemurlo, a fortress sixteen miles north of Florence.[1]

Like all baptisms in Florence, this one would take place in the city's
glorious Romanesque Baptistery, with its glittering gold mosaic ceil-
ing and Lorenzo Ghiberti's gilt bronze Doors of Paradise. Cosimo
ordered Vasari's friend Niccolò Tribolo to decorate the building,
inside and outside, with elaborate classically inspired ornaments.
Proudly, Giorgio declared, "He made that beautiful old temple seem
like a new modern temple, masterfully designed, along with the seats
all around [the baptismal font] richly adorned with gold and painted
decoration."[2] (In Vasari's day, using the ancient word "temple" rather
than the more modern "church" was thought to sound more elegant.)

Only one thing was missing, as the proud father discovered just six

days before the ceremony was to take place. Vasari reports in his *Life* of Tribolo,

> One day the Duke went to see this apparatus, and as a person of taste he praised everything and recognized how well Tribolo had adapted to the site and the place and everything else. The only thing he criticized, in a torrent of oaths, was the fact that no care had been taken of the tribune, and in a sudden impulse, resolute as he was, he ordered that this whole section be covered with a huge canvas painted in chiaroscuro showing the *Baptism of Christ.*[3]

Tuscans were, and are, famous for their ability to swear, usually by the Madonna; when Vasari reports that the duke objected "in a disorderly manner" (referring to his vigorous swearing, *sconciamente*), the meaning is clear.

Cosimo had already assembled a team of artists to help Tribolo with the decorations, managed by Pierfrancesco Ricci. An opportunity unexpectedly opened up:

> When Messer Pierfrancesco Riccio, the Duke's major domo at the time, and Tribolo asked Jacopo da Pontormo, he refused to do it, because he didn't think the available time, only six days, would be enough; and the same thing happened with Ridolfo Ghirlandaio, Bronzino, and many others.
>
> At this moment, when Giorgio Vasari had returned from Bologna and was working for Messer Bindo Altoviti, . . . he was not held in much esteem, despite his friendship with Tribolo and [Giovanni Battista del] Tasso, because a clique had formed around that Messer Pierfrancesco Riccio, and whoever did not belong found no favor with the court, no matter his talent and reputation; this was the reason that many artists who could have developed into excellent masters were jobless. . . .

Now these people were somewhat suspicious of Giorgio, who laughed at their foolish vanities, and the more he tried to improve himself with studying art rather than currying favor, the less attention they paid to him. When the Duke ordered him to make that painting with [the Baptism of Christ], which he completed in chiaroscuro in six days, he delivered it finished in such a way that everyone who saw it remembers what grace and ornament he gave to the whole decorative apparatus, and what a festive air he gave to that part of the temple most in need of it, and indeed to the magnificence of that whole festival.[4]

Like the rest of the temporary decorations, Vasari's large painting disappeared shortly after the baptism, but most of the artists involved in the festivities merrily recycled their designs in later projects. This was an especially easy process for Florentines, because their elaborate preparatory drawings recorded every creative choice of a work. Vasari did the same: he would paint another *Baptism of Christ* for Arezzo Cathedral in 1549.

The group of artists who gathered around Pierfrancesco Riccio may have formed a clique, but it was a clique of undeniable talent. Ridolfo di Ghirlandaio, born like Raphael in 1483, was the son of the popular fifteenth-century painter Domenico Ghirlandaio, who had always worked in the Medici circle and could boast Michelangelo as his former pupil. Jacopo Pontormo, ten years younger than Ridolfo, had also spent most of his life painting for families close to the Medici; Agnolo Bronzino, born in 1503, had been trained in Pontormo's workshop. Ridolfo's style had been forged, like Raphael's, at the beginning of the sixteenth century, and after Raphael's death in 1520 he continued, like his contemporaries Andrea del Sarto and Fra Bartolommeo, to paint velvet-textured oils in warm earth tones. Pontormo, on the other hand, broke new ground. His model was Michelangelo, whose cool pastels and taste for exaggerated figures he admired and adapted to his own work. Unlike Michelangelo's robust, muscular men and

women, Pontormo's bodies are long-limbed and graceful. He was not afraid to paint extremes of emotion, as in his moving *Deposition* in the Florentine church of Santa Felicita, where the Madonna falls into a dead faint at the sight of her dead son, and even the angels weep. Bronzino began by working in Pontormo's shop, so closely that their work can be almost indistinguishable; both favor pearly flesh tones and a cool pastel palette. The younger painter showed a particular talent for portraiture, including an image of the stark naked Duke Cosimo posing as the ancient Greek musician Orpheus, painted shortly before the duke's marriage to Eleonora di Toledo.

In this company of Florentines, Giorgio Vasari still counted as a provincial from Arezzo. Pontormo had been born outside the walls of Florence, but his native Empoli was just downriver, and he had moved to the city as a child. (He was also a quirky loner—Vasari relates that he had a removable ladder leading up to the top floor of his house, where his bedroom and a studio lay, so he could pull up the ladder and close the trap door, in order not to be disturbed.) An outsider Vasari may have been, but he had two particular talents that distinguished him from his competitors: he could work exceptionally fast, and he could write as well as he could draw. Furthermore, twenty years of conflict with Florentine insiders had taught him all about self-sufficiency. He had done Duke Cosimo a tremendous favor by completing the baptismal decorations for baby Francesco de' Medici in less than a week, but he was still in no hurry to become a permanent member of the ducal court. He would have liked to go to Rome again and work for Bindo Altoviti.

Instead, he wrote, "I was forced to go to Venice, because Pietro Aretino, who was my close friend, wanted to see me very much."[5] He had put off visiting Aretino earlier in the year, and he could also look forward to seeing another old friend, Francesco Salviati, who had moved to Venice after a long period in Rome. But Giorgio also had professional aims: he "was quite willing to go because [he] could

see the works of Titian and other painters on that trip."[6] There was even the possibility that he might meet Titian himself, because Pietro Aretino and the painter were close friends—frequent participants, along with Sansovino, in raucous parties (Aretino is said to have died of a stroke at one of these gatherings, induced by his laughing too enthusiastically at a dirty joke about his sister).

For some time, Vasari had also been corresponding with Giulio Romano, Raphael's most talented (and spirited) protégé. They had never met, because Giulio had been ensconced in the northern Italian city-state of Mantua since 1524, serving the young lord Federico Gonzaga as painter, architect, and gentleman-in-waiting. The two artists' friendship had been forged by correspondence or, as Vasari puts it, "by reputation and by letters," *per fama e lettere*. Long-distance friendships by correspondence had become a common practice among scholars since the fifteenth century; first in Europe, and then across the globe, they boasted of having created an entire "Republic of Letters" knit together by a constant stream of correspondence. Among artists, however, only the best educated and articulate were in any position to participate in this international community. Giulio had been lucky; he had grown up in Raphael's sophisticated Roman workshop, where scholars, poets, and dignitaries mingled with the artists. Pietro Aretino in particular had become a good friend. After Raphael's death, the two of them collaborated on an infamous project with the printmaker Marcantonio Raimondi, which has the dubious distinction of being the world's first printed pornography. Giulio created a series of sexy engravings, *I Modi* (*Ways to Do It*), for which Aretino supplied descriptive sonnets. Shortly after the scandal broke, both Giulio and Aretino moved north, where censorship was less stringent. Marcantonio stayed behind in Rome and was convicted of copyright violation rather than of disseminating obscene material— an outcome softened by his influence and the high esteem in which he was held, particularly for his role as official printmaker for engravings

of Raphael's paintings, the dissemination of which made Raphael famous throughout Europe.[7]

Now, nearly twenty years later, Giulio Romano was a grand old man in Mantua, and he had invited his young Tuscan correspondent to see the wonders he had created for Duke Federico Gonzaga. By this time, the Gonzaga family had governed Mantua for more than two centuries, since 1328. Professional soldiers immersed in the chivalric tradition, they were considered more aristocratic than the Medici, a family of bankers who had been in government for only a century. However, the Gonzaga were less wealthy and less powerful than the Florentine dynasty, with a territory hemmed in by Milan, Venice, Genoa, the Papal States, and a host of smaller cities. For Duke Federico and Giulio Romano, however, that limited realm provided more than enough resources to live exceedingly well. Surrounded by three artificial lakes (created in the twelfth century), their beautiful city seemed (and seems) to sit on its own island, with fertile farmland all around it. Giorgio Vasari stopped for four days on his way to Venice, after visiting Modena and Parma to see the work of Correggio, and before seeing the monuments of Verona, ancient, medieval, and modern:

> When Vasari arrived in that city, when he went to see that friend [Giulio] he had never seen before, when they met they recognized each other as if they have been together in person a thousand times. This made Giulio so content and merry that for four days he never parted company, and showed [Giorgio] all his works and especially the plans of the ancient buildings of Rome, Naples, Pozzuoli, and Campania, and all the other antiquities known to memory. . . .[8]

The greatest treasure of Giulio's collection was Raphael's 1517 portrait of Pope Leo X flanked by two cardinals. But Vasari had news for

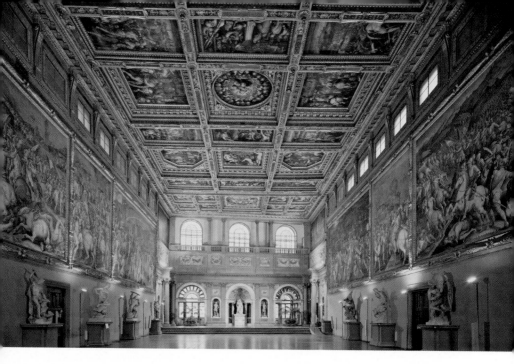

The Sala dei Cinquecento is the site of a famous treasure hunt. Clues suggest that Vasari moved and walled over Leonardo's Battle of Anghiari *when he renovated the room, and the search is on to uncover it.*

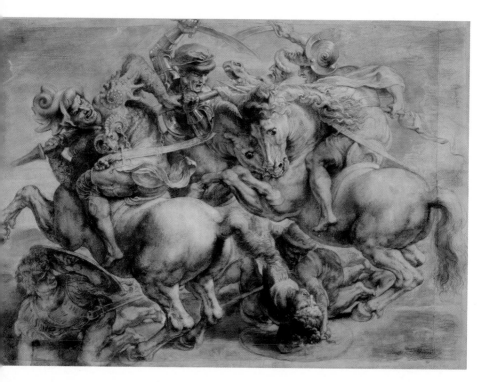

We know what Leonardo's Battle of Anghiari *looked like only thanks to this black chalk and pen sketch by Rubens.*

A study for the never-executed Battle of Cascina *fresco that Michelangelo was asked to do opposite Leonardo's* Battle of Anghiari.

Vasari was tasked with renovating and expanding the Sala dei Cinquecento, as well as painting its walls. This is a sketch of his planned renovation.

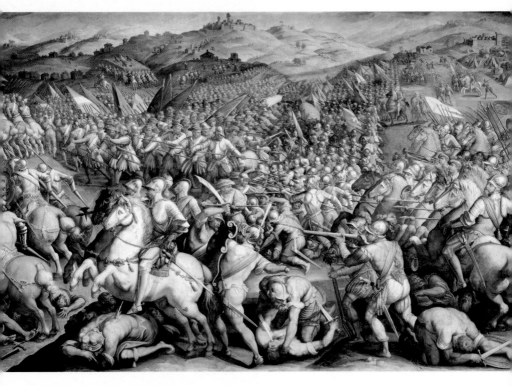

The fresco by Vasari in which a clue is concealed that may point to the whereabouts of the lost Leonardo: the words Cerca trova, "Seek and you shall find."

Detail of soldiers in battle with the inscription CERCA TROVA on a banner. Sala dei Cinquecento; east wall.

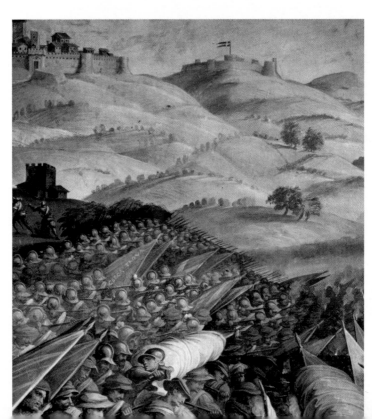

A self-portrait by Vasari, made during the period between the two editions of his Lives.

Vasari's studio at his home in Florence, his primary base of operations.

Vasari portrayed his onetime schoolmate, Alessandro de' Medici, who was dramatically assassinated.

Vasari is renowned for his book, which established the academic study of art history. But he was also a top-level painter and architect. Here is his painting of Saint Luke, patron saint of painters, who was said to have made the first icon, a portrait of the Madonna.

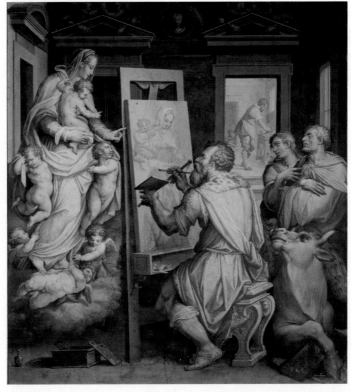

Vasari's posthumous portrait of Lorenzo was flattering and idealized, making him more magnifico *than he had appeared in life.*

Raphael's most famous fresco, School of Athens, *is the zenith of High Renaissance painting.*

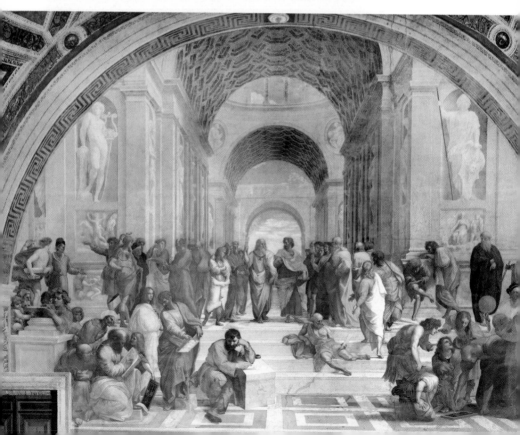

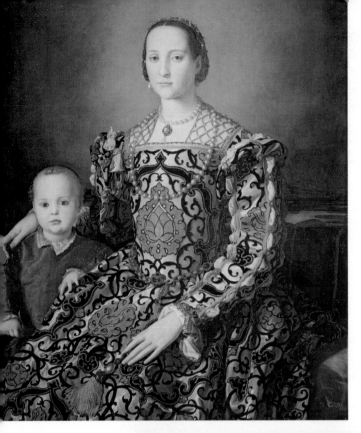

Portrait by Bronzino of Cosimo's beloved wife, Eleonora di Toledo, with one of their sons, Giovanni.

Cosimo de' Medici, Vasari's friend and patron, as portrayed by Bronzino.

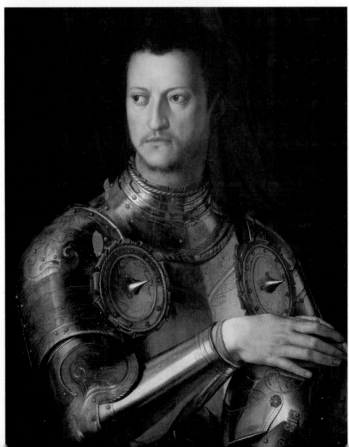

Bronzino's Allegory of Love and Lust *is an example of how an over-reliance on Vasari has led art historians astray; only when Vasari was set aside was progress made in interpreting this famously riddling painting.*

The first page of Vasari's Life of Michelangelo, *with a portrait of the master surrounded by personifications of Painting, Sculpture, and Architecture.*

The frontispiece of the first edition (1550) of Vasari's Lives of the Most Eminent Painters, Sculptors, and Architects, *framed by the Medici coat of arms and a view of Florence.*

his friend about this prized possession: the painting was not the original by Raphael but a copy by Giorgio's own master, Andrea del Sarto:

> When, after many antiquities and paintings, Giulio showed him that painting by Raphael as the best thing in the world, Giorgio said, "The work is beautiful, but it's not by Raphael's hand." "How can it not be?" said Giulio. "Shouldn't I know, when I recognize my very own brushstrokes?" "You forgot," Giorgio replied, "because this is by Andrea del Sarto, and I'll prove it. Look at this mark (and he showed it to him) that was made in Florence, because when the two paintings were together they were switched." On hearing this, Giulio turned over the painting, and when he saw the mark, he shrugged his shoulders with these words: "I don't think any less of it because it's not by Raphael, in fact I think more of it, because it's an extraordinary thing that one excellent man can imitate the style of another so well, and make it so similar."[9]

The switch had happened, Vasari went on to explain, when Alessandro de' Medici had asked Ottaviano de' Medici to give him the painting; instead, Ottaviano had asked Andrea del Sarto to make a copy and passed the copy off to his relative as the original. Eventually, Ottaviano would give the real original to Cosimo, a Medici duke of an entirely different caliber.

Giulio Romano inspired his younger friend on many levels. In the first place, he represented a direct link to the great Raphael, who had died when Giorgio Vasari was only nine. As Raphael's most gifted assistant, Giulio inherited many of his master's drawings and completed his unfinished commissions; Vasari was especially fascinated by the collection he had amassed of architectural drawings, both of ancient buildings and of new designs.

Giulio had also learned Raphael's gracious manner. In 1550, with

the memory of their meeting still fresh, Vasari began his *Life* of Giulio
Romano with an outburst of admiration:

> When among men one sees witty spirits that are affable and
> cheerful with a pleasant gravity to all their conversation, and
> who are stupendous and marvelous in the arts that proceed from
> the intellect, one can truly say that these are gifts that Heaven
> extends only to a few, and these people may walk proudly above
> the rest for the felicity of the qualities I have mentioned, for their
> courtesy in helping others can accomplish as much among other
> people as their wisdom in the arts can accomplish for their works.
> In these qualities Giulio Romano was so endowed by nature that
> he could truly be called the heir of that most gracious Raphael,
> as much for his manner as for the beauty of his figures in the art
> of painting, and again for the marvelous buildings he made in
> Rome and Mantua, which seem not so much human dwellings
> as houses of the gods.[10]

From Mantua, galvanized by this encounter with Giulio Romano
and his vast collection of architectural drawings, Vasari set out for
Verona, with its beautifully preserved Roman theater and arena.
Then, at last, as 1541 drew to an end, he reached Venice.

Vasari had not come empty-handed. Almost immediately, he sold
two drawings he had made from cartoons by Michelangelo to the
Spanish ambassador to Venice, Diego Hurtado de Mendoza y Pacheco.
Selling drawings was unusual at this time, because they were consid-
ered a preparatory tool for a statue or painting, not something worth
collecting and displaying. Hurtado's interest in drawings speaks well
of his taste, and of interests and an aesthetic sense shared with Vasari.
A skilled diplomat, Hurtado was also a book collector with a special
interest in Greek texts, a poet in Italian and ribald Castilian, and a
novelist; recently, he has been identified as the author of *Lazarillo de
Tormes*, the first picaresque novel.[11] Hurtado was exactly the kind of

person who would have enjoyed the company of Pietro Aretino, he of the dirty jokes, extensive parties, and sexy sonnets.

Aretino, for his part, was a perfect host for his younger friend; he provided not only food and lodging but also a new commission. An aristocratic Venetian dramatic troupe, the Immortals (*i Sempiterni*), had decided to stage Aretino's 1534 play, *La Talanta*, for Carnival. Giorgio had come just in time to provide the designs for the theater.[12] The *Sempiterni* were one of the male clubs known as *Compagnie delle Calze*, "Companies of Men in Tights", identifiable by their brightly colored, form-fitting hose.[13] These wealthy fraternities added spice (and satin) to Venetian life by producing theatrical events at Carnival in winter and in the summer, when Venice officially marries the sea; on the latter occasion, they often performed on floating platforms. For Carnival in 1542, the *Sempiterni* intended to build a whole temporary theater; they had already bought an unfinished house in the outlying neighborhood of Cannaregio just for the purpose.

There was no way that Vasari could undertake so large a project on his own. In order to complete his set design, he summoned three assistants, including Giovan Battista Cungi and Cristofano Gherardi. Once again, he ran into criticism for his collaborative working method. The Florentine antiquarian Luigi Lanzi, in his 1792 *Storia Pittorica della Italia dal Risorgimento* (*History of Painting in the Italian Renaissance*, an intentional update on Vasari's *Lives*), joked that Vasari had as many assistants for his paintings as he employed laborers to make his buildings.[14]

Vasari did not want to begin work without his assistants, but they had to make the arduous journey from central Italy to Venice, which was no easy feat. Travel was feasible by horse up to Padova, though the roads were regularly patrolled by bandits and travel meant carrying a sword and taking your life into your hands. But once at Padova, things got trickier. A raft would escort you along the Brenta River until a vast mud bank stopped further access in the direction of Venice. The raft would be dragged by pulleys onto a wheeled carriage and

then hauled, by many men straining at winches, to the mouth of the Venetian lagoon, where it could once more be used to float to one's destination. Depending on whose travel account you read, this whole procedure, from Padova to Venice, took between twelve and thirty-six hours—quite a difference when today a train or car can take you the distance in about one hour. Vasari's biographer Robert Carden assures us that, at the end of the nineteenth century, this journey was no shorter: a contemporary of his told of having to spend nearly three days to cover twenty-two miles![15] The poor assistants got as far as the Venetian lagoon, when a storm hit, blowing them so far off course that when they finally reached land, it turned out to be Istria, on the opposite side of the Adriatic Sea. Meanwhile, Vasari was growing more ornery with every passing day, refusing to begin the project without help.

Eventually, however, the assistants arrived in Venice, doubtless exhausted. The Elizabethan travel writer Thomas Coryat, just a generation older than Vasari, described the sight that would have met their tired eyes: "the most glorious and heavenly show upon the water that ever mortal eye beheld, such a show as did even ravish me with delight and admiration."[16] Spectacular as Venice is today, it must have been far more so in the sixteenth century, when it was one of the dominant powers in the Mediterranean, and the wealthiest city in Europe. It is easy to forget that many of the palaces of Venice were originally frescoed and gilded on the outside. Owing to the humidity of the city, almost none of these exterior frescoes have survived to the present day, and many crumbled within a generation of their having been painted. Still, a dazzling array would have been in place when Vasari's travel-weary assistants finally landed.

The assistants included Cristofano Gherardi, whose career would be transformed by the Venetian project, a career successful enough to merit a place all its own among Vasari's *Lives*. Giorgio provided all the drawings for the theater's architecture and decoration; Cristofano did most of the actual painting:

And he did so well that everyone was amazed. . . . In short, in this project he outdid himself as a competent and highly experienced painter, especially of grotesques and foliage. Once they had finished that festival apparatus, Vasari and Cristofano stayed some more months in Venice, painting the ceiling of a chamber for the Magnificent Messer Giovanni Cornaro with nine oil panels.[17]

The person who arranged Vasari's meeting with the aristocratic Cornaro was none other than Titian.[18] The two had met through Aretino almost immediately and become friends. Giorgio had also made contact in Verona with the gifted architect Michele Sanmicheli, and in Venice with Jacopo Sansovino (another friend of Aretino and Titian), who had just engaged Vasari to paint three ceiling panels in oil on canvas for the church of Santo Spirito. His reception in Venice— the proliferation of friends and steady flow of commissions—had been encouraging enough for him to think about staying for years rather than months. It was Cristofano Gherardi who brought him back to his Tuscan senses. The Venetians might be great colorists, the faithful assistant noted, but their painting suffered from a fatal flaw: they lacked any concept of *disegno*: "Yet without [*disegno*] painters cannot attend to their art, and it would be better to return to Rome, which is the true school of all noble arts, and where true quality is recognized far more than in Venice."[19]

And so, Vasari writes in his autobiography, "I left, even though I was overwhelmed with the commissions that had come into my hands, on the sixteenth of August 1542, and returned to Tuscany." The task of painting the three panels for the vault of Santo Spirito fell instead to Titian, who "carried them out in splendid form, contriving with great skill to portray the figures as if seen from below [*di sotto in su*]."[20]

Vasari's first stop was Arezzo, where he frescoed the ceiling of his new house. The subject? *Disegno*:

All the Arts belong to *disegno,* or depend on it. In the center is Fame, who sits on a globe of the world and sounds a golden trumpet while tossing away one made of fire, which stands for Slander; and around her in order are all the Arts with their tools in hand. And because I did not have time to finish the whole, I left eight ovals for eight portraits of the outstanding practitioners of our Arts.[21]

The room in Casa Vasari is now called the *Camera della Fama,* the Chamber of Fame.

However, Vasari was loath to linger in Arezzo when Bindo Altoviti awaited his return to Rome. Their reunion was a fond one, and also productive:

I made [Messer Bindo] an oil painting with a life-size Christ taken down from the Cross and set on the ground at his Mother's feet, and in the air Apollo darkens the face of the Sun and Diana that of the Moon. In the landscape, darkened by these shadows, you see some stone mountains breaking apart, shaken by the earthquake that occurred when the Savior died, and you can see the bodies of sleeping Saints arising resurrected from their tombs.[22]

Recently, this painting was rediscovered, sold at auction in New York in 2000 for $547,000, and put on public display in 2003–4 for an exhibition devoted to Bindo Altoviti and his patronage at Boston's Isabella Stewart Gardner Museum.[23] Its surface is worn and damaged, and what must have been the radiant pastels of the Virgin's robes and the flushed skin of the gods have faded, dimmed by the dark brown of the prepared canvas showing through from beneath the painted surface. Still, this is recognizably the work that Giorgio Vasari presented to Bindo Altoviti in the autumn of 1542.

Fresh from the easel, moreover, it impressed several important

viewers, in addition to Bindo himself and an old friend of Vasari's, the writer and painter (and owner of the villa on Lake Como that featured the first "museum") Paolo Giovio: "When this painting was finished its grace did not displease the greatest painter, sculptor, and architect who has ever lived in our era, and perhaps in all time. And by means of this painting . . . I was also introduced to the most illustrious cardinal Farnese."[24] The "greatest painter, sculptor, and architect who has ever lived" was, of course, Michelangelo Buonarroti. But that did not mean that there was no competition for that title.

RENAISSANCE MEN

Leonardo, Raphael, and Michelangelo

W HILE MICHELANGELO WAS VASARI'S SUPREME PRO-
tagonist, it is important to compare the apotheosis of this
"hero" with the exploits of his close rivals for the title of "greatest
artist who ever lived." Vasari showers praise on Giotto, Brunelle-
schi, Raphael, and Leonardo, the men who came closest to attaining
Michelangelo's level of accomplishment (at least according to Vasari's
subjective opinion). Giorgio, versatile himself, particularly admired
the fact that these artists, like Michelangelo, excelled in a variety
of media. Aside from Brunelleschi (for whom there is no record
of achievement as a painter), all were brilliant practitioners of the
three arts singled out in the title of *Lives*: painting, sculpture, and
architecture.

In building his narrative strucure, Vasari would draw significant
parallels among the three heroes who dominate their respective cen-
turies: Giotto for the fourteenth century, Brunelleschi for the fif-
teenth, and Michelangelo for the sixteenth. All three were, as Giorgio
describes himself, short of stature and plain of face, if not downright
ugly. To counter this inconvenient fact (for Renaissance aesthetics
linked external beauty with goodness of spirit), Vasari would take
pains to insist that, despite their outward appearances, all had beautiful
minds and souls. As a short man himself, not particularly handsome—
if we are to judge from his portraits—and afflicted with eczema or
psoriasis, he had his own reasons to insist on interior beauty, just as the

elderly Vitruvius had once begged the emperor Augustus to overlook his feeble physique and value him instead for the quality of his treatise on architecture.

Michelangelo's biography takes up the longest chapter of Vasari's *Lives*. It is also the chapter most clearly shaped as a work of literature to prove its overriding point.[1] Giorgio begins this crucial *Life* as eloquently as he knew how, summoning all the weapons of classical rhetoric. In a single, intricate, complex sentence, he uses both parallels and contrasts to sing the praises of Michelangelo and, at the same time, sharpen his criticisms of all the lesser artists who came before the supreme master. It is a technique borrowed from the ancients. The architect Vitruvius begins his *Ten Books on Architecture* with a similarly grand (and endless) opening sentence. Both classical orators and their Renaissance admirers, especially in Italy, prized a quality they called *copia*, abundance, the ability to say the same thing in several different ways, the more flowery the better. Classical rhetoric originally developed to help lawyers argue their cases effectively in court, and *copia* was valuable because it enabled a speaker to drive home a point securely without sounding redundant. As heirs to this glorious tradition, modern Italians continue to enjoy displays of *copia* just as much as their ancestors. Michelangelo, therefore, makes his entrance in a flourish of flamboyant oratory, a clue to readers that this is an artist of supreme importance:

> While outstandingly industrious spirits strove, by the light of the most famous Giotto and his followers, to show the world what competence the favor of the stars and the balanced mixture of humors had granted their talent, and toiled one and all, albeit without success, in their desire to imitate the grandeur of nature through the excellence of art in hopes of arriving, as best they could, at that supreme knowledge that many call Understanding, the most benevolent Ruler of Heaven mercifully turned his eyes earthward, and seeing the endless futility of such effort,

the passionate but fruitless zeal, and the presumptuous opinions
of mortals, far more distantly removed from truth than dark-
ness is removed from light, he decided to redeem us from such
error by sending to earth a spirit universally capable, by single-
handed effort in every art and profession, of exhibiting perfec-
tion: in the art of *disegno*, by delineating, outlining, shading, and
highlighting to give painting a sense of three dimensions; as a
sculptor, to work with right judgment; and in architecture, to
make our dwellings comfortable and safe, sound, cheerful, well-
proportioned, and rich in the variety of their ornament.[2]

Few are the orators who could declaim this mighty sentence in a
single breath, but it does reveal Vasari's gifts as a publicist extraordi-
naire. Not only does Michelangelo uniquely possess "a spirit univer-
sally capable, by single-handed effort in every art and profession, of
exhibiting perfection," but he also has been created by God as a sort of
savior of the arts, the fulfillment of the prophecy of Giotto, Donatello,
Masaccio, and Brunelleschi, all rolled into one. The art historian
Andrew Ladis perceptively notes the parallel with "the heroic gran-
deur of Michelangelo's scenes of creation for the Sistine ceiling, for
Vasari's portrayal is conceived in the epic spirit of Michelangelo's own
work."[3]

Was Vasari correct in his judgment? Had there ever been an artist as
universally excellent as Michelangelo? If we look at some of the great
man's rivals and contemporaries, we can see that Vasari had a point.

During the Renaissance, it was not uncommon for artists to fill
numerous roles, and to create works in many media. The term "Renais-
sance man" today describes someone who excels at a broad variety
of activities, with the implication that such breadth is unusual—and
in our day it is. Higher education and advanced training encourage
us to specialize, to develop a tight and deep expertise, rather than to
experiment more broadly. We look with some suspicion at those who
try to do too many things at a high level, tempted to think of these

people as dilettantes, incapable of performing outstandingly in more than one field.

But in Vasari's time, artists, like most people, were often called upon to fill multiple roles. The majority of artists in the *Lives* produced, to an exceptionally high degree, in more than one medium. Vasari himself was a painter and architect and, of course, a biographer. Giotto painted and practiced architecture (the campanile of the cathedral of Florence is attributed to him). Andrea del Verrocchio painted and sculpted—at least until his young pupil Leonardo outstripped him. Benvenuto Cellini trained as a goldsmith, worked as a sculptor, wrote a rollicking autobiography, and, like many artists when war broke out, was also dragooned into work as a military engineer, preparing the bastions of Rome against assault from rampaging German troops in 1527 (and personally defending Pope Clement VII from the entire horde, if his own account is to be believed—which it shouldn't be).

Among artists, a diversity of production was not uncommon and was often expected. Raphael was best known as a painter, but also practiced architecture, curated the papal antiquities collection, and was an active member of the papal court (just as his father, Giovanni Santi, had been both painter and poet at the court of Urbino). Even among painters, wall paintings (in fresco) and panel paintings in tempera or oil were very different undertakings, employing distinct techniques—yet many painters were obliged to engage in both. Sculpting in wood or stone could hardly have been more different from bronze casting, which first involved building up a model in soft material rather than hewing away a block with chisels and sandpaper, and then involved casting metal, like the makers of bells and cannon.

Vasari also praises Leonardo for the same versatility, spurred in part by what we might today call attention deficit disorder.

And every day he made models and drawings showing how to level mountains easily, and tunnel through them to pass from one

level to another, and how to raise and pull great weights with the help of levers, cranks, and screws, and ways to dredge harbors and funnels to drain water from low-lying terrain, because that brain of his never stopped spinning fantasies. And you can see many drawings of his thoughts and labors dispersed among the members of our profession—I myself have seen a great number. Furthermore, he passed the time by drawing groups of cords arranged in a pattern that allows you to follow along from one end of the cord to the other, filling up a roundel—there is a print of one, extremely complicated and very beautiful, and in the center are these words: LEONARDUS VINCI ACCADEMIA.[4]

Evidently Leonardo, thanks to his understanding of art, began many projects, but he never finished any of them. It seemed to him that the hand could never perfectly craft the things that he imagined, because in his imagination he created things so difficult, subtle, and marvelous that even the most excellent hands could never express them. So whimsical was he that, when he examined the phenomena of nature, he aimed to understand the properties of plants by observing the motions of the heavens, the course of the moon and the path of the sun.

LEONARDO WAS BORN IN the village of Anchiano, some thirty miles from Florence, on 15 April 1452. His father, Ser Piero da Vinci, was a wealthy notary of Florence who had impregnated Leonardo's mother, a young peasant woman, out of wedlock. But Ser Piero took in Leonardo shortly after his birth and raised him as a legitimate son (between future unions of Ser Piero and Catarina, Leonardo would have seventeen half siblings). Neither Piero nor his son was aristocratic enough to have a real surname; "Piero da Vinci" simply means "Piero from Vinci," the town where he was born, and the same applies to Leonardo.

By the age of ten or twelve, Leonardo had shown his talents in a number of arts. His best prospect appeared to be in music: he was a prodigy with the *lira da braccio*, a seven-stringed ancestor to the violin, played with a bow). But at age fourteen, after having spent much of his youth in Florence, he was apprenticed to the master Andrea del Verrocchio, a friend of Ser Piero's who, at the time, was active in both painting and sculpture. Young Leonardo kept good company, and Verrocchio proved to be a teacher for the ages—out of his studio emerged the stars of High Renaissance Florence: Ghirlandaio (who would in turn teach Michelangelo), Perugino (who would teach Raphael), and Botticelli, a friend of Verrocchio's and regular at his studio. Verrocchio was not only an able teacher but, by all accounts, a kind man, who took an especial shine to Leonardo. He was also the leading artist of Florence in the 1460s, one who much preferred sculpture to painting. As a sculptor, he dominated the field in Northern Italy between the time of Donatello (a generation older) and Michelangelo (a generation younger). But he would accept the occasional painting commission, and it was one such painting that gave Leonardo his "big break."

At the time, Leonardo was apprenticed to Andrea del Verrocchio, who was painting a panel of Saint John baptizing Christ. Assigned to work on an angel who held some of Christ's clothing, Leonardo, still a youth, carried it out so well that his softly modeled angel, with its halo of golden curls, drew attention away from Andrea's harsher, more rigid figures. No wonder Andrea never again wanted to touch paint.[5]

By now, we can see Vasari sounding a familiar theme—the apprentice outdoing the master. Another familiar theme in his biographies, a youth astonishing elders with his drawing prowess, holds true for Leonardo as well. Vasari describes him as having painted a buckler, a small round shield, with the snake-writhing head of Medusa, which he set up in good light before calling his father into the room:

Ser Pietro, at first glance and not really thinking, started at the sight of it, sure that this object could not possibly be the buckler, or that those figures could only be painted. As he stepped backwards, Leonardo steadied him, saying, "This work does what it is made to do. You can take it away now; it serves its purpose."[6]

Young Leonardo knew how to play a good prank, and the anecdote fits the Vasarian trope of the hyper-precocious youth fooling someone more experienced with the surprising naturalism of his art.

Leonardo began to work independently from 1477, creating many works but finishing few of them. He left an unfinished *Saint Jerome* and an unfinished *Adoration of the Magi*, as well as an unfinished altarpiece for the chapel of the Palazzo Vecchio (a space that Bronzino would later decorate). Leonardo's personality combined perfectionism with a love for experimentation and an enthusiasm for perhaps too many things. His oeuvre of paintings, finished or unfinished, is very small. He earned more money as a military engineer and musician than as an artist over his career, and he seemed more interested in anatomy, biology, invention, engineering, and scientific research than in the business of art. When he wrote a letter, in 1482, to the duke of Milan, he described what services he could offer, mentioning his designs for multishot cannons, tanks, armored ships, and portable bridges. Sculpture came second. Of the ten categories of work in which he claimed capability, painting seems to have been lowest on the list. In 1494, he was summoned to the court of the warlord Duke Ludovico Sforza, in Milan, but art had nothing to do with it.

Lionardo was brought with great fanfare to play before the Duke, who greatly enjoyed the sound of the lira, and Lionardo brought the instrument he had made with his own hands, mostly made of silver in the form of a horse's skull, a bizarre, new thing, that increased the size of the instrument's bell and the resonance of

its sound, and thus he surpassed all the other musicians who had been brought to play.[7]

It may seem ironic that someone remembered as the greatest artist of his era should have been hired as a musician (and bring his invention of a newly designed instrument). Vasari continues, "Furthermore he was the best reciter of improvised rhyme of his day." Popular music at the end of the fifteenth century featured improvised verses called *strambotti*, with a rhythmic accompaniment; Leonardo, then, was something between a pop singer and a rapper.[8] He would also be employed as a military engineer and, as if an afterthought, was commissioned to do some paintings while in Milan.

One of these works was his *Last Supper*, which was likewise unfinished, for all the praise that has since been showered upon it. Alas, Leonardo's interest in experimentation carried over to his art, and he worked in nontraditional media: this, perhaps the most famous "fresco" in the world, is not a true fresco, painted into wet plaster, but a *fresco secco*, in which paint is applied directly to the dry plaster wall. It is also painted with oil paint, rather than tempera—oil paints, being translucent, are not suited for fresco—as a result, it began peeling and deteriorating within a few years of having been (in)completed. Perhaps the prior of the convent for which the *Last Supper* was painted knew Leonardo's reputation, but Vasari explains that he worried that the work was taking too long, and asked the duke to intervene on his behalf. The duke spoke to Leonardo about this, mildly and politely:

> Lionardo, knowing that that prince had a sharp, discerning wit, . . . conversed with him extensively about art, and made him understand that for lofty talents, the less they labor manually, the more they are truly at work, seeking out new inventions in their minds and forming those perfect ideas that they will later express,

and their hands will then form the portrait of what the intellect has already conceived.[9]

He was a master of many things, including creative rationalizations and excuses. The duke found this very funny and did not press his resident genius.

When the French took over Milan and drove out the Sforzas, one of Leonardo's greatest unfinished projects was lost. In 1482 Ludovico Sforza commissioned him to make a statue of a horse that would be the largest equestrian statue in the world, in honor of his father, the deceased Duke Francesco Sforza. Leonardo was more interested in the logistics than in the sculpting—he wanted to make the entire horse in a single bronze casting. The engineering required, using the lost wax method on such a scale, had never been done before—large bronze statues were normally cast in pieces and then welded together. Leonardo went so far as to build a full-size terracotta model, twenty-four feet tall, and this could have been used not only as a mock-up but also as the actual clay base for the bronze casting. The "lost wax method" required a full-size clay statue, fired and hardened, then covered with wax, before another layer of clay was added all over the statue, resulting in a "sandwich" with fired, hard clay on the inside and outside and wax in the middle. This would then be buried underground with tubes running down through the outer layer of clay to allow molten bronze to be poured in, displacing the wax, and to let the ensuing steam escape. Once the bronze had hardened, the statue was dug up and the external clay broken away, leaving a thin layer of bronze where the wax had once been. But on 10 September 1499, when the French army took over Milan, some Burgundian archers decided to use the great clay model for target practice and destroyed it. It may be small comfort to know that modern experts are convinced that if Leonardo had ever tried to cast his gigantic monument it would have exploded in the ground.[10]

Ironically, when King Francis I arrived in Milan, sixteen years

later, he greatly admired Leonardo's *Last Supper* and asked engineers to devise a way to remove it from the wall of the refectory of the convent in which it was painted and bring it to France, but they had no idea how to do so without ruining the convent and the already damaged painting.

Throughout his career, Leonardo kept notes and sketches, wrote on art and mathematics, examined and theorized human and animal anatomy (he wrote a lost manuscript on the anatomy of a horse and, along with Michelangelo in Florence, illegally dissected human cadavers, in the basement of the Ospedale di Santo Spirito).

Leonardo was a pen-wielding mercenary, moving from one princely court to another as opportunity arose. In 1502, he joined the court of Cesare Borgia, duke of Romagna, primarily as an architect and military engineer, with duties that included fortifying papal territories (Borgia was the son of Pope Alexander VI). He returned to Florence and served as a field engineer when the Florentines campaigned against Pisa. But he was flexible about whom he worked for—he even wrote to Bayezid II, the sultan of Turkey, to offer his services, particularly keen to be the first to build a bridge across the Golden Horn. In 1506, he was back in Milan, now serving the French governor of the city, Charles d'Amboise, and became official court painter to the French king, Louis XII, who was at the time residing in Milan. He lived in Rome, working for Pope Leo X, from 1513 to 1516, where he was left largely to his own devices, working on scientific experiments, while also suffering from arthritis, which may have dissuaded him from picking up brushes or chisels.

King Francis I ascended to the throne in 1515, and the following year Leonardo accepted his invitation to move to France. Francis was a lover of all things Italian: art, women, and culture, and he collected all of the above—including artists. He would write not only to Leonardo but to Raphael, Rosso Fiorentino, Cellini, and Michelangelo, to name a few, offering rich rewards for anyone enterprising enough to move to France. Leonardo, Rosso, and Cellini are among those

who took the king up on his offer. Leonardo took up residence at the castle of Clos Lucé in the town of Amboise and, as Vasari describes, became a dear friend of the monarch, who, when he heard that the elderly Leonardo was nearing death, came to stand by his bedside.

> The King, who visited him often and with great affection, arrived; and so, out of reverence, [Lionardo] drew himself up to sit on the bed, told the story of his sickness and its details, and confessed how greatly he had offended God and the people of the world by not having devoted himself to art as he should have done. Suddenly a seizure overtook him, a harbinger of death, and so, as the king stood up and took his head to help him and comfort him until his pain was relieved, his spirit, which was divine, knowing that it could receive no higher honor, breathed its last in the King's arms, at the age of 75.[11]

This melodramatic account of Leonardo's death is a packed paragraph, full of inaccuracies, but also full of symbolic meaning. Leonardo was sixty-seven when he died in 1519. It is highly unlikely that Francis was present at his death. In May of that year, Francis was busy raising money and campaigning to be crowned Holy Roman Emperor (he narrowly lost to Charles V). While Francis certainly esteemed Leonardo and thought well of him, it is improbable that he "visited him often and with great affection," and they did not enjoy the sort of artist–patron relationship that blossomed between Vasari and Duke Cosimo. It is also implausible to imagine Leonardo, with his last words, apologizing for not having spent more time on his art. This is simply Vasari, offering his readers a moral message. Leonardo may have been a more productive version of Buffalmacco, but both spent too much time on "less-important" things: in Buffalmacco's case, finding creative ways not to do any work at all, in Leonardo's, dabbling in engineering and music and science. When Leonardo died, his belongings, including another unfinished painting, *Mona Lisa*,

were bequeathed to his assistant Gian Giacomo Capretti, from whom Francis purchased the entire collection, for the handsome sum of 4,000 écus.[12]

Leonardo's legacy in art was far greater than his modest output would suggest. The development of techniques like sfumato (the intentional blurring of color to create a smoky, atmospheric effect), chiaroscuro (the dramatic focus on emerging from darkness), and replicating nature with as much accuracy as possible (such as employing "atmospheric perspective," in which objects far in the distance appear hazier, as we view them through layers of atmosphere, and pinpoint accurate anatomy as studied from dissections) all made a lasting impression and influenced future generations of artists. His books (on art and on mathematics) helped to disseminate his ideas. His inventions, more of them designed than actually built, showed tremendous forethought: he was the first to conceive of helicopters, machine guns, tanks, parachutes, foldable bridges, and more.

RAFFAELLO SANZIO, RAPHAEL, seems to have been irresistibly charming in the eyes of everyone who knew him, except Michelangelo and his sharp-tongued acolyte, Sebastiano del Piombo. The artist's sudden death on his thirty-seventh birthday only added to his mystique. Yet, as Giorgio Vasari knew with rare empathy, Raphael's reputation rested above all on his uncanny technical skill, both as a painter and as an architect and designer. They never met—Raphael died when Vasari was nine—so the *Life* of Raphael, unlike those of Michelangelo and Titian, lacks the intimacy of personal contact. Instead, the biography pays tribute to a consummate artist by consciously reviving the ancient literary art of ekphrasis.

Literally, *ekphrasis* means "speaking out" in Greek, but in classical rhetoric the word took on a specific significance: a vivid description, or as the classicist Ruth Webb describes it, "the art of making listeners and readers 'see' in their imagination through words alone."[13] Ancient

orators in political meetings and courts of law used all their eloquence to conjure up a person, an event, or a work of art for their audiences, and Renaissance writers, inspired by their example, tried to cast the same spell. In the *Life* of Raphael, Vasari therefore helps us visualize both the artist, as the living person he never knew, and the works themselves. We learn, for example, that Raphael's father, the painter Giovanni Santi, insisted that Raphael's mother breastfeed her own baby rather than sending him out to a wet nurse, "so that in his tender years he could develop his father's manners rather than learning less genteel, or downright crude, conduct among peasants or plebeians." Raphael was famous for his paintings of the Madonna and Child, all of them showing an intense bond between mother and son that Vasari traces right back to the artist's first years of life.

Giovanni Santi worked for the duke of Urbino, a small, refined city-state east of Tuscany, in the mountainous region called the Marches. When the boy began to show signs of exceptional talent, Giovanni placed him with Pietro Perugino, the most successful painter in central Italy: "Taking the boy, not without many tears shed by his mother, who loved him tenderly, Giovanni sent him to Perugia, where Pietro, seeing Raphael's beautiful way of drawing and his beautiful manners and behavior, formed an opinion of him that time would bear out."

From Perugia, Vasari reports, Raphael proceeded to Florence, and then in 1508 to Rome, where he joined a team of painters involved in decorating the apartments of Pope Julius II. Raphael's distant relative Donato Bramante had become one of the pontiff's closest friends, and he not only supplied Raphael with an introduction but also began to instruct him in architecture. The young painter's career blazed like a meteor across the skies of Rome. No one had ever seen anything quite like him. Vasari tried to describe the power of his art for readers who may or may not have seen it: "In him, Nature gave a gift to the world, when, already vanquished in artistry by the hand of Michelangelo Buonarroti, she let herself be defeated by Raphael in both art

and good manners together."[14] "The truth is that other paintings can be called paintings, but Raphael's paintings are living things, because the flesh trembles, the spirit is made visible, the senses encounter his figures and feel the vivid pulse of life, and this gave him a reputation far beyond the praise he had already received."[15]

Vasari's descriptions may be works of high rhetoric, but they also capture the uniqueness of Raphael's technique: unlike Titian, who visibly reveled in paint and brushstrokes, Raphael almost tried to make the paint go away, building up layer after layer of transparent glaze to suggest the throb of veins beneath human skin, or using a tiny brush to record every nuance of light and shadow across a textured surface. No painter has ever mastered the art of fresco so completely; Raphael could make the chalky surface of a plaster wall look like glistening velvet, as he did on the skirts of the Swiss Guards in his *Mass of Bolsena* on the wall of the papal apartments. And Vasari enjoyed going over each of Raphael's works in loving detail, artist to artist.

He zeroed in on the tiny landscape at the bottom of Raphael's *Vision of Ezekiel*, a perfect river valley in deep perspective, but no more than an inch and a half high:

> He made a little painting of small figures with Christ looking like Jupiter in the heavens, and around him the four Evangelists as Ezekiel describes them: one with the figure of a man, one a lion, one an eagle, one a bull, with a tiny landscape beneath, painted at ground level, no less rare and beautiful in miniature than the other figures at their own scale.[16]

Vasari also traces, with genuine fellow feeling, how Raphael turned his artistic talent into a large, diversified studio with an international clientele, driven by the voraciously curious intellect of the artist himself. Of the artists who merit biographies in the last section of the *Lives*, Raphael's students form the largest collective group. Had Raphael lived beyond 1520, Giorgio Vasari might have been one

of them. In any event, Raphael's studio, which included painting, sculpture, architecture, printmaking, decorative arts, and scholarly research, set the most eminent precedent for what Vasari himself hoped to accomplish through the Accademia del Disegno. A long passage near the end of the *Life*, when Raphael has reached his artistic maturity and international renown, describes how the artist continually transformed his style, absorbing the work of his contemporaries but also that of past masters.[17] The great teacher was also a great learner from others, not only fellow artists but scholars and statesmen as well. Michelangelo complained that Raphael had stolen his ideas, but Vasari, for all his loyalty to his own teacher, knew that every borrowing was then filtered through Raphael's own rigorous creative process.

And yet the paragon of perfect manners and perfect technique was also human: "Raphael was an amorous person, and very fond of women, always at their service, and his continual delight in carnal pleasures made him more respected and popular among his friends than was, perhaps, quite seemly." One of those friends was the banker Agostino Chigi, the richest man of his era, who eventually—at least this is what Vasari says—locked Raphael and his mistress into his villa so that Raphael would finish painting the entrance loggia.[18] Local Roman legend identifies the mistress as a baker's daughter from Trastevere, but the story is a romantic invention of the nineteenth century. There is no question, however, that Raphael found women attractive—the portrait known as the *Donna Velata*, the *Veiled Woman*, uses paint to produce precisely the effects Vasari describes: the senses, including virtual hearing, smell, touch, and taste, encountering the vivid pulse of life.

Raphael's death, he reports, resulted directly from the artist's sexual excess:

> It happened that once he indulged more than usual in his amorous pleasures, and when he returned home with a fever, the

doctors thought he was overheated, and then, because Raphael kept quiet about his overindulgence, they unwisely bled him, so that he began to faint from weakness just when he needed a restorative.[19]

He knew how to go out with a bang, dying on Good Friday, 10 April 1520, which also happened to be his birthday, followed four days later, the day after Easter, by his friend Agostino Chigi. Rome, according to one Venetian visitor, slowed to a standstill for the two funerals. Vasari's final tribute, appropriately, is another flourish of classical rhetoric, this time the technique known as apostrophe, an outburst directly addressed to a specific person. First he addresses Raphael:

O happy and blessed soul, for every man gladly speaks of you and celebrates your accomplishments and admires every drawing you have left behind!

Then he addresses his own profession:

In short, he lived not as a painter but as a prince. And hence, O Art of Painting, you could count yourself supremely happy, having a practitioner who raised you above the heavens of excellence and breeding. Truly could you be called blessed, for in the footsteps of such a man your students have seen how to live, and how important it is to possess both art and virtue together, as they were joined together in Raphael.[20]

But art, in Vasari's scheme, could not die with Raphael in 1520, even though some of the young artist's epitaphs suggested that it had, and nature along with it. For a generation born well into the sixteenth century, art had just begun to move once and for all in the right direction. If Raphael was the teacher Vasari never had, Michelangelo was a living, breathing, mentor who was better than good enough.

IN THIS MULTITALENTED COMPANY, did Michelangelo in fact achieve an unprecedented level of success in an unprecedented number of fields? The answer seems to be yes.

Consider Michelangelo's production. Though he had little interest in painting, he did paint very well, both in fresco (the Sistine Chapel ceiling) and on panel (the *Doni Tondo* in the Uffizi Gallery, to name one). He drew exceptionally well, so well that he was instrumental in turning drawing from a purely practical skill to an art form valuable in itself. His sculpture needs no introduction (his *Pietà* and *David*). He was a pioneering architect (the Laurentian Library, St. Peter's Basilica). He published poetry. He was a proto-archaeologist, supervising the extraction of the ancient statue of the priest *Laocoön* from the ruins of Nero's palace in Rome in 1506. Like Raphael, he curated the papal antiquities collection. He engaged in scientific experiments of a sort, in his illegal dissection of human cadavers, along with Leonardo da Vinci, at the Ospedale di Santo Spirito, in order to learn the mechanics of human musculature. Did any other artist approach this breadth of talent?

Perhaps Leonardo came closest. Vasari claims that Leonardo worked as an architect, but no buildings survive, except on paper. His most impressive sculptural project, the Sforza Horse, never got beyond the stage of a terracotta model. In any event, Leonardo saw the commission as a scientific challenge: whether he could create the world's largest cast-bronze statue.

As a painter, Leonardo introduced new techniques, promoting chiaroscuro and sfumato, but he did not establish a distinctive movement of the sort that Vasari attempted to set up with the Accademia del Disegno, the first European art academy, which he would establish in Florence under the patronage of Duke Cosimo.

This admiration for the multifaceted abilities of what today we would call Renaissance men also envelops Vasari. For there were few

artists who wore as many caps as he: painter, draftsman, set designer, courtier, architect, historian, and, of course, author of *Lives*.

Even with the benefit of hindsight, it is difficult to conceive of an artist who excelled at more fields than Michelangelo and Leonardo. Perhaps Gian Lorenzo Bernini, a century later, is a candidate, as Leon Battista Alberti might have been for the fifteenth century. But future eras were less inclined to praise an array of talents; focused specialization increasingly became the norm, so that those who professed to excel at many things were regarded with skepticism, or as dilettantes. Today, a musician acting in a film, or an athlete attempting a second professional sport, is seen as a curiosity, an exception, often someone set up to fail for his or her audacity. It is unlikely that today's atmosphere will cultivate a new renaissance of Renaissance men or women. The originals retain the crown.

SYMBOLS AND
SHIFTING TASTES

M ICHELANGELO BUONARROTI, VASARI'S HERO, WAS
born to a family that had once enjoyed the status of minor
nobility in Florence, but no longer. His father worked in various gov-
ernment jobs, primarily in the small town of Caprese, before moving
to Florence. Whereas most apprentices began work at the age of eight
or so, young Michelangelo did not start until the age of thirteen.
Artisanal crafts were certainly not the preferred domain of the once
noble Buonarroti. But the young man was finally accepted into the
studio of the leading painter of the time, Domenico Ghirlandaio.
Although he signed on for three years, Michelangelo left after one.
His early authorized biographer, Ascanio Condivi, claims that he
left because he had nothing more to learn. Vasari concurs, stating
that Michelangelo sketched scaffolding that Ghirlandaio was using
to paint a chapel. The master looked at the young man's drawing and
conceded, "He knows more than I do." Michelangelo also learned
from foreign masters, despite the prevailing Tuscan tendency to
regard Florence and Rome as the twin centers of the art world.
Vasari describes how the teenage Michelangelo admired a famous
print by the German engraver Martin Schongauer, *Saint Anthony
Attacked by Devils*, and copied it diligently, first in pen, then in paint.

At the time, Lorenzo il Magnifico employed an aged sculptor (and
onetime pupil of Donatello's), Bertoldo di Giovanni, to oversee the
Medici collection of antiquities with an eye to stimulating the art

of sculpture, which had lacked a dominant figure since Donatello, more than a generation before (Verrocchio was just coming into his own). Bertoldo therefore asked Ghirlandaio whether any of his pupils showed a talent for sculpture; Ghirlandaio nominated Michelangelo, who was thus invited into the circle of Lorenzo il Magnifico, a particular treat since it came with access to the Medici family collection of ancient statuary. The young artist gained thereby access to the Medici family collection of ancient statuary. It was Bertoldo who taught Michelangelo the basics of what quickly became his favorite medium. He also loved to draw, but throughout his long life he complained about having to paint. He traced his obsession with sculpture, especially in marble, to his early childhood in the stony mountains above Florence. He refined his technique by sketching the Medici collection of antiquities, as well as the work of his older contemporaries. Michelangelo was already cocksure as a teenager. When he mocked a fellow apprentice, Pietro Torrigiano, as the two of them were sketching from Masaccio's frescoes in the Brancacci Chapel, Torrigiano put down his charcoal and punched Michelangelo in the face, breaking his nose—a disfigurement that can be seen in all the great man's surviving portraits (including his self-portrait in the flayed skin of Saint Bartholomew in the *Last Judgment* fresco).

Vasari's account of the incident puts the blame on Torrigiano and omits what Michelangelo had done to provoke it:

> It is said that Torrigiano, who had become his friend, spurred by envy at seeing how Michelangelo was more honored than he and more skilled in art, punched him in the nose when they were horsing around, breaking it and flattening it badly, marking him forever.[1]

Torrigiano, not to outdone, told his side of the story to the equally untrustworthy Benvenuto Cellini:

This Buonarroti and I used, when we were boys, to go . . . learn drawing from the chapel of Masaccio. It was Buonarroti's habit to banter all who were drawing there and one day, among others, when he was annoying me I got more angry than usual and, clenching my first, gave him such a blow on the nose that I felt bone and cartilage go down like a biscuit beneath my knuckles; this mark of mine he will carry with him to the grave.[2]

Torrigiano, for his pains, was hustled out of town, despairing of his future in Florence. He eventually made his way to England, where he created some of the finest sculpture in Westminster Abbey.

Although Michelangelo was nearly a generation older than Vasari, both men's careers were intimately linked to the fate of the Medici. When his patrons were expelled from Florence in 1494, Michelangelo left for Bologna, while the Dominican preacher Domenico Savonarola stirred up Florence with his rabble-rousing sermons and bonfires of the vanities. When the pope excommunicated the forceful friar in 1497, Florentines began to grow more skeptical of him, especially after a public trial by fire in April of 1498 turned into a fiasco. By May, Savonarola had been arrested, tortured, convicted, hanged, and burned at the stake in the Piazza della Signoria. Florence reverted to a republican government. Michelangelo ventured a return home, where he carved a sleeping Cupid that was presented as an antique to the powerful cardinal Raffaele Riario. Riario detected the hoax, but he was intrigued enough to invite Michelangelo to Rome, where the young artist created his first large-scale sculpture, the strange Bacchus that is now in the Bargello Museum in Florence but resided for many years in the Roman garden of Riario's associate, the Roman banker Jacopo Galli.

Michlangelo's reputation in Rome was cemeted when he received a commission for a *Pietà*, the crowning element of a tomb for the patron, Maréchal Rohan. Michelangelo was only twenty-four, and when the *Pietà* was displayed, it caused a sensation; in this case, we

can probably believe Vasari's glowing praise. He also relates an amusing anecdote:

> One morning [Michelangelo] had gone to the place where [the *Pietà*] stands and observed a number of Lombards who were praising it loudly. One of them asked another the name of the sculptor, and he replied, "Our Gobbo of Milan." Michelangelo said nothing, but he resented the injustice of having his work attributed to another, and that night he shut himself in the chapel with a light and his chisels and carved his name on it.[3]

As his reputation grew in Rome, a tempting prospect emerged for Michelangelo in Florence. A huge, partially carved block of Carrara marble had been lying in the cathedral yard since 1464, unusable because a flaw had emerged in the stone. In 1501, almost half a century later, the republican government of Florence, headed by Piero Soderini (ironically, a cousin of Lorenzo the Magnificent), decided to commission a statue from the intractable block from a new generation of talented young sculptors. Most of the possible candidates, as Vasari reports, would have broken up the magnificent block into usable parts. Michelangelo relished the challenge of leaving it intact, and rushed back to Florence to secure the marble for himself. It took him two years to transform his challenging material into a finished sculpture, but in the end, in Vasari's words, "What Michelangelo did was an absolute miracle, bringing the dead back to life." Florentines called his work "The Giant," and decided to place *David* right by the entrance to city hall, Palazzo della Signoria, along the raised platform called the *ringhiera*, in those days enclosed by a marble balustrade and used for outdoor meetings and formal presentations of the government. The architect Antonio da Sangallo prepared a beautiful plinth for the colossus to stand on, and after a hair-raising ride from the cathedral yard to the *ringhiera*, *David* took his place as a public expression of the Republic's civic pride and defiant spirit.

Michelangelo liked to say that he had no external inspiration, that his genius was unique and arrived organically, with little effort. But art historians have noted how his style changed when Leonardo da Vinci returned to Florence from Milan in 1500, after almost twenty years away, serving at various princely courts. His return was an occasion for young artists to learn from a living local legend. Michelangelo's single surviving panel painting, the *Doni Tondo* (circa 1507), pays homage to Leonardo's influence in the twisted, spiraling pose of the Holy Family, reminiscent of Leonardo's paintings of the Christ Child and John the Baptist, the earliest intimation of Mannerist style.

We also know from Vasari's accounts how hard Michelangelo worked on his innumerable preparatory sketches. Embarrassed at the effort they betrayed, he burned scores of his drawings in old age, hoping to hide all the clues to his effort. It was only thanks to good timing and keen pleading by Vasari himself that so many were saved for posterity.

With the *Pietà* in Rome and the *David* in Florence, Michelangelo could afford to pick and choose his subsequent projects. It was in 1504, shortly after completing his *David*, that the republican governors invited him to participate in the "artist's duel" of battle scenes for the Sala dei Cinquecento, featured in the introduction to this book. The artist would have seen this commission not simply as a friendly competition, but also as a passing of the mantle from generation to generation. The following year, he accepted a vast commission to sculpt the twelve apostles for Florence's cathedral. He completed only one, a *Saint Matthew*.

When the pope called, Florence had to wait. In 1506, Julius II summoned Michelangelo to Rome. The pope had just placed the cornerstone for a new version of St. Peter's Basilica, designed by Donato Bramante to replace the dilapidated fourth-century original, and he wanted his own massive tomb to stand beneath an arch of the crossing that would sustain a dome as impressive as the Pantheon. Julius also commissioned a bronze portrait that would show the pontiff seated on the throne of St. Peter. This was destined for Bologna, to serve as

a permanent reminder that the city was officially a vassal of the Papal States (and it was melted down to make a cannon named "la Giulia" when the citizens drove the papal army out of the city in 1509). In 1508, as work on the ambitious tomb slowed to a halt, Julius asked Michelangelo to paint the ceiling of the Sistine Chapel.

The upper registers of the chapel walls had been painted in 1481–83 by a team of the most illustrious painters of the late fifteenth century, including Botticelli and Perugino.[4] The vaulted ceiling, however, was covered in a simple design of gilded stars on blue. Pope Julius originally envisioned images of the twelve apostles, but the design evolved quickly into something much more complex, a history of the Church from the creation of the universe to the time of Noah. Standing upright on a scaffolding that bridged a small segment of the chapel's gently curving vault, Michelangelo started with the story of Noah's Ark, painting that scene to completion with a broad brush before determining that he had made the figures too small to be viewed comfortably from the floor, so far below. But rather than repaint the scene, he moved on, and viewers today can see clearly that the painter decided to "zoom in" for the other scenes to make them more legible from nearly sixty-five feet away. The intentionally contorted bodies, the paintings that looked like painted sculpture, and the vibrant colors, in novel shades of sea green, orange, and pink, cemented Michelangelo's unique style, galvanizing what his followers would call the *maniera*, what is now sometimes called the Mannerist style.

Shortly after finishing the ceiling in 1512, Michelangelo returned to the pope's tomb, for which he carved his monumental *Moses*, a statue that could almost be a three-dimensional, marble extension of the Hebrew prophets on the Sistine Chapel ceiling. The hyper-accentuated musculature and tense pose recall the *Laocoön*, the ancient sculpture group pulled from the ruins of the emperor Nero's Golden House in 1506 and taken immediately to the Vatican collection, where it kept company with another antique statue dear to Michelangelo, the fragmentary, magnificent Belvedere Torso.

Julius died in 1513 with his tomb barely underway, and his successor, Pope Leo X (the son of Lorenzo de' Medici), had no intention of spending anything further on the project. Instead, he shifted Michelangelo away from the Vatican and back toward the glorification of Florence and his own family, whose members had reclaimed their native city in 1512. Michelangelo went to work on a Medici family tomb at the church of San Lorenzo in Florence. He continued to work in the style he had developed in the Sistine Chapel, particularly evident in his handling, in paint and stone, of female figures. Michelangelo thought that the athletic male nude, the centerpiece of classical statuary, was the most beautiful form in nature, and that posing such figures in an S shape, which he called *figura serpentinata* (serpentine figure), recalling the flickering of a candle flame, showed them off to supreme advantage. His female figures are slender and muscular, following the same aesthetic preferences.

While at work on the Medici family tomb in the church of San Lorenzo, he designed a library space for the attached convent to house the phenomenal book collection first begun by Cosimo the Elder.

He also continued to work on the tomb for Julius II, producing a series of *Slaves* or *Prisoners*, meant to represent the provinces that Julius had conquered. Four of these unfinished figures are now preserved in the Galleria dell'Accademia in Florence (Michelangelo had stone shipped to Tuscany as well as to Rome so that he could work on the tomb wherever he was). They emerge from their enveloping marble, as Vasari puts it, as if they are being gradually raised from a pool of water.[5] Michelangelo himself described how he would envision the completed figure within the block of marble and simply carve away all the excess, revealing the figure that he saw as inherent within the block, and thus, for Vasari, these incomplete statues provided an excellent object lesson in how to carve marble.[6] Today, the *Prisoners* seem strikingly modern, for we have grown used to seeing completed works with abstract components that resemble these unfinished statues from five hundred years ago. But they provide an object lesson

about a certain kind of pride. The experience of carving *David* gave Michelangelo supreme confidence in his ability to hew stone, which he did much more quickly than any of his contemporaries. He began to cut by feel, without always resorting to preliminary drawings. A close look at each of the *Prisoners* will reveal that none of them *can* be completed; in his haste, Michelangelo has not left enough room to accommodate the rest of the figure he had in mind. He was a phenomenal artist, but he, too, was only human.

The Sack of Rome and flight of the Medici pope Clement VII meant that Michelangelo was reassigned to military engineering and fortifications. He left Florence for the last time in 1534. For the rest of his life, he would live in Rome. Under the patronage of Pope Paul III, his primary project was the dome of St. Peter's and another fresco in the Sistine Chapel, a *Last Judgment* on the altar wall. This was to be his last major work of painting or sculpture, for he then turned almost exclusively to architecture—plans that he could draw and supervise but that were less physically taxing.[7] He designed the Capitoline Square on the first hill of Rome, transporting the ancient equestrian statue of Marcus Aurelius from the piazza outside St. John Lateran, where it had stood throughout the Middle Ages, to the center of the Capitol, symbolically uniting ancient Rome, the realm of emperors, with contemporary Rome, the kingdom of popes—he and his contemporaries thought that the image showed the emperor Constantine. He worked on some private buildings as well, like the top story of the Palazzo Farnese, the family home of Pope Paul III.

He also worked on the dome of St. Peter's, modeling its building methods and shape on Brunelleschi's dome at the cathedral of Florence, and likewise echoing it conceptually—these were the first domes meant to be visually striking when viewed from afar, rather than simply admired from within. So many architects, over so many years, had added their designs to plans for St. Peter's that it had become a confusion of concepts. Michelangelo stripped these away and focused primarily on the simpler designs of Bramante, his

onetime rival (by then long deceased). He shifted the overall plan of the church away from an equilateral cross to a Latin one (with shorter "arms" across the transept and a longer nave). He also made the interior of the church simpler, if not minimalist—it had developed too many details, small decorated chapels, and votives, which had been added piecemeal and which made the immense space feel cramped, smaller, and less grand. The most obvious change to the interior was to close the apse, the wall behind the main altar, with a long curve.

Michelangelo did not live to see the dome completed; it underwent further modifications after his death. As if architecture, sculpture, easel painting, frescoes, drawings, urban planning, and military engineering did not offer enough breadth for his abilities, Michelangelo also penned at least three hundred poems, including many fine ones (he was a much better poet than most artists, including Vasari). There are many bones one can pick with Vasari, but he makes a persuasive argument for his candidate as the "greatest" artist in history. To this day, Michelangelo Buonarroti seems a reasonable choice as Giorgio's ultimate hero.

HOWEVER GREAT HIS ARTISTIC PROWESS, Michelangelo was never generous with either his money or his praise; in fact, he was downright stingy. By contrast, Bindo Altoviti, handsome and magnanimous, was one of the most discerning patrons of the sixteenth century. Giulio Romano, for all his irreverence, was the dominant figure in Raphael's workshop, the man Raphael treated as if he were a son, and not simply a gifted assistant. Ottaviano de' Medici, discreetly working behind the scenes in Florence, was the arbiter of taste for his entire family. However little these men had in common, they all agreed that Giorgio Vasari was both an excellent artist and an excellent companion. Clearly they saw something in him, and in his work, that our own era does not appreciate to the same extent. Unlike modern critics, Giorgio's contemporaries did not consider him

a second-rate practitioner; instead, they entrusted him with the greatest responsibilities an artist could take in hand: magnificent public projects and intensely private devotional works.

Tastes change, for individuals and for societies at large. At the beginning of the twentieth century, most people who cared about such things regarded the work of painters like Bronzino, Pontormo, Rosso Fiorentino, Vasari, and Caravaggio as ugly beyond redemption. Today, a century later, visitors to the Vatican Palace exclaim over Michelangelo's work in the Pauline Chapel, but pass quickly over Vasari's frescoes in the Sala Regia next door. They would no longer be described as ugly, but while Caravaggio has shot to prominence in recent decades, thanks to (rather than in spite of) his revolutionary aesthetic, which viewers once found off-putting, Vasari remains marginalized, considered by many to have been an important historian, but a decidedly derivative painter. Typically, Robert Carden's 1911 biography, the only extensive biography of Vasari to date, buries his subject beneath a heap of negative judgments except, grudgingly, to praise him as a writer. Visitors to Florence dream of pulling down his great battle scenes in the Palazzo Vecchio to find out whether anything remains beneath them of the Leonardo's *Battle of Anghiari* or Michelangelo's *Battle of Cascina*. Only two places in Italy still take real, uncomplicated pride in their surviving works by Giorgio Vasari: Arezzo, his birthplace, and Naples, where his decorations for the church of Monteoliveto Maggiore are treasured by the people who keep them constant company. Ironically for someone who wrote so acutely on evaluating works of art, Vasari seems to have fallen victim to changing definitions of good, bad, and beautiful.

The most essential of these changes in opinion may well be the modernist conviction that art should be direct, simple, and honest, rather than studiously artificial—and there is no art more studious and artificial than Mannerism. This criterion of simple directness had already come into play at the end of Vasari's life, in 1563, when the Catholic Church, at the close of its reforming Council of Trent, issued

general guidelines for the creation of religious art, architecture, and
music. Both the words accompanied by sacred music and the images
portrayed in sacred art were to be immediately intelligible: simple
rather than elaborate.[8] Church buildings were to gather clergy and
congregation into a single shared space where everyone could hear,
see, and experience the Mass. The riddles of paintings like Botticelli's
Primavera or Titian's *Sacred and Profane Love*, still debated today by
scholars, were suddenly regarded as a waste of time.

This emphasis on emotion, clarity of idea, provoking empathy,
and encouraging more vivid meditations on religious subjects were
all part of the Church's counterinsurgence against Protestantism, in
which art would be a silent weapon to secure the hearts and minds
of their constituents, and as propaganda against "heretical" threats.

When Martin Luther initiated the Reformation (by posting his
Ninety-Five Theses onto the door of Wittenberg Castle Church in
1517), he sparked a crisis in the Catholic Church. Among Luther's
many objections were the Catholic tradition of selling indulgences
(the wealthy could buy their way into Heaven with cold cash) and the
cult of saints (the hundreds of saints to which Catholics might pray
smacked to him of polytheism—praying to Saint Nicholas for a safe
sea voyage sounded suspiciously like praying to Poseidon for a safe sea
voyage). The Church was indeed a terrifically corrupt organization,
which had long ago chosen to overlook Christ's contention that "it is
easier for a camel to pass through the eye of a needle, than for a rich
man to enter the kingdom of Heaven." Reformists also disliked how
Catholicism exerted absolute control over every aspect of life (from
birth to marriage to death), and limited interpretation of the Scrip-
tures, not least because Mass was always held in Latin. The vast major-
ity of churchgoers could not understand Latin, and would parrot the
sounds of the language when praying in church, but relied on the
priest's sermon (which was usually in the local vernacular) to explain
what they should believe and think. Reformers wanted the Bible to
be translated into the local language, and services that everyone could

understand. Luther also promoted developing a personal relationship with God, without the necessity of the Church as intermediary.

In art, this led some Protestants, particularly the Calvinists, to ban figural religious art altogether (Calvinist churches, like those in Amsterdam, are painted all-white, with architectural or botanical stucco motifs but not figurative art). They drew their convictions from the Ten Commandments' ban on graven images (neither Judaism nor Islam permit figurative religious art, since depictions of God are anathema). But Catholicism had always featured figural painting, from the earliest secret meeting places of the first Christians. For the illiterate, who likely counted for some 98 percent of the European population, figurative art helped them understand religion. But the art-related discussions of the Council of Trent led to a shift in approach. While continuing to permit figurative religious art, the council's decrees put a greater emphasis on art as a personal meditational aid, provoking sympathy or empathy in the viewer (hence the tearful or pained saints, for sadness and suffering were easy emotions to convey in art, and for viewers to understand). The tendency just after Vasari's time, when the Council of Trent had concluded and a series of popes began to apply its provisions to art, was to shy away from visual puzzles, complex allegories that the intellectual viewer could pleasantly unpick. Vasari was among the last generation of artists to work in the riddling style of the Renaissance, where symbolism trumped emotion.

Christianity had developed a long tradition of symbolism, established by the earliest believers, who borrowed Apollo imagery to depict Christ on the candlelit walls of catacombs and used a lamb as a stand-in for Christ's sacrifice. These beginnings developed into a set visual vocabulary of allegory, hagiographic icons, and disguised symbols. But the system was never codified or laid out in a dictionary, or emblem book, until the end of the sixteenth century, when Cesare Ripa published his *Iconologia overo Descrittione Dell'imagini Universali cavate dall'Antichità et da altri luoghi* (*Iconography; or, A Description of Uni-*

versal Images Derived from Antiquity and Other Sources), first published in 1593. Ripa, who worked for a cardinal as butler and cook (he was not an artist but an amateur enthusiast interested in symbols in art), was the first to create a sort of image database, in the form of a book filled with exemplary prints to represent the most common allegories and symbols that had appeared in art (primarily Italian art) up to that point. Artists would draw upon traditional ways of depicting such subjects, referring to the designs of past artists, particularly those under whom they studied, but their choices were not codified. The effect was a bit like the spelling of the English language before the first published dictionary. People spelled as they thought best and had seen words spelled in the past (the seventeenth-century English naval officer Sir Cloudesley Shovell wrote his name twenty-four different ways), until the dictionary laid out one preferred way to spell each word, and became a universal point of reference. The second edition of Ripa's *Iconologia* (1603) contained 684 allegories, 151 of which were illustrated with woodcuts.

The *Iconologia* was a dictionary of allegory and symbol, a basic reference work for artists and patrons, who might keep a copy in their libraries. Commissioned to paint a fresco for a courthouse? You might refer to Ripa's pages of Dignity and Justice, and base your own painting on them, helpfully reminded that Dignity should be a female figure carrying an ornate chest on her shoulders, and Justice should be a blindfolded woman carrying scales in one hand and a sword in the other. Ripa gathered images that had been in use for centuries, but never before compiled in a systematic way. Developing an iconographic scheme was part of an artist's *invenzione* for a new work. For more complex commissions, scholars or theologians could be consulted. But it is rare to find artists explicating their own symbolic scheme in writing as Vasari did.[9]

Vasari's odd choices of iconography are in keeping with a rich tradition. In addition to hagiographic icons, art has what the perceptive art historian Erwin Panofsky called "disguised symbolism": inani-

mate objects that are inserted into works of art not because they have a narrative or descriptive function but because they convey an idea about the scene or person depicted.[10]

While inanimate objects can convey ideas, people can function likewise. Already in classical times, allegorical personifications were used to express abstract ideas visually: Love, Wealth, Fortune, Rome, Egypt, Prosperity. Most of these abstract concepts are feminine nouns in both Greek and Latin and are therefore represented as stately women. Love is a boisterous boy. The blindfolded woman mentioned above, with a sword in one hand and scales in the other, stands for Justice. Victory flies to the rescue of beleaguered armies, like the winged victory of Samothrace now in the Louvre, brandishing a palm branch, her symbol. Christian martyrs, at the moment of their death, are offered the same victor's palm by an angel.

And then there are the riddling pictures that no one will ever unravel, mysterious paintings like Botticelli's *Primavera*, a secret code to be understood only by the inner circle of Lorenzo di Pierfrancesco de' Medici, cousin of the more famous Lorenzo the Magnificent, and his political opponent. We can guess about its meaning, but we will never really know. And sometimes it takes more work than usual to unravel a painted riddle. Raphael's suite of rooms for Pope Julius II can be picked out in its general outlines, as can Michelangelo's Sistine Chapel ceiling, but the wealth of ideas that went into the conception of these works is so great that scholars have been discussing them for centuries, and will continue to do so. Understanding iconography provides a few clues to unlock Giovanni Bellini's *Sacred Allegory*, but most of it remains veiled to us. The debate over what these intentionally puzzling works mean provides the welcome excuse for a closer look at some of the world's transcendent works of art. *Sacred Allegory* was likely meant to be the subject of learned debate even for its contemporaries. Works of art that provoked thoughtful meditation, that required puzzling out, offered a pleasurable intellectual exercise for viewers, prompted engagement with sacred themes, and provided a

thought-provoking entertainment as well as a decorative object. In the Florentine convent of San Marco, each monastic cell contains a different painting (some by the great Fra Angelico, who lived there), and the paintings vary in their conceptual complexity. Younger friars would begin dwelling in the cells with the simpler subjects (a Crucifixion, for example) and move up to cells painted with more complicated scenes, like the Holy Trinity, which shows God, Jesus, and the Holy Spirit as both one combined being and three separate entities, often depicted as Masaccio did in his *Holy Trinity* painting at Santa Maria Novella (the one Vasari would save by building a false wall over it, when the church around it was renovated), with the three figures painted one atop the other.

Thus there are two levels to the works we twenty-first-century viewers see as puzzles. First, we must relearn the standard visual vocabulary of past eras, an act that very quickly peels away the mystery and allows us to identify saints and allegorical personifications with some ease. But there were also works, which we might call "mystery paintings," that were always intended to provide riddles to the viewers, even contemporaries.

Bronzino's *Allegory of Love and Lust* (sometimes called *Allegory with Venus and Cupid*) is a case in point. One of the most memorable and well-known works in London's National Gallery, it shows a shockingly erotic embrace of a marble-white-skinned nude Venus tonguing an adolescent Eros (her son), while surrounded by gorgeously painted, but mystifying, allegorical personifications, including a girl-monster with the face of a beautiful courtly lady, the tail of a snake, lion's legs, and hands affixed to the wrong arms, in which she offers sweet honeycomb while concealing a scorpion.

Vasari's *Lives* was used by centuries of art historians who tried to unravel the meaning of this striking, eroticized riddle of a painting. In this case, it was a mistake on Vasari's part that misled art historians. Only in 1986 did an art historian, Robert Gaston, offer a plausible interpretation of a famous mystery painting that confounded four

centuries of scholars, all because of their determination to use Vasari as their major source.[11]

Translations of Vasari are rife with annotations and footnotes that correct or clarify his text, which, while remarkably accurate for the time, is still pocked with misinformation. This is understandable, because Vasari was inventing a type of book that had not previously existed, sewing together the lives of artists on the basis of hearsay, anecdotes, found letters, and his own memory. But such is Vasari's enduring power that only since the late 1980s have art historians realized they must not take his words for granted, laced as they are with erroneous information. Reliance on Vasari has inhibited the interpretation of some works, just as it has provided a key to interpret countless others.

Bronzino wished to make his *Allegory* difficult to decipher, inserting layers of interpretation and even toying with the viewer physically by forcing him or her to approach a wildly erotic painting and view it as closely as possible. Without stepping right up to it, you cannot see details like the fact that a child personifying the joy of the first flush of a love affair has actually stepped on a thorn, which has pierced his foot, with blood bubbling to the surface. The child does not care, because love has so distracted him that he will only notice the pain it has caused at a later moment.

Vasari does not devote much time to Agnolo Bronzino in his *Lives*. This is probably a matter of professional rivalry (before Bronzino's death, Vasari did not say much about him, but afterwards admitted how much he liked and admired him).[12] Bronzino held the post of official court portraitist to the Medici family just before Vasari's succession to that role. He was a prodigiously talented painter, arguably the best of Vasari's era. His portraits are glassy, painted with such sheen and finish that brushstrokes are invisible. By contrast, Vasari's portraits are functional but ungainly. It is perhaps unsurprising, then, that Bronzino is not awarded further praise by Vasari in the form of his own chapter, his own *Life*, but is rather mentioned in passing, lumped

inside a group chapter entitled "On the Members of the Academy of Design." Within this chapter, even less is said of Bronzino's individual works, although Vasari is quietly praising. But one small paragraph on the *Allegory* was, for centuries, the only clue available to art historical detectives in their attempts to unravel the meaning of one of the world's most famous works.

The physical history of Bronzino's *Allegory* is nearly as mysterious as its interpretation. Painted around 1545, it was sent as a gift to King Francis I, who loved Italian art and naked ladies, making this work an ideal present. This is all that Vasari has to say about it:

> [Bronzino] painted a picture of singular beauty that was sent to France to King Francis, in which there was a nude Venus with Cupid kissing her and Pleasure on one side, with Play and other cupids, and on the other side were Deceit, Jealousy, and other passions of love.[13]

This short comment is all that scholars have had that seemed to refer to the painting in question from the time that it was painted to the present day. Vasari (1) tells us the painting was sent to Francis I, king of France (though he does not specify that it was painted for him); and (2) he names the figures and allegorical personifications present in the painting: Venus and Cupid, as well as personifications of the concepts of Play (alternatively translated as Playful Love or even Folly), Deceit, and Jealousy, as well as other "cupids" or baby angels, and the rather enigmatic "other passions of love."

It is from this short paragraph that centuries of scholars have departed, seeking to match up the personifications described by Vasari with the figures in the painting that hangs in London's National Gallery. A quick look at Bronzino's painting makes Venus and Cupid easy to spot, although "Cupid" is in fact present in his adolescent form, usually called Eros. But what of Play, Deceit, Jealousy, "other cupids," and "other passions of love"? This is a game of mix and match, affix-

ing the titles mentioned by Vasari to the figures painted by Bronzino. Jealousy might be the yellow-skinned figure on the far left, tearing its hair out and screaming with a mouth full of rotting teeth. Play could well be the naked child about to fling an armful of rose petals over the embracing Venus and Cupid (the one who doesn't notice he's got a thorn stuck in his foot). Deceit could be the girl-monster, she of the swapped hands. So far so good. Other cupids and other passions of love? That's less clear. There do not, in fact, appear to be any other "cupids" (Vasari calls them *amorini*, "little loves"). For "other passions of love," we might likewise look, but remain unsatisfied. There is a clear allegorical personification of Time, with his traditional wings and hourglass, whom Vasari does not mention. Odd. There's that weird figure in the top left corner who appears to be working against Time and who is missing the rear portion of its head. There are masks on the ground, bearing the faces of a satyr and a maenad. Why no mention of these? They hardly qualify as "cupids" and "other passions of love."

Despite the difficulties in cleanly matching Vasari's description with the London *Allegory*, every scholar who examined the painting did so through the lens of Vasari's text, for lack of any other written reference to the work in question. Despite many theories, no one made convincing progress. Bronzino's *Allegory* remained one of art history's great mysteries. And then along came Robert Gaston, who recognized something no one else did, though it stood out in plain sight.

Vasari, Gaston suggested, was describing a *different painting*. His description simply does not jibe with the London *Allegory*. Had Vasari perhaps misremembered the content of the painting, since he had not seen it for several decades when he wrote about it (the relevant passage appears only in the 1568 edition of *Lives*)? If he ever saw it in person (and we cannot be certain that he did), it would have been prior to 1545, when it was shipped off to France. Either Vasari misremembered the painting or, as seems more likely (since the description

lacks the most obvious allegorical personification, that of Time), in this passage he described an entirely different painting, a variation on the same theme.

Vasari's description had been a crutch for art historians, who lacked other clues beyond the work itself. But that crutch had been so leaned upon by generations of scholars that they had forgotten that they could walk on their own. Only when Gaston cast Vasari aside could he conclude that Bronzino, a poet as well as an artist, painted his *Allegory* to challenge the claims of his poet friends that only they could detail all the pleasures and agonies of love:

> The lover-beholder of the picture is shown, in the exquisite, erotic, incestuous love of Venus and Cupid, and the playful participation of [Play], how he will be drawn into and will enjoy the embraces of his [mistress]. She, with the honey-poison of her words and body, and especially with her serpent's tongue, will create such a state of simultaneous pleasure and pain in the lover that he will rend his hair and beg for deliverance from Time and Forgetfulness, who will heed his cries with such agonizing slowness that his suffering will seem eternal. But who can resist the direct gaze of such a beautiful creature, monster though she be?[14]

16

TO NAPLES

W HILE VASARI'S COMPLEX IMAGERY PRESENTS MODERN viewers with witticisms that no longer register, it provided his contemporaries with delightfully arcane puzzles. For sophisticated connoisseurs of art like Bindo Altoviti, Paolo Giovio, Michelangelo, and Alessandro Farnese, the inclusion of the figures of Apollo and Diana in the heavens above a *Pietà* was not only clever—mixing pagan deities with a Christian theme—it was profound, for it showed that the tragedy of Christ's death affected the whole pagan world, as well as the newly formed Christian consciousness. By showing that Apollo and Diana mourned Jesus no less than the Virgin and the disciples did, Vasari deepened the sadness of the event. He also blended Catholic piety with the excitement of the classical world that characterized the Renaissance. This ability to create new ways of giving formal expression to ideas, *invenzione*, is what Vasari and his peers prized as one of an artist's essential skills.[1]

The fashionable Virgin Mary in Vasari's *Pietà* departs from contemporary ideas about how the mother of Jesus ought to look, especially at this terrible moment in her later life, when she was already an elderly woman. Yet by showing the Virgin as eternally youthful and eternally stylish, dressed in gorgeous robes that shimmer like satin, Vasari conveyed what he and his contemporaries saw as her most important quality: her supreme spiritual serenity, despite the lacerating experience of losing her son to public crucifixion. In a

visual medium, the most effective way to communicate this triumphant interior beauty was to show the sorrowing Mary as a woman of extraordinary physical attractiveness, and to hint at her immortality by emphasizing her youth. Her looks may not conform completely to twenty-first-century tastes, but she pleased Bindo Altoviti, and that was all that really mattered to Vasari, her creator.

Even Bindo's impeccable taste, however, was not infallible, at least by our own standards. Raphael's portrait of the young Altoviti dazzles us today because of the way its simplicity concentrates our full attention on the handsome sitter and his vibrant youth. Benvenuto Cellini's bronze bust of a mature Bindo, executed more than three decades later, presents the same personage as a complex interplay of textures, from his lush, curling beard and beetling eyebrows to the smooth sweep of his satin jacket to the elaborate hairnet that masks his balding pate. The male hairnet made a brief appearance among fashionable European males in the mid-sixteenth century, and Bindo must have taken pride in his headgear (foreshadowing the preferred accoutrement of twentieth-century lunch ladies), since he decided to have Cellini immortalize it in bronze. A few years later, when snoods for men had gone out of fashion, he may have repented his decision.

The same languorous figures, busy composition, and arcane imagery that Vasari provided for Bindo Altoviti's *Pietà* are, if anything, more conspicuous in his first work for Cardinal Alessandro Farnese: an *Allegory of Justice* commissioned and completed in 1543.[2] The artist writes proudly about its complicated *invenzione*,

> Just as [the cardinal] desired, on a panel eight *braccia* high and four wide, I made a Justice who embraces an ostrich loaded with the Twelve Tables [the oldest Roman code of law], and holding a scepter that has a swan at its head, and wearing a helmet of iron and gold, with three feathers, the emblem of the righteous judge, in three different colors; she was nude from the waist up. At her waist she has the seven Vices contrary to herself bound as prison-

ers with chains of gold: Corruption, Ignorance, Cruelty, Fear, Treachery, Lies, and Slander, and above these Truth is set with her back to us, all nude, offered by Time to Justice with a present of two doves, made to symbolize Innocence, and this Truth crowns the head of this Justice with a wreath of oak leaves to stand for Strength. And I did the best I could to finish this work with my most attentive care.[3]

As the art historian Stefano Pierguidi notes, in many ways this figure stands as the pagan equivalent to the *Immaculate Conception* that Vasari had painted three years earlier for Bindo Altoviti, and it ranks beyond doubt as one of the most important allegorical paintings of the sixteenth century.[4] It was also wackily creative—sticking an ostrich into a painting was not the least bit normal, particularly one that has been "loaded with the Twelve Tables" and is being embraced by Justice. Here Vasari demonstrates his willingness to push the envelope, to be a bit weird, in order to provide new *invenzione*. Whether or not he was a fan of ostriches, the cardinal commissioned the painting to hang in the papal chancellery in Rome, to provide an inspirational image of Pope Paul III as a just ruler (he was, in fact, one of the better popes). It has hung in the Capodimonte Gallery in Naples since it was transferred there, with much of the Farnese collection, in 1734.

Entrée into the Farnese circle also drew Vasari closer to Michelangelo, who was hard at work on a series of commissions for Pope Paul III, including the Farnese family's Roman palazzo, a new papal chapel, and St. Peter's Basilica. The clique of Florentine artists who flocked around Cosimo de' Medici may have liked to snub their colleague from Arezzo, but in Rome the Tuscan émigrés who formed the city's inner social and artistic circle were far more hospitable, including Michelangelo (who, like Vasari, had been born outside Florence). Michelangelo would now encourage Vasari to follow his career path:

Because I was attending carefully on Michelangelo Buonarroti and soliciting his opinions on all my activities, he . . . [counseled] me, after seeing some of my drawings, to devote myself once again and with greater attention to the study of architecture, which I would never have done if that most excellent man had not said to me what he said—but out of modesty I won't repeat it.[5]

Like most of his successful contemporaries (Cellini, for example), Vasari was not immune to vanity. But he had also done remarkably well for himself, becoming one of the best-paid artists of the time, and largely on his own terms, without locking himself into a princely court. Still, keeping in touch with all his patrons meant moving constantly from city to city. In late June of 1543, the heat of Rome drove him back to Florence; thermometers had not yet been invented to tell him that Florence, trapped in its river bottom, is hotter in the summer than Rome, where at least a sea breeze called the *Ponentino* can be counted on to clear the evening air. By now, however, Ottaviano de' Medici's palazzo had become a second home (Vasari called it "casa mia"), and in this hospitable setting, he painted another allegory for Ottaviano himself, along with several panels for other local patrons.

By 1544, Giorgio was back in another of his second homes, the Palazzo Altoviti in Rome, painting a *Venus* for Bindo, his host, based on a drawing by Michelangelo. More commissions followed, including a series of works for Cardinal Tiberio Crispi, Pope Paul's illegitimate son (Pier Luigi Farnese, father of Cardinal Alessandro Farnese, though born out of wedlock, had been legitimized by a papal decree). For these projects, Vasari had moved into his own studio in the artists' quarter near the Vatican, where he had lived as a young man. "But I felt so indisposed and tired from all this work," he wrote, "that I was forced to return to Florence." His period of rest and recovery did not last long; instead, he set out for Naples, the most populous, chaotic city in all of Italy.

The road from Rome to Naples was notoriously dangerous, running alongside the malarial swamp of the Pontine Marshes before striking across a rugged, mountainous borderland, swarming with bandits. But after years of service to the Medici and some promising commissions in Rome, Giorgio Vasari of Arezzo was still a traveling artist, and Naples was one of Europe's great ports of call. Ruled by a Spanish viceroy, the city acted as Italy's prime gateway to Spain, and to the wealth of the Spanish Empire.

His assignment in Naples was to paint the dining hall, or refectory, for a congregation of Olivetan monks. The Olivetans were a branch of the Benedictine order, dedicated to lives of seclusion and prayer. As monks, they vowed to live separated from the world; this is why, at the time of its foundation in the early fifteenth century, the monastery of Monte Oliveto was set just outside the city wall of Naples. It was a magnificent Renaissance construction that made the most of the contrast between the gray local volcanic stone called piperno and whitewashed stucco. Rather than the usual enclosed cloister, Monte Oliveto boasted a dramatic open, two-story arcade, overlooking the city and the port. King Alfonso himself had endowed the monastery and loved to visit; the dramatic cloister was made for him, too.

To a modern visitor, the complex of Monte Oliveto is one of the most beautiful places in a city famous for its breathtaking vistas. To Giorgio Vasari, however, the first sight of the graceful Renaissance convent came as a shock:

When I arrived I almost refused the commission, because that refectory and that monastery were made in old-fashioned architecture, with pointed cross vaults, low and windowless, for fear that I could gain little honor there. Still, with the urging of Don Miniato Pitti and Don Ippolito of Milan, close friends who were guests of that Order at the time, I finally accepted the project, knowing that I could do nothing of value except by creating a great profusion of ornament, dazzling the viewers' eyes.[6]

It took the encouragement of these two northern Italian friends, one from Florence and one from Milan, to convince Giorgio that a challenge also meant an opportunity. But once convinced, the artist adapted to his conditions:

> I decided to cover all the vaults of that refectory with stucco, using lavish modern framed compartments to remove all those clumsy old pointed arches. It was a great help to me that the vaults and walls were made, like everything in that city, of volcanic stone, which can be cut like wood, or better like half-baked brick, so that I was able, by cutting, to deepen the fields between squares, ovals, and octagons, reinforcing with nails and sometimes putting the very same stone back in place. Once the stuccoes had brought the vaults into good proportion—the first in Naples to be made in the modern way—I added six oil paintings, three on a side.[7]

Naples had been searching for centuries for an artistic and architectural style that it could count as its own. As a dependency of France and then Spain, the city habitually bent its local tastes to the tastes of its overlords.

Vasari's sponsor was Ranuccio Farnese, archbishop of Naples, for whom Vasari painted ornamental doors for the cathedral organ—but he painted the panels in Rome, under the wing of the reigning pope's immediate family and back in contact with his literary friend Paolo Giovio. Unlike Rome, Florence, and Venice, Naples in the mid-sixteenth century lacked a stable Italian literary community: the rulers of the city and its kingdom were Spanish, at perpetual loggerheads with the local feudal aristocracy. A group of scholar-writers had formed in earlier decades, around figures like Giovanni Gioviano Pontano and Jacopo Sannazaro, but by the mid-sixteenth century, the Spanish government had become increasingly repressive, so a poet like Luigi Tansillo was compelled to make his way as a mercenary

soldier in service to the king of Spain, and some of the most significant literary works of the period were scurrilous, anonymous satires against Spanish dominion and a new kind of imported Spanish tale about wily people from the lower classes who adventure into the world of the aristocracy—like the adventures of Lazarillo de Tormes, the first picaresque novel, written by Vasari's recent patron Hurtado. Giorgio Vasari's upward mobility was of an entirely different, more serious and successful sort.

Vasari, for his part, hoped to bring the city's artists into what he considered the contemporary mainstream:

> It is an amazing thing that after Giotto, in such a great and noble city no masters had done anything of any importance in painting up to that time, even if a thing or two by the hand of Perugino or Raphael had been brought there from outside. For that reasons, I tried to work, to the best of my limited knowledge, in a way that would open the eyes of the talents in that country to creating great and honorable works. And because of my work, or some other reason, from that moment on there have been many exceedingly beautiful works of stucco and paint.[8]

This criticism is not entirely fair. After Giotto, for example, the great Roman painter Pietro Cavallini worked in the Neapolitan church of San Domenico Maggiore—but to Vasari's loyally Tuscan eyes, Cavallini's departures from Giotto's style were deficiencies, not differences.

Nevertheless, Vasari's work in Naples had two effects. The citizens of Naples loved his efforts and continue to point out his refectory in Monte Oliveto with proud appreciation. Rightly so, for the challenge of this apparently inhospitable setting stimulated the artist to do some of his very best work. Recall that Michelangelo refused to paint his *Battle of Cascina* opposite Leonardo's *Battle of Anghiari*, because he felt he'd been given the wall with poorer lighting and been set up to fail in that duel of artists. To triumph in an awkward space was a feather in

one's cap. Furthermore, as he himself notes, his work in the Olivetan monastery gave a firm new direction to Neapolitan art.

Naples would once again inspire and challenge a masterful painter sixty years later, in 1607, when a Milan-born exile from Rome, Michelangelo Merisi da Caravaggio, spent a year in the city and catalyzed an artistic revolution that was still more significant to Neapolitan art than Vasari's classical *maniera*. To Caravaggio's own mind, the best painting he ever did was a *Resurrection* for the church of Sant'Anna dei Lombardi, destroyed in an earthquake in 1799. Afterwards, the congregation of that ruined church merged with its near neighbor, Monte Oliveto, where Giorgio Vasari was, and is, a treasured presence.

Giorgio's work caught the eye of the Spanish viceroy, Don Pedro de Toledo, whose new westward expansion of the city had just transformed Monte Oliveto from a suburban monastery into an urban convent. (Don Pedro was also the father of Eleonora de Toledo, Duke Cosimo's beautiful, beloved wife, married in 1539.) The commissions, both sacred and secular, followed thick and fast. Vasari's assistants, however, grew homesick and left. Shortly thereafter, Giorgio himself decided to move back to more familiar ground: "Despite the fact that I was viewed most favorably by those lords, earned a great deal of money, and the works multiplied day by day, with my assistants gone, I decided that it was a good idea, after I had done all that work in that city for a year, to return to Rome."[9]

This new stay in Rome would inspire two of the artist's best-known works. One was a pictorial commission for Cardinal Alessandro Farnese, furthered by the efforts of Paolo Giovio. The clerics of Vasari's time were a far cry from the ascetic, impoverished eager martyrs of *The Golden Legend*—the group biography of saints that describes their unblemished lives and messy deaths. Alessandro Farnese held a supremely privileged position as the pope's close relative. The Latin term that described him, *nepos*, Italian *nipote*, can mean either "nephew" or "grandson" (the root of the word "nepo-

tism"), and although Alessandro pretended to be a cardinal nephew, he was really a grandson, by Paul's son, Pier Luigi. In addition to holding sixty-four different benefices (income-paying offices), Cardinal Alessandro served the Papal States as its chief financial officer, vice-chancellor of the Apostolic Chamber, working out of an office in the majestic late fifteenth-century Palazzo della Cancelleria, where Vasari's painting of *Justice* hung in state on the wall.[10]

By then the famous structure was fifty years old, except for a small portion that was much older: the Early Christian church that the new building had swallowed whole. Now Cardinal Alessandro planned to decorate the spacious hall that occupied the space above the right aisle of the church. He wanted modern work, and he wanted it fast; it was the perfect assignment for Vasari, well known already for his obsessive work habits and his dedication to finishing on time. The cardinal wanted fresco, the normal Roman medium for wall painting, but a slow and challenging medium to work with; every day the artist had to mix a fresh batch of plaster, paint it while still wet, and then work a different section the day after as he waited for the previous work to dry. The colors of the paint changed as the plaster dried; fresco was not a technique for amateurs or beginners.

The result is called the Sala dei Cento Giorni, the Hall of a Hundred Days—and the usual comment, from the moment it was unveiled as a model of celerity, has been "And it looks like it!" In order to finish the job quickly, Vasari had to entrust much of the actual painting to assistants, some of them better than others. He was not entirely happy with that decision, as his autobiography reveals:

This whole project is full of wonderful inscriptions and mottoes made by Giovio, and in particular there is one that says these paintings were all done in one hundred days. . . . Though I worked extremely hard on making cartoons and studying the design of the work, I confess that I made a mistake in entrusting it afterwards to the hands of my assistants to get it done

more quickly. It would have been better to have suffered one hundred months painting it by my own hand. That way, even if I hadn't carried it out in the way I would have best liked for the cardinal's service and my own honor, I would still have had the satisfaction of having done it myself. But this mistake was the reason I decided never again to create a work that had not been finished by my own hand after my assistants' preliminary work, and on my own design.[11]

On the other hand, the room itself was a bureaucratic office, the decoration provided a durable version of custom-themed wallpaper, and the Farnese prized size and quickness as much as quality in many of their artistic and architectural choices; for its purposes, Vasari's fresco in the Sala dei Cento Giorni was good enough. If nothing else, it confirmed Giorgio's reputation as a quick worker, responsive to his patrons' wishes.

THE BIRTH
OF *LIVES*

T HE PROJECT THAT WOULD BRING VASARI FAME OF AN
entirely different caliber began as table talk over dinner one
evening in the Palazzo Farnese. Not just anyone's dinner, but the car-
dinal's dinner, which he ate on a dais in public view as the members
of his court entertained him with music and conversation. Eventually
they would get their own food, but not until the great man himself
had eaten (at least they could hope to dine on his tasty leftovers):

In those days I often went after the day's work to watch the Most
Illustrious Cardinal Farnese eat dinner. There were always people
around to entertain him with wonderful, refined conversation.
. . . One evening the conversation turned to, among other sub-
jects, Giovio's Museum, and the portraits of famous men he had
placed there in marvelous order with inscriptions, and passing
from one topic to another, as one does in conversation, Mon-
signor Giovio said that he had always cherished, and still did, a
great desire to enhance his Museum and his book of Eulogies
with a treatise that discussed men who were famous in the art of
disegno, from the time of Cimabue up to our own. Elaborating
on that theme, he revealed a great deal of expertise and judg-
ment with regard to our art, but it is also true that by aiming
for a great overview, he did not look so closely at the details.
Often, in speaking about artists, he either mixed up the names,

birthplaces, and works, or he didn't describe things precisely, but only in broad general terms. When Giovio had finished this discourse, the cardinal said, turning to me, "What do you say, Giorgio? Wouldn't this be a wonderful project?" "Wonderful," I replied, "Most Illustrious Monsignor, if Giovio will accept help from someone in the field who can sort things out and describe them as they really are. I speak this way because, even though this discourse of his was marvelous, he mixed up the specifics, and said one thing in place of another." "So," added the cardinal . . . , "you could give him a summary, and an orderly account of all those artists and their works in order of time, and that way you could also give them the benefit of your expertise." I promised willingly to give this project my best effort, although I knew it to be beyond by capabilities. And so I sat down to search through my own memories and my own writings about art and artists (this had been my hobby ever since my youth, because of the affection I have for the memory of our artists, so that every scrap of information about them was precious to me). I put together everything that seemed relevant to the project and took it to Giovio, who, after he had lavished praise on my efforts, said to me, "My Giorgio, I want you to take over the task of setting down the whole text in the way you have done so well here, because I don't have the heart for it. I don't know the artistic styles, and I don't know all the details that you will know; if I were to do the writing, it would turn out to be a little treatise like Pliny's. Do what I say, Vasari, because I can tell it will turn out beautifully."[1]

And with those few words by a perspicacious cardinal, the *Lives* were born.

Vasari's autobiography lingers on that momentous conversation in the Palazzo Farnese, the one that changed his life, as he suggests, one evening in 1545. The account itself dates from 1568, more than

twenty years after the event it describes. Its details, therefore, are carefully chosen, not just as a matter of Vasari's selective memory but to make a point, several points in fact.

Rather than providing an accurate record of real conversations, these two anecdotes about the birth of the *Lives* are really meant to spell out the book's ambitions. This they do with the same professional precision that Vasari claims for his memory when he compares his ideas with Giovio's: Vasari promises the cardinal and his friends that he will provide them with a sixteenth-century insider's look at "modern" art from the thirteenth century to the sixteenth, written in the words of an experienced practitioner rather than a learned amateur. As a project, it was nothing short of revolutionary.

As Giovio is the first to make clear in his conversation with the cardinal, no writer, ancient or modern, had ever written a series of artistic biographies before, despite the remarkable importance of visual art in classical antiquity and in contemporary Italian society. Biographies themselves were immensely popular: lives of famous men and women, lives of philosophers, lives of saints—all these, in both Latin and the vernacular, attracted readers from a broadening segment of society. Up to now, however, famous people almost always belonged (apart from a few saints like Catherine of Siena) to the uppermost, literate classes. Artists, on the other hand, were mostly manual workers with a spotty education and intensive technical training; by conventional standards, the meanness of their hardscrabble, hardworking lives could hold no interest for aristocratic writers and readers. The artists themselves, at least up to the fifteenth century, were too poor and too poorly educated to become part of the reading public.

18

RENAISSANCE
READING

RENAISSANCE THINKERS THRILLED AT EACH NEWLY DIS-covered, or newly translated (and therefore legible to them for the first time), ancient text. They already had a sense of the greatness of past civilizations, particularly those of Athens and Rome (Tuscans were fascinated with their Etruscan predecessors, but the Etruscans left less of a visible material tradition, and nothing written that could be read in the sixteenth century). For them each text or fragment brought west from Constantinople by nomadic clerics, or pillaged by Crusaders, or carefully gathered by scholars from remote monastic libraries, opened another window onto the ancient world.

The miracle is that any texts from the ancients survived at all. With the fall of Rome, and the literal and figurative scattering and slaying of thinkers, libraries, treasure-houses, galleries, and other trappings of rooted, intellectual civilization at the hands of successive waves of mighty, but often illiterate, barbarian warriors, the cultural fruits of ancient Greece and Rome were lost or irrevocably transformed by the advent of Christianity, the passage of time, and changes in taste. Some were indeed lost forever, ideas buried in the earth together with the minds that had conceived them. Others were consumed by fire, as was almost certainly the case for thousands, if not tens of thousands, of papyrus scrolls and parchment books incomprehensible to nomadic conquerors, deliberately destroyed by Christian fanatics or inadvertently

damaged by the flames of sacked cities. Although a far greater and unknowable quantity of texts was lost, a remarkable number survived. And with them, shards of knowledge.

The manuscripts that did survive largely found a haven in monasteries, where scribes continued to copy ancient pagan texts alongside works by Christian writers. From these monasteries and forgotten libraries, Renaissance manuscript hunters, linguists, and thinkers plucked texts by Plato and Horace, Aristotle and Lucretius, bringing about what fifteenth-century scholars began to call the "rebirth of letters." We use the French version of the term, "Renaissance," to describe the rediscovery, the resurrection from the ashes, of the intellectual treasures of the ancient world. The rediscovery of lost Greek and Latin texts a millennium after the fall of Rome felt, in the words of Francesco Petrarca (Petrarch), one of the real pioneers of this new movement, like "finding a glowing spark beneath a heap of ash."[1]

In the fifteenth century, Plato made a return, brought to Italy by Greek refugees fleeing Asia Minor and the growing power of the Ottoman Empire. Settling in city-states like Florence, Ferrara, and Verona, these refugees brought along manuscripts and taught the ancient language to Italian scholars.[2] The guiding star of the renewed interest in ancient Greek texts, and a dominant figure at the fifteenth-century Medici court in Florence, was Marsilio Ficino, a Florentine physician who was also a Catholic priest.

Ficino was especially close to the grand old patriarch Cosimo, who had earned the sobriquet "Father of his Country" (*Pater Patriae*) for his generous endowments to the city. With the help of his scholarly friend, Cosimo took a passionate interest in Plato and Platonic philosophy, a path to enlightenment both found perfectly compatible with Christian faith and with contemporary Italian civic life. In 1462, unable to read Greek himself, and with no time to learn it, Cosimo commissioned Ficino to translate Plato's works from Greek into Latin, making them widely accessible, as they had not been since

late antiquity. To the translations, Ficino added his own commentaries, providing his insights into the ancient texts.

Ficino and his followers read Plato as faithful Christians: for them, the allegory of the cave in the *Republic* presented the contrast between a shadow world of a life without faith, and a real world warmed by the sunlight of God's grace. Because Platonic ideas were prominent in Christian writers from the Gospel of John and St. Paul to St. Augustine, Renaissance readers of Plato felt that they stood on familiar ground. But that sense of familiarity could be deceptive. The beauty of Plato's Greek, and the excitement of discovery, so dazzled Ficino that he tended to read the dialogues as straightforward expressions of Plato's opinions, rather than as conversations among different people of widely varying degrees of insight, as ancient readers would have done.

But we can be grateful to Ficino, all the same. His vision of the Platonic tradition, beautiful in itself, inspired beautiful ideas in others and beautiful works of art, none more so than Raphael's frescoed tribute to ancient philosophy, painted on a wall of the Vatican Palace in 1511 (the year of Vasari's birth) for Pope Julius II. The work has been known as *The School of Athens* since the seventeenth century, and it centers on the figures of Plato and his most illustrious student, Aristotle, presented as the "Two Princes of Philosophy," in a magnificent vaulted hall filled with statues of the ancient gods. Plato points heavenward, holding a copy of his cosmological dialogue *Timaeus*, to let viewers know that his thoughts are turned to the celestial spheres (and Raphael addressed *all* viewers, not just classical scholars—the book is labeled *Timeo*, in Italian). Aristotle stands close by, gesturing forward, holding a copy of his *Ethics*; as Socrates says in the *Republic*, all the enlightenment in the world is worth nothing, unless it is brought back down to earth to help other people. It is the philosopher's duty to bring humanity out of its cave, to bask in the sunlight of true reality; the *Ethics* of Aristotle points out how to do so most effectively.

Ficino's many translations and commentaries brought this ancient philosophy into harmony with the concerns of the fifteenth century, from religion to business to the preservation of good health, on which, as a physician, the Florentine had a great deal to say. He spearheaded a movement that saw classical texts at the core of thought and debate in the fifteenth and sixteenth centuries. His was also the first generation for which the most influential works were printed books, rather than precious, rare handwritten manuscripts. In 1450, Johann Fust, a banker from the German city of Mainz, lent money to Johann Gutenberg to develop movable type and use it to print the most authoritative book of all, the Bible. In 1455, Fust sued Gutenberg and won, taking away both his books and his equipment, just before the Bible came out in 1456. The following year, Fust published a Psalter, and then, in 1465, the first classical text, Cicero's *On Duty*. By 1500, some 100,000 copies of Cicero had been published, making him, alongside the Bible, the first bestseller of the modern world. The only Latin work to precede Cicero in print was a medieval grammar ascribed to the fourth-century grammarian Aelius Donatus.[3] By 1475, ten years later, most of the Latin classics had been published. Greek followed more slowly, because fewer people knew the language (Aristotle was printed in 1495 and Plato only in 1494–96, so was truly fresh and exciting for Vasari's era).[4] Furthermore, Greek was written in an elaborate Byzantine cursive script with a series of diacritical marks and ligatures (tied letters) that made carving a legible typeface a technological challenge. The great staples of a modern education in classical Greek—Homer's *Iliad* and *Odyssey*, the works of Hesiod, the tragedies of Aeschylus, Sophocles, and Euripides, the histories of Herodotus and Thucydides—were known to only a few readers. Despite his stellar reputation in antiquity, the fourth-century comic playwright Menander could not be read until series of Egyptian papyri containing fragments of his texts were discovered, in the twentieth century.

Lᴇᴏɴᴀʀᴅᴏ ᴅᴀ Vɪɴᴄɪ ᴏᴡɴᴇᴅ 116 ʙᴏᴏᴋꜱ, a large number for anyone in the sixteenth century (Lucrezia Borgia, for example, had just 15). These books provide a glimpse of the kinds of texts that formed the body of knowledge of contemporary readers, Vasari included.

Leonardo's reading list is fascinating but peculiar—like the man himself.[5] For one thing, it is far longer than the total number of books that most educated men like Vasari could possibly have read in a lifetime. It is also heavy on mathematical texts and some rather esoteric selections, making it less than ideal as a representative list. But drawing on a number of known personal libraries, as well as working backwards from the books most frequently illustrated in fifteenth- and sixteenth-century Italian artworks, we can arrive at a list of some of the books Vasari, and most early modern Italian artists, depended upon for artistic inspiration.

Leonardo described himself as a "man without letters" (*uomo sanza lettere*), by which he meant that he had no formal training in Latin. Like his good friend the architect Donato Bramante, who also claimed to be "without letters," Leonardo nonetheless probably read the language well enough to get by (as did another "unlettered" artist, Raphael). None of these men could write and speak Latin with the mastery of a literary scholar like Leon Battista Alberti, a leading theo-retician and architect of the fifteenth century. Vasari relied heavily on Alberti, but considered his versatility as something fundamentally different from the versatility of Leonardo, Brunelleschi, or Michelangelo. As a scholar with an effortless command of Latin, Alberti occupied an entirely different rung of the social ladder from that of these artists, no matter how intelligent they may have been, and how close their friendships with their patrons. He worked as a papal bureaucrat in Rome while undertaking his architectural projects for Pope Nicholas V, and he composed his architectural treatise, *De Re Aedificatoria*,

in Latin. He was certainly an architect of the highest caliber, but his social status was determined by his literary achievements, rather than his achievements in the visual arts.

Vasari, as an artist with a Latin education, stood somewhere between Alberti and most of the other artists who people the *Lives*, and one of the chief aims of his book is to bridge the distance between "illiterate" figures like Leonardo or Bramante and "literate" figures like Alberti.

Vasari and his dear friend Vincenzo Borghini, for example, may have known Virgil and Ariosto by heart, but the most difficult mathematical operation they could conceive of was long division, one of the four simplest operations for a modern elementary school student. Everyone in Vasari's day felt the pull of gravity as strongly as we do, and most of them knew that the earth was round (the story about Columbus's dispelling the idea of a flat earth is a modern myth), yet only a handful of "natural philosophers" dared to guess that the sun might be the center of our planetary system, rather than the earth.

Vasari's Latin, on the other hand, would have been honed to a certain scholarly polish, though not as thorough a polish as Vincenzo Borghini's. Vasari had read the Latin classics with his tutor in Arezzo, and presumably consulted them when he set about "inventing" his paintings (that is, developing the *invenzione*). When it came to the *Lives*, however, a book by an artist about artists addressed to artists, it was more appropriate to write in the vernacular. There was also a patriotic aspect to this choice. Duke Cosimo encouraged a policy of composing official documents in the vernacular, convinced that Tuscan dialect preserved precious Etruscan words (which it does, but not the words Cosimo and his court identified as Etruscan). Tuscan scholars labored to prove in precisely these years that the expressive range of Tuscan was as ample as that of Latin, if not more so. Dante provided living proof that the vernacular could be employed in epic tones about matters as lofty as Heaven itself.

Vasari's readings would have included Latin and vernacular

authors, both literary and technical. The knowledge of Greek, however, was still confined to an elite, so Greek authors were largely still read in translation. Recall the appropriation of the story from Pliny, now starring Giotto, who painted a fly onto the nose of a figure in Cimabue's painting, so lifelike that Cimabue tried to swat it away. Pliny was one of the authors whose tales would have been known to Vasari's contemporaries—whether or not they had read them, the vivid anecdotes floated in the cultural oxygen and such references would therefore have been recognized.

The primary sources of stories that were absorbed and illustrated by artists in Vasari's era were the Bible and its Apocrypha, writings on the Bible by early Church fathers like Saint Augustine and later authorities like Thomas Aquinas, Greek and Roman mythology, Ovid (the Latin poet whose *Metamorphoses*, tales of gods' transforming into various shapes in order to pursue affairs with mortals, was a popular literary source to illustrate, often simply as an excuse to paint naked ladies), Dante, Petrarch, Ariosto, and *The Golden Legend*. These texts would have been standard reading, and stories from them general knowledge among the learned and churchgoers of Vasari's time (even for those who did not or could not read). But for the intellectual and cultural elite, it was the rediscovery of long-lost ancient texts in Greek that provoked the most excitement.

When we consider the sources on which Vasari could call when researching his *Lives*, the texts are limited: Boccaccio, Sacchetti, and Dante were authors of fiction who also wrote about real artists. Ghiberti, Leonardo, and Alberti were artists who wrote about art and fellow artists. Vasari could refer to physical works of art from Naples to Venice. A direct inspiration was Plutarch's *Parallel Lives*, a series of biographies pairing and comparing a famous Greek with a famous Roman, written circa AD 100 and first published in Latin translation in 1470. Another popular ancient group biography that offered a logical template for Vasari's writing was *The Lives of the Twelve Caesars*, by Suetonius—full of salacious gossip, the lives of the emperors of

Rome had sold out eighteen editions by the year 1500.[6] Suetonius also penned a *Lives of the Grammarians, Rhetoricians, and Poets*, which, though far less popular than his saucy emperor biographies, likewise inspired Vasari, for it was a group biography of "artists" of the quill and spoken word. It is clear that these classical texts, which Vasari would have read as part of his education, influenced writers during the Middle Ages and Renaissance. The popular third century AD *Lives and Opinions of Eminent Philosophers* of Diogenes Laertius was read either in Ambrogio Traversari's Latin translation of 1433 or— much more often—in little vernacular digests, which is likely how it would have come to Vasari. These ancient "lives" offered the format, if not the content, for Giorgio's own group biography.

Suetonius's second-century AD research methods of his group biographies were very similar to Vasari's. Both consulted archival material when it was available, in the form of letters, contracts, and less formal writings. At Vasari's request, letters held by family and friends of the artists he included were copied and sent to him. The providers of these letters and recollections understood that they were helping to secure the legacy of their family, though they could hardly have imagined just how lasting that legacy would prove to be. But the majority of his stories would have come through interviews and remi-niscences: the oral tradition. In an era that prized a good memory, these recollections may have been quite reliable, particularly for the figures in part three of his book, many of whom he knew personally (Michelangelo, Cellini, Bronzino, Pontormo)—although we must always keep in mind that Vasari's personal opinion and agenda col-ored the account he left for posterity.

As the first biographer to focus on artist who created objects, Vasari drew from some unusual sources. Christian saints provided the focus for the thirteenth-century archbishop Jacopo da Vora-gine's *Golden Legend* but Jacopo's format, in particular, parallels Vasari's: each short chapter covers a different holy life, with an emphasis on oral tradition, often of dubious veracity, and full of

memorable tales of the miracles, produced through faith rather than wit and artistic skill. It has even been suggested that we read *Lives* quite directly as a *Golden Legend* of the plastic arts, "a compendium of artistic lore for a credo whose ultimate savior is the warrior angel Michael," a play on Michelangelo's name, which breaks down to Michael and angel.[7]

There is also an element of Aesop's *Fables* in Vasari's *Lives*. Instead of animals, Vasari uses artists to teach moral lessons through anecdotes about their adventures. He uses a story about Pietro Perugino to teach a moral lesson against greed, much as Aesop uses a tortoise to warn against pride and hubris.

From what I've heard before, the prior [of San Giusto alle Mura in Florence] was very good at making ultramarine blue, and because he had his own supply he wanted Pietro to use it generously. . . Yet at the same time he was so stingy and suspicious that he mistrusted Pietro and always wanted to be present when [the painter] used blue in the work. Hence Pietro, who was by nature sincere and respectable and wanted nothing except what he had earned by his own effort, took that prior's suspicion badly and decided to put him to shame. Whenever he decided to paint blue and white draperies or the like, he did it in tiny steps so that every time the prior, turning stingily back to his little sack, added the ultramarine into the little vase that contained the pigment, Pietro set to work, took one or two strokes, and then rinsed his brush in a basin of water, until there was more blue in the rinse water than in the work itself. And the prior, who saw his emptying bag and the work not taking shape began to complain, "Oh, this plaster consumes so much ultramarine!" Then, when the prior left, Pietro extracted the ultramarine from the bottom of the water basin, and when the time seemed right he presented it back to the prior, saying, "Father, this is yours. Learn to put

your faith in good men who never cheat those who trust them, but would know exactly how to cheat suspicious people like you whenever they liked."[8]

Both overt and covert references to classical sources were entirely intentional, and a frequent tactic of Renaissance authors. The invoking of earlier sources, preferably classical Greek or Roman, added authority to contemporary comment and opinion. It was the equivalent of citing scholarly sources or scientific studies in today's books, with the implied assumption that the ancient authors were to be relied upon—that they, possessed of an ancient wisdom, knew more than contemporary readers. Citations also flattered the reader, who would feel particularly knowledgeable when recognizing the references in the contemporary text (authors today continue to understand that making the reader feel smart is an excellent tactic).

In the Perugino ultramarine story, we see the artist not just as a painter but as a master of sleight of hand, making pigment disappear and then reappear. If this recalls some of the tales of Buffalmacco, that is no coincidence—Vasari scatters similar morality tales throughout his text, making his views very clear. A major theme of *Lives* is the idea of the artist as illusionist/magician. Visual tricks cast a spell of enchanting naturalism, demonstrating the artist's near-magical powers: Leonardo's "Medusa" shield terrified his father, who thought it was real; to a parallel in the *Life* of Brunelleschi, Donatello stumbles on Brunelleschi's carved crucifix and spills the eggs he's been carrying in his apron.

While a knowledge of Latin, if not Greek, was generally required to understand the old stories in their full complexity, they were so often retold in simpler form that every artist was bound to know something about them, including those who could not read at all.

Meanwhile, the very act of writing elevated Vasari's status, as it had Alberti's a generation before. With classical sources to inspire him,

and provide assurance that his subject matter was sufficiently elevated (for if the admired classical authors wrote group biographies of eminent men, then it was surely an honorable endeavor), Vasari was ready to begin. He had only to choose his protagonist, but this required no deep searching.

THE NEW
VITRUVIUS

MICHELANGELO, WHO COULD NOT WRITE IN LATIN BUT wrote beautiful Tuscan vernacular, was surely the man best qualified, in Vasari's world, to be the protagonist of a vernacular history that aspired to a level of literary elegance enjoyed by Latin, a hero whose destiny and greatness were already written in the stars. He would be an ideal model, as a person and a creator, to act as the focus of Vasari's literary project.

Giorgio himself had a parallel in the classical world, an ancient writer from the working artistic classes who had achieved lasting fame by writing about his profession from an expert's perspective: the architect Vitruvius, whose *Ten Books on Architecture*, dedicated to the emperor Augustus, still maintained its distinctive authority in Vasari's day. Vitruvius was well educated, well traveled, and highly intelligent, but he was also a manual worker who had traveled through Gaul outfitting catapults for Julius Caesar. His treatise presented architecture as a liberal art, rooted in philosophy; an architect's education, in his view, ranged from the lofty ranges of cosmology and city planning right down to the fine details of mixing plaster and laying water pipes. It was a book that combined rare theoretical rigor with a wealth of practical advice, and it was written in a distinctive, sometimes rough-and-ready style. There was nothing quite like it in the ancient world, and it exerted a tremendous influence on the Middle Ages and Renaissance.

The importance of Vitruvius in Vasari's own circles can be gauged by the presence alongside Cardinal Farnese, Vasari, and Giovio on that momentous evening of Claudio Tolomei, the Sienese scholar who had founded the Vitruvian Academy in Rome, with a daunting program of activities that brought together artists, architects, and scholars dedicated to studying the venerable text. The first printed translation of Vitruvius into Italian vernacular had come out in 1521, the second in 1535. The book was every learned architect's constant companion. When Giovio suggested that Giorgio Vasari write in his own words, therefore, it was certainly with this illustrious ancient author in mind, especially when he went on to say that his own efforts would be as superficial as Pliny's—for Pliny discussed works of art in the midst of disquisitions on stone and metallurgy; for Giovio, a man of genuine taste, nothing was more deadly dull than Pliny's evident lack of artistic sensibility.

By urging Vasari to do the writing, Giovio was also implicitly suggesting that the book appear in the vernacular rather than in Latin, in order to reach a broader literate public. In the preface to his *Ten Books*, Vitruvius promised to teach Augustus how to evaluate the quality of works of architecture in order to become a more informed, effective patron; in later passages of the book he aims his remarks at other readers, characterized as busy men with scant time for leisure, and several times lets slip an interest in how women use and experience buildings, for there were women in the ancient Roman world who certainly read, wrote, and made decisions about what and how to build. Giovio was directing his own thoughts toward a similarly extended public.

There is also an explicit political agenda attached to the project of a vernacular book. In Vasari's day, "Italy" existed as an idea, but not as a political unit. The peninsula was divided into a whole series of independent city-states and one large kingdom, the Kingdom of Naples, each with its own distinctive vernacular, with different grammar, different pronunciation, and different words. Some communities spoke

another language altogether: Greek, Albanian, German, Provençal. Vasari himself grew up speaking Tuscan, proudly aware that this was the dialect that had also been used by Dante and Petrarch.

Rome presented a special case. The local dialect was a branch of southern Italian, laced with Tuscan supplied by the papal court, but gradually, over the course of the fifteenth and sixteenth centuries, the Church developed a special, more universal version of the vernacular for its transactions: *lingua aulica*, or court language, a mixture of dialects that was also used to communicate in other Italian cities. Vasari had the choice, then, of writing in *aulica* or in Tuscan.

By setting the initial conversation about the *Lives* in Cardinal Farnese's dining room rather than a Florentine palazzo, he shows that he has opted for *aulica*, for universal rather than local resonance. The implicit viewpoint of Giovio's project is catholic, with two thousand years of cultural history to back it up. The original discussion may have occurred in 1542 or 1543 (so many Vasari scholars believe) or as late as 1546, but by insisting that it occurred in 1545, after his trip to Naples, Vasari is seen to speak with an authority that stems from having traveled (and worked in) the length and breadth of Italy.[1]

This carefully staged series of conversations reveals one more essential truth about the *Lives*: although the book would be published under the name of a single person, Giorgio Vasari, it was, from its moment of conception to the final touches in the printer's shop, a collaborative venture. The idea of creating a great collection of artistic biographies was close in many respects—ambition, collaboration, openness to different kinds of expertise—to the grand designs of Claudio Tolomei's Vitruvian Academy. But there was one crucial difference, which had everything to do with Giorgio himself and his efficiency: by 1550, the first edition of the *Lives* was ready to go to press. The mighty labors of the Vitruvian Academy, on the other hand, still existed mostly in Claudio Tolomei's head.

Vasari's closest collaborator for the *Lives* was a Florentine literary scholar and Benedictine monk, Vincenzo Borghini (1515–80). The

two could have met either in Arezzo, where Borghini served as abbot from 1541, or in Florence, where Borghini had grown up and where he moved permanently in 1545. Unlike Giovio, a generation older and affectionately talkative (Vasari once called him a "chatterbox," in a letter to Aretino), Borghini was four years younger than Giorgio, and belonged to the group of eager young men who meant to propel the court of Duke Cosimo to the forefront of Europe's literary and artistic culture.[2] Borghini's role in the first edition of the *Lives*, researched and composed over the course of about five years, was much less conspicuous than it would be in the second, published eighteen years later under much different circumstances. But the friendship they forged was a lasting one.

From Vasari's letters, Vincenzo Borghini emerges as his dearest friend and the person with whom he is most honest in correspondence: "Wherever I go I meet many friends, many great minds; but I look in vain for anyone like you—you, the best thing I have on earth and whom I love so much." Giovio ended a letter to Vasari with "gently kissing your forehead under your lovely curly locks." Such strong terms of endearment between educated men were not unusual in the sixteenth century and did not necessarily indicate homoerotic feelings (although they could).[3] Spend enough time in southern Italy today, and you'll see that men likewise call each other *caro* ("dear one"), embrace, and kiss on the cheeks with great affection. In Shakespeare's England, just a few decades later, etiquette was exactly the same: gentlemen kissed each other on the lips. It was not unusual for a sixteenth-century man to express his greatest emotional closeness to a best male friend, in terms that today we would think should really be reserved for a spouse. Marriages were rarely love matches at this time; they were more likely to be alliances of convenience, business transactions between parents, or acceptable domestic balances. Love was a bonus, to be sure, but not to be expected or deemed commonplace. One chose one's friends with more reliability and more independence than one chose one's spouse.

In his autobiography, Vasari carefully links the idea of the *Lives* to the circle of Pope Paul III and to his own work in the Palazzo della Cancelleria in 1545–46, yet he claims that the text of the *Lives* was almost finished by 1547, a remarkably short time span for so ambitious a volume, especially considering that he had moved once again, from Rome back to Florence, in 1546. Completing the book occasioned yet another move, this time to the ancient Roman colony of Rimini, on Italy's east (Adriatic) coast:

> Now, while I was carrying out these projects, having brought the book of the Lives of the creators of *disegno* to a successful conclusion, there was nothing left for me to do but have it nicely transcribed, when Father Gian Matteo Faetani, an Olivetan monk from Rimini, a person of art and wit, came my way to ask me to execute some works in the church and monastery of Our Lady of Vendetta, Rimini, where he was abbot. And so, once he had promised to have one of his monks do the transcription for me, an excellent scribe, and to do the proofreading himself, he dragged me to Rimini to make the altarpiece and the main altar of that church, which is about 3 miles outside the city.[4]

The altarpiece he painted for the Olivetans during his stay, an *Adoration of the Magi*, still hangs proudly in the apse of the church, which is now called either San Fortunato or the Abbey of Santa Maria Annunziata Nuova della Scolca (the New Virgin Mary Annunciate of the Vendetta). Vasari took particular pride in the way he gave each of the Three Kings a distinctive appearance: one white-skinned, one brown-skinned, one black.

While he waited for the transcription to proceed, he produced another altarpiece for the church of San Francesco in Rimini, a *Saint Francis Receiving the Stigmata*, which fortunately survived the Allied bombing of the city in 1943–44. San Francesco made a powerful impression on the aspiring author, for the fourteenth-century Gothic

church had been remodeled in the mid-fifteenth century to become a funeral chapel for the local warlord Sigismondo Pandolfo Malatesta. Handsome, ruthless, and cultured, an outstanding military architect in his own right, Sigismondo Malatesta also had the unique distinction of being condemned to Hell while still living, by a decree of Pope Pius II. Sigismondo's taste was as impeccable and avant-garde as his character was vicious. As the supervising architect for his "Malatesta Temple," he chose Leon Battista Alberti, writer, scholar, and designer. In his *Life* of Alberti, Vasari approved: "[Battista] made a model of the church of San Francesco and a model specifically of the façade, which was executed in marble. . . . In short, he transformed that structure in such a way that it is certainly one of the most famous temples in Italy."[5]

Transcribing the *Lives* was only the first step toward getting them published. Now that the text had been turned into a fair copy, Vasari sent it out to his scholarly friends for inspection, beginning with Benedetto Varchi. The manuscript arrived in Rome, addressed to Paolo Giovio, in December of 1547. Any author would be glad to receive a response like the one Vasari received from his talkative old friend: "I devoured your book just as soon as I had it, and I am impressed to the point that it seems impossible that you could be so good with the brush, when you advance yourself so with the pen."[6]

Giovio then passed the book on to Annibale Caro, who was also in Rome, and by January 1548 the *Lives* were back in Vasari's own hands. In effect, the book had undergone the equivalent of a modern peer review, and the peers were all in favor of publication. First, however, Giorgio handed the manuscript over to his friend Vincenzo Borghini to give its prose the kind of style and scholarly depth that marked an important book in mid-sixteenth-century Italy. The combination of Vasari's professional insight and Borghini's literary flair, not to mention their shared wit and enthusiasm, gave the *Lives* an air of indisputable authority.

As he waited for the reports to come in from his learned friends,

Giorgio Vasari kept himself busy and distracted by painting. From Rimini, he went up the coast to Ravenna, and then cut back southward over the Apennines to Arezzo:

> And at the same time I made many drawings, paintings, and other minor works for friends, so many of them and so diverse that it would be hard for me to remember more than a few of them, and readers may not want to hear so many tiny details.
>
> In the meantime, my house in Arezzo was under construction, and so I went home that summer and drew up the plans for painting the hall, three rooms, and the façade, just for fun. Among the designs I made personifications of all the provinces and places I had worked, bringing tribute through my earnings to this house of mine.[7]

The façade paintings are long gone, but the interior decorations of Casa Vasari survive in all their joyous profusion. This is the one place where Giorgio probably relied on his own hands for most of the work rather than on the lesser skills of his assistants, and hence the quality of the frescoes is exceptional. The house is a *casale*, a simple country house on the edge of Arezzo rather than a palazzo in the city center, set within a walled garden with outbuildings rather than a formal courtyard. It is the house of a prosperous worker, not an aristocrat, but it is also comfortable and cozy as no palazzo could ever be.

Right down the street from Vasari's new house stands the thirteenth-century Abbey of Sante Fiora e Lucilla, now entirely redesigned by Giorgio himself (he began in 1565), but in 1548 still a thoroughly medieval complex. The abbot, Giovanni Benedetto da Mantova, asked his talented neighbor to provide a painting for the monks' refectory, perhaps a Last Supper, the customary theme for this setting. "Once I had resolved to accept his invitation," Vasari writes, "I decided to do something out of the ordinary," and he did. With the

abbot's approval, he chose an unusual theme, the wedding of Queen Esther and King Ahasuerus; he also chose an unusual technique: not a fresco on the wall, but rather a huge oil painting on wood panels (9 × 24 feet), which he insisted on creating right there on the wall where it was meant to hang: "This system (as I, who have tried it, can affirm) is truly the one to adopt if you want to ensure that pictures have their own correct lighting, because in fact working in a ground-level studio or some other available space changes the light, shadows, and many other properties of paintings."[8]

Oil, moreover, allowed him to use brilliant, glistening colors that stand out to dazzling effect in the cavernous room (now part of a high school dedicated to Michelangelo Buonarroti). Queen Esther's sky blue satin bodice and red velvet skirt draw the eye inevitably to the bride, counterbalanced in the composition by a bystander's saffron yellow robe. Fresco, which is colored plaster, always retains plaster's matte surface, and no one except Raphael ever learned how to make it shine like velvet. Raphael and Leonardo had both struggled to find a way to bond oil paint to the surface of a plaster wall, but the only way to make fresco shine is to melt wax into the surface, as the painters of ancient Rome and Pompeii did. Vasari, working in oil on wood, was able to finish his monumental painting in a mere forty-two days. It now ranks among his absolute masterpieces.

Thanks to a perspicacious cardinal, Giovanni Maria Ciocchi del Monte, Giorgio began to experiment with architectural designs, first with a farmstead below the nearby hill town of Monte San Savino, where the cardinal had an elegant little palazzo with a spectacular view, designed by a native son, Jacopo Sansovino. Here Vasari stayed for a kind of country vacation, *villeggiatura*, before returning to Florence and a host of new small-scale projects. The cardinal, in the meantime, proceeded on to Bologna, where he was papal legate, and from there, shortly afterwards, he sent Vasari a message to join him. This time, conversation between the two had nothing to do with art. Del Monte had other plans for his protégé:

When I had stayed with him for a few days, along with many other topics of conversation, he spoke so well, and persuaded me with so many excellent reasons, that I decided, under pressure from him, to do something I hadn't wanted to do up to now, that is, to take a wife, and so I married, just as he wished, a daughter of Francesco Bacci, a noble citizen of Arezzo.[9]

Niccolosa de' Bacci was nearing fourteen, her prospective husband was thirty-eight, but this age difference was of no concern. Nor was it apparently problematic that Vasari had enjoyed an affair, out of wedlock, with Niccolosa's elder sister, Maddalena—an affair that had even produced Vasari's two children (nine-year-old Anton Francesco and eight-year-old Alessandra). A marriage came down to what each family could offer the other, and perhaps it was best to link Vasari officially to the Bacci family, when he had already been active with Maddalena in an "unofficial" capacity (she subsequently died of the plague, leaving the children motherless). Niccolosa had a magnificent dowry to offer the marriage, while Vasari had assets that included a stupendous career, a charming house, and two children who would now have a proper mother, in the person of their aunt. Negotiations began in 1548 for a marriage that took place in 1549.

Vasari called his wife Cosina, "little thing," and dedicated affectionate poems to her, as well as portraits. Precious little is known about her because, aside from queens and princesses, women tended to draw scant attention from premodern historians, making a biographer's job difficult. A typical man of his era, Vasari left her at home in Arezzo for long stretches of time whenever his career called him elsewhere. It also is not unusual that he should write relatively little about her—like most men, Vasari was career driven, and friendships with influential men were considered of far greater import to note in letters than the quotidian dealings with one's spouse. Did his deceased sister-in-law perhaps arouse stronger emotions in him than his living wife?[10]

After discussing his future with Cardinal del Monte, Giorgio returned to Florence, where he painted again for Bindo Altoviti and fretted about the fate of his manuscript, which now took a decisive turn. Passing the *Lives* to Benedetto Varchi and Vincenzo Borghini had been his most effective means to attract Duke Cosimo's interest, and certainly Vasari could hope for no more appropriate sponsor for a book that lauded Tuscan artists as the best the world had ever produced. In 1549, Cosimo decided to underwrite publication of the *Lives*.[11]

Cosimo, naturally, was devoted to promoting the supremacy of the Tuscan vernacular language and Tuscan art, and the *Lives* would have to be reshaped accordingly. The text was sent out to a team consisting of members of the Florentine Academy, the institution Cosimo had created in 1541 to promote the Tuscan language: Giovambattista Gelli, Pierfrancesco Giambullari, and Carlo Lenzoni. Varchi and Borghini may have added further refinements as well. A page of Vasari's original Rimini manuscript still survives with Giambullari's notes in the margin.

The initial response to the publication of the first edition was positive, but then it circulated among an audience inclined in its favor—the literati between Tuscany and Rome. Comments for and against it, coming from farther afield, are largely directed at the wider-reaching second edition (1568): praise is recorded by William Aglionby in London in 1685, who thought reading it might inspire British painters to excel in history painting, which had never been their strong point. Annibale Carracci, on the other hand, leader of the predominant art academy of the seventeenth century, based in Bologna and aligned with a Raphaelesque style (hence distinctly unimpressed by the Tuscan *maniera*), covered his copy in marginal notes, most of which express dismay at the skewed view Vasari presents as one universally accepted. More than a dozen late sixteenth- and early seventeenth-century artists' copies of *Lives* are preserved with rich marginalia: El Greco penned, "All this bears witness to [Vasari's] ignorance,"

perhaps a surprise considering that El Greco's distinctive style is often described as Mannerist. Federico Zuccaro was outraged at Vasari's disparagement of Raphael in favor of Michelangelo: "Vice of an evil tongue that, where it can't lambast, finds a way to diminish the glory and dignity of others!" But this was perhaps unsurprising, as the two were rivals with no love lost at the end of Vasari's life. And one of the Carracci family members (Annibale, Ludovico, and Agostino all ran the Carracci Academy in seventeenth-century Bologna) wrote, "Oh, what a shitface Vasari is, he speaks so scathingly that he drags me with him beyond the bounds of good manners."[12] But these were private grumblings, shared no doubt among friends at boisterous dinner parties, but not part of a published pamphlet condemning the text or its author. And the dismay is more about Vasari's prejudiced preferences in terms of style and artists, rather than a global objection to the writing style, format, or conceit. There is also little consistency in what the early marginalia say against the book; they have been described simply as "the anti-Vasarian reaction of the late 16th century,"[13] a series of very personal dissatisfactions with Vasari's overt prejudices, rather than a more objective stance. These negative comments were not made on a wide public scale, and so it is unlikely that they reached Vasari (like those, for instance, from Michelangelo himself, who, after reading the first edition, suggested some "corrections" to his own life, as he would for Condivi's 1553 biography, which itself was meant to provide a corrective to Vasari's biography of the subject published three years earlier). The book sold well, made the Medici, Florence, and Tuscany proud and won them further fame. A few marginal grumblings aside, the response was all good.

The publication was meant to speak with absolute authority on behalf of Tuscan genius and Tuscan art. The German scholar Gerd Blum has shown how closely the final text of 1550 hews to the standard late medieval scheme of biblical history: it begins with the creation of Adam and culminates in Michelangelo's newly painted fresco of the *Last Judgment* on the altar wall of the Sistine Chapel. The first

word of the book is "Adam;" the last, "death." At every step in the tale of artistic progress that unfolds through the biographies of the painters, sculptors, and architects from the thirteenth century to the mid-sixteenth, Tuscan artists lead the way: Giotto, Donatello, Leonardo, and the greatest of them all, Michelangelo.

But Giorgio Vasari would have scant time to enjoy his debut as a man of letters. Instead circumstances put him back into the position of traveling artist. His autobiography tells what sounds like a preposterous tale:

> In the meantime, because Lord Duke Cosimo wanted to have the book of the *Lives* published (now almost brought to completion with the best efforts of which I was capable and with the help of some of my friends), I gave it to Lorenzo Torrentino, the ducal printer, and thus printing began. But the introductory chapters had not even been finished when the death of Pope Paul III made me fear that I would have to leave Florence before the book had been entirely printed. For this reason, I went out to Florence to meet Cardinal del Monte, who was passing through en route to the Conclave. No sooner had I made my bow and a bit of conversation than he said, "I am going to Rome and will surely be elected Pope. Finish up whatever you are doing right now, and come to Rome as soon as you hear the news. Don't wait around for any further orders."
>
> Nor was the prediction wrong; it was Carnival in Arezzo, and after setting up certain masques and celebrations, I heard the news that this cardinal had been elected Pope. So I saddled my horse, rode to Florence, and with the Duke's encouragement I went to Rome to be present at that Pope's coronation and take part in designing the coronation festival.[14]

The story is a fiction, but it spares Vasari from having to admit the uncomfortable truth. He had desired a position in Cosimo's court.

The book was his application, his tribute. But the hoped-for invitation failed to come. Giorgio still had enemies in the duke's inner circle, like his inveterate rival, the sharp-tongued, brilliant Benvenuto Cellini. There was nothing for him to do but try his fortunes in Rome.

Paul III died on 10 November 1549. Despite his rough-and-ready Roman manners, his eye for young men, and his garlic breath, sixty-seven-year-old Cardinal Giovanni Maria Ciocchi del Monte had earned a reputation as a capable diplomat, and he was therefore able to position himself as an all-around compromise candidate in the hotly contested conclave of 1550. He took office as Julius III on 7 February 1550. As pope, he would be a colossal disappointment, withdrawing from politics and making his teenage lover Innocenzo a cardinal. As a patron, however, he ranked among the greats of the sixteenth century, spending most of his time and money on the arts, sponsoring the likes of Giorgio Vasari, Giovanni di Pierluigi di Palestrina, Jacopo Barozzi da Vignola, Bartolommeo Ammannati, and Michelangelo. It was worth Vasari's while to ride to Rome, leaving his young wife, Niccolosa, behind, especially with the ambiguous blessing of Duke Cosimo speeding him forth.

PART THREE

20

SEMPRE
IN MOTO

A S SOON AS HE REACHED ROME IN FEBRUARY OF 1550, Vasari says, he paid a quick visit to Bindo Altoviti on his way to greet the new pope. The Palazzo Altoviti stood only a few yards from the Ponte Sant'Angelo, the bridge that connected Rome's banking district with the Vatican. It was, therefore, the ideal place for a travel-worn Giorgio to stop before making his formal appearance at the Apostolic Palace. Built in 1514, sited directly on the river (and for that reason, alas, demolished in 1880, to make room for the modern Tiber embankments), Bindo's home was as elegant as the man himself, and would soon boast Vasari's frescoes in its halls, added in November of 1553.

But this stop at the Palazzo Altoviti also made a definite political statement. Beginning in 1537, Duke Cosimo had confirmed Bindo Altoviti's position as official Florentine consul in Rome. He even appointed Bindo a senator in Florence in 1546. But Cosimo had read his Machiavelli (indeed, *The Prince* had been written as a primer for Lorenzo il Magnifico) with its lesson to keep your friends close and your enemies closer. Cosimo knew that the Altoviti family had never abandoned its hopes to rid Florence of the Medici and restore republican rule. During the reign of Pope Paul III, a shrewd politician in his own right, Florentine republicans like Michelangelo and Bindo Altoviti enjoyed secure protection in Rome, but with Paul's death in 1549 and Cosimo's increasingly secure hold on his dukedom, the

situation began to shift. Duke and banker would grow increasingly hostile to each other in the ensuing decade.

Jacopo da Carpi's 1549 portrait of Bindo Altoviti shows a mature man dressed in luxurious satin and velvet with fur trim. Dark robes were considered appropriate for the merchant class; only aristocrats wore bright colors.

Beyond the evident richness of his apparel, however, Bindo Altoviti comes across as a wily, powerful man. The painter emphasizes his watchful eyes, imposing physical presence, and carefully composed hands. And no one can miss the fact that, although he was nearing the age of sixty, the Florentine consul in Rome was still extraordinarily handsome. With enough wealth to raise an army, he was also potentially dangerous, at least for the Medici and their supporters.

The political leanings of bankers were important, because money, then as later, made all the difference in war and peace. As artists, however, Michaelangelo and Vasari were held to different standards of loyalty. They might be at the top of their profession now, but the future was always uncertain; it was perfectly understandable that artists would work for any patron who would hire them. Thus Buonarroti carved his triumphant *David* in 1504 to celebrate the expulsion of the Medici from Florence, and twenty years later set to work designing the Laurentian Library for the Medici pope Clement VII. For Vasari, Bindo Altoviti had been an important patron for many years, and probably a real friend. At a time of great uncertainty, it was only natural that Giorgio should stop to greet his longtime patron, before crossing the Ponte Sant'Angelo to the Vatican.

The pope, however, came through swiftly with a commission: a funeral chapel in the church of San Pietro in Montorio for his uncle Antonio, the first person to have been named Cardinal Ciocchi del Monte, and his other uncle Fabio. Perched on the commanding slope of the Janiculum Hill, San Pietro was run by Spanish Franciscans and financed by the Spanish crown. Soon after its foundation in 1483, it had become a showcase of innovative art and architecture. In 1502,

Donato Bramante built his famous round church, the Tempietto, in the cloister, the first building since antiquity to use Doric columns and entablature (although Bramante himself was probably trying to re-create Etruscan architecture, rather than Greek).[1] Inside the church, with its frescoed arcades, the great (and greatly underestimated) Antoniazzo Romano had painted a Madonna and Child, beneath a protective Saint Anne. There were decorative frescoes by Pinturicchio and Baldassare Peruzzi, and Michelangelo's disciple Sebastiano del Piombo (the "keeper of the leads") had created a spectacular *Flagellation of Christ* in a curved niche, just to the right of the entrance. For anyone interested in the development of contemporary art, San Pietro was a thoroughly inspirational place to work, and Vasari rose to the occasion. The Ciocchi del Monte chapel commission involved all three of the arts, painting, sculpture, and architecture, and it was here, in the shadow of Bramante's pioneering Tempietto, that Vasari began to show the makings of an outstanding architect in his own right.

His is a distinctly sculptural architecture, with strong projecting cornices and deep recesses, incorporating deliberately "Etruscan" touches, like the round cushion molding above the entablature, for his Tuscan client. Vasari also painted the altarpiece, a *Conversion of Saint Paul*, creating clever echoes between the painted architecture of the canvas and the real architecture of its frame. The tomb statues were carved by another Florentine artist temporarily resident in Rome, Bartolommeo Ammannati.

To a present-day viewer, the combination of painting, sculpture, and architecture works beautifully. Half a century later, in the 1620s, Gian Lorenzo Bernini would perfect the *Gesamtkunstwerk*, that German term for a "complete work of art," one in which painting, architecture, and sculpture are all conceived by a single artistic mind (and sometimes other arts, like poetry and theater, were also considered) to create a whole, multidimensional art space. But while Bernini is often credited with establishing this interdisciplinary spatial art experience (approaching his Cornaro Chapel, featuring his *Ecstasy*

of Saint Theresa, one engages with the architectural space, paintings, relief sculpture, theatrical lighting effects, inlaid marble floor, and even the scents of incense in the church, all adding to the experience of the central sculpture group), Brunelleschi's Pazzi Chapel at the church of Santa Croce in Florence was a mid-fifteenth-century predecessor. And Vasari's was an impressive example of excellence in multiple media. But when Vasari compared his painting of Saint Paul with Michelangelo's fresco in the Pauline Chapel in the Vatican, he was disappointed:

> To create a variation on what Buonarroti had done in the Pauline Chapel, I made St. Paul young, just as he wrote of himself. He has already fallen from his horse and the soldiers have brought him to Ananias, the blind man, who regains the lost light of his eyes when Paul lays hands on him and is baptized. In this work, either because of the narrowness of the space, or for some other reason, I did not entirely satisfy myself, although the painting did not displease others, particularly Michelangelo.[2]

Another painting was less successful, at least in the eyes of the pope:

> Likewise, I made another panel for that Pope to put in a chapel in the Apostolic Palace, but I later brought it to Arezzo . . . and installed it on the high altar of the Parish Church. But if I did not fully satisfy either myself or others with this, or with the altarpiece in San Pietro in Montorio, it would not have been such a problem, because to keep up with the whims of that Pope I was in constant motion.[3]

This simple statement, "Ero sempre in moto"—"I was in constant motion"—might have stood as Giorgio Vasari's epitaph.

Aside from entertaining his young cardinal lover (who was also,

lest we forget, keeper of the pope's pet monkey), Julius III did little
in his tenure. He is best remembered for building a pleasure villa
in a valley, just north of the center of Rome. For this project, in
1552 he hired Vasari to act as supervising architect, with two dis-
tinguished collaborators: the Florentine sculptor and architect Bar-
tolommeo Ammannati and another architect, Jacopo Barozzi. Barozzi
came from Vignola, a prosperous town in the Po valley, famous for
its orchards, and had spent time in Rome, Bologna, and Fontaineb-
leau (at the court of Francis I) before returning to the Eternal City
in 1543. Vasari's autobiography insists on the importance of his own
contribution to what would become known as the Villa Giulia, one
of the most beautiful buildings to survive from Renaissance Rome.
Now it has been engulfed by the sprawl of Rome, and what was once
a country retreat is just a jaunty walk from the city center. Today the
villa houses the National Etruscan Museum, a fitting role for a build-
ing designed for a proudly Tuscan pope with a wealth of "Etruscan"
details. Even the pope's enemies had to agree that his taste in sylvan
retreats was impeccable.

By his own account, Vasari was the first architect to be assigned
the commission:

> Although it was executed by others after my time, nonetheless I
> was the one who transformed the Pope's whims into drawings,
> which were then passed on to Michelangelo for revision and
> correction, and Iacopo Barozzi of Vignola finished the rooms,
> halls, and other ornaments with many of his [Michelangelo's]
> designs. But the lower fountain was my design and Ammannati's;
> he stayed on and made the loggia that is above the fountain.[4]

What Giorgio calls the "lower fountain" is now called the Nym-
phaeum, an ancient Roman term for a water shrine, and it is one of
the most magical places in all of Rome. Since the 1950s, the Ninfeo

di Villa Giulia has served as the setting for the awarding of the Strega literary prize; the cool, sunken precinct may look small by comparison with the villa itself, but it can hold a substantial crowd. If the idea of a sunken grotto was Giorgio's, it is easy to see why he wanted to claim credit: the villa has no more brilliant feature than this.

It also makes poetic sense that Vasari's cave, his grotto at the Villa Giulia, should be sunken below ground, a space from which to emerge into the light of the elegant palace grounds. Plato's famous allegory of the cave in the *Republic*, with its literal process of enlightenment, would have been a reference inescapable to Vasari and his circle, particularly when their own academy took its name from Plato's Academy, founded nearly two millennia earlier.

No matter what Vasari's contribution to the Villa Giulia may have been, his time on its team of architects was short and troubled. His autobiography tries to explain both the problem and its eventual solution:

> But in that project it was impossible to execute what had been decided, or to do anything, because that Pope was always having new whims that had to be carried out, according to whatever instructions Messer Piergiovanni Aliotti, bishop of Forlì, declared as the order of the day.[5]

In practical terms, after a little more than a year, Vasari was edged out of the team at the Villa Giulia. Vignola and Ammannati took over. Fortunately, Duke Cosimo had plans for him.

> In the meantime, I had to return to Florence twice in 1550, once to finish the panel of Saint Sigismund, which the Duke came to see, and it pleased him so much that he told me to come back to Florence and serve him as soon as I finished my projects in Rome, and I would receive orders about what to do.[6]

Bindo Altoviti also came through with a new commission in November of 1553: fresco decorations for a loggia in the palazzo by Ponte Sant'Angelo, and another series for Altoviti's villa in the meadows just north of the Vatican, the verdant area called Prati.

Nothing remains of Villa Altoviti today. In the twentieth century, Prati became an attractive bourgeois neighborhood, its streets defiantly named after classical figures in the shadow of Vatican City's fortified walls. The Palazzo Altoviti, as mentioned before, was razed in 1880 when the river Tiber was enclosed behind tall embankments to eliminate flooding. Before the demolition crews began their work, however, Vasari's frescoes, using mythological figures to celebrate the wealth and antiquity of the Altoviti family, were removed from the walls and reinstalled in the fifteenth-century Palazzo Venezia, where today they form part of a city-run museum.

Although he was not known as an archaeologist, Michelangelo oversaw the excavation of an ancient Roman sculpture that transformed the way he conceived of art, and through his own preferences, the way the *maniera* developed in the sixteenth century. The site, we now know, was part of the Golden House of the Emperor Nero, the Domus Aurea, built as a sprawling pleasure palace between AD 64 and 68. The structure was buried forty years later by the foundations of Trajan's bath complex, but this burial preserved it, along with the statue that sparked Michelangelo's imagination as no other would.[7]

For centuries, Rome had been a layer cake of a city. It was easier to build over old or damaged buildings than to remove them, especially when they were made of ancient Rome's nearly indestructible concrete. The Tiber's floods and erosion of the Seven Hills progressively raised the ground level, so that now the entire city floats above multiple archaeological sites.

Petrarch wrote of the frequent discoveries made by accident in the Eternal City:

A man who finds a gem inside a fish is not a better, but a more fortunate, fisherman. . . . The farmer who, while tilling the soil, happened to discover, under the Janiculum [hill in Rome] seven Greek and seven Latin books and the tomb of King Numa Pompilius was really doing something else; often there came to me in Rome a vine digger, holding in his hands an ancient jewel or a golden Latin coin, sometimes scratched by the hard edge of a hoe, urging me either to buy it or to identify the heroic faces inscribed on them. . . . Much more worthy of the name of artist is the man who is stopped short, while performing his rightful labor, by a serpent sliding from a cave, than the man working blindly who is happily bedazzled by the unexpected brilliance of hidden gold.[8]

But what of the artists who enhanced their "rightful labor" and produced more wondrous artworks after having blindly stumbled upon the "unexpected brilliance of hidden gold"? Amateur spelunking by artists, dropping into newly excavated ancient Roman villas and wandering through them by the gutter of candlelight, perhaps the first humans to walk those rooms for a good millennium, became an influential source of inspiration.

The rediscovery of ancient Roman wall-painting techniques led to a Renaissance style called grotesque. In the late fifteenth century, the first rooms of the Golden House were excavated. At the time, they were thought to belong to the Baths of Titus rather than an enormous imperial palace complex.[9] Nero's mansion enclosed parts of the Palatine, Caelian, and Oppian hills, and overlooked an artificial lake; it was colossal and opulent, and many of its ceilings were highlighted with gold leaf. And a statue that rose 30.3 meters (99.4 feet) into the sky, according to Pliny, stood guard at the entrance: the Colossus Neronis, a bronze statue of the emperor, now lost, which lent its name to the amphitheater that eventually rose from the drained bed of Nero's private lake, the Colosseum. Locals referred to the buried rooms as *grotte*, "caves," and so the paintings that decorate their walls and ceil-

ings were described as *grottesche* ("grotto-like"—"grotesque"). These decorations were playful and various, with botanical, arabesque, and monstrous images set within moldings of stucco. The frescoes are specked with many smaller figures, often framed by painted garlands, architectural motifs, or geometric patterns. Chimeras, dragons, masks, birds, candles, harpies, demons, and acanthus leaves are woven around these linking painted frameworks: a demonic face might spew curlicue botanical tendrils from its mouth while symmetrical gorgons squat on either side. The result is a bit like wallpaper, rather than a single focal painting, and at a distance the frescoes appear like abstract designs, but ones calculated to delight upon closer inspection. Renaissance painters loved what they saw, and it became stylish around 1500 to create modern frescoes similar to these captivating images. The ceiling of the loggia of Vasari's Uffizi offers one example, lined with newly painted grotesques.

In February 1506, workers excavating a vineyard broke through a portion of the Golden House and found a sculpture. Michelangelo was called to the site, along with Giuliano da Sangallo and his then eleven-year-old son, Francesco da Sangallo, who later wrote about the event:

> The first time I was in Rome, when I was very young, the pope [Julius II] was told about the discovery of some very beautiful statues in a vineyard near Santa Maria Maggiore. The pope ordered one of his officers to run and tell Giuliano da Sangallo to go and see them. And he set off immediately. Since Michelangelo Buonarroti was always to be found at our house, my father having summoned him and having assigned him the commission of the pope's tomb, my father wanted him to come along, too. I joined up with my father and off we went. I climbed down to where the statues were when my father suddenly said, "This is the Laocoön, which Pliny mentions." Then they dug the hole wider, so that they could pull the statue out. As soon as it was visible, everyone

started to draw, all the while discoursing on ancient things, chatting as well about the ones in Florence.[10]

Giuliano da Sangallo was right; this is the same statue Pliny mentions in his *Natural History* (36.5) when he discusses artistic collaborations:

> The Laocoön, which is in the palace of the Emperor Titus, is to be preferred to all other works of painting and sculpture. Working together, the consummate artists Hagesander, Polydorus, and Athenodorus of Rhodes made him, his sons, and the marvelous coils of the serpents from a single block of stone.

In fact, the three sculptors used at least seven separate pieces of marble, cleverly patched together, but Pliny's account spurred Renaissance sculptors to try their hand at carving multiple figures from a single block. Laocoön was a Trojan priest strangled by divine serpents because he warned against dragging the huge wooden Trojan Horse into the city; Virgil has him say, memorably: "I fear the Greeks even when they are bringing gifts" (*Aeneid* 2.119–227). The statue is astonishing for its realism, the hyper-accurate musculature of Laocoön and the adolescent bodies of his sons as they struggle against the tightening coils of the serpents, one of which is about to bite Laocoön's flank. It is a frozen moment of highest tension. Muscles are taut, the serpent's jaw is set to clamp down, an expression of adrenaline-pumped effort, pain, and hopelessness can be read into the face of Laocoön. This dynamic tableau contrasted dramatically with the aura most sculptors were trying to convey in the early sixteenth century: a sense of calm, introspection, balance, and harmony. Contrast the *Laocoön* to Michelangelo's *David*. David is in no danger of moving, his weight leaning on one leg (termed *contrapposto*), a sling slung over his shoulder as he eyes up Goliath, long before he prepares to hurl the fatal stone.

The *Laocoön*, as we saw in chapter 15, changed the way Michelangelo would approach art. And thanks to Michelangelo's fascination

with it, this life-size sculpture group, now on display at the Vatican, is truly one of the most influential in history.

VASARI AND BINDO ALTOVITI also looked across the river to the frescoed halls of the villa, richly decorated in grotesques, that Raphael and other artists had created for the banker Agostino Chigi. For wealth, political power, and patronage Chigi, with a fortune based on industry and an international financial network, had surpassed all his contemporaries. He died in 1520, just four days after Raphael's passing. Vasari waxes eloquent about the great financier and his easygoing relationship with the young painter. He knew neither of them, of course; when they died, he was only a nine-year-old boy from Arezzo. Bindo Altoviti, on the other hand, had known both artist and banker and was compelled to admire their distinct varieties of genius.

Like Altoviti, Agostino Chigi had used his wealth to move armies. He engineered a coup in his native Siena and masterminded at least one, if not all, of the military expeditions mounted by his own great patron, Pope Julius II (though as a papal financier, one might argue that Chigi was the pope's patron).[11] Shortly after Giorgio Vasari reached Florence in 1554, both Cosimo de' Medici and Bindo Altoviti would march to war on opposing sides in the name of Florence.

Before this showdown came to pass, however, a weary Vasari went home to Arezzo, a mature man in his forties, a successful painter and the newly famous author of the newly published *Lives*. He had been rejected by a capricious pope and had nothing more substantial in hand than vague promises from the duke of Florence. The line between success and failure was a fine one in the Renaissance, and this may be one of the reasons that Vasari can write with such feeling about the talented artists, like Buffalmacco, who never quite found the fame or security they deserved.

21

SHAKE-UP IN
FLORENCE

IN 1553, COSIMO DE' MEDICI DECIDED TO ATTACK SIENA,
the last independent city-state in Tuscany. He knew that he could
probably extend his reach no farther than that: his influence in Italy
was limited by the presence of major political powers like the Papal
States, with territories from south of Rome to north of Bologna, and
the Kingdom of Naples, ruled by a Spanish viceroy, and the Republic
of Venice, as well as a clutch of smaller city-states. Marriage to the
viceroy's daughter, Eleonora of Toledo, had consolidated Cosimo's
dealings with Naples and Spain, all the more so because the marriage
had been such a resounding success, a rare union that led to true love
and produced nearly a dozen offspring. But the real key to European
politics still lay, as it had for decades, with Holy Roman Emperor
Charles V. To Charles, therefore, Cosimo appealed for support for
his plans to bring Siena under Florentine control, and he received it.

At the same time, Cosimo strengthened his position on the home
front by practical measures and a propaganda campaign, both of
which had lasting effects. In art, literature, music, and festival, he
presented Florence to its citizens as the perfect amalgam of republican
state and one-man rule. By consolidating the bewildering variety of
Florentine bureaucracies into a single apparatus, he turned the state
into a marvel of efficiency, while concentrating greater and greater
power on himself.

If Cosimo de' Medici was determined to seek glory at the beginning

of 1554, Giorgio Vasari was almost ready to renounce his ambitions. On 4 January, he wrote his friend Borghini in Florence, expressing all his mixed feelings about the situation in which he found himself:

> Behold your Giorgio, returned from Rome, freed from the pre-occupations of Julius III, having finished off Montorio and the Villa, and here, having decided to live like a normal human being,[1] I want, before closing these eyes of mine, to have my wife at my side and my good mother, which could happen if you and your friends could negotiate a project for me to do there in Florence. . . . I don't want to make a name for myself, or make a fortune . . . but I do want to enjoy you, this homeland, so many friends, and having a family, all of this will be my occupation.[2]

Borghini must have done some swift work. Soon thereafter, a letter sped off to Arezzo offering Vasari an appointment to Cosimo's court at a promised salary of 300 scudi. The sum was impressive: at the same moment, the court sculptors Benvenuto Cellini and Baccio Bandinelli were each receiving 200, the brilliant painter Agnolo Bronzino 150, and the garden designer Tribolo (Niccolò di Raffaello di Niccolò dei Pericoli), 140.[3] Vasari's higher salary may have reflected his abilities as an architect as well as a painter; in theory, then, he could make himself useful to the duke both by burnishing Cosimo's image in paint and by building fortresses.[4] It was the fulfillment of a hope he had nourished, off and on, for nearly twenty years, since his early attempts to gain the salaried position of "keeper of the leads," which eventually went to Sebastiano del Piombo. A salary was the rarest of luxuries for a Renaissance artist, the equivalent of tenure for a modern-day university professor, with similarly intense competition. It offered him not only regular high income (which provided a foundation onto which he could add commissions) but also respect and a solid role in court life. Vasari had taken advantage of his time wandering, and had avoided the potential dangers of being officially linked

to the court of the Medici when their position was in doubt. It was anyone's guess how the tides of power might turn, but Cosimo's rule appeared solid, and the forthcoming defeat of Siena made it more so. Vasari would enjoy a real friendship with the duke, so this was an ideal time for him to step into the role of highest-paid court artist.

Giorgio intended to move his entire household, and he thus took his time. He had picked up some local commissions in Arezzo and Cortona, and finished them before transferring north.[5] There were sound practical reasons for moving as slowly as he did: Cosimo had begun his assault on Siena in late January 1554, and the conflict, like every conflict between these two Tuscan powers, threatened to move to one of the most contested borderlands between the two city-states: the flat floodplain of the river Chiana. The Vasari clan's home territory lay between the hill towns of Arezzo, Cortona, and Monte San Savino. The Sienese made a foray into the Val di Chiana on 17 July, followed by an unsuccessful assault on Arezzo itself. Giorgio must have seen Cosimo's military engineers at work in Cortona that spring and summer, shoring up the city's massive old Etruscan fortifications.

From Rome, Bindo Altoviti was moving his forces into place to defend Siena. In 1548, Pope Paul III had appointed Bindo's son Antonio archbishop of Florence, but Cosimo had prevented the younger Altoviti from taking office (and would continue to do so until 1563). Under the charge of another son, Giovanni Battista (the same son who had been present as a child at the Battle of Montemurlo in 1537), Bindo assembled eight companies of Florentine republican exiles, who joined their green flags to the colorful banners of the multinational Sienese forces, headed by another Florentine exile, Piero Strozzi, and including a host of French and German troops.

The decisive clash took place on 2 August at a locality called Scannagallo, near Marciano in Valdichiana. There were about 11,000 infantry on each side. As Roman Vucajnk, a specialist in European martial arts, writes, it was "a midday over tame waves of cultivated soil, speckled with vineyards and short lines of trees, blurred in the

haze of summer heat, silent save for the buzz of insects and the ringing of the Angelus bell from a nearby church."[6]

Hundreds of Florentine heavy cavalry, in full suits of heavy armor, bristling with lances, routed the mounted arm of the Franco-Sienese forces and plowed through their broken lines on the overwhelmed flank. Contemporary military strategy held that the army that maintains its shape solidly, working and moving like a flock of well-armed birds, shifting in unison and remaining intact, will persevere. Knowing that, the Florentines tried to scatter the Sienese with artillery salvos fired from five cannons perched on a gentle slope, filling the hot August air with the stench and smoke of gunpowder, as well as striking with a cavalry charge aimed at the Sienese flank. The Sienese soldiers fought primarily with pikes, arquebuses (highly inaccurate proto-rifles that were often as dangerous to the wielder as to the intended target), swords, and a small round shield for close combat, called a *rotella*. The Florentines were similarly armed, but had more horsemen. Artillery and cavalry are effective against infantry, but a mounted charge at infantry can be repelled by a tight formation of pikes through which the horses instinctively will not charge (though some painstakingly trained warhorses could be desensitized to this instinct after years of practice, and were even known to have thrown themselves off cliffs, if their riders demanded it). If the phalanx of pikemen breaks, then the horses can run through, their riders cutting down the infantry, whose pikes are useless impediments at close range.

The Florentine cavalry broke the line. But the Sienese employed German mercenaries, who counterattacked. Vucajnk describes the scene as they "roared down the slope with their pikes aimed at the Imperial Spaniards [on the Florentine side], veterans of Sicilian and Neapolitan campaigns. Rows of protruding long pikes from both sides formed walls of hardened flesh encased in steel breastplates and rounded helmets." The result was a sort of ultra-violent rugby scrum. Vucajnk continues,

Each side tried to push through the other, while individual agile soldiers crawled under the creaking shafts and tried to slash the tendons of the enemy opposing the first lines. Above the clash and grind of steel and wood, dust from blasting firearms and scorched earth mixed with Spanish and German commands yelled into screaming masses of decades-long adversaries. Cries of wounded, wails of despair, roars of intimidation and shouts of encouragement pierced the air below Medicean *palle*, the red *Cruz de Borgana*, and French lilies that flapped violently on swarms of flags carried over the battlefield, accompanied by rolling drums and blaring trumpets.[7]

Within two hours, 4,000 Sienese soldiers (including French allies and German mercenaries) had been killed and another 4,000 wounded or taken prisoner. It was a disastrous rout—the Florentines (with their Spanish allies) lost only a few hundred. The creek around which the battle was fought had a prophetic name: Scannagallo, from the Italian (*scannare*, "to slaughter" and *Galli*, "Gauls, the French tribe").

Gian Giacomo Medici pressed on to Siena, which had been under siege since January. For all practical purposes, Bindo Altoviti's hopes for a revolution in Florence died at this battle, together with Siena's hopes of maintaining its independence. Giovanni Battista Altoviti managed to escape back to Rome, where he returned to banking; on 17 September, Cosimo declared him a "public rebel" and exiled him from Florence.

Vasari was a victim of this battle, too. In a letter to Michelangelo on 20 August, he writes from Florence about "my houses, sheds, and grain burned and my animals stolen by the French."[8] These were the French troops ranged on the side of Siena, and the houses were properties in the countryside that Vasari owned, along with his house in Arezzo. There had long been tension between the French and the Italians. Case in point: Italians referred to syphilis as "the

French disease," while French referred to it as "the Italian disease." No one knew its origin, but it seems to have spread through Italy when French troops either brought it to or contracted it in the brothels of Naples in 1495—some of the soldiers stationed there had been to the New World, and may have thus imported it from America. The usual remedy to alleviate symptoms (there was no cure) was the ingestion of mercury, which, as we now know, is a devastating poison. This sexually transmitted disease causes rashes, sores, and swellings, and can finally eat away at flesh. Machiavelli included a dramatic account of the disease in his description of a prostitute he visited in the darkness, and who, on seeing her for the first time in lamplight, vomited all over her, when he saw her as a toothless, sore-ridden old woman, covered in "purple flowers," as the symptomatic skin lesions were euphemistically known. Cesare Borgia contracted the disease at twenty-two in Neapolitan brothels, and his sufferings were carefully recorded by a well-meaning, but ultimately useless, court doctor, Gaspar Torella. The disease spread throughout Europe, likely borne through the international soldiers who would visit brothels wherever they happened to be stationed. It spread from Naples as far as Edinburgh. A 1539 treatise by a doctor in Seville estimated that a million people suffered from it. In 1530, the poet-physician Girolamo Fracastoro's epic poem *Syphilis, or the French Disease* supplied the malady a name and a founding myth: Apollo, god of plagues and healing as well as the sun, struck the insolent shepherd Syphilus with the disease to punish him. Albrecht Dürer wrote, "God save me from the French disease. I know of nothing of which I am so afraid. . . . Nearly every man has it and it eats up so many that they die."[9] A proper cure was only developed in 1910.

Vasari's hostility to France, however, stemmed from the damage French troops had inflicted on his property. But his three hundred scudi a year provided good compensation and encouraged him to side enthusiastically with Florence. He soon plunged into a new set of

artistic commissions. If the year 1555 brought settled productivity for the artist from Arezzo, for Siena and its citizens, January 1555 marked a year under siege, which had seen terrible atrocities committed by both sides. In April 1555, starving, the city finally surrendered to Florence. Duke Cosimo's conquest of Tuscany was complete.

To celebrate his accomplishments, Cosimo asked Vasari to redecorate a suite of rooms in the Palazzo della Signoria, the grim old thirteenth-century palazzo that had served the Florentine republic as its city hall. It was here that Cosimo and his wife, Eleonora, had taken up residence in 1540, implicitly taking the institutions of the republic under their wing, and leaving the ancestral Palazzo Medici on Via Larga to a more distant branch of the family. Cosimo was careful to disturb as little as possible when he first moved into this structure, which represented the physical as well as the administrative and symbolic center of the city. Michelangelo's *David* still stood at the entrance, as it had since 1504, when it was carved to celebrate the Medici family's expulsion from Florence. The statue was simply too magnificent to remove. On the right side of the entrance to the Palazzo Signoria stands Baccio Bandinelli's statue of the other symbolic Florentine hero: Hercules, another short man, as strong as David was intelligent. Bandinelli portrays him standing triumphant over the giant Cacus; this time, however, the victorious figure symbolizes the Medici, while Cacus represents the republican cause.

To this pair, Cosimo had added a third statue in 1545: Benvenuto Cellini's bronze image of the Greek hero Perseus, brandishing the head of the monster Medusa as he stands over her lifeless body (which Cellini has somehow managed to wrap around the hero's feet on the top of a narrow pedestal). Perseus is Florence, too, and Medusa symbolizes the spirit of rebellion that Cosimo had confronted from the beginning of his rule, and had crushed so devastatingly at Marciano and Siena.

In the aftermath of these latest conquests, Giorgio's assignment within the ducal suite was to create a painted tribute to the Medici

dynasty, from its fifteenth-century founder, the first Cosimo, through Lorenzo to the Popes Leo X and Clement VII, to the living Cosimo. By presenting a unified image of the family, the duke could smooth over the rough places in its recent history—those expulsions, conspiracies, and murders—and insist (against all the evidence) that he himself had always been the family's obvious, divinely ordained successor, a vision entertained at the outset only by his own mother.

The ducal apartments consisted of a rabbit warren of rooms, spread over a mezzanine and an upper floor. Tucked in behind the imposing main block of the Palazzo della Signoria and the cavernous fifteenth-century assembly hall, was the Hall of the Five Hundred—the one-time site of Leonardo and Michelangelo's inconclusive artistic duel.

Vasari began on the second-floor suite, painting a series of myths with thematic ties to the Medici ancestors, starting with a hall dedicated to the four elements. Oil paintings on the theme of Air were set into the ornately coffered ceiling, with Earth, Water, and Fire honored on the walls, Fire, needless to say, shared a wall with an ample fireplace that boasted both a fresco of Vulcan's forge by Vasari and a sculpted mantel by Ammannati. Thanks to his early literary education and his industrious habits, Giorgio was well versed in mythology, but he also took advice from Cosimo's cadre of scholars.

As Vasari proceeded with his usual efficiency, Cosimo posed him a larger challenge: remodeling the interior of the city hall itself. Originally the duke had assigned this task to the architect Battista del Tasso. Tasso's death in May of 1555 left the commission open, as Giorgio notes in his autobiography:

> When Tasso died, the Duke, who had a great desire to correct that palazzo, which had been built ad hoc at various times, and more for the convenience of the officials than for any idea of good order. He therefore decided that it should be regularized in every possible way, and that the great hall should be painted, and that Bandinelli should continue with the tribunal he had already

begun. Thus to bring the whole Palazzo into harmony, that is, the built part with what needed to be built, he ordered me to make many plans and drawings, and finally a wooden model, based on the designs he had liked best.[10]

In his *Lives*, Vasari had lauded architecture as ranking highest among the arts. Like Giorgio himself, many of the architects he discussed had been trained in other fields: Brunelleschi as a goldsmith, Alberti as a scholar, Bramante as a painter. Architecture came later, an art these men approached in their maturity. Like any of the arts, whether painting, sculpture, or writing a book, good architecture was a matter of good organization, but organization was, if anything, more important in architecture because building was such a complex and expensive activity. Organization was also, perhaps, the supreme skill that bound Duke Cosimo and Giorgio Vasari together, a shared genius for ordering, planning, and execution that they applied to every aspect of life, public and private.

The wooden model of the palazzo, which Vasari distinctly describes as their joint creation, became their definitive guide for new construction work:

so that it would be easier to accommodate all the apartments according to [the Duke's] sense of things, and straighten out or replace the old staircases that he thought were steep, poorly designed, and no good at all. . . . With its guidance, by constructing bit by bit, doing one thing here and another thing there, we arrived at the results you see today. And while we were doing all of this, I decorated the first eight of the new rooms we had created with sumptuous stuccoes. These are on the same level as the Great Hall, and include reception rooms, bedchambers, and a chapel, with various paintings and endless portraits in the histories that begin with Cosimo the Elder, and each room is named after some great and famous descendant of his.[11]

Above all, the suite singled out three Medici patriarchs: Cosimo the Elder, Lorenzo the Magnificent, and Pope Leo X. This, the year when Duke Cosimo consolidated his own power, was the moment that birthed the legends of Lorenzo de' Medici and of Medicean Florence. During his own lifetime, Il Magnifico had been seen as considerably less *magnifico* than family legend, in retrospect, liked to depict him. He had been a ruthless statesman and an impressive figure, but he was a mediocre banker and, as a ruler, rarely had the money to sponsor works of art and architecture—the huge paintings by Botticelli in the Uffizi Gallery were commissioned not by Lorenzo but by his republican cousin Lorenzo di Pierfrancesco. Duke Cosimo, however, in light of his own ability as a statesman, soldier, and promoter of culture (which went hand in glove with propaganda and the creation of a legacy), decided to project his talents generously backwards onto his predecessors, transforming the story of Florence and its ruling dynasty into a century-long tale of progressive, inspired leadership. Even the moody, short-lived Lorenzino received his own frescoed tribute on the walls of a building that had been designed to host a rotating body of citizen leaders, but had turned into the abode of an absolute ruler in the latest modern style, a small-scale peer of the kings of France and Spain and, at least for one more year, of the Holy Roman Emperor, Charles V. In 1556, Charles abdicated and retired a remote monastery at Yuste, in the region of Spain known as Extremadura, "the frontier," where he died in 1558.

Duke Cosimo, on the other hand, had no intention of retiring. He had pressed the pope to award him the title of grand duke, but Julius III died in 1555, having done little except create the Villa Giulia. His successor was a popular Tuscan cardinal, Marcello Cervini, who took the name Marcellus II and raised great hopes. Sadly, the excellent Cervini managed to reign only three weeks (feeble and sickly when elected, he was bled by his doctors, which only made him weaker— he suffered a stroke and died). The second conclave of 1555 took place under the watchful eye of the dean of the College of Cardinals,

a Neapolitan cardinal and close ally of the Farnese, Giovanni Pietro Carafa.

Conclaves were held inside the Sistine Chapel, with Michelangelo's prophets and sibyls staring down from the ceiling as the cardinals were locked inside, theoretically not permitted to leave until they selected a pope. To speed the discussion, the meals provided were reduced in portion and quality the longer the conclave lasted. In the streets of Rome outside, locals liked to gamble on which cardinal would be elected: there were daily reports on voting and even on portion size, and the gambling odds were adjusted accordingly.

As usual, the votes split between French and Spanish factions, but Carafa took advantage of the situation to secure his own election. He took the name Paul IV, in homage to his mentor, Paul III (who had made him cardinal, launching him on his lucrative and influential career path). Once vested with supreme power, however, this onetime faithful associate of Paul III turned into a holy terror. Like most Neapolitan barons, Carafa loathed the occupying Spaniards and Charles V, who had imposed their hated viceroys on Naples and its kingdom. He was equally set against Jews, Protestants, and heretics. He is still notorious for having empowered the Inquisition in Rome and for ordering that the Jews be confined to ghettos.

It was not a moment for Cosimo, with his Spanish wife, to press his luck with Rome. Instead, he passed decrees that guaranteed an unusual degree of religious liberty in Tuscany, so that the duchy quickly emerged as an important place of refuge for Jews fleeing the repressive regime of the Papal States.[12] Many of these refugees were highly educated: doctors, lawyers, and rabbis, who only enhanced the cultural flowering of Florence and its territory.

In the meantime, work began on the Hall of the Five Hundred— no longer simply a meeting place for the Florentine city council, but the audience hall for an ambitious monarch. Vasari knew what he had to do: he had seen the huge timbered council hall in the Doge's Palace in Venice, the Gothic vaults of Castel Nuovo in Naples, the towering

vaults of ancient Rome and the Sistine Chapel. He raised the ceiling of the old hall by a staggering eight meters (increasing its height by about one-third), and punched huge windows into either end, filling the now vast room with light, even in gloomy weather. His frescoes, set within fashionably elaborate plaster frames high on the lofty walls, would declare the triumphs of Cosimo's Florence.

With the frescoes planned for a position far above viewers' heads, Cosimo ordered a series of statues, slightly over lifesize, to line the walls. These the duke entrusted, of course, to his court sculptor, Baccio Bandinelli. The most famous of them portrays another labor of Hercules, his struggle with the giant Antaeus, who could be vanquished only if he were lifted completely off the ground, the source of his strength. Hercules has lifted Antaeus aloft and flipped him upside down, but this change of perspective has given the giant perfect access to Hercules's most vulnerable appendage, which he has clasped in an iron grip. The slightest move, and Hercules's manhood is at stake. There they stand frozen, poised for five centuries in perfect, hilarious balance.

Vasari, needless to say, was entrusted not only with the architecture of the new hall but also with its fresco decorations (and designing the frames that enclosed them). Here, where Michelangelo and Leonardo had squared off with their competing battle paintings, the *Battle of Cascina* (commissioned, designed, but never painted) and the *Battle of Anghiari* (partially painted and abandoned). The theme of the newly expanded room would remain battle, but this time the victor was not the Florentine republic but rather Cosimo himself—representing the Florentine republic. The adversaries were Pisa, once again, and the perennial enemy of Florence, Siena.

Cosimo had no qualms about covering over old works of art with new. In 1568, he would ask Vasari to renovate the interior the venerable Dominican church of Santa Maria Novella (its façade designed by Leon Battista Alberti). Part of this included sacrificing Masaccio's fresco the *Holy Trinity* (1427–28), to be replaced with Vasari's new

Madonna of the Rosary painting. On that occasion, Giorgio protected the old fresco by building a new wall in front of it, discovered when the church was remodeled again in 1860. It is not clear whether this decision to preserve the Masaccio was made with the duke's knowledge; since that painting had no particular personal resonance for Cosimo, Vasari's decision to preserve rather than destroy a work he so admired may have been his alone.

The duke had much stronger reasons to decorate the walls of the renovated Hall of the Five Hundred with a new series of paintings. Neither the *Battle of Anghiari* nor the *Battle of Cascina* had ever been completed, and Leonardo's wall painting, as we know, was in ruinous condition, because he had attempted to apply oil paint to plaster. The cartoons were well known and often copied, and this may well have meant that the paper drawings were in better shape than the wall paintings themselves. From Cosimo's standpoint, moreover, the two works had been commissioned by the anti-Medicean Florentine republic. His own expensive decision to remodel the Palazzo della Signoria and its great hall symbolized his effort to consolidate and master republican institutions within an efficient one-man Medici state.

In ancient Rome, "old master" paintings and mosaics from Greece were sometimes set into new walls or floors, deliberately preserved as treasured relics of the past. In medieval and Renaissance Rome, artists had begun to set venerable icons of the Virgin into larger painted surrounds. Today, walk into many Roman churches, like Santa Maria al Popolo, and the oldest work on view will be an ancient icon, embedded in a lavish Baroque altarpiece, which functions as a dwarfing, oversize frame around it. In the mid-seventeenth century, Francesco Borromini displayed fragments of the old painted walls of the Lateran Basilica within frames of his own design. These, however, were special cases. Borromini happily tore down a Bernini chapel to create another chapel in its place (the two architects were bitter rivals, to be sure), and stripped the Senate House in the Roman Forum of its doors to put them on the Lateran instead. Historic preservation was

not unknown in this historically minded period, but novelty was more exciting still.[13]

The enlarged hall was vast enough to take three battle scenes on each side. For the Pisan campaigns, Cosimo and Vasari chose to show the *Rout at San Vincenzo*, *Maximilian I Attacks Livorno*, and *Pisa Attacked by Florence*. The conquest of Siena was divided into three episodes: the *Capture of Siena*, the *Capture of Port'Ercole*, and the *Battle of Marciano*, the battle into which Bindo Altoviti had sent his eight divisions and his son. Discreetly, Vasari puts these troops, with their green flags, in the center rear ground of the painting and focuses attention instead on the French troops who would devastate his own lands. The landscape in the background is Vasari's own home turf, lovingly painted. For Cosimo, the new hall was a resounding success. He could give audience from Bandinelli's stately tribunal and look up to the ceiling, where he and his dynasty were celebrated in a series of oil paintings set within coffered frames, their themes devised by Vincenzo Borghini. Borghini's original idea was to have an allegory of Florence in the center of the room, but Cosimo had another plan in mind: an image of his apotheosis, as if, like an ancient Roman emperor, he was becoming a god. He sits enthroned in highest heaven, where the blue of the normal sky gives way to the golden light of the space beyond the celestial spheres, framed by a circle of shields bearing the symbols of the cities he rules. When your boss asks you to paint him as a god, you do not beg to differ.

This was not Cosimo's only self-portrayal as a divinity. In Eleonora de Toledo's private chapel, the duke appears in a painting by Bronzino as Jesus Christ. He may not have been a grand duke yet, but he was certainly grand.

And what of Leonardo's lost *Battle*? It seems probable that Vasari used the same trick he employed to cover over, but preserve, the Masaccio—erecting a wall in front of it. His renovations to the hall, from the raised ceiling to the grand new windows, required reinforcing the basic structure on all four sides. But what, if any, of the

Leonardo remains, painted in oil on plaster (rather than tried-and-true, long-lasting tempera), sealed for half a millennium in a gap only a few centimeters wide? And what did the fact of Vasari's taking such measures to preserve a Masaccio and a Leonardo say about his thoughts on the legacies of his own architectural remodeling and painting? Might he have felt that the novelties he was asked to execute were not as good as the past works that he was told to demolish, as they stood in the path of progress? Might he have hoped that some future generation would break down his false walls in Santa Maria Novella and the Palazzo Vecchio, even though doing so would mean tearing through his own creations?

22

THE ACCADEMIA
DEL DISEGNO AND
THE *LIVES* REVISED

THE PALAZZO DELLA SIGNORIA WAS ONLY ONE OF VASA-
ri's commissions for the ambitious duke. Cosimo was trans-
forming the cityscape of Florence as quickly as he transformed its
institutions. For the Palazzo della Signoria, a medieval piazza in front
of city hall, he added fountains and statues, turning it into a showcase
of modern sculpture. To house his growing family—Eleonora bore
him eleven children, eight of whom survived infancy—Cosimo took
over a palazzo built by the banker Luca Pitti on the opposite side of
the Arno, turning it into an immense and luxurious abode. At the
same time, he asked Vasari to design a building to house the civic
offices, putting the entire Florentine bureaucracy and the city magis-
trates under a single roof. Of this commission, Vasari writes,

> I have never built anything more difficult or more dangerous,
> because the foundations stand above the riverbank, almost in
> midair. But it was necessary, among other reasons, to provide a
> place to attach, as we did, the great corridor that crosses the river
> from the ducal Palace to the Pitti palace and gardens. It took five
> months to complete the corridor according to my design, although
> it looks like the kind of project that would take at least five years.[1]

That building is now known as the Uffizi, "the Offices," and it is
Giorgio Vasari's finest achievement as a visual artist. It was a difficult

commission, not only because the huge building had to be anchored in river sand but also because clearing the site meant razing an entire Florentine neighborhood, including a church. Vasari would not live to see his design completed, or to experience, as we can, how the grand balcony overlooking the river Arno seems to be part of the natural landscape. The idea of creating a long, street-like piazza between two mirroring façades works so well that it, too, seems natural. Appliquéd pilasters, consoles, and window frames in a repeating rhythm give the two long buildings a sculptural quality that is enhanced by the simple color scheme: white stucco on gray *pietra serena*. We have to look twice to see how different the two facing structures really are.

Cosimo had deliberately chosen to keep the grim old shell of the Palazzo della Signoria, and thus by juxtaposing that historical memory with the innovative new look of the Uffizi, he and Vasari told a capsule history of Florence, of both its civic institutions and its leadership in the arts.

These monumental works, and several others in Florence and other Tuscan cities, kept Giorgio Vasari busy from 1555 into the 1560s. In 1557, he and his family moved into a house on the street at Borgo Santa Croce 8, which Giorgio began to decorate in what little space he found, as richly as he had decorated the house in Arezzo. Like the house in Arezzo, it is modest in size, but comfortably arranged and charmingly painted. To his regret, he and Niccolosa Bacci never produced any children, although for a time Vasari's two children from his premarital union with La Cosina's sister lived with the couple in Florence.

Despite his political and military successes and his thriving cultural projects, Duke Cosimo could not escape his own personal tragedies. In November of 1562, malaria carried off two of his sons, Giovanni and Garzia. One month later, the same disease killed his wife, Eleonora, already weakened by tuberculosis and a terrible calcium deficiency (surely exacerbated by her eleven pregnancies).[2] She was only forty. Cosimo was devastated.

On 13 January 1563, Giorgio Vasari's position in Florentine cultural life took yet another remarkable turn, when Duke Cosimo approved the foundation of the Accademia e Compagnia dell'Arte di Disegno, the Academy and Company of the Art of Drawing. The company unofficially succeeded the Confraternity of Saint Luke, the medieval painters' guild, which was really the guild of the pharmacists and doctors—that is, *medici*, a coincidence never lost on the Medici family. The Accademia was intended to act as the equivalent in the visual arts of the Accademia Fiorentina, the group that Cosimo had founded in 1540 to promote the Tuscan vernacular language. In urging its formal approval by the duke, Vasari edged out another, more informal artistic academy, directed by Baccio Bandinelli.

The new academy's first meeting place was the cloister of the church of Santissima Annunziata, facing onto the same square as Filippo Brunelleschi's Hospital of the Innocents (1419), a structure that has often been defined, following Vasari's own lead, as the first Renaissance building. The organization's activities included a strong teaching mission, aimed at producing young artists who would be well trained in manual arts, but also well educated in literature and what we would call the sciences (they would have called these subjects natural philosophy). The curriculum included anatomy, geometry, mechanics, mathematics, architecture, perspective, music, counterpoint, oratory, and chemistry—pigments were chemical compounds, after all.[3]

The academy, like its literary equivalent, also took an advisory role, working with the duke to promote a Florentine artistic style and a proudly Tuscan sense of culture. From Cosimo's standpoint, these formal organizations gave him extensive control over artistic and literary production in the Tuscan state.

Like the *Ten Books* of Vitruvius, Vasari's *Lives* played a fundamental role in the educational program of the Accademia del Disegno. Originally, Giorgio had composed his artistic biographies on the model of saints' lives, Suetonius's *Lives of the Twelve Caesars*, and Plutarch's *Paral-*

lel Lives, presenting the artists as examples of good and bad behavior, in terms both of *disegno* and of social conduct. The book had been an experiment. Now it was an institution, and its author had exchanged the status of a vagabond artist for that of an established courtier. It was time to revise the *Lives* to express what the literati of Florence believed was the true position of the visual arts in Tuscany and in Italy as a whole, the one arena in which Cosimo could hope to achieve an authority beyond the physical limits of his city-state.

The revision must have been underway for years, if printing the second edition began in 1564. Vasari's original printer, Lorenzo Torrentini, had died in 1563, and the manuscript went instead to the venerable Giunta firm (still an Italian publishing house today). The three-volume work would finally be available in 1568.

In the meantime, however, Giorgio Vasari had to take on yet another assignment: the 1565 wedding festivities for Cosimo's heir, Francesco de' Medici. In 1564, the duke, exhausted and despondent after so many deaths in his family, appointed Francesco his regent and sent the young man off to visit his relatives in Spain. A second trip to Innsbruck and Vienna in 1565 led to the promise of a Habsburg bride. In December of 1565, she arrived. Joanna of Austria was the youngest daughter (and fifteenth child) of the Holy Roman Emperor Ferdinand I, the niece of Charles V, and sister of Maximilian II, who had succeeded his father as emperor in 1564. Like a true Habsburg, she had a protruding lower jaw, as well as severe scoliosis and a deformed hip that would make giving birth an agony. Because the match was so illustrious—no Medici had ever married so high up the social ladder—the wedding celebrations went on for weeks. Vasari decorated the courtyard of Palazzo Pitti with temporary gilded sculptures, and filled the lunettes with pictures of Austrian towns. Plays and intermezzi were put on, banquets held, and, through it all, the eighteen-year-old bride became more and more homesick. The marriage was not a success in any respect. Joanna gave birth to six girls, only two of whom survived infancy, and one of these inherited her

mother's deformed hip. Like her own mother before her, Joanna died in childbirth, a result, perhaps, of her deformity, but by that time her husband had long since taken up with a Venetian mistress, Bianca Capello, who would become his second wife. Francesco's siblings were scandalized.

The preparations for the wedding and the ceremony itself completely exhausted Vasari. He had been the motor at the center of the entire operation, while also juggling his other projects for Duke Cosimo: the tomb of Michelangelo, the church and palace of the Knights of St. Stephen in Pisa, a corridor connecting Palazzo della Signoria with Palazzo Pitti that crossed the Arno at Ponte Vecchio, as well as architectural work for the Loggia dei Lanzi, the medieval portico that stands perpendicular to the Palazzo Vecchio. Now a showcase for sculpture (including Cellini's *Perseus*), the loggia once provided shelter for the Swiss mercenary bodyguard of the Medici, the *Landesknechte* and an "apparatus used in the tribune of Santo Spirito," some kind of stage mechanism for religious pageants. Thus we can add "religious special effects engineer" to Vasari's endless list of talents.

Giorgio needed a holiday and was granted four months' leave to recuperate in Arezzo. He hoped to use the free time to design his own memorial for the city of Arezzo and complete the second edition of the *Lives*. But this holiday was canceled in March of 1566, and he was called back to work. The walls of the Sala Grande had yet to be painted, and Duke Cosimo was getting anxious. The enormous whitewashed plaster walls, too large to be covered with tapestries, would have looked shockingly bare, and unsuitable for a reception room meant to impress foreign dignitaries. But before Vasari began work again, he did manage to carve out a shorter holiday, which he spent traveling the Italian peninsula, looking at art treasures that he had not seen since his previous "grand tour," in 1542, when the *Lives* were only the glimmer of an idea. He set out in March to visit his home in Arezzo, and then a three-day journey carried him on to Perugia.

One of the many delights of reading Vasari's letters is what we learn about daily life in the mid-sixteenth century. We have already seen the difficulties Vasari endured in trying to get to Venice, a multi-day affair involving rafts, swamps, horses, mud, and ferries. The much simpler trip from Arezzo to Perugia, barely forty-five minutes by car today, took him three days and was exacerbated by the fact that his pack mule, loaded with three unfinished paintings and his luggage, got sick. Clomping through muddy, rain-slicked roads was an ordeal under any circumstance; with a sick mule it was torturous.

> We got the panels, or rather the canvases, for Perugia as far as Quarata with great difficulty, and the mule that was carrying them is sick, so it's been a real chore to transport them. This morning, some other beasts have been sent to Quarata to carry on. I won't leave the paintings, and will make sure that they are loaded and delivered. . . . Lord have mercy on all this rain.[4]

A slightly older contemporary, the Roman scholar Blosio Palladio, had the same impulse to call on the Almighty when faced with travel in the rain before the days of paved roads. His simple declaration sounds strikingly modern: "Oh God. Oh. My. God."[5]

In a letter to Vincenzo Borghini from Perugia, Vasari is able to report a happy ending to the tale:

> The canvases have arrived safely in one piece and have been taken out of their cases. They and I arrived about an hour apart, and they hadn't been taken out of their cases yet, but then the monks and the abbot couldn't control their impatience; I'd barely had time to take off my boots before they undid the packages, and with the abbot and the whole convent present they put the paintings on display, and they had reason to go crazy with delight, the abbot most of all. Not only had his commission been carried out just as he wished, but the paintings also seemed worthy to him.[6]

The arrival of long-awaited, expensively commissioned art from the acknowledged master of the era would have certainly triggered celebrations, especially considering that such works, intended as altarpieces for the monastery church, would guide the lives of the monks for generations, indeed centuries to come. One can imagine just how exciting it would be to see them for the first time. The only preview that the monks and the abbot might have enjoyed would have been a cartoon or preparatory sketch. Now Vasari's *Saint Jerome, Saint Benedict,* and *Marriage in Cana of Galilee* (which included a hidden portrait of Niccolosa Bacci, Mrs. Vasari) were unveiled. Paintings on canvas could be rolled for transport; paintings on panel had to be boxed. The works for Perugia were canvases, but they were also small enough to have been nailed to wooden stretchers and boxed, as the letter indicates.

Throughout this trip, Vasari corresponded with his dear friend Vincenzo Borghini. Borghini would be most regular, detailed, and honest correspondent of the artist's entire career (224 letters between the two survive). The artist felt free to write without the weight of etiquette required with, say, Cosimo de' Medici, who was as much of a friend as their differing social status could permit, but whose stature always required delicacy and the frequent insertion of titles and superlatives. With Borghini, Vasari could be as much himself as could be hoped for in a sixteenth-century exchange of correspondence—which means that he calls his friend "Your Lordship" and Borghini calls him "Messer Giorgio magnifico." To give a feel for this freedom of ideas, here is the entire text of Vasari's next letter from his miniature grand tour, this time posted from Rome on 14 April 1566. It was Easter morning:

My Reverend Don Vincenzio,

I wrote you about Perugia, that the panels were delivered, and it didn't take much to put them up because I was there with Maestro Bernardo and

Jacopino. They have turned out very nicely, and the Abbot of Perugia should have written you already, because they really do have a special light and it works better than in the refectory of the abbey in Arezzo. He arranged it so that I've taken a commission to provide an altarpiece for San Lorenzo in Perugia, the principal church, on behalf of the Merchants' Guild. For ten years they have wanted to assign it to Titian, Salviati, and other masters. Finally, this work of mine made them decide the question, and it will be on canvas like this last one, and that's it as far as work goes in Perugia.

I'm obliged to the Lord Abbot Don Jacopo Dei and I am very fond of him. In fact, now I'm so fond of him that he's made me decide that over the inner doorway of the refectory, which is undecorated, he shall have a painting to decorate that strip, and it will be Christ appearing to the Apostles, where Saint Peter sets out that roasted fish and the honeycomb, just to stay within the theme of stories of Christ that involve eating, and at the same time commemorating St. Peter [to whom the abbey is dedicated]. Your Lordship will see the Father Abbot, who is passing through Florence, and you'll find out how much I've satisfied him, aside from the pictures, with many little repair jobs, masonry and the rest, for that monastery; and he is your very great supporter.

We finally took off after staying three extra days in Perugia because of the rain (which I didn't want to do), and I passed through Assisi, Foligno, and Spoleto, where I went back to see Fra Filippo's chapel in the Cathedral, a lovely thing. He was a great man. And we got to Rome on Good Friday. I went to see our Don Teofilo on the Quirinal, who treated me so kindly that up to now I don't feel I've left home, and my life has improved so much that to these Romans and artists I don't seem any older than the last time I was here. . . . They've certainly grown flabby.

The air here eats up marble and ages painting prematurely; think what it does with living people, who labor in it all the time. Proof enough: I saw Daniele da Volterra, who died four days later, they say

out of fury that his [bronze] horse didn't come out right the first time, and he had to recast it. It's still down there in the mold just the way the master left it; God have mercy on him. I'll pick up some of his work from the people in his studio to write his biography and add his portrait to the book.[7]

I have received your first and second letter, and the check for 100 gold scudi from the Montaguti. If they need it, I'll cash it, but I don't think they will.

I have been greatly enjoying the theater and you know that I always felt that way when there was something playing. I talked at length about this with Nicolò del Nero.

I'll do whatever you say with Messer Annibale Caro. Up to now I haven't seen him, but I haven't seen anyone; during Holy Week I'm attending to my soul.

I mean to keep active for the whole holiday. Then I'll take off for Loreto. In the meantime, if Your Lordship wants to write me, send the letters to Bologna to Signor Prospero Fontana, a painter who lives in the Vinacci, and send your letters to me by post, so I get them immediately, so that if anything runs out there I can order what's needed.

If Don Silvano has arrived there, please let him know that the Lives are progressing, and I'll write him a letter to be included with these; my [brother] Ser Piero can pass it on to him or Your Lordship can, so long as the work doesn't get behind. All the letters that I send him, please, Your Lordship, give them to Ser Piero, who will either send them to Arezzo or give them to the right people.

I have seen almost everything here, and some artists look good to me and some not so, but of the things that are being done by the masters of the moment, from Salviati on out, not one pleases me—and yet they are regarded as good men. Enough about this; we'll have time enough for long discussions. I can't think of anything else except to send my best wishes.

From Rome, Easter morning 1566.

Say hello to Battista and Ser Gostantino and the other friends.

P.S. I found Anibal Caro and told him what you're thinking. He loves you and will do whatever you wish.

Your Lordship's Servant,
Giorgio Vasari.[8]

Vasari also mentions a letter of credit, the Renaissance equivalent of a check. Sixteenth-century bankers maintained a dense network of international connections; a banker in one city could write out a letter with the right proofs of authenticity, including the symbol of the bank and wax or lead seals, permitting its holder to withdraw cash from a colleague in another city. In those days, Italian bureaucracy was the most streamlined and advanced in Europe.

Vasari wrote with a quill pen on expensive handmade paper, folded his letter in quarters, addressed the outside, sealed it with wax and handed it over to a courier on horseback. But what he wrote, despite the formality of titles, was a letter to a close friend, updating him on daily life—and on the whole, the letter reads as surprisingly modern. We can still feel the shiver of nervousness when Vasari tells Borghini to reassure a certain Don Silvano that the *Lives* are "progressing." This is Don Silvano Razzi, a Florentine playwright and Camaldolese monk who helped draft some of the artists' biographies for the second edition of Vasari's masterwork. All over the Italian peninsula the writers and artists in Giorgio's network were pulling together biographies of local artists, hoping for inclusion in the new edition. While Vasari had to beg and quest for information for the first edition, he was now flooded with it.

It may not be surprising to read that Vasari's visits to artists' studios in Rome left him unimpressed. After struggling to arrive at his own privileged position, he was reluctant to give credit to his rivals, real or potential. There was no threat in dead masters like Raphael, or old masters like Michelangelo, and to them he could be generous with his praise. But he tended to treat his own contemporaries harshly, or

ignore them altogether. Art historians have largely followed his lead. Only recently have they begun to investigate the artists passed over by Vasari (Pinturicchio is a good example), such has been his primacy and influence.

Among his activities during his five days in Rome (fully as active as he told Borghini they would be), Giorgio kissed the feet of the new pope, Pius V, and made sketches for the Sala Grande. He was also puttering through antiquary shops and the collections of acquaintances, looking for more drawings to fill up his *Libri dei Disegni*.

On 17 April he wrote Borghini,

> This Rome is more miraculous for its ancient things than for the modern. I haven't found any good prints, you have everything already and here there's just stuff. Here there's no work on the construction sites, not even for painters. I've discovered that all the young artists have left. I couldn't get drawings because there's nothing from the old masters. I have gotten them from everyone, but long before this, and they are in my Book [of Drawings].[9]

Apparently, then, Vasari was looking for new artists to include in the *Lives* as well as new drawings. He came away from both quests disappointed. There were two significant problems for artists in the Rome of Pius V. One was the pope's own hostility to what he called "pagan art"—he transferred some statues from the Vatican to the Capitoline and gave others away.[10] Focused as he was on new art that would follow the guidelines of the Council of Trent (stressing piety, ease of understanding, and avoiding classical references in favor of a "purer" reading of Christian subject matter), Pius finally planned to sell off the Vatican's collection of ancient statues, and was prevented from doing so only by the press of his other concerns. The first of these was internal reform of the Catholic Church.

Before becoming Pope Pius V, as a cardinal, Michele Ghislieri had been prominently involved in the Council of Trent, the decades-long

Catholic effort at internal reform that followed on the Protestant Reformation. When the council issued its final decrees in 1563, they included a number of guidelines for art and architecture as well as liturgy, music, and Church doctrine. The advice was general rather than specific: "let so great care and diligence be used herein by bishops, as that there be nothing seen that is disorderly, or that is unbecomingly or confusedly arranged, nothing that is profane, nothing indecorous, seeing that holiness becometh the house of God."[11]

In effect, responsibility for coming up with creative but religiously acceptable work fell entirely to the artists and architects themselves, and to their patrons. It is no wonder that so many young artists left Rome, where the pope threatened to leap on any hint of heresy, flanked by agents informing him of every suspicious activity. Vasari did not worry excessively about Rome and the pope. Cardinal Paleotti, the author of the new guidelines for art and architecture, was his good friend.[12]

Rome's architecture took a more conservative, almost neoclassical turn in the late 1560s and 1570s, away from the Florentine extravagance of Michelangelo and back to the precedents of early Antonio da Sangallo and Raphael, before they, too, pushed at the limits of classical form. Painters kept to the pastel palette that Michelangelo had brought in with the Sistine Chapel ceiling and developed over the course of the century, but Pius had no use for the elaborate myths and allegories that Vasari and his literary friends had so enjoyed inventing; the new regime favored saints' lives, with lurid tales of martyrdom, and the simplest, most accessible Bible stories. The extravagant *maniera* that had become a hallmark of Cosimo's Florence still shaped taste, but in Rome it was a toned-down version of Bronzino's and Vasari's stretched anatomy, improbably clinging garments, and elaborately ornamental footwear. No one in the Papal States was in the mood to take artistic risks. A full generation would pass before a foul-tempered Lombard nicknamed Caravaggio dared to challenge the Council of Trent's vague but intimidating definition of successful religious art.

23

ON THE
ROAD

TODAY, WHEN VISITORS COME TO ROME, THEY DO SO BY car (a slow, traffic-pocked route through an ugly industrial zone) or by train, pulling into the chaotic Termini station, with its loafers, crazies, and pickpockets. Not much of a grand entrance.

But in Vasari's time, visitors approached Rome on foot or on the back of a horse or donkey, and the points of entry were carefully designed to awe. The city had been rebuilt after the Sack of Rome to accommodate throngs of spiritual tourists. Its gateways now matched the expectation of travelers who had journeyed weeks, perhaps longer, to reach this legendary place.

The main point of entry to the north was the Porta del Popolo, the Gate of the Poplar Tree. Built around the former ancient Porta Flaminia by Pope Sixtus IV for the Jubilee Year of 1475, it was damaged in 1527 and rebuilt in 1565. What we see today—the grand piazza, the gate itself, the church of Santa Maria del Popolo, and the three great avenues (which form the prongs of a trident, if viewed from above, hence the Roman name for the neighborhood, Tridente)— looks very much as it did then (minus a pair of undistinguished brick guard towers that flanked the gate until they were dismantled in 1879 in favor of two extra portals to accommodate urban traffic). In those days, the Porta del Popolo marked the far edge of the city. Today, new neighborhoods sprawl for miles beyond.

When he left Rome in 1566, Vasari struck straight north through

the Porta del Popolo, following the ancient Roman track (built in 220 BC) of the Via Flaminia over the Apennines to the east coast of Italy, where it turns left at the seaside of Fano and bends north to Rimini. At Rimini, the Via Flaminia became the Via Aemilia, which described a straight line leading across the flat plain of the Po valley to northern Italy. Even today, much of the old Roman road survives, from paved stretches to impressive stone bridges and a tunnel; for a sixteenth-century traveler, these ancient remains would have been much more visible and often were still in use. The countryside is some of the most spectacular in Italy, with wooded mountains and plunging limestone gorges. Vasari took the route called the Flaminia Nova, the "new Flaminia," which was itself ancient. Wandering over brooks on ancient bridges, amid waterfalls and spring flowers, he was ecstatic. He wrote joyously to Borghini from Ancona on 24 April, four days after leaving Rome:

> After my departure from Rome, the third day after Easter, taking the road through Narni, Terni, Spoleto, and the Varchiano valley, we finally arrived at Tolentino, Macerata, Recanati, and Loreto [a famous shrine of the Madonna]. There, yesterday morning, which was the feast day of my Saint George, with great spiritual satisfaction we took communion at the Madonna's shrine, and yesterday evening we come to Ancona. This morning, early, we are leaving for Fano, Pesaro, and from there on to Rimini, Ravenna, and we think we'll be in Bologna by Sunday, and there you'll have news from the trip about what's to be done or about my plans to come home. Enough, we've found so many friends, seen to many things, and yesterday my old friend Cardinal Gambara was so kind and courteous, and we have seen so many fortification walls that there's no time to describe them, or discuss them.
>
> I love seeing these things; ours have more *disegno*, more order, and are better built, and more innovative. And our Duke and

the things he does are well known and recognized by others for what they are. . . . We are all healthy and riding merrily along; and it has been a great help to my life and my brain to have seen all this variety.[1]

The Flaminia was a rugged route, but because Ancona belonged to the Papal States it was relatively secure, nothing like the dangerous roads between Rome and Naples or Rome and southern Tuscany. Six years after Vasari made his tour, the young Neapolitan friar Giordano Bruno was summoned from Naples to Rome to demonstrate the feats of memory for which he was renowned for Pope Pius V, with the rare privilege of riding there and back in a carriage. What he remembered most about his trip up and down the Appian Way was not the carriage but the number of corpses lying by the side of the road, victims of banditry and malaria. The bleak borderland between the Papal States and Tuscany suffered from the same plagues: malaria on the coast, bandits on the interior. Duke Cosimo's conquest of Siena had helped to subdue the bandit population, made up of locals, Corsican pirates, and Tuscan exiles, but the region has maintained its reputation for wildness to this day.

Less privileged travelers had to deal with local inns of widely varying quality; Vasari, a famous artist and a member of the Florentine court, stayed with a network of patrons, including Cardinal Gambara and the abbot of San Pietro in Perugia.

The English traveler Thomas Coryat, who came to Italy at the beginning of the seventeenth century, was amazed at one of the objects Italian travelers carried with them:

Also many of them doe carry other fine things of a far greater price, that will cost at the least a duckat, which they commonly call in the Italian tongue umbrellaes, that is, things that minister shadow unto them for shelter against the scorching heate of the Sunne. These are made of leather something answerable to the

forme of a little cannopy, & hooped in the inside with divers little wooden hoopes that extend the umbrella in a pretty large compasse. They are used especially by horsemen, who carry them in their hands when they ride, fastening the end of the handle upon one of their thighes, and they impart so long a shadow unto them, that it keepeth the heate of the sunne from the upper parts of their bodies.[2]

Umbrellas were an Etruscan invention, simultaneously discovered by the ancient Chinese, but both societies used these supremely useful contraptions as sunshades rather than protection from the rain. The term comes from Latin and means "little shade." Because they were expensive, umbrellas also came to signify social status. The pope was never seen outdoors without a canopy of some sort above his head.

By 30 April, Vasari was in Bologna, as he wrote Borghini: "To tell you the truth, the more my eyes open, the more I'm confirmed in my opinion that there in Florence we have the greatest attention paid to our art, with the best artists and better quality than elsewhere."

Vasari's company was traveling in style, drawing attention wherever he went (with people hoping for a handout following him, as he says, "like crazies"). In his self-portrait from these years, he wears an elaborate gold chain with a coral medallion over his dark robes, and holds an architect's dividers rather than a paintbrush. Architecture was not only the most complex and expensive of the arts but also the neatest. Paint could splash and get under the fingernails, and sculptors were always powdered with marble dust, which could also cause respiratory problems. Vasari is perfectly clean, perfectly dressed, and perfectly composed. Benvenuto Cellini's nasty remarks about his personal hygiene (dirty claw-like fingernails to scratch his extensive psoriasis, as well as his bedmates) are a world away and refer to a time long past.

From Modena, Vasari's grand tour brought him to Parma, Reggio, Piacenza, Pavia, and Milan. The second edition of the *Lives* would

devote an entire section to new artistic developments in this part of northern Italy, the regions of Emilia-Romagna and Lombardy. He drafted a preface for that specialized section:

> In this part of the *Lives* that we are writing now, we will make a brief anthology of all the best and most excellent painters, sculptors, and architects in Lombardy up to our time. . . . As I am not able to write a *Life* for each individual, it seemed enough to me to discuss their works, which I could not have done, or made any assessment of them, had I not seen them first. And because between 1542 and the present, 1566, I had not traveled the length and breadth of Italy as I had before, nor seen these works and others that in the past twenty-four years have grown greatly in number, I wanted, as I neared the end of this work, to see these things and judge them with my own eyes.[3]

For the most part, that judgment confirmed what he had already written to Borghini: Florence and Rome were the true centers of modern art. The Lombard artist Girolamo da Carpi, for example, regretted not having come to Rome earlier in his life, where he could have studied the works of the ancients, and of Michelangelo and Raphael, rather than Correggio, the master painter of Parma, who had a pleasing soft style, but lacked *disegno*.

The real problem with the Lombards, however, ran deeper. They were descended from northern European invaders who swept into Italy in the seventh century, distinctive for their long beards (*Longobardi*, their Latin name, describes this distinguishing feature—even Lombard women tied their hair in front of their faces, to look like beards, when they lined up for battle alongside their men). They were neither Etruscan nor Roman, let alone Greek. The Tuscans considered them pure barbarians, and Vasari thought that their art showed it. On 9 May, he wrote Borghini from Milan to describe his feelings about we would call Gothic architecture:

We took off for Pavia, where I saw all the things the Goths have done. I observed many things, but I drew nothing, because there's nothing worth drawing. This Monday I was at the Charterhouse of Pavia, a grand and worthy thing, but carried out by persons lacking *disegno*; however, they were diligent and put in a great effort and achieved impossible things.[4]

The charterhouse of Pavia is indeed "a grand and worthy thing," an enormous, ornate façade that is difficult to dismiss, no matter your feelings about Gothic architecture. When most people think of Gothic today, they think of French churches, like Notre Dame de Paris or Chartres, which date from the same period. But Gothic architecture in Italy responded to a sunnier climate; there was no need for gigantic windows to admit every last glimmer of daylight. And the ruins of Roman antiquity provided an ever-present model. Buildings like the charterhouse of Pavia, or Orvieto's magnificent cathedral, do not have flying buttresses (the stone arms that support the walls of churches like Notre Dame), and they are clad in white, green, and salmon-colored marble panels, as opposed to a single shade of stone. Stained glass and statues do feature, but they reflect the legacy of antique art, sometimes with shallower geometric patterns in marble inlay, sometimes, as at Orvieto, by sculpture that looks almost classical.

Gothic art as we define it was not created by the Goths, who invaded Italy in the fifth and sixth centuries and were followed by the Lombards. (In fact, the Gothic general Theodoric built a classically inspired rotunda in Ravenna.) The style developed in France from classical roots and came down to Italy in the twelfth century. It can be found as far afield as Milan, Naples, and Sicily, all places with a strong French (or Norman) influence, in the cathedrals of the merchant cities of central Italy such as Pisa, Lucca, Siena, Florence, and Orvieto, and in a few places in Rome itself.

For a Renaissance architect from northern Italy like Cesare Cesariano, the Gothic cathedral of Milan was perfectly acceptable as an

illustration for his edition of Vitruvius, because it exhibited all the qualities that the ancient Roman writer had prized in good architecture: stability, utility, attractiveness. Even the great Raphael, who termed Gothic architecture the "German style," admitted that it had its own good order and design, although he remarked that pointed arches were slightly inferior structurally to the round arches favored by the ancient Romans.[5]

What, then, did Vasari and his Renaissance aesthetics dislike so intensely about a style he described in the introduction to the *Lives* as "barbarian" and "monstrous," "devoid of order," wailing, "All Italy is filled with their abominable erections." Benvenuto Cellini, who normally loved to disagree with Vasari, was happy to concur that "architecture [had been] crippled and wasted at the hands of the Germans."

Their prejudice had little to do with aesthetics. The Gothic was "other"; it was northern, foreign, old-fashioned (but not old enough—had it been Etruscan, and therefore local and storied, then there would have been no objection), and its elongated columns exceeded the range of proportions recommended by Vitruvius. Ironically, however, the glorious heights of Gothic interiors did leave a lasting impression on these architects of the classical revival: all over Rome, for example, they raised the rooflines of Early Christian and medieval churches. After these lofty Gothic spaces, classical spaces suddenly seemed much too squat.

In the sprawling, prosperous monastery of San Benedetto Po, Vasari saw a copy of Leonardo's *Last Supper*, as he noted in his account of the Lombard painters:

> In the same place there is an oil painting by the hand of a certain Friar Jerome, a Dominican lay brother, portraying the beautiful Last Supper that Leonardo da Vinci made in Santa Maria delle Grazie in Milan, reproduced, I tell you, so well that I was amazed. And I gladly make note of the fact, having seen the original in Milan this year of 1566, in such bad shape that you

can't distinguish anything any more except a dazzling blotch. And so the piety of this good monk will always bear witness in this part of the world to the excellence of Leonardo.[6]

This otherwise insignificant-seeming aside bears more weight when we consider Vasari's preservationist tendencies, particularly in the case of Leonardo. We learn that the famous *Last Supper* was already in a sorry state, mere decades after it had been painted (the main culprit was Leonardo's relentless toying with materials other than the tried-and-true tempera paint on wet plaster—painted in *fresco secco*, on dry plaster, the *Last Supper* began to flake off its wall almost immediately). But we see Vasari's appreciation that a good copy has been made, which allows people to "bear witness in this part of the world to the excellence of Leonardo."

If not for Vasari, we might also have lost track of some of the very few female artists of the Renaissance. In Cremona, Vasari stopped to visit Sofonisba Anguissola, and three of her six sisters, Lucia, Minerva, and Europa, for whom he had words of high praise: "This year in Cremona I saw in her father's house a painting by her hand made with great diligence showing her three sisters playing chess, and with them an old housemaid, with such diligence and attention that they truly seem to be alive and missing nothing but the power of speech."[7]

The Anguissola family belonged to Cremona's aristocracy, as we can see from the painting Vasari described, still preserved in the Narodowe Gallery, Poznań, Poland. The sisters' status is indicated by their gorgeous brocades and the lace at their collars and cuffs, not to mention the fact that they have the leisure to play chess and study painting. Lace was just beginning to appear in Italy from the Low Countries, and the Anguissola girls may well have tried their talented hands at making it. Unlike most of her male colleagues, Sofonisba paints textiles with an accuracy born of knowledge (Italian men liked to look fashionable, but were unlikely to study the intricacies of clothing design). Their father, Amilcare Anguissola, ensured that

his daughters had a superb education and promoted their skills in the arts without fearing that a career would compromise their marriage-ability; high birth granted them a certain degree of independence. Sofonisba traveled to Rome to meet Michelangelo and eventually became a court painter to King Philip II of Spain. There she married a Spanish grandee, with whom she moved to Palermo in 1528. Two years later, a recent widow, she fell in love with a sea captain en route to Genoa and married him. The marriage would last for forty years, until her husband's death in 1620. Her career continued to thrive. In 1624, at the age of ninety-two, she sat for a portrait by the young Antony van Dyck during his stay in Genoa. She lied about her age, claiming to be ninety-six, and Van Dyck's portrait confirms what he also said in words: this remarkable woman was still sharp as a tack.

Sofonisba had already shown up in Vasari's discussion of another woman artist, Properzia de' Rossi of Bologna, who died in 1530 and had merited a *Life* of her own in the first edition. Giorgio's prefatory words are quite poetic:

> Nor have [women] been ashamed to put their tender white hands to mechanical things, and amid the coarseness of marble and the roughness of iron to follow their desires and bring fame to them-selves, as did our Properzia de' Rossi, a young woman talented not only in household matters but in infinite forms of knowledge that are the envy of men as well as women.[8]

Properzia could carve tiny figures into a peach pit (some of which still survive in the Medici collection). These examples of a once-admired art form were "executed so well and with such patience that they were singular and marvelous to behold, not only for the subtlety of the work, but also for the grace of the little figures that she made in them, and the delicacy with which they were distributed." One of Properzia's most intricate works involved carving "the whole Passion of Christ, wrought in most beautiful carving, with a vast number of

figures in addition to the Apostles and the ministers of the Cruci-
fixion." Vasari was astounded that a woman could also hew marble,
considering "their little hands, so tender and so white."

Not surprisingly for so unconventional a figure, Vasari credits
Properzia with a volatile temper and an active love life. He would
not live to know, much less write, the full biography of Sofonisba
Anguissola, but her adventures would have amused him immensely.

From Cremona, Giorgio began to head homeward. It was time to
finish the second edition of the *Lives*.

24

SECOND
LIVES

V ASARI RETURNED TO FLORENCE IN JUNE 1566 WITH
two urgent projects. One was, of course, the *Lives*. The other
was an architectural challenge he had taken on three years earlier:
designing a dome for the church of the Madonna of Humility in Pis-
toia, a commission he termed an "opera importantissima"—a work
of the first importance. The church had become a significant pilgrim
sanctuary in 1490 when its frescoed altarpiece of the Madonna report-
edly began to weep—out of despair, it was said, at the city's vicious
family feuds. Pistoia was known for violence—the stiletto dagger was
said to have been invented there. Lorenzo de' Medici had solicited
competitive plans to expand the little fourteenth-century church into
an impressive basilica. Giuliano da Sangallo won the competition,
but dropped the commission in 1494 when the Medici were expelled
from Florence (Lorenzo himself had died in 1492). Responsibility
passed on to a local artisan, Ventura Vitoni, a skilled woodworker
who specialized in the ornamental inlays called *intarsie*.

As it turned out, the job may have been slightly beyond Vitoni's
talents. Nearly a quarter century later, he had completed the drum
of the cupola, but when he died, in 1522, the dome itself was still a
yawning hole. For the next forty years nothing happened.

The long delay may, however, have been a blessing in disguise.
By the time Duke Cosimo assigned the project to Vasari in 1563, a
generation of young architects had trained in Rome on the construc-

tion site of St. Peter's Basilica, both demolishing the old Late Antique church, a marvel of Roman structural engineering, and building its magnificently domed replacement. The most experienced of all these seasoned architects was surely Antonio da Sangallo the Younger, Giuliano's nephew, who had worked with Bramante, Raphael, and Baldassare Peruzzi on St. Peter's before becoming chief architect in his own right (Michelangelo took over the position from Antonio when the latter died in 1546). Sangallo's massive wooden model of his design for the basilica still survives today in splendid condition. Shoulder high, it opens out on hinges to expose its interior, allowing us to compare it with what was eventually built on the design of Michelangelo and Giacomo della Porta. Vasari's training and his friendships in Rome gave him access to four decades of collective engineering and design experience that enabled him to bring the dome at Pistoia to completion in only five years.

The dome of Pistoia provides a perfect example of the way in which Vasari put his theoretical, historical knowledge to practical use. It was a very particular, forward-looking form of research, for his methods were remarkable for their range, from poring over drawings, books, and works of art and architecture to personal interviews with people from every level of society. Time and again, his historical researches presented him with the answer to a contemporary problem. He learned from history and profited from it—no need for him to reinvent the wheel.

This was another way in which Vasari was remarkably forward thinking. There was, of course, an ancient tradition of historians (Pliny, Tacitus, Herodotus) who drew moral lessons from history. But Vasari also plumbed history for practical information on matters like artistic and engineering technique.

One tangible embodiment of Vasari's interest in learning from past masters was his lost *Libri dei Disegni*, which functioned as a neat parallel to his *Lives*. They began as twelve large folio volumes of blank paper, into which Vasari pasted drawings by those he admired, as he

was able to collect them: a sketch by Giotto here, a design by Raphael there. Then he added his own drawings, modeled on the style of the master featured on that page, to the margins around the original drawing. Part homage, part historical lesson, part competition (can I draw in Raphael's style as well as he did?), it is an object lesson in what he was doing in his *Lives*, a portable (if twelve large volumes can be called "portable") museum at a time when museums were just developing as dedicated spaces to preserve physical objects (the first public museum was probably the Capitoline Museum in Rome, founded in 1471 by Pope Sixtus IV).[1]

But much as Vasari enjoyed his researches, he did need to keep on top of his extraordinary artistic workload. At the end of July, he complained to Borghini about the heat and the number of his commitments:

> I greet you with this heat and know that you aren't any cooler, because the village cicadas have told me so—nonetheless, stay put at Poppiano [Borghini's villa in the Chianti region], stay away from Florence, and while you're there, think of me . . . to tell you the truth I haven't felt well since you left, I'll come to see you one day by and by, if it rains.[2]

By mid-August, seasonal thunderstorms had swept away the heat, but the torrid summer still took its toll: his mother-in-law lay dying in Arezzo. "I was planning to go up there," he wrote Borghini on 17 August, "but La Cosina's mother has had extreme unction, and I've put it off in order to avoid the funeral." We do not know how the Bacci family felt about Giorgio; he had produced two children with Maddalena out of wedlock, and then married La Cosina after Maddalena died. But we can guess that Signora Bacci may well have taken a dim view of her son-in-law, given his tangled, and not entirely compassionate, relationships with her daughters.

At the Medici court, on the other hand, Vasari was as welcome

under Francesco's regency (he began as regent in 1564, when his father stepped aside to let him carry the major workload of rule) as he had been with Cosimo, and he regularly called upon the young duke at breakfast. Typically for a man in his position, Francesco dined in public, in a high-backed chair with a canopy over it, with the door to his chamber left open so that any proper personage could enter with a petition. In Vasari's case, the petitions often involved money. He may have been by far the leading artist in Florence and a favorite of the court, but he never knew when he would be paid and how much he would earn aside from his basic salary. He rarely established prices beforehand by contract, at least not with his chief patrons, the popes and the Medici dukes.

Contracts between a master artist and a patron could be highly specific. Not only was the subject matter dictated, the dimensions of the work and the price fixed, but iconographic elements that were important to the patron were specified. For example, a commission for a Dominican church might require the inclusion of Saint Dominic in the background, while the Jesuits might wish to have the emblem of their order, the letters IHS, appear in the painting. Also specified were the number of "heads" (faces) included, because more faces, considered difficult and time-consuming to do well, would cost more. If a work were as elaborate in its iconographic scheme, then a scholar or theologian might design all or most of the *invenzione*, as Paolo Giovio and Borghini had sometimes done for Vasari. A time frame would also be specified, but it was understood to be flexible, or at least it had to be flexible for a great many artists, at a time when war or plague could provide setbacks, and when more influential patrons could call an artist away.

Contracts were sometimes funny, and often telling. Luca Signorelli specified in his contract to fresco the chapel of San Brizio at Orvieto Cathedral that he would receive all the local white wine he could drink (what we now call Orvieto Classico, a favorite, since the time of the ancient Romans). Luca knew a good thing when he saw it.

Vasari would regularly ask for money, but rarely for a specific amount. The promises of payment he received from his patrons could be equally vague. On 31 January 1567, he wrote to Cosimo with an outright request for money, moving in and out of formal speech with a man who was a superior, a monarch, and at the same time a friend:

My most Illustrious and Excellent Lord,

Giorgio Vasari, your Lordship's most humble and faithful servant, having repeatedly commended himself viva voce to Your Most Illustrious Excellency, [asking] that his many labors be recognized, you told him that you would do so, and with this pledge he finally requests a payment of whatever amount should please Your Lordship, so that he, faced with resuming work on the façade of the Great Hall, may complete what is left more effectively with the help of Your generosity, and travel on to Rome and back with a spirit eager to put an end to so great a project, declaring that any sign that Your Lordship should make, however small, will seem great indeed to him, knowing as he does that Your Lordship has always helped him with endless favors, and shown him in what great regard Your Lordship holds his faithful service and his talent, on which he calls in Your service, as he had said, even unto death.

And because Your Lordship knows that Giorgio the petitioner is already old and needs help for many reasons, that he has nephews and nieces and poor relatives, he commends himself to you praying Our Lord God that He will keep you well and happy.[3]

On the bottom of the letter, Cosimo or, more likely, one of his officials, has written instructions: "Let him go to Rome and come back, for His Excellency will not fail him, and in the meantime let him say what he wants, because when he returns he will find his case dealt with. Granted the 18th of February 1566."[4]

By the same process of constant petitioning, Vasari first acquired a rental house in Florence on Borgo Santa Croce in 1557 and then,

two years later, managed to have the rent waived in perpetuity. The duke was not particularly stingy. He simply needed constant pushing because he had so many possible ways to spend his money. Yet Cosimo couldn't afford to spend his money unwisely. Like King Philip II of Spain, although on a much smaller scale, he was building a navy to protect the Tuscan coast from pirates and explorers from the Ottoman fleet, who had their eyes on Livorno, the new port he was building south of Pisa.

The financial woes of Giorgio Vasari were common among highly successful painters. Heads of state may have led to prestigious commissions, but they tended to pay less reliably than merchants like Bindo Altoviti, whose reputation hinged on prompt movements of money. King Philip II of Spain commissioned an endless stream of paintings from Titian, for example, but he actually paid the artist on only a single occasion. The Venetian master continued to send oil paintings to Madrid, because the publicity was priceless, but not all the pictures he sent were great, or by his own hand rather than that of his studio assistants. Philip had little way of judging the difference. He loved looking at art, but he spent what money he had on war and on his grim gray palace, the Escorial. Considering what happened to his Invincible Armada, wrecked in a storm off the English coast in 1588, he would have made a better bargain by paying Titian what he was worth.

Vasari was too shrewd to rely entirely on Cosimo for financial support. That is why he went to Rome in the spring of 1567, with, as we saw in the letter cited above, the duke's blessing—the trip allowed Cosimo to put off paying Vasari for another while. For Pius, he created a temporary structure, what he himself called a "macchina grandissima," an immense machine, which was a sort of temporary triumphal arch intended for the church of Santa Croce del Bosco. The impressive structure included over thirty pictures, and it was dismantled shortly after it was put into use. He declined the invitation to build a new chapel for the pope, since it would have taken him away from Florence for too long.

He also provided Pius with artistic advice. Pirro Ligorio, architect to St. Peter's after Michelangelo's passing in 1564, had new ideas for the basilica that would have deviated from Michelangelo's plans. Vasari intervened with the pope to get Pirro dismissed and to maintain Michelangelo's architectural program. Thus, Vasari acted as an early guardian of his hero's legacy, much as private societies today (the Calder Society, the Warhol Society) safeguard the legacy of modern artists.

Pope Pius V certainly saw Vasari as Michelangelo's successor and his "repository of all secrets," a description that Vasari cultivated. It must have delighted him when the pope asked him to lecture to the Fabbrica di San Pietro ("St. Peter's Factory," the team of workers who maintain the building and its surroundings) on how best to carry out Michelangelo's plans.

Whenever builders began (and begin!) digging a foundation trench in Rome, antiquities came to light. Most of these objects were sold off for a tiny price. Both Pope Julius II and Lorenzo de' Medici had been avid collectors, who ensured that the most impressive discoveries went straight into their own museums. Cosimo continued the tradition, as did his son Francesco. Pope Pius V was more inclined to sell off the Vatican's pagan statues than to keep them, and the Medici took advantage of the opportunity.

During this visit to Rome, Vasari saw two fauns that had been unearthed during restoration work, "about the same size as the Bacchus of Sansovino, inexpressibly beautiful." Knowing how Pope Pius felt about ancient statues, he wrote quickly to Duke Francesco, urging the young regent to buy them for the Medici collection:

I have found two statues in the round of nude Fauns, . . . and they satisfy me as much as anything I've seen, which isn't much. Because here they're more interested in blessings than statues, and whoever wants to eat wants bread, not marble. Hence I think you can get them for less than 100 scudi apiece. If I were rich, I'd

snap them up, but for Your Excellency they seem to me a divine decoration for a room. Let me know your thoughts, and if I've already left Rome, I'll leave it to the Ambassador. Nor do I have any doubt that so long as this pope lives, the statues will be available, along with many other things, which I have noted here.[5]

Vasari also persuaded the duke to buy the ancient statue called the Arrotino, the Knife Sharpener, once the pride of Agostino Chigi's collection.[6]

The Uffizi Gallery today contains an extensive gathering of ancient sculpture, mostly displayed along the main corridors of the U-shaped building. Most visitors pass by the antiquities, their attention focused on the extraordinary paintings. But ancient works played a definitive role in forging the whole Renaissance sensibility. Recently, therefore, the Uffizi has begun to concentrate more attention on its ancient collection and its relationship to the formation of Medici taste.

As we have already seen, Vasari had little enthusiasm for the new projects in Rome. The austerity of Pius had made itself felt. As he declared to Bartolomeo Concini, the ducal secretary in Florence,

> Have pity on me, it's as if the sun of the splendor of those Lords, our shared patrons, blinds the great things here which are reduced to smoke, so diminished are they by the stinginess of life, the mediocrity of dress, and the simplicity of so many things. Rome has fallen into great poverty, and it's true that Christ loved Poverty, and wanted to follow her; well, soon Rome will become a beggar.[7]

Artists in Rome, as we noted before, faced the difficult problem of reconciling a Renaissance style inspired by ancient art with the new religious strictures imposed by the 1563 Council of Trent (and a notably strict pope). Vasari, as it turned out, had contrived ways to bring religious art and architecture into harmony with the council's

decrees, thanks to his friendship with Cardinal Gabriele Paleotti of Bologna, the prelate who bore chief responsibility for the decrees regarding art.

For the great Florentine churches of Santa Croce and Santa Maria Novella, following the council's encouragement to create a single unified space for worship had meant dismantling the rood screen, the architectural barrier that had kept the congregation separate from the clergy since early Christian times (and still exists in Orthodox churches). Duke Cosimo, the pious widower of a pious wife, ordered the remodeling of Santa Maria Novella, the Dominican stronghold, as early as 1565. Vasari describes these changes in his autobiography:

And because it pleased the lord Duke, truly outstanding in all things, not only to construct palazzi, cities, fortresses, loggias, piazzas, gardens, fountains, villages, and other such things, beautiful, magnificent, and useful for the convenience of his people, but also, as a Catholic prince, to build, or to improve and beautify, the temples and holy churches of God, imitating the great king Solomon, lately he has had me remove the rood screen from the church of Santa Maria Novella, which took away all its beauty, and make a new, ornate choir behind the high altar, removing the one that stood in the center of the church and took up so much space. This makes it look like a new church, as indeed it is.[8]

In Rome, Giorgio's advice to Pope Pius about St. Peter's Basilica addressed the same effort to build both beautifully and piously, which basically meant toning down the extremes of the Florentine style, or *maniera*, for Roman audiences. Pirro Ligorio, the Neapolitan architect who had taken over the St. Peter's project, had a deep grasp of Roman imperial architecture, based on his studies of Hadrian's Villa, but his work was too exuberant, fanciful, and inspired by the ancients for the stern old pope. We know him best now from the marvel-

ous pleasure villa he designed in Tivoli for Cardinal Ippolito d'Este, which includes fountains decorated with owls, dragons, and sphinxes, a water organ (which still plays several times a day), waterfalls, and the fertility goddess Artemis of Ephesus, squirting water from her twenty-two breasts. It is easy to see why Vasari, with Paleotti's powerful backing, would have urged Michelangelo's sterner Tuscan style on the pope.

Writing provided Giorgio with another stream of income, but in order to earn money on a book, he first had to publish it, which meant a tremendous expenditure of cash before he ever saw a return. Paper was made of rags and was very expensive, but sixteenth-century paper is also remarkably durable. When the terrible floods of 1966 inundated the Florentine National Library with water and oily mud, the recent books were destroyed. The fifteenth- and sixteenth-century books, on the other hand, are still being washed clean in a painstaking process. When the washing is done, these "libri alluvionati" (flooded books) look almost as good as new.

By the end of 1566, Giorgio had consigned the manuscript of the second edition of his *Lives* to the printer Filippo Giunti the Younger and resigned himself to a long wait. Early modern books were printed in signatures, separately sewn sections of four or five folio pages each. A signature could be altered right up to the moment that the type was set in place, leaving time to correct later sections of a book in press. Often the final pages were reserved for corrections that had already been noticed by copy editors or readers. In Vasari's case, he could spend almost two more years seeking out additional information for his later chapters and working on his own biography, which formed the penultimate section of the book. (The final section, appropriately, was an open letter from "the author to the creators of disegno," addressed as "honored and noble creators.")[9]

At fifty-five, Vasari was considered an old man, but his enormous energy showed no signs of flagging. He begged the painter Taddeo Zuccari to supply more information about his brother Federico when

printing had already begun, confident because contemporary artists came at the end of the book.

A letter to Borghini from 20 September 1567 hints at the trials of dealing with the Renaissance printing industry, including rival printers, Cino and Giunti:

> Cino is fighting with the Giunti, who don't want to have to print these masques, entrances, and triumphs, because it wrecks their workshop [Vasari includes a long description of Duke Federico's wedding in the last section of the *Lives*]. So finally I spoke with the Duke. He says go ahead, but quickly. So I've written to Cino, who went to Le Rose [a villa in Tavarnuzze, south of Florence], and I don't think it will take long to finish everything. I wrote him that I want to give satisfaction, too, with my own biography and everyone else's, but it's hard to see how.[10]

And then, in 1568, the project was done. The new edition sang the praises of two luminaries: Duke Cosimo and the Accademia del Disegno. After a letter of dedication to Cosimo, the 1568 edition of the *Lives* provides a long description of the academy's curriculum, and only then proceeds to the biographies themselves. Much of the text has been carefully revised to reflect Vasari's own position at the artistic center of a stable, efficient monarchy. A large number of new biographies of contemporary artists, Titian notable among them, expand the work to epic scale. As a final touch, Giorgio also provided a list of his own works, declining, with the modesty deemed appropriate for an artisan, to write a full-fledged biography of himself, instead tacking on a "Description of the Works of Giorgio Vasari" at the end of the second edition, which served to include himself but retain a measure of humility.

Giorgio Vasari knew that readers loved stories about artists and their eccentricities, and the second edition was vastly expanded in that direction, from Raphael locked up with his lover in Agostino

Chigi's villa, to Piero di Cosimo's living entirely on hard-boiled eggs, to Morto da Feltre, the "Dead Man" from northern Italy who spent his entire life underground sketching the buried remnants of antique frescoes. The new edition of the *Lives* was even more successful than the first.

The modest tone of the first edition is patently missing from the second. Furthermore, although the text had been corrected, the book still contained errors, not least because it included so much new material about living artists. For example, Gabriele Bombaso wrote to Vasari in December 1572 on behalf of Prospero Clementi, thanking him for the book, but with distinct reservations:

> Yesterday I went to visit Messer Prospero Clementi, who is in bed with a bit of phlegmatic fever. . . . So I thank you in his name [for the mention you make of him]. . . . This much to satisfy Clementi.
>
> To satisfy myself, I need to tell you this in addition: although he may be most grateful to Your Lordship, it seems to me that he has little reason to be grateful to the person who informed you about him and his work, because, to begin with, he comes from Reggio rather than Modena, and has never been or been regarded as anything but a Reggiano.[11]

This confusion between Reggio and Modena, enough to outrage any loyal Reggiano even today, is just the start of the list of errors that Bombaso points out from Clementi's life alone. Clementi may have been grateful for having a biography at all, but his loyal friends regretted that it was largely incorrect.

In the case of the Zuccaro brothers, Taddeo and Federico, the reaction was still stronger. Federico Zuccaro filled the margins of his own copy of the *Lives* with a series of angry notes, dismissing Vasari as "a false friend, who speaks ill without any reason," guilty of "stupid definitions" and "insubstantial gossip."[12] He created his own *Life of Taddeo*

in pictures to counteract Vasari's biography.[13] Zuccaro had a thin skin for criticism, but he also recognized, as a non-Tuscan artist, that Vasari had his patriotic prejudices or, as Zuccaro put it, a "blindness of good taste, and lack of objective judgment about his Tuscans."[14] Raphael, in Zuccaro's opinion, had fallen victim to Vasari's:

> Vice of a sharp tongue, which, where it cannot cast blame, finds a way to diminish the glory and dignity of others. But there is no reason to say what he does in criticizing Raphael, who on the contrary, deserves greater praise and honor for constantly increasing his greatness and mastery, and the excellence of his style . . . more than any Tuscan.[15]

In a letter to the Sienese grandee Antonio Chigi (a Tuscan through and through), Zuccaro wrote with more anger than tact:

> Messer Giorgio . . . never knew how to praise anyone but his Tuscans, good or bad, may God have mercy on him. He had gotten so arrogant because of the patronage of Michelangelo and Duke Cosimo that he turned on anyone who failed to tip his hat to him. And you know how he treated my poor brother, even though, as everyone said, there was not a single Tuscan who could do better than he, least of all poor Giorgio, who could do nothing but work fast and fill walls with figures so that they look as if they're out of place.[16]

Don Antonio, a great-nephew of Raphael's illustrious and indulgent patron, Agostino Chigi, may have found Vasari's ideas about Tuscan superiority perfectly correct.[17]

25

STILL
WANDERING

WITH THE ACCADEMIA DEL DISEGNO FIRMLY INSERTED into the artistic life of Florence, and the second edition of the *Lives* in the hands of readers, Giorgio Vasari had achieved two of his most cherished ambitions. As an artist, however, his most challenging, prestigious commissions came only now, in his late fifties. He would spend the rest of his life, another six years, moving almost constantly between Florence and Rome, with occasional stops in Pisa to check in on his work for the Tuscan naval order, the Knights of Saint Stephen, and in Arezzo, to take care of business at home. The Medici dukes, Cosimo and Francesco, were competing with Pope Pius V for Vasari's services, but, at the same time, his vast web of connections made him a particularly useful go-between for the rulers of Florence and Rome. Like many court artists before him, he also served as a diplomat; by the nature of his work, he met a variety of people from various levels of society, and enjoyed unusually close access to people in power. Vasari kept studios in Florence and Rome, but he traveled so often that he preferred to work with local hired assistants rather than apprentices. Keeping apprentices required staying in one place—the master was expected to house, feed, and teach his charges, and Vasari's shuttling between Florence, Rome, and Arezzo (not to mention frequent journeys to Venice, to remote monasteries, to Pisa, and to places in between) made it logistically impossible to have the large, grounded studio that many of his contemporaries maintained.

In many ways, the Accademia del Disegno became Vasari's real studio, from the moment of its foundation in 1563. Run by his dear friend Borghini, with lectures from illustrious intellectuals like Benedetto Varchi, and chaired by fellow artists like Cellini and the French sculptor Giambologna, the Accademia was the place where Vasari's art lessons, theoretical and practical, were put into practice. Its graduates, for all intents and purposes, were his pupils (although he would not necessarily have taught them face-to-face). The Accademia's first project, organizing Michelangelo's funeral (at which Varchi gave the eulogy), was indicative of the direction the Accademia would take, by teaching the methods and style of Michelangelo. With Borghini at the helm, Varchi providing the scholarly voice, Cellini leading the way in sculpture, and Vasari in painting, it might well have been called the Accademia Michelangelesca.

But Michelangelo's funeral did not meet with universal approval. The Buonarroti family had wanted a modest, small-scale affair, a request that Vasari and Borghini simply overlooked. The death of their hero was simply too great an opportunity to miss. Their motives were not only self-serving; they were eager to celebrate the life of someone they loved and admired with what they felt to be appropriate pomp. But Cellini, for one, refused to be involved once he saw how Borghini and Vasari intended to drive the project.[1]

Cosimo offered the Medici family church, San Lorenzo, for the ceremony. Like Vasari, the duke recognized an opportunity when he saw it: the funeral would not only honor the deceased but also showcase his own patronage of the arts, of Michelangelo, and of the Accademia. The extended ceremony, which included temporary installations of paintings and sculptures and a litany of speeches, succeeded admirably in raising the profile of this new academy. One year later, four leading Venetian artists, including Tintoretto and Titian, wrote to ask for membership. In 1567, King Philip II of Spain, a great collector, wrote to ask for advice about his own palace, El Escorial, in Madrid.[2] In addition to his pioneering achievement as

a writer on art, Vasari thus also played a crucial role in guiding the academic teaching of fine art and art history for subsequent generations.[3] Like its predecessor, the Company of Florentine Painters, the Accademia del Disegno was modeled on medieval confraternities, but it tailored the teaching of art to an increasingly sophisticated modern European state: subjecting it to a more centralized, corporate model that implied not only a "right" way to teach and create art but also a "right" (and suitably Tuscan) style, inspired by the works of Michelangelo.[4] The second edition of the *Lives* serves, in effect, as a textbook for this academy.

Characteristically, Vasari was already planning a third edition of his book as soon as the second edition appeared on the market, but he would not live long enough to see it through.

As always, he kept up a busy stream of letters. Normally these are couched in the highly evolved language of politics and artful flattery, but sometimes they take the form of short, practical instructions. His dealings with his patrons, especially young Duke Francesco de' Medici, can be surprisingly frank. For example, Francesco hoped to save money on the great hall of the Palazzo della Signoria, still unfinished, by employing only a single mason to prepare the room for frescoing. Vasari protested that this was a false economy:

> Wanting to have one mason do everything slows things down, so that you spend more in appearing to save money, and neither my workers nor I can do what needs to be done. But I will continue, given that this is Your Excellency's opinion, because it is enough for me to serve you. Be aware that I am not wasting my time; in truth, slowing down the completion of the Hall matters, because Giorgio is getting older; he's losing his sight, and his strength is wearing down, and death ends every story.[5]

Old Giorgio knew how many artists had died before their major projects were finished—he had written their biographies, after all. He had struggled to retain Michelangelo's plans for St. Peter's after the master's death, and had no intention of leaving his own affairs in such a vulnerable state. When he wrote this letter to Duke Francesco, protesting his old age and weakness, he had completed cartoons for the frescoes in the great hall, the *Battle of Pisa* and *Fall of Siena*, but the walls still had to be painted. His other important work in progress for the Medici, the headquarters for the Knights of Saint Stephen in Pisa, was also unfinished. It may have been impossible for young Duke Francesco to fully appreciate Vasari's sense of life's fragility. But his father, Duke Cosimo, could and did.

In 1569, Pope Pius V elevated Cosimo to the position of grand duke of Tuscany, making him the highest-ranking lord in Italy. (Naples, ruled by a Spanish viceroy, and the Papal States, ruled by the pope, did not count in this tally.) It was not a moment too soon; after a life of intense physical activity, riding long hours on horseback, burdened with heavy armor, the grand duke's body had begun to give way. Cosimo's doctors ascribed his aches and pains to gout, but a recent forensic examination of his body shows that the pain stemmed from arthritis.[6] By contemporary standards, Cosimo would have been a giant, nearly six feet tall, with powerful muscles in his chest, shoulders, and legs; no wonder people found him such a charismatic presence. His mummified body reveals that his worst problem was an acute, premature case of hardening of the arteries. The arteriosclerosis cut off the blood supply to his body and brain, paralyzed his left arm, and weakened his whole right side. In addition to arthritic pain, arteriosclerosis subjected him to increasing mood swings and eventually left him incontinent and unable to speak or write.

Like many widowers who have enjoyed happy marriages, Cosimo longed for female companionship after Eleonora's death. He found it, in 1565, through a discreet affair with a Florentine noblewoman of

twenty-two, Leonora degli Albizzi (whose name perhaps recalled that of his beloved Eleonora). In 1566, the mistress gave birth to a frail daughter who died almost immediately. Cosimo's longtime manservant, Sforza Almeni, who had been with Cosimo for twenty-four years, decided to inform Duke Francesco about the liaison. Francesco and his siblings reacted angrily, and Cosimo took out his discomfiture by killing Almeni with his own hands. Soon afterwards Leonora gave birth to a son, Don Giovanni de' Medici, but in 1567 the couple separated. Cosimo found a quick replacement: another young Florentine noblewoman, Camilla Martelli. Their daughter, Virginia, was born in 1568. Pope Pius, living up to his name, delayed awarding Cosimo the title of grand duke until he and Camilla had been properly married, although her stepchildren ensured that she would never bear the title of grand duchess. On 29 March 1570, the newlywed Cosimo formally became grand duke of Tuscany.

Titles were particularly important to the Medici, because they were not royalty. They were bankers, and their power stemmed from the workaday world. The military title of duke put them into the category of feudal aristocracy, and grand duke implied not just a military leader but a head of state.

The commissioning of magnificent artworks had long been a sign of taste, power, and largesse for the Medici. As the paint and plaster were still drying in the Sala dei Cinquecento at the very moment when the pope summoned Vasari for a prestigious commission at the Vatican, Cosimo conceived a new project that was more profoundly symbolic for the people of Florence than the political bastion of Palazzo Vecchio: painting the cupola of the cathedral of Florence, the interior of Filippo Brunelleschi's dome. The original plan had been to decorate the vast space (nearly 38,000 square feet) with mosaic, and Brunelleschi had built in supports for scaffolding as part of the dome's construction. Ultimately, however, the Florentines feared both the expense of mosaic and its potential weight (they already had experience with the mosaic dome of their twelfth-century Baptistery).

Modern engineers have deduced that weight would not have posed a problem, so well did Brunelleschi design the structure, but the expense would have been astronomical, and there were no longer many workmen skilled in the ancient art. It took Cosimo's flush treasury and firm will to resurrect the idea of a decorated dome, in the more practical medium of fresco.

Vasari may have been feeling his age, but he took up the new challenge with his usual energy. Painting the cupola was not just a matter of combining *invenzione* and *disegno*; it was a logistical puzzle as well. It would require *ingegno*, ingenuity of the sort he had praised in his *Life* of Brunelleschi. Before he could paint the cupola, he had to devise a place to stand.

Michelangelo had painted the Sistine Chapel while standing on a mobile platform that arched across one small segment of the vast oblong space, anchored on the chapel's protruding cornice. Painting the curved interior of a dome presented another challenge altogether. Vasari planned to begin painting from the top down, to avoid dripping on his own work, and this decision made a fixed scaffolding the most practical solution, covering the whole enormous space with a timber frame. It took four months to complete the massive structure, from February to June of 1571.

On September 22, Giorgio's old friend Cosimo Bartoli sent a present from Venice: four pairs of eyeglasses: "God willing, they'll help you."[7] Vasari must have been complaining about his eyesight, because in a letter of 8 September Bartoli had tried to lift his spirits by saying, "I know you lost your eyesight on making little things. Well, now that you're making gigantic things, are you going to lose your spirits too?"[8]

The cupola would be Vasari's final project, and it require all his *ingegno* to sort out the logistics of getting his aged self some hundred feet up in the air to paint it. But before he could begin, Pope Pius summoned him back to Rome. His new assignment involved a space as illustrious as Florence cathedral: frescoes for the Sala Regia, the

"Royal Hall," the opulent reception room for diplomatic visitors in the Vatican's Apostolic Palace.[9] Begun by Antonio da Sangallo for Pope Paul III Farnese in 1540, the sala, which connects directly to the Sistine Chapel, was still under construction when Pius summoned Vasari in 1572 (it was completed only in 1573). It was, in many ways, the equivalent for the pope of the Sala dei Cinquecento to the Medici dukes. An eager Giorgio arrived in four days—a rapid pace for an aging physique.

BETWEEN THE
CUPOLA AND THE
SALA REGIA

For the next months, Vasari shuttled between Florence and Rome, the cupola and the Sala Regia. Deeply engaged with both commissions, he retained his close ties to all three of his major patrons: the faltering Grand Duke Cosimo, Duke Francesco (whose official title now was duke of Florence), and Pope Pius V, who issued an unending stream of new commissions for the artist in Rome. Giorgio's close connection to Cardinal Paleotti continued to guarantee that his work would satisfy the standards imposed by the Council of Trent. His commissions therefore provided a model for other artists to follow at an especially difficult moment, reconciling the inspirational value of classical antiquity with the demands of modern piety. For Vasari himself, however, there were more exacting judges lurking in the halls of the Vatican than Pope Pius V: the ghosts of Raphael and Michelangelo. As he wrote Francesco de' Medici on 7 December 1570,

I have begun work on the first chapel, which is now serving as [the Pope's] bedchamber, because he wants to enjoy it. And I will be quick about it, because there is much to do; in the other two chapels, where the stucco work has been completed according to my design, the number of painted scenes has grown and the stucco work too. But in spite of all this I will make a point of serving him well, because I must: here are Raphael and Michel-

angelo, and for the honor of Your Highness I will try to come up to their level. Already, with God's help, I have made a good start.[1]

The pope certainly liked what he saw, and Vasari was delighted to have been asked, like his heroic predecessors, to decorate official apartments at the Vatican. In a nod to Michelangelo, he forbade the cardinals from sneaking a peek at his works in progress, much as they had been forbidden to look in on the Sistine Chapel a few decades earlier.

In addition to drawing up plans for the Sala Regia, he produced fifty-six cartoons for the papal apartments. And he brought La Cosina to see the pope. On 4 May 1571, he wrote proudly to Francesco de Medici, "Madonna Cosina, my wife, who was here for Lent, has left now, and she received many favors from Our Lord, who enjoyed having her see the whole [Apostolic] Palace, including the places forbidden to women, and she even went into his bedchamber."[2]

Pius also presented Vasari with a knighthood and a set of golden spurs. Ever the pragmatist, Giorgio was particularly pleased with the financial bonus that accompanied his new title as a Knight of Saint Peter: a handsome twelve hundred scudi. With renewed vigor, the elderly artist returned to Florence and finished the fresco of the *Battle of Marciano* in the Sala Grande in a six-week binge that ended on 4 September 1572, a remarkable feat of concentration and his characteristic speed. This was the fresco that stood closest to the former site of Leonardo's *Battle of Anghiari*, the one that features a Florentine soldier bearing a banner with the words *Cerca trova* (Seek and you shall find) upon it. And then it was time to return to Rome.

When the pope finally decided on a subject for the major fresco for the Sala Regia, *Battle of the Turks*, Vasari put on his researcher's hat before donning his painter's bib. He spent time with a veteran of the Battle of Lepanto, Marcantonio Colonna, and other warriors to learn the details of combat, to make his fresco as realistic and accurate as possible. In this way Vasari was something of an investigative journal-

ist. Most artists would imagine the battle (perhaps drawing on other battles that they had witnessed). Interviewing people who had been present, in order to strive for historical accuracy and realism, was new. Part painter, part historian, part journalist, Vasari threw himself into each product with an energy that belied his years.

The most dramatic of the oversize wall paintings in the Sala Regia depicts the crush of galleys in the last clash of the Battle of Lepanto. Another painting in the room shows the moment before, when the Christian and Turkish navies are carefully lined up facing each other in the sea. But once the battle commences, Vasari leaves the idealized bird's-eye view and takes us into the hot, sweaty heart of the fighting. Roman Vucajnk notes that the scene takes place after the formations in which the ships were first lined up to engage the enemy were broken, and the battle plan transforms into a scatter-shot of smaller fights between soldiers on one or more ships. Galleys were not equipped with long-range weaponry, so they had to close on the enemy in order to do any real damage. Vucajnk explains, "Ramming into the enemy was the usual tactic, but also using projectiles like arrows and early naval artillery, until boarding the enemy deck."[3] Galleys would attack head-on, as they would first try to ram, then board the enemy ship by means of a gangplank at the bow. The broadside cannon-fire exchanges of eighteenth-century naval warfare were had not yet come into play. Galleys were maneuvered into combat by rowers, so that swinging broadside would lead to a messy tangle of oars, and loss of control over the ship's movement. Nor did the Lepanto fighters face cannon fire, for artillery was still in its early stages of development. Ships were equipped with cannon, but these were slow to be reloaded, had limited range (a maximum of around 550 yards), and limited accuracy, which meant that they were fired at the last possible moment, and usually only once per battle, because the target galley would try to ram, shoot, or board you before you had a chance to reload.

The Ottomans relied on composite bows. The rain of arrows

would have been a vivid memory, and the primary danger, for a veteran like Marcantonio Colonna, and Vasari covers his painting with them. Historians argue that the loss of so many archers during this battle marked a sharp downturn in the military success of the Ottomans—they had to train a new generation of bowmen to replace those floating face-down in the sea after Lepanto.

Vasari also peppers the painting with arrow-like diagonals, not only from arrows themselves but from the crossbeams of the ships (sails were dropped at the last minute, to remove a combustible target from the enemy), the tilted cross resting on the shoulder of an allegorical personification of Victory (holding a cross and a goblet with Eucharistic wafer inside it, to let us know that a Christian victory was inevitable), and sword-wielding saints (Christ included) up in Heaven, apparently about to lay into the enemy. The classical world is full of stories of gods taking up arms in support of their favorites (*The Iliad* is the most obvious case in point), but the passive, forgiving Christ is not often shown as a warrior. Here, Vasari surely recalls Raphael's warrior saints from the papal apartments and Michelangelo's *Last Judgment* from the Sistine Chapel, he of the eight-pack stomach muscles and raised right arm, about to slap the Devil back into Hell.

The fight itself sparkles with marvelous detail. A soldier crouches as he delicately adds fresh powder to his arquebus, an action that requires preposterous calm and accuracy in the midst of havoc. Compatriots reach out their hands to pull fellow soldiers out of the sea and back onto the ship. The galleys are so tightly packed that one could almost walk between them, and the sea positively bubbles with Turkish dead, so that the newly slain fall atop them, to create a surreal stack of floating corpses bobbing on the waves.

A ROYAL
HALL

P ope Pius died on May Day of 1572, when Giorgio
Vasari had returned to Florence to work on the cupola. Only
thirteen days later, the College of Cardinals elected his successor,
Gregory XIII (he of the Gregorian calendar), who wasted no time
in calling Giorgio back to Rome. Once again, the grand duke and
the duke of Florence let their artist go, for there was no better way
to sound out the new situation in the Eternal City than to ask their
experienced courtier to go and report back.

In his own way, Pope Gregory XIII was as stern a Catholic as
Pius V. When, shortly before his election as pope, he heard about the
massacre of thousands of French Protestants by Catholics on Saint
Bartholomew's Day (23 August 1572, an event overseen by Caterina
de' Medici), he had ordered the singing of the celebratory hymn "Te
Deum Laudamus." In other ways, he was more like earlier pontiffs: he
appointed his illegitimate son to two important positions: castellan of
Castel Sant'Angelo and gonfalonier (standard-bearer) of the Church.

Like Pius, he treated Vasari with great respect, providing the artist
with an opulent apartment in the Vatican Palace that had been occu-
pied up to then by the eminent Polish cardinal Stanislaus Hosius
(who had a wide choice of other places to stay in Rome). Giorgio
was in an exultant mood when he wrote Vincenzo Borghini on 5
December 1572,

Certainly up to now I have found great solicitude from the Pope, and although he is severe and a man of few words, nonetheless he shows that he loves me and holds me in high regard. . . . He evicted the Polish cardinal [Hosius] from the Belvedere so that I could have nicer lodgings, because he is putting me up, and I'm living like a king, with trappings that show his respect for patrons, virtue, and me.[1]

Those trappings included fresco decorations by Federico Zuccaro, but from his new viewpoint as the occupant of such a luxurious suite Vasari had nothing but high praise for his rival's work. No one, he declared, had ever had such favor with a ruler as he had found with Pope Gregory, not even the great Apelles, whose gifts from Alexander the Great had included the right to marry the king's own mistress.

In his old age, secure at last in his own career, Vasari could look at his former rivals with a more appreciative eye; as members of the same generation, they had shared the same training in *disegno* and the same concerns about elevating the social status of art and artists. As colleagues and competitors, they had made Florence and Rome two of the greatest artistic capitals of Europe. When the great Florentine court painter Agnolo Bronzino died on 23 November 1572, shortly after Vasari's arrival in Rome, the news struck hard. He confided his sorrow to Borghini:

I was very sorry about Bronzino . . . and I wrote a letter of my own to Alessandro Allori [Bronzino's pupil], and to tell you the truth, Lord Prior [that is, Borghini], I wept for him. It is a great loss. God help these young people! I hope that art doesn't die out altogether, which I fear. Here there is no one, and there are no subjects; everyone runs away from work. I comforted Messer Alessandro by saying that he would have to carry on the name of that good man, so pleasant and talented, and I will do what I can to support him and compensate for what I have neglected.[2]

Bronzino, born in 1503, was eight years older than Giorgio, and almost the last to survive of the generation of artists that had forged a distinctive Florentine style for the young Duke Cosimo. Michelangelo, Rosso Fiorentino, and Pontormo were all long dead, and Vasari, although younger than all of them, could hardly be described as young any more. A creaky, aging Cosimo addressed letters to him as "magnifico nostro carissimo" ("our dearest magnificent one"), and Vasari was still the top artist in Italy south of Venice, given every honor by the new pope. But no honor could keep his body from slowing down. Travel was becoming more difficult. He had fallen ill as soon as he arrived in Rome, and was forced to delay his first meeting with the pope. Gregory sent his personal physician to care for the ailing artist. Vasari suffered from a chronic cough and found it increasingly hard to climb up and down the high scaffoldings that were an inevitable aspect of fresco painting. In the cathedral of Florence, with Brunelleschi's dome looming more than three hundred feet above the ground, he devised a pulley-and-basket elevator system to bring him up to his working platform. He worried that he would die before completing the commission, and in fact he lived to paint only its uppermost register.

But Vasari, for all his complaints, was still in good physical shape. In early February 1573, when the days were short and snow lay piled in the streets around the Belvedere, he made the traditional twelve-and-a-half-mile pilgrimage of the Seven Churches—only to be reprimanded by Pope Gregory for overexerting himself. He told Borghini about the exploit: "[Gregory] found out that I'd done the Seven Churches on foot, and he scolded me a little, but I wasn't tired in the least, and thus His Holiness granted me remission from my sins."[3]

The devotion of the Seven Churches was a relatively new tradition in Rome, devised by the charismatic priest (and future saint) Filippo Neri, a Florentine three years younger than Vasari, transplanted to Rome in 1534. Although he had wanted to go abroad as a missionary, Neri eventually decided to carry out his work among Rome's sick and

poor. Quickly, however, his cheerful personality, his wide-ranging conversations, and his passionate interests in Church history and in sacred music attracted followers from every stratum of society. The reasons for his popularity are obvious: he turned visits to historical churches into picnics, and put Bible stories to music, composed by, among others, his friend Giovanni Pierluigi da Palestrina.[4]

In 1552, Filippo Neri led the first pilgrimage to the Seven Churches for six or seven people. Within ten years, the numbers had risen to six thousand. Visiting all of the churches in a single day led to a plenary indulgence, full remission of one's accumulated sins. Adjustments to the grueling itinerary made it accessible for the physically frail. Wealthy pilgrims often made the round of the Seven Churches by carriage, and eventually the devotion could be spread over several days. Most people preferred to go in spring or summer, taking advantage of longer daylight hours and warmer weather. That Vasari, a wealthy man of sixty-two, undertook the devotion on foot during the short, cold days of February shows what a persuasive missionary Filippo Neri could be.[5] The day's pilgrimage was accompanied by devotional songs, and ended, in typical style, with a homily, often by Neri himself, and, of course, a convivial meal together.

In addition to settling his soul, Vasari wisely organized his earthly affairs, in anticipation of his death. Although he and Niccolosa never had children, in 1573 he altered his will to divide his goods and properties between five nieces and two nephews. (There is no mention of his own children by La Cosina's sister, which shows how little we really know even about this rather well-documented man.) He left his home in Arezzo, with its garden and its beautiful frescoes, to his brother Pietro's children, with a caveat that they must not alter anything within it—an instruction that preserved it, and allows us to see the house much as he left it. La Cosina received another of his properties. Originally, their family chapel was located in the parish church (*pieve*) of Santa Maria, but in the nineteenth century it was transferred to the Abbey of Saints Flora and Lucilla. This complex began in the

thirteenth century as a monastery on the edge of town, but by Vasari's own day the city had engulfed it, and he had remodeled the church itself on an elegant classical design. This is where his self-portrait with La Cosina has come to rest, the two of them disguised as the saints Mary Magdalene and Nicodemus.

By March of 1573, Vasari was certain that he could finish painting the Sala Regia in time for the feast of Corpus Domini, which fell that year on 21 May. Like most painters of the time, he often painted the faces and hands of the most important figures last, after the rest of the work had been painted by the master and his assistants. With Borghini's help, he also devised an inscription for the fresco that honored both his masters: the pope in Rome and the grand duke of Tuscany.[6]

Three weeks before the dedication ceremony, Borghini, while refining Giorgio's Latin, also advised him to be careful about honoring another head of state in the text of an inscription on display within the Vatican:

> I think that those words Grand Duke of Tuscany, etc. might be an occasion for blame, and so long as things are in flux, I'm not sure it's good to endanger the name of our masters, because, if it were forbidden to mention them, the text would be too open a demonstration, and it would be worse if you had to remove it— and thus in such cases it's better to dissimulate.[7]

We have already seen how praise and blame, that is, the concern for outward appearances, and dissimulation, the careful concealment of one's real thoughts, were the keys to survival in the public life of sixteenth-century Italy.[8] The political situation was always changing and always delicate, so much so that at one point a piqued Gregory considered ordering Vasari to alter the content of one of his frescoes. One of the inscriptions that accompanied the paintings would later be adjusted by Gregory's successor to fit the immediate political circumstances.

A last temptation emerged for Vasari when the king of Spain, Philip II, a great patron of the arts and collector, tried to lure him to Madrid as official court painter, with the enticing salary of fifteen hundred scudi per year (five times his current salary), as well as a separate payment for each picture. Twenty, or even ten, years earlier, he might have taken up the gamble. But now in his sixties, with his friends dead or dying, exhausted and physically shaky, it was no time to move. "I don't want any more fame," he wrote Borghini on 16 April 1573:

> I don't want any more honor, any more stuff, and no more toil and trouble. I praise the Lord for these honors, and I'll gladly return to enjoy what little I have, which will be a great deal for me, now that I've made so many armed conflicts, so many wars, and fought so many competitions with my labors, and also earned all I need to keep me until the grave.[9]

Perhaps he also knew from Titian, who worked for Philip and was almost never paid, that the king rarely kept his lavish promises.

This letter to Borghini shows, too, a Vasari who was slowing his pace, concentrated on finishing his outstanding commissions, rather than starting any new ones. The Sala Regia was dedicated on schedule on 21 May 1573, and both Vasari and the pope were pleased. Vasari went so far as to consider the Sala Regia to be his masterpiece. Although it was meant to rival Raphael's Vatican *stanze* and Michelangelo's Pauline Chapel, the Sala Regia differs radically from both in its focus on recent events. Rather than Raphael's lofty evocations of divine justice and triumphant philosophy, or Michelangelo's biblical scenes of the *Conversion of Saint Paul* and the *Crucifixion of Saint Peter*, Vasari was compelled to paint, as he says to Borghini, "so many armed conflicts and so many wars": *The Massacre of the Huguenots* (1572), *The Battle of Lepanto* (1571), and *The League between Pius V, the Spaniards, and the Venetians* (an alliance that was already dissolving by 1573). The atrocities of Saint Bartholomew's Day were a frustratingly

ugly subject to paint so near Raphael's sublime and uplifting *School of Athens*.

Vasari always had mixed feelings about Rome. It had brought him lucrative commissions, papal honors, and the inspiration for an epoch-making book, but for a Tuscan, especially a Tuscan from the brisk climate of Arezzo, it was hot and crowded and not a particularly pleasant place to live. The Rome Vasari knew best was a constant construction site. Vasari sometimes called Rome by its pejorative *Romaccia* ("rotten Rome"). But as he prepared to leave the city in May of 1573, he was already feeling nostalgic about it. He confided his feelings, as ever, to Borghini:

> My Lord Prior, this Rome is a good Rome for me, it's lifted me out of rags already so many times, and now the blind can see: this is a grand and beautiful hall, and the Lord God in these dangerous circumstances has removed all the assistants who criticized me and by doing this all myself has awarded me all the victories, nor do I have to pay the hangman to flog me.[10]

The same letter mentions a return to Rome the following spring, but perhaps he sensed that the current trip would be his last. He stopped with members of the Farnese family at Caprarola and Orvieto, before catching up with his wife at Castel della Pieve (today's Città delle Pieve) and traveling with her to Cortona, Arezzo, La Verna, Camaldoli, Valle Ombrosa (today Vallombrosa), and finally Florence.

He arrived just in time. By 1573 the grand duke was truly an invalid, leveled by arthritis, largely bed-ridden, his voice reduced to a hoarse whisper, evidently not long for this world. The patron and the painter had been linked for most of their lives. Vasari was eight years older than Cosimo and had seen the murder of Alessandro de' Medici and Cosimo's accession. Aside from Cosimo's wars, Vasari had been present for most of the crucial events of the grand duke's thirty-six-

year reign. Cosimo used Vasari's creations to win contemporary and enduring recognition as a great patron of the arts, a man of cultivated tastes. Cosimo may have founded the Order of Santo Stefano, but it was Vasari who designed the order's church and palace. Now, with both men ailing, Vasari describes their visits: "I've spent this whole holiday with the grand duke, who wants me to be near him, and though he can't speak, he still wants to hear something, and he was extremely happy at the drawings I showed him of the great cupola."[11] There would always be a profound social division between them, but there were few people a grand duke like Cosimo could consider his true friends. And he valued the artist's company to the end.

Vasari shuttled between his patron's bedside and his lofty perch inside the dome of Santa Maria del Fiore. The toughest part of his commission was the climb up to the scaffolding. He could have meals sent up by pulley basket, and a chamber pot sent down in a similar fashion, but he still had to ascend and descend those three hundred vertical feet in order to do his work.

Giorgio's last two letters date from 18 July 1573. Fittingly, they both deal with Pope Gregory and Grand Duke Cosimo. To Vincenzo Borghini, he writes of a long visit to the Palazzo Pitti: "Yesterday the grand duke was greatly contented, because I stayed four hours to show him that drawing; he marveled at it." He signs this final letter to his old friend "Tutto Tutto Tutto Vostro"—"totally, totally, totally yours, Sir [Cavaliere] Giorgio Vasari."[12]

Despite his desperate condition, Cosimo survived for almost another year, until 24 April 1574. Giorgio Vasari died shortly after his patron, on 27 June. He was sixty-three years old. The Florentine diarist Agostino Lapini noted his death among those of luminaries like Cosimo and Archbishop Antonio Altoviti, Bindo's son:

On June 27, 1574, Giorgio Vasari of Arezzo died, an excellent architect and painter, who was the architect of all the new mag- istrates' offices, to the front and side of the mint of the city of

Florence. He also painted the beautiful balcony and the sides of the great hall in the duke's palace and began the painting of the Florentine cathedral, getting as far as those kings beneath the lantern, and of many other beautiful things that are here in Florence.[13]

Amazingly, Lapini has entirely omitted the *Lives* from Vasari's curriculum.

Giorgio was buried in a chapel of his own design in the Romanesque parish church of Santa Maria in Arezzo, which was dismantled and taken to the Abbey of Saints Flora and Lucilla in the nineteenth century. Eventually the male Vasari line died out altogether, and the family properties reverted to the Confraternity of Santa Maria della Misericordia, which often received the goods of families with no male progeny. His greatest legacy, however, is clearly the one he has transmitted to posterity through the combination of art, architecture, biography, art theory, and the invention of an entirely new discipline: the history of art.

THE LEGACY
OF *LIVES*

Vasari's death was merely the beginning of the life of his *Lives*. Although he is often called the first art historian, he himself traced the history of art back to the ancient Greeks, the Egyptian and the Etruscans. Today, thanks to modern dating techniques, we can project that history back tens of thousands of years, when the earliest humans still lived in caves.

What first prompted humans to produce art? Was it some primal urge to create? The pivotal element in a proto-religious ritual? In part, the answer depends on what we mean by "art": so far as we know, neither the word nor the developed idea existed in the ancient or medieval world. In fact, the modern conception of art, the "invention" of art as we conceive of it today, owes its popularization, if not its origin, to Giorgio Vasari.

A distinguished historian of art, Salvatore Settis, writes, "Art history . . . presupposes the modern notion of 'art,' a cultural creation that came about in the 18th century, and that has its heart in artistry as a value and in the delimitation of 'art' to creations of the highest quality."[1] Settis is correct to say that the modern definition of art became more universal in the eighteenth century and solidified still further with the creation of academic art history in the nineteenth century. But the concept of art in its modern sense was already present in Vasari's writing. It simply took a few hundred years before the general thought patterns of intellectual Europe, with the Enlighten-

ment, caught up with Vasari's ideas and used him as the starting point for new viewpoints on art and culture.

If Vasari was the first art historian, for all his flaws and lacunae, what of those who followed him? There are too many to name, and to set aside the advances offered by each would feel a bit too much like a shopping list. Suffice it to say that art history developed Vasari's thought in several directions, each branch sprouting new shoots and leaves with the work of new theoreticians. The great art historian Ernst Gombrich summed up his own career by observing, "I see the field of art history much like Caesar's Gaul, divided into three parts inhabited by three different, though not necessarily hostile tribes: the connoisseurs, the critics and the academic art historians."[2] To Gombrich's three we might add a few more categories: the artists themselves, often unreliable but always loquacious on the subject of art and wont to see their work either as being in conversation with art history or as a direct rebellion against the past (which of course is also a "conversation" of a sort, by way of rejection); priests and politicians, to whom art is a tool of propaganda and power; as well as more modern categories, like the neuroscientist, who plumbs the mechanics of the mind to see what effect art has upon it.

Each of these elements extends from Vasari, who was a historian, a connoisseur, and a critic, while also practicing as an artist whose work was certainly, delightedly in conversation with the past. He was even engaged with clergy and politicians of his time, as a member of court—all roles in one. Thus the legacy that outlived Vasari, passed down through his *Lives*, is the "invention" of the study of art in an organized, logical, narrative way, based on iconographic analysis of artworks and closely linked to the personal biographies of the artists who made them.

A flurry of artist-biographers followed most directly in Vasari's footsteps, including Karel van Mander, whose 1604 *Painter Book* was a corrective attempt to add the wonders of northern Europe to the art historical dialogue, an entire region that Vasari largely ignored.

Seventeenth-century authors made a distinction between "academic" art (like that produced by graduates of the Carracci Academy in Bologna) and the revolutionary work of artists beyond the academy, particularly Caravaggio.

The most tangible relic of Vasari's ideas about how art should be categorized and displayed came down through the person of Dominique Vivant Denon (1747–1825). A French artist and art historian, best known as Napoleon's art adviser, and the first director of the Louvre in Paris, he oversaw its conversion from a royal residence into an enormous museum that housed both the French royal collection and the tens of thousands of artworks looted by Napoleon's armies and sent to Paris for display. He was one of the first scholars of the modern era to appreciate pre-Renaissance Italian artists (then called "primitives" and sidelined, thanks to Vasari's prejudices). He is also responsible for the dramatic curating schemes still used in museums today. The ideas that museums should be curated by artistic style, period, or region and that the location of a painting or sculpture should be displayed so that it will be "framed" by a doorway are Denon's legacies.[3] But within an art world that revolved around Paris, Vasari himself was not widely read.

Born into the art world that Denon created, and the museums that rose in the wake of the British Museum and the Louvre, Jacob Burckhardt (1818–97) is widely considered the first professor of art history in a modern sense, and he might be considered the originator of academic art history and theory. He also was a great proponent of art of the Florentine Renaissance, and therefore continued to promote Vasari's own pro-Florentine and Tuscan agenda. Burckhardt, and the English enthusiasts of Florence, rediscovered him: the first major modern edition of Vasari with annotations and notes correcting his many errors appeared in 1868, published in Italian by Gaetano Milanesi. Many others would follow, in dozens of languages.[4]

Another major shift in the interpretation of art came in the form of psychoanalysis, which, like Vasari, used biography as a spyglass

through which to examine the artist himself—specifically his personality and sexual preferences. Sigmund Freud explored Leonardo's art as a clue to his sexual life, and published a study of Michelangelo's *Moses*, which he was inspired to write after reading Vasari. Freud's colleague Carl Jung (1875–1961), did not write about art per se, but his writings have been used by art historians to further their interpretations of artworks. A Swiss psychiatrist, Jung is best known for his writing on archetypes: categories of images (horses, decapitations, columns) that have specific coded meanings in our subconscious, tying in to Vasari's own sixteenth-century language of symbols.

From symbols imbued with meaning to finding symbols in the traces of an artist's hand, connoisseurship found a public face in Bernard Berenson (1865–1959). Born as the Lithuanian Jew named Bernhard Valvrojenski before his family moved to Boston, Berenson transformed himself into perhaps the best known of all art historians, communicating his passion for the Italian Renaissance to a new audience of affluent Americans in a series of scholarly studies and in personal advice to collectors. For the first half of the twentieth century, he embodied the ultimate connoisseur. Charming and handsome, Berenson cultivated an almost mystical aura about his expertise, and his ability to recognize an artist's hand depended not on scientific analysis of empirical data but on a sort of profound empathy. Of course, the fact that he earned a percentage of the sale price for works he certified as authentic could have led to corruption, but his main business partner, the rapacious art dealer Joseph Duveen, tried and failed to lead him astray.[5] Berenson and Duveen are two of the earliest Jews who studied and loved Christian art (though Berenson would convert to Episcopalianism and Duveen was not observant), the forefathers of the rich vein of Jewish art historians who continued to write eloquently on Catholic art.

Berenson's *The Drawings of the Florentine Painters Classified, Criticised and Studied as Documents in the History and Appreciation of Tuscan Art, with a Copious Catalogue Raisonné* (two volumes, published in 1903)

continues in the vein of Vasari's *Libri dei Disegni*, the books of draw-
ings. Berenson, four centuries later, was the first modern art historian
to focus specifically on drawings as his point of entry into the world
of the Florentine Renaissance.

Berenson's career also signals a moment when the history of art
began to develop as a distinctive academic discipline, but this fascinat-
ing story, intimately connected with the mass emigration of Jewish
scholars from Fascist Europe to Britain and the United States, is so
large and complicated that tracing it would take us far away from
Vasari and his legacy. There are now an estimated half a million stu-
dents in the United States alone, per year, studying art history.

So far we have dealt with the study of art history through tradi-
tional means: centuries of scholars who worked as Vasari had shown
them. Archival research, gathering stories in bits and pieces, closely
examining and analyzing artworks, linking the biography and cul-
tural surroundings of the artist to the interpretation of the artwork.
But where did the study of art go from here? These traditional
methods have only recently been complemented by a rather higher-
tech approach, engaging science as a means of solving art historical
mysteries that have eluded connoisseurs, critics, stylistic analysts,
and archival researchers.

Major steps forward in history sometimes come down to luck, to
finding a picture, a manuscript, or an archival document that has
somehow eluded past scholars. Art history, inevitably an interdisci-
plinary field of study, often progresses when someone from another
field (theology, philosophy, chemistry or mathematics) approaches art
with fresh eyes. Mathematicians have built virtual models of Piero
della Francesca's paintings, to see just how remarkably precise and
complex was his use of painted perspective, and a doctor teamed with
an art historian to examine Bronzino's *Allegory of Love and Lust* to
identify an allegorical personification of syphilis.

Likewise, two scientists who only later in life turned to art history,
Maurizio Seracini, whom we met in the introduction to this book, in

his tracking of Vasari's *Cerca trova* clue to find the lost Leonardo *Battle of Anghiari*, and Martin Kemp, a former Oxford art historian and one of the world's leading Leonardo specialists, have made progress, thanks to their scientific approaches, where more traditional historical research methods have not. Seracini's use of neutron gamma-rays to see through walls and hunt for lost paintings employs technology that would be unfamiliar, or perhaps intimidating, to traditional archive-and-intuition scholars. Kemp is best known for his work in the science of optics in art (*The Science of Art: Optical Themes in Western Art from Brunelleschi to Seurat*), considering physically how the eye perceives art, what happens in the brain when we see art, and how artists harnessed this and used it to their advantage. Kemp combines traditional methods, like connoisseurship, with a comfortable grasp of scientific technology.

Perhaps there is a poetry to this. Vasari, the first art historian, also had a scientific streak in him. He was an architect who used inventive methods—for instance, his attempts to rig a pulley system to get him up to and down from the cupola of Santa Maria del Fiore, so he could paint the *Last Judgment* without having to hoof his sixty-year-old bones up three hundred feet and down again several times a day. And as Vasari taught us, Brunelleschi's greatness came from his invention, his ability to think unconventionally, and conceive of a new way to build the dome of Florence's cathedral, the very dome that Vasari would paint from the inside.

CIRCLING BACK TO
GIOTTO'S O

R ECALL THE TALE OF GIOTTO'S O. HOW, WHEN ASKED
for a sample drawing to send to the pope, on the basis of which
a future lucrative commission would be determined, Giotto simply
drew a circle in red ink and handed it the messenger. But it was a
perfect circle, and an act of confidence, simplicity, wit, and minimal-
ism lost, perhaps, on the outraged messenger, but which the pope
understood and which won Giotto his admiriation (and the commis-
sion). Moreover, this striking and extremely early act of minimalism
(Giotto was, after all, an artist of the fourteenth century) forecast a
direction in which art sailed some seven centuries later, but which
Vasari forecast, in the admiring way he tells the story.

Were we to walk into a gallery today and see a drawing of a perfect
circle hanging on the wall, we would never connect that circle with
a medieval painter, let alone the author of the gloriously "realistic"
fresco cycle in the Arena Chapel of Padua. That is not to say that
Giotto would have considered his circle to be a finished, complete
work of art, ready for public display. Another six centuries would
elapse before European artists dared to *exhibit* something as simple as
a circle and call it art.

The movement known as minimalism arose in New York during
the 1950s and 1960s, but the idea that less is more in art has much
deeper origins, beginning with those primordial images on the walls
of caves. The Cycladic figurines from the Greek islands date from

around 3300–2000 BC and are among the oldest works of art produced by stable civilizations. In one sense, they are little more than sculpted stick figures with stylized triangular heads, sometimes with two dots for eyes and a protrusion for a nose, horizontal lines symbolizing crossed arms, and a pubic triangle. One gorgeous specimen in the Louvre, called a Spedos type, from the Early Cycladic period (roughly 2700 BC) is a female head distilled to a shield-shaped oval with a triangular protrusion for a nose.

It is tempting to argue that the painters and sculptors of early civilizations simplified forms because they were incapable of more naturalistic work. It is true that the illusionistic developments of the Renaissance (single vanishing point perspective, foreshortening) were a long way off, but works of art from every period and every part of the world prove that a series of lines or shapes can evoke a subject (a person, a bull, a bird) as powerfully as, if not more than, a painstakingly wrought reproduction of what the eye actually sees. Cycladic figurines would not look out of place alongside Brancusi sculptures, or Mondrian paintings, and the reason is that both ancient and modern artists have chosen a preference for stripping away excess and focusing on the most elemental ways to suggest a living thing, a place, or an object.

Piet Mondrian and Constantin Brancusi, two renowned early twentieth-century abstract artists, were entirely capable of painting and sculpting realistic representations. Their choice not to do so stemmed from similar philosophies. Mondrian, for example, was fascinated with trees. Early in his career he painted trees as the eye sees them: a trunk with articulated bark, branches tufted with leaves. Then he would try to pull back, distill, reduce the level of naturalism. So his next painting might be just a trunk and branches, still recognizable but without all the detail of the bark and leaves and irregularities. He repeated this process until he had a series of lines, one for the trunk, a few for the branches, that still suggested tree-ness. At a certain point, Mondrian could no longer remove any more lines and still

have his work suggest a tree, and that was where he would stop. His most famous work today is *Broadway Boogie Woogie*, which belongs to a series of paintings featuring colored squares and lines, nothing formal (in the sense of suggesting a specific form), but still suggesting the lights, excitement, movement, and liveliness of Broadway. Brancusi is an exact parallel in sculpture. His *Bird in Flight* strips away all of the naturalism possible, while still suggesting to Brancusi (and, he hopes, to viewers) the idea that his bronze sculpture represents a flying bird.

By retelling the story of Giotto's O, which so wonderfully evokes a combination of skill and chutzpah, is Vasari praising abstract art? No, that would be asking too much of him. He opens his Giotto chapter by praising the same artist, in his youth, for a hyper-realist drawing of a sheep, which the great Cimabue saw in passing and took as a sign that this youngster should be apprenticed to him. Vasari goes on to say that, in time, Giotto surpassed his master, Cimabue. Back in *Purgatorio* (canto 11), Dante likewise uses Cimabue and Giotto to discuss the transience of fame, a medieval equivalent to Andy Warhol's prediction that we are all destined to fifteen minutes of fame:

> *Credette Cimabue nella pittura*
> *Tener lo campo, e ora ha Giotto il grido,*
> *Si che la fama di colui e oscura.*

> In painting Cimabue thought he held
> The field, but now it's Giotto who's the star,
> And so the other's fame has lost its shine.[1]

This is a regular trope with Vasari, the apprentice surpassing the master. Vasari also says that Giotto "freed himself from the rude manner of the Greeks," by which he means Byzantine-style altarpieces, which were en vogue when Cimabue and his competing star pupils Giotto (from Florence) and Duccio (from Siena) set about cre-

ating a new form of art, one with greater dimension, emotion, and illusionism.

What Vasari most consistently praises is illusionism provoked by artistic realism, not abstraction. No, the perfect-circle anecdote is about the artist as magician, using his talented hand to do what most people could do only with instruments. It is also about the increasing status of artists in early modern Italy. Instead of begging the popes for a commission, Giotto relies on a combination of his own skill and his patron's ability to understand a cryptic but essential demonstration of pure art.

For most of the history of art, creative works could be defined by a positive answer to Aristotle's three questions, which we addressed in an early chapter: (1) Is it good? (2) Is it beautiful? (3) Is it interesting? Then along came Marcel Duchamp, a radical thinker, a great Cubist painter, a chess master, and art's enfant terrible. Around 1917, Duchamp bought a urinal, signed a fake artist's name to it ("R. Mutt," actually the name of the company that mass-produced the urinal), and brought it to a museum in Paris, claiming to have found the greatest sculpture ever made, and insisting that the museum acquire it. He was laughed out of the room at first, but several years later, the museum did acquire what would be called *Fountain*.

From that point on, art split. There are still artists today who follow Aristotle's ideals: that art should exhibit manual skill, that it should be aesthetically pleasing, and that it should be interesting. But from 1917 onward, another avenue opened up, one in which art *only* had to be interesting. Conceptual art, performance art, temporary installations, and a world of interesting, reactionary, revolutionary, and often just plain bad art has risen from Duchamp's ingenious, iconoclastic move. Giotto's perfect circle could suddenly become a finished artwork unto itself, not a demonstration of skill through simplicity to win a classical-style commission.

A problem really arises only when one tries to compare traditional art with idea-based art. So often one overhears someone (inevitably

with little background in art or art history) saying that he "hates modern art," by which he usually means minimalist art, or art that does not overtly exhibit the skill of the artist—something that the commenter feels "he could do" himself. Of course, Jeff Koons is no match for Benvenuto Cellini. Of course, Damien Hirst's paintings are laughable when compared with Perugino's, as Hirst would gladly admit. They are not meant to compete with one another in terms of the demonstration of artistic skill. There is no competition between Marina Abramović and Michelangelo—Michelangelo would win by miles on all counts. The key is not to compare the two styles of art directly, but to consider them each as his or her own field, each one brilliant and flawed. The "classical" artists strove to make works that were good (exhibiting technical skill), beautiful (morally uplifting and aesthetically pleasing), and interesting (provocative in terms of thought and emotion, with intriguing references to history, theology, philosophy, and other artworks). Duchampian artists of the twentieth century are not *trying* to make art that is either good or necessarily beautiful. That it is interesting is all that matters to them.

What would Vasari make of twentieth-century conceptual art? He praised skill and beauty above all, even above inventiveness, and so he would probably not give conceptual art the time of day. But he also praised the avant-garde of his time, Michelangelesque *maniera*, when the early sixteenth century thought that the balanced beauty of Raphael and Perugino was the best that art could achieve. The avant-garde is constantly shifting.

Where might art go from here? And what would Vasari have made of it?

30

CONCLUSION

Cerca Trova

Centuries of scholars have used Vasari's methods of archival research, oral history, closely examining and analyzing artworks, linking the biography and cultural surroundings of the artist to the interpretation of the artwork. But where did the study of art go from there?

Digital imaging, especially infrared reflectography, has been responsible for some of the biggest discoveries of the past few decades. Maurizio Seracini has led to the expansive multispectral diagnostic imaging and analyses of dozens of works, including Leonardo's unfinished *Adoration of the Magi* (1480). Analysis of 2,400 high-quality infra-red images of every portion of the painting produced a shocking revelation.

It seems that, as long as fifty years after Leonardo died, someone else had clumsily applied a new layer of paint to cover over a part of his work. This patch of paint concealed what is the most theoretically interesting part of the painting.

In the background of the *Adoration of the Magi*, a scene that marks the beginning of Christ's life and therefore the origins of Christianity, one can see with the naked eye what looks like a sketch of a ruined tower or temple. Most scholars have interpreted this as Christianity rising, triumphant, out of the ruins of paganism. But the infra-red imaging revealed that the temple, thought to have been a quickly sketched

underdrawing, was in fact an under*painting*, and one carefully considered and applied. It was not merely sketched in but painted with a brush, in a combination of lamp black and a sealant of lead white. The underpainting showed that the ruined temple in the background included a lotus capital, a column seen in Egyptian temples, and that a team of laborers was hard at work in *reconstructing* the temple. This was not about the triumph of Christianity obliterating paganism—in Leonardo's interpretation, the birth of Christ represents the rebirth of paganism in a new form.

This success fueled tantalizing speculation about what Seracini might find if the red tape were cleared and he were permitted to complete his exploration beneath Vasari's fresco in the Sala dei Cinquecento, in search of the lost *Battle of Anghiari*. In August 2012, the project was put on hold because of protests from art historians. As of this writing, it has not been resumed.

The media love the story of the lost fresco and like to frame it as a black-and-white question: is it worth destroying a Vasari to possibly find a Leonardo? But Seracini argues that there has never been any danger of "destroying" the Vasari. Several techniques exist to remove a fresco from a wall to check what lies beneath, and then to put it back, or to transfer it elsewhere for display (such techniques have been used often since the 1966 flooding of the Arno River, to save paintings from water damage). The six holes drilled to insert endoscopes into the wall of the Sala de Cinquecento were drilled by conservators working for the Ministry of Culture and did not pierce any of Vasari's paint. Media reports have overlooked the fact that, in the 1980s, the Ministry of Culture had already removed a section of Vasari's fresco on the opposite wall of the room to look for remnants of the *Battle of Anghiari*. Finding nothing, they replaced the fresco, and no one seems to have noticed.[1]

For Seracini, who is passionate about both Leonardo and Vasari, the situation is most frustrating. "After almost forty years, I'm still

struggling to get an answer," he says. "But if there is a chance, even to find a small portion of this . . . ," he puffs his cheeks. "Wouldn't *that* be something."

The situation is rife with irony, of course, for it is first and foremost because of Vasari's praise that the world idolizes Leonardo da Vinci. Furthermore, Vasari's painted words *Cerca trova* launched Seracini on the treasure hunt for the *Battle of Anghiari*. Using Vasari's written words, from his *Lives*, as a guide to what Leonardo painted and when. It is through Vasari that Seracini knew of the affair of the Sala dei Cinquecento, of the fresco duel between Michelangelo and Leonardo, and of Leonardo's completion of a part of his painting there.

"Leonardo was truly marvelous and heavenly," Vasari reports. If we mourn the loss of the *Battle of Anghiari*, it is thanks to Giorgio, who praises the beauty of its preparatory cartoon.

Vasari is also our source for the story of the fresco's ruin. Without his testimony, it would have been forgotten long ago:

> It is said that to draw the cartoon he made an ingenious scaffolding that rose when you compressed it and lowered when it was expanded. And imagining that he wanted to paint the wall in oils, he made a composition for the plaster on the wall so coarse in texture that while he was still painting in the hall, it started to drip, and so he abandoned it, seeing that it was going to ruin.[2]

So the fresco was "going to ruin" almost as soon as it was painted, at least if we are to believe our source. This was not the only time that Leonardo tried a new technique for fresco with disastrous results; the *Last Supper* in Milan also decomposed shortly after it was painted. The *Battle of Anghiari* could have fallen off the wall before Giorgio Vasari ever came to Florence as a young man, let alone remodeled the Hall of the Five Hundred at the end of his long life. For now, the project awaits word whether or not it can proceed.

Cerca trova could indeed be a clue. But before we drill through Vasari's frescoes to look for a lost Leonardo (an action that the Italian Ministry of Culture has already done), we should take a good look at the gigantic hall itself, remembering that what we see is *not* the same room that Leonardo saw. The room in Leonardo's time was twenty-three feet lower, with fewer and smaller windows. It would have seemed cave-like by comparison with the lofty space Vasari created in the same location. Maurizio Seracini and the Ministry of Culture team have not spoken to the press about the alteration of the room. If it has been raised by twenty-three feet, and the *Cerca trova* is located in this raised portion, then there is no Leonardo underneath—because this stretch of wall did not exist in Leonardo's time.

In the shining web of an art historical treasure hunt, no one seems to have considered that *Cerca trova* might refer to something other than the lost Leonardo. Vasari's frescoes stand high on the walls of the Sala dei Cinquecento, emphasizing the room's soaring spaciousness— if a reminder is still necessary that Giorgio Vasari was a superb architect, as well as a painter and a biographer, then this room provides as fine an example as any. Leonardo's *Battle of Anghiari* had to have been painted at a much lower level, to fit with the proportions of the Sala dei Cinquecento as they were in his own day. *Cerca trova*, therefore, is not an invitation to wipe away a Vasari fresco to find a Leonardo underneath—as a painter, our biographer was enough of a professional to value his own work more than that.

If anything, *Cerca trova* should direct our attention lower down on the wall, where the painted surface is monochrome. There, if anywhere, is the place to look for a wall that might have held the *Battle of Anghiari*. And we might think about what else we can "seek and find" in this immense room. There are the stately proportions, for example, designed by Vasari, the abundant light, directed in by Vasari, the endless inventiveness of Vasari's paintings, which have been patiently standing on their own, waiting for our attention (like that amazing nighttime scene illuminated by huge paper lanterns.) There are Baccio

Bandinelli's amusing statues, and here, too, in his vehement invective against his rival, Vasari has made that long-ago sculptor and excellent draftsman live in our imaginations. All around us, we experience a certain vision of Florence, the city of art—a reputation definitively shaped by Vasari. As we scan the Sala dei Cinquecento for hidden treasure, we might remember that the best hidden treasures are, like Vasari himself, usually the ones standing right before our eyes.

Acknowledgments

INGRID would like to thank Elizabeth Israel and Crispin Corrado for introducing Noah one summer's day in Rome. Liana di Girolami Cheney, Livio Pestilli, Marco Ruffini, and Paul Barolsky have generously shared their expertise. Tom Mayer and Eleanor Jackson have been unfailingly patient with my schedule. At the University of Notre Dame's Rome Global Gateway, Theodore Cachey and Krupali Uplekar Krusche have been stalwart supports. To the late Robert Silbers, my debt is incalculable.

NOAH would like to thank Tom Mayer for his brilliant, thoughtful editing and remarkable patience. To my family, Urška, Eleonora, and Izabella (as well as Hubert van Eyck), which expanded twice while this book was being written. Eleanor Jackson, whose family also expanded twice during the raising of this book, has been a friend, ally, and bodyguard, as well as super-agent. The teachers who, early on, inspired my love for art history: Madame Poupard, teaching the wonders of Parisian museums in French to me, when I was a cow-eyed sixteen-year-old; and my Colby professors, as much friends and dinner party companions as teachers, Veronique Plesch, Michael Marlais, and David Simon. To my parents, for bringing me to museums, from New York to Europe, from an early age: even when I was thoroughly creeped out by certain statuary, I absorbed the art vibes and transformed them into a career. To the folks at ARCA, the research group on art crime that I founded, who fight to protect and recover art (www.artcrimeresearch.org). To my friends

who have inspired my art writing and have helped make me a better writer in general: Danielle Carrabino, Nathan Dunne, John Stubbs, Lena Pislak and Ulay, Roman Vucajnk, Matjaz Jager, and countless others. I am grateful and humbled to include this book in the catalog of art history texts, written by minds far greater than mine. I hope Giorgio would approve.

Notes

2. HOW TO READ VASARI'S *LIVES*

1. Andrew Ladis, *Victims and Villains in Vasari's* Lives (Chapel Hill: University of North Carolina Press, 2015), 72.

2. "risuscitò et a tale forma ridusse che si potette chiamar buona," in Vasari, *Vita di Giotto*, 2:95. All quotations from Vasari are translated by Ingrid Rowland. The original Italian texts are taken from the online version of the 1550 and 1568 editions, edited by Rossana Bettarini and Paola Barocchi, published in print (Florence: Sansoni [later S.P.E.S.], 1966–87) and put online by the Scuola Normale Superiore di Pisa at http://vasari.sns.it/consultazione/Vasari/indice .html. Page references are to the Bettarini-Barocchi print edition, reproduced online. Translations are based on the 1568 edition.

3. "perché da noi più tosto celeste che terrena cosa si nominasse," in Vasari, *Vita di Michelagnolo Buonarroti fiorentino, pittore, scultore et* architetto, 6:4.

4. John R. Spencer, "Cimabue," in *Encyclopædia Britannica*.

5. Vasari, *Vita di Michelagnolo*, 6:3.

6. "diletteranno e gioveranno," in Vasari, *Prefazione a tutta l'opera*, 1:29.

7. David Ekserdjian, introd. to Giorgio Vasari, *Lives of the Painters, Sculptors and Architects*, trans. Gaston du C. de Vere (New York: Knopf, Everyman Library, 1997), xv.

8. This is a concept developed in the fifteenth century by the Italian humanist poet (and egomaniac) Angelo Poliziano (called Politian in English), who was a friend of Lorenzo de' Medici's and who tutored Lorenzo's sons. Poliziano translated *The Iliad* into Latin, but also wrote poetry in the vernacular, helping to raise the Italian language to a higher level of literary estimation.

9. Ladis, *Victims and Villains in Vasari's* Lives, i.

10. Ibid., ii.

11. Ibid., 4.

12. Antonio Paolucci, "Angelico l'Intellettuale," *L'Osservatore Romano*, 23 April 2009, http://www.vatican.va/news_services/or/or_quo/cultura/093q05a1.html.

3. FROM POTTERS TO PAINTERS

1. Vasari, *Descrizione dell'opere di Giorgio Vasari, pittore e architetto aretino*, 6:369.

2. Robert W. Carden, *The Life of Giorgio Vasari: A Study of the Later Renaissance in Italy* (New York: Henry Holt, 1911), vii.

3. Pindar, *Pythian*, 10.54.

4. Eric Cochrane, *Florence in the Forgotten Centuries, 1527–1800: A History of Florence and the Florentines in the Age of the Grand Dukes* (Chicago: University of Chicago Press, 1973), 85.

5. Vasari, *Vita di Lazaro Vasari Aretino pittore*, 3:294.

6. Ibid.

7. The Piero pilgrimage is inspired by John Pope-Hennessey, *The Piero Della Francesca Trail: The Walter Neurath Memorial Lecture* (London: Thames and Hudson, 1991), a book that was itself inspired by Aldous Huxley's 1925 essay "The Best Picture," *Along the Road: Notes and Essays of a Tourist* (London: Chatto and Windus, 1925), 177–89. Both works are now reprinted together in *The Piero Della Francesca Trail* (New York: Little Bookroom, 2002).

8. Vasari, *Vita di Lazaro Vasari*, 3:295.

9. Ibid., 294.

10. Ibid., 293.

11. Paul Roberts, "Mass-production of Roman Finewares," in *Pottery in the Making: World Ceramic Traditions*, ed. Ian Freestone and David Gaimster (London: British Museum Press, 1997), 188–93.

12. Richard DePuma, *Etruscan and Villanovan Pottery* (Iowa City: University of Iowa Museum of Art, 1971).

13. Vasari, *Vita di Lazaro Vasari*, 3:297.

14. Salvatore Settis, "Art History and Criticism," in *The Classical Tradition*, ed. Anthony Grafton, Glenn Most, and Salvatore Settis (Cambridge: Belknap Press of Harvard University Press, 2010), 78.

15. Ibid.

16. Ibid.

17. Henri Zerner, *Renaissance Art in France: The Invention of Classicism* (Paris: Flammarion, 2003).

18. Vasari, *Vita di Lazaro Vasari*, 3:297.

19. Giovanni Cipriani, *Il mito etrusco nel rinascimento fiorentino* (Florence: Olschki, 1980).

20. Vasari, *Vita di Lazaro Vasari*, 3:298.

21. Letter from Giorgio Vasari in Rome to Niccolò Vespucci in Florence, 8 Feb. 1540, in *Carteggio Vasariano*, no. 36, at http://www.memofonte.it/autori/carteggio-vasariano-1532-1574.html.

22. Christiane Klapisch-Zuber, *Women, Family, and Ritual in Renaissance Italy* (Chicago: University of Chicago Press, 1985), 151.

23. *Vita di Benvenuto Cellini orefice e scultore fiorentino scritta da lui medesimo*, ed. Francesco Tassi (Florence: Guglielmo Piatti, 1829), bk. 1, chap. 87.

24. Ibid.

25. See Maddalena Spagnolo, "La biografia d'artista: Racconto, storia e leggenda," *Enciclopedia della Cultura Italiana*, vol. 10 (Turin: UTET, 2010), 375–93; Victoria C. Gardner Coates, "Rivals with a Common Cause: Vasari, Cellini, and the Literary Formulation of the Ideal Renaissance Artist," in David Cast, ed., *The Ashgate Research Companion to Giorgio Vasari* (Burlington, CT: Ashgate, 2014), 215–22.

26. Vasari, *Vita di Luca Signorelli da Cortona pittore*, 3:639. Girolamo Cardano, a contemporary of Vasari's, praises the use of red jasper to stop the flow of blood, in *De Gemmis*.

27. Vasari, *Vita di Luca Signorelli*, 3:633.

28. Samuel Y. Edgerton, *The Mirror, the Window, and the Telescope: How Renaissance Linear Perspective Changed Our Vision of the Universe* (Ithaca: Cornell University Press, 2009).

29. Leon Battista Alberti, *On Painting: A New Translation and Critical Edition*, ed. and trans. Rocco Sinisgalli (Cambridge and New York: Cambridge University Press, 2011).

30. Edgerton, *Mirror*.

31. Vasari, *Vita di Luca Signorelli*, 3:634. "Reflections" is one possible translation of "riverberazioni"; see John Florio, *A World of Words* (1611), s.v. *Riverberare*.

32. Vasari, *Vita di Luca Signorelli*, 3:639.

33. Vasari, *Vita di Piero della Francesca dal Borgo a San Sepolcro pittore*, 3:262.

34. Vasari, *Vita di Guglielmo da Marcilla pittore franzese e maestro di finestre invetriate*, 4:217–30.

35. Tom Henry, "Centro e Periferia: Guillaume de Marcillat and the Modernisation of Taste in the Cathedral of Arezzo," *Artibus et Historiae* 15, no. 29 (1994): 55–83.

36. Vasari, *Vita di Guglielmo da Marcilla*, 4:217–18.

37. Cited in Italian by Carden, *Life of Giorgio Vasari*, 27, presumably from Ugo Scoti-Bertinelli, *Giorgio Vasari Scrittore* (Nistri, 1905), 283.

38. Vasari, *Vita di Francesco detto de' Salviati pittore fiorentino*, 5:512.

4. FROM AREZZO TO FLORENCE

1. Vasari, *Vita di Guglielmo da Marcilla*, 4:221.

2. "Disegnia Antonio, disegnia Antonio, disegnia e non perder tempo," on a drawing now in the British Museum, Department of Prints and Drawings 1859,0514.818; Johannes Wilde, *Michelangelo and His Studio* (London: Britism Museum Press, 1953), 31; Nicholas Turner, *Florentine Drawings of the Sixteenth Century* (London: British Museum Press, 1986), 75.

3. Vasari, *Che cosa sia disegno*, 1:111.

4. Ibid.

5. Vasari, *Descrizione dell'opere di Giorgio Vasari*, 6:369.

6. Vasari, *Che cosa sia disegno*, 1:112.

7. Vasari, *Vita di Francesco detto de' Salviati*, 5:511–12.

8. According to the Sienese chronicler Sigismondo Tizio, Caterina's conception was almost miraculous; in 1517 he reported the rumor that Lorenzino's private parts were "almost devoured" by the French disease; see Biblioteca Apostolica Vaticana, MS Chigi G.II.38, II2v.

9. Catherine Fletcher, *The Black Prince of Florence: The Spectacular Life and Treacherous World of Alessandro de' Medici* (Oxford: Oxford University Press, 2016). His mother, Simonetta da Collevecchio, was a servant girl in the Medici household in Rome; after bearing Alessandro, she was married off to a groom in the Medici household, by whom she had two more children. In 1529, she would write to her eldest son begging him for financial support in her "extreme poverty"; they had not seen each other from the time of his birth.

10. Joaneath Spicer, ed., *Revealing the African Presence in Renaissance Europe* (exhibition catalog) (Baltimore: Walters Art Museum, 2012).

11. Guido Rebecchini, *Un' altro Lorenzo: Ippolito de' Medici fra Firenze e Roma (1511–1535)* (Venice: Marsilio, 2010).

12. Lauro Martines, *April Blood: Florence and the Plot against the Medici* (London: Cape, 2003).

13. Vasari, *Vita di Francesco detto de' Salviati*, 5:512.

14. The building's address is now Borgo San Iacopo 2r–16r.

15. The Knights had just been expelled from Rhodes in 1522 and were temporarily resident in Viterbo. They would take possession of Malta in 1530.

16. Julia Haig Gaisser, *Pierio Valeriano on the Ill Fortune of Learned Men: A Renaissance Humanist and His World* (Ann Arbor: University of Michigan Press, 1999).

17. Brian Curran, *The Egyptian Renaissance: The Afterlife of Egypt in Early Modern Italy* (Chicago: University of Chicago Press, 2007), 227–34; Luc Brisson, *How Philosophers Saved Myths: Allegorical Interpretation and Classical Mythology* (Chicago: University of Chicago Press, 2004), 142, 193.

18. Dick Higgins, *Pattern Poetry: Guide to an Unknown Literature* (Albany: State

University of New York Press, 1987), 98. Valeriano modeled his compositions on the work of the Late Antique poet Optatian.

19. Pierio has found the perfect translator in Gaisser, *Pierio Valeriano*.

20. Giovanni Cipriani, *Il mito etrusco nel rinascimento fiorentino* (Florence: Olschki, 1980).

21. Vasari himself is inconsistent about this date; it is either 1524 or 1525.

22. Michelangelo provides a rare counterexample to normal Renaissance practice, and his story, as embroidered by Giorgio Vasari, largely colors our expectation that artists should work alone. Though Michelangelo did employ apprentices, most notably Daniele da Volterra, he preferred to work in solitude whenever possible. His own correspondence makes it clear that the Sistine Chapel frescoes are almost entirely by his hand, executed in a standing position. Even so, Michelangelo would have had assistants beside him to mix pigment and fetch everything from brushes to lunch.

23. Vasari, *Vita di Andrea del Sarto eccelentissimo pittore fiorentino*, 4:341.

24. Ibid., 395.

25. This letter, cited in Robert W. Carden, *The Life of Giorgio Vasari: A Study of the Later Renaissance in Italy* (New York: Henry Holt, 1911), 7, appears in Johann Wilhelm Gaye, *Carteggio inedito d'artisti dei secoli XIV, XV, XVI*, vol. 2 (Florence: Presso G. Molini, 1840), no. 207, pp. 278–80.

26. Gaye, *Carteggio inedito d'artisti*, no. 208, p. 282.

27. Vasari, *Vita di Baccio Bandinelli scultore fiorentino*, 5:241.

28. Leonard Barkan, *Unearthing the Past: Archaeology and Aesthetics in the Making of Renaissance Culture* (New Haven: Yale University Press, 1999), a wonderful account of Bandinelli.

29. *Vita di Benvenuto Cellini orefice e scultore fiorentino scritta da lui medesimo*, ed. Francesco Tassi (Florence: Guglielmo Piatti, 1829), vol. 2, chap. 18.

30. Ladis, *Victims and Villains in Vasari's* Lives, 129.

31. Ibid., 113.

32. Vasari, *Vita di Baccio Bandinelli*, 5:254.

33. Ibid., 241.

5. PLUNDER AND PLAGUE

1. Machiavelli, *The Prince*, chap. 12.

2. Voltaire, "Ce corps qui s'appelait et qui s'appelle encore le saint empire romain n'était en aucune manière ni saint, ni romain, ni empire," in his *Essai sur l'histoire générale et sur les mœurs et l'esprit des nations* (1756), chap. 70.

3. Vasari, *Vita di Francesco detto de' Salviati*, 5:512–13.

4. Vasari, *Vita di Michelangelo Buonarroti*, 6:5.

5. Ibid., 7.

6. Ibid., 18.

7. Vasari, *Vita di Francesco detto de' Salviati*, 5:512–13.

8. Ibid., 513.

6. ARTIST VERSUS ARTIST

1. Vasari, *Vita di Giotto*, 2:97.

2. Ibid., 103–4.

3. Ibid., 104.

4. Andrew Ladis, *Victims and Villains in Vasari's* Lives (Chapel Hill: University of North Carolina Press, 2015), 2

5. This reference appears in Petrarch's *Familiarum rerum libri*, in which he likens Giotto to Apelles (2.5.17), and Boccaccio would likewise paraphrase this in *Genealogia Deorum*, 14.6. For more on this, see Norman E. Land, "Giotto as Apelles," *Notes in the History of Art* 24, no. 3 (Spring 2005): 6–9.

6. This is Franco Quartieri's clever translation of *fingo*, in *Benvenuto da Imola: Un moderno antico commentatore di Dante* (Ravenna: Longo, 2001), 140.

7. Boccaccio, *Genealogia Deorum*, 14.6

8. Vasari, *Vita di Giotto*, 2:121.

9. Pliny the Elder, *Natural History*, 35.29. Translation by Ingrid Rowland.

10. Vasari, *Vita di Buonamico Buffalmacco*, 2:161–62.

11. Ladis refers to Buffalmacco as akin to Ferris Bueller, which is a wonderfully apt analogy. Ladis, *Victims and Villains in Vasari's* Lives, 13.

12. Daniela Parenti, "Nardo di Cione," *Dizionario Biografico degli Italiani*, vol. 77 (2012), online at http://www.treccani.it/enciclopedia/nardo-di-cione _(Dizionario-Biografico)/.

13. Norman Land, "Vasari's Buffalmacco and the Transubstantiation of Paint," *Renaissance Quarterly* 58 (2005): 881–95.

14. Vasari, *Vita di Buonamico Buffalmacco*, 2:168.

15. Ladis, *Victims and Villains in Vasari's* Lives, 54.

7. THE OPPORTUNITIES OF WAR

1. Ugo Tucci, "Biringucci, Vannoccio," *Dizionario Biografico degli Italiani*, vol. 10 (1968), online at http://www.treccani.it/enciclopedia/vannoccio-biringucci _(Dizionario-Biografico)/; Vannoccio Biringucci, *The Pirotecnia of Vannoccio Biringuccio*, trans. Cyril Stanley-Smith and Martha Teach Gnudi (New York: American Institute of Mining and Metallurgical Engineers, 1942).

2. Robert W. Carden, *The Life of Giorgio Vasari: A Study of the Later Renaissance in Italy* (New York: Henry Holt, 1911), 10.

3. Guido Alfani, *Calamities and the Economy in Renaissance Italy: The Grand Tour of the Horsemen of the Apocalypse* (London: Palgrave Macmillan, 2013).

4. Vasari, *Descrizione dell'opere di Giorgio Vasari*, 6:370.

5. Vasari, *Vita di Francesco detto de' Salviati*, 5:513.

6. See the website for the Tasso Museum in Cornello dei Tasso, Province of Bergamo, http://www.museodeitasso.com/it, with bibliography of publications by the museum.

7. Sergio Chieppi, *I servizi postali dei Medici dal 1500 al 1737* (Fiesole: Servizio Editoriale Fiesolana, 1997).

8. Andrea is registered that year with the painters' guild, and Raffaello probably registered too, but the book with the R's is missing. Gaetano Milanesi, ed., *Le Opere di Giorgio Vasari*, vol. 7, *Le Vite de' più eccellenti pittori, scultori ed architettori, scritte da Giorgio Vasari con nuove annotazioni e commenti* (Florence: Sansoni, 1881), *Vita di Francesco detto de' Salviati*, 9 n. 1.

9. This Raffaello is not the Olivetan monk, also called Raffaello da Brescia, who excelled in the wooden inlay technique called intarsia.

10. Vasari, *Descrizione dell'opere di Giorgio Vasari*, 6:370.

11. Vasari, *Vita di Francesco detto de' Salviati*, 5:513.

12. Iris Origo, *The Merchant of Prato: Francesco di Marco Datini, 1335–1410* (New York: Knopf, 1957).

13. Ingrid D. Rowland, *The Correspondence of Agostino Chigi in Vatican MS Chigi R.V.c: An Annotated Edition* (Vatican City: Vatican Library, 2001).

14. For more on this ritual, see Reginard Maxwell Woolley, *Coronation Rites* (Cambridge: Cambridge University Press, 1915).

15. Mary Beard, *The Roman Triumph* (Cambridge: Belknap Press of Harvard University Press, 2007).

8. BACK AMONG THE MEDICI

1. Vasari, *Descrizione dell'opere di Tiziano da Cador pittore*, 6:155.

2. Ibid.

3. Ibid., 156.

4. Ibid.

5. Ibid., 157.

6. Ibid., 166.

7. Ibid., 170.

8. Patricia Fortini Brown, *Venice and Antiquity: The Venetian Sense of the Past* (New Haven: Yale University Press, 1996).

9. Vasari, *Descrizione dell'opera di Giorgio Vasari*, 6:371.

10. Vasari, *Vita di Francesco detto de' Salviati*, 5:514.

9. ROME AFTER THE SACK

1. F. H. Taylor, *The Taste of Angels: A History of Art Collecting from Rameses to Napoleon* (Boston: Little, Brown, 1948), 31.

2. Vasari, *Vita di Filippo Brunelleschi scultore e architetto fiorentino*, 3:137.

3. Ibid., 137–38.

4. Ibid., 159–60.

5. Vasari, *Vita di Donato scultore fiorentino*, 3:201–2.

6. Vasari, *Vita di Francesco detto de' Salviati*, 5:514.

7. Ibid., 515.

8. Letter of Giorgio Vasari to Ottaviano de' Medici, 30 Nov. 1539, also quoted in Robert W. Carden, *The Life of Giorgio Vasari: A Study of the Later Renaissance in Italy* (New York: Henry Holt, 1911), 52.

9. Vasari, *Vita di Francesco detto de' Salviati*, 5:515.

10. Ibid.

11. Ibid.

12. Noah Charney, *Stealing the Mystic Lamb: The True Story of the World's Most Coveted Masterpiece* (New York: PublicAffairs, 2010).

13. Giorgio Vasari in Rome to Niccolò Vespucci in Florence, 8 Feb. 1540, in *CV*, no. 36.

14. Ingrid D. Rowland, *The Culture of the High Renaissance: Ancients and Moderns in Sixteenth-Century Rome* (New York: Cambridge University Press, 1998).

15. Quoted in Carden, *Life of Giorgio Vasari*, 16.

16. The letter appears in Giovanni Gaetano Bottari, *Raccolta di lettere sulla pittura, scultura ed architettura scritte da' più celebri personaggi dei secoli XV, XVI, e XVII*, vol. 5 (Rome: Niccolò e Marco Pagliarini, 1757), no. 65.

17. Letter to Ottaviano de' Medici, [mis]dated 13 June 1540 [really 1532], in Stefano Audin, ed., *Le Opere di Giorgio Vasari Pittore e Architetto*, vol. 2 (Florence: David Passigli e Socj, 1838), 1422.

18. Letter to Bishop Paolo Giovio, [mis]dated 4 Sept. 1540 [really 1532], ibid., 1423.

19. Carden, *Life of Giorgio Vasari*, 19.

20. Frank Snowden, *The Conquest of Malaria, 1900–1962* (New Haven: Yale University Press, 2006).

10. A FLORENTINE PAINTER

1. Catherine Fletcher, *The Black Prince of Florence: The Spectacular Life and Treacherous World of Alessandro de' Medici* (Oxford: Oxford University Press, 2016).

2. Vasari, *Vita di Iacopo di Casentino*, 2:274.

3. Giorgio Vasari in Poggio a Caiano to Alessandro de' Medici in Florence, Jan. 1533. See Liana di Girolami Cheney, "Giorgio Vasari's Portrait of Lorenzo the Magnificent: A Ciceronian Symbol of Virtue and a Machiavellian Princely Conceit," *Iconocrazia*, Jan. 2012, accessed 4 Oct. 2014, http://www.iconocrazia.it/archivio/00/02.html.

4. Giorgio Vasari in Florence to Antonio de' Medici in Florence, Feb. 1533 in *CV*, no. 5.

5. Julius Kirshner, "Family and Marriage," in *Italy in the Age of the Renaissance, 1300–1550*, ed. John Najemy (Oxford: Oxford University Press, 2010), 93.

6. Christiane Klapisch-Zuber, *Women, Family, and Ritual in Renaissance Italy* (Chicago: University of Chicago Press, 1985), 44.

7. Giorgio Vasari in Florence to Carlo Guasconi in Rome, 1533 (otherwise undated), in *CV*, no. 177.

8. Ingrid D. Rowland, *Vitruvius, Ten Books on Architecture: The Corsini Incunabulum* (Rome: Edizioni dell'Elefante, 2003).

9. Giorgio Vasari in Florence to Pietro Aretino in Venice, 11 Dec. 1535, in *CV*, no. 13.

10. Ludovico Antonio Muratori, *Annali dell'Italia dal principio dell'era volgare sino all'anno 1750*, ed. Giuseppe Catalano, vol. 24 (Florence: Leonardo Marchini, 1837), 269–70.

11. Palazzo Medici, http://www.palazzo-medici.it/mediateca/en/Scheda_1536_-_Visita_di_Carlo_V_e_le_nozze_di_Alessandro_I_e_Margherita_dAustria.

12. Charles certainly did use different languages for different purposes, as noted by Hieronymus Fabricius, *De Locutione et eius Instrumentis* (Padua: Ex Typographia Laurentii Pasquati, 1603), 23: "As I hear, Emperor Charles V used to say that German was a military language, Spanish amatory, Italian oratorical, French noble. But someone else, a German, reports that this same emperor sometimes used to say that if he had to speak with God, he spoke in Spanish, because Spanish had the most gravitas and majesty; if he was among his friends, he spoke Italian, because he was familiar with Italian dialects. If he had to flatter, he used French, because there was no softer language than French, and if he had to threaten someone, German, because the whole language is menacing, harsh, and vehement."

13. Vasari, *Descrizione dell'opera di Giorgio Vasari*, 6:374.

14. Vasari, *Vita di Andrea dal Castagno di Mugello e di Domenico Viniziano pittori*, 3:351. The translation has trimmed some of Vasari's *copia*.

15. Giorgio Vasari in Florence to Raffaello dal Borgo in San Sepolcro, 15 March

1536, in *CV*, no. 16. Rather than saying "the Borgias' hit man," Vasari gives his name: "Don Micheletto," Michele da Coroglio.

16. This letter of Giorgio Vasari in Florence to Pietro Aretino in Venice, dated May 1535, does not appear in the *CV*, but only in Vatican Librarian Giovanni Gaetano Bottari's *Raccolta di Lettere sulla Pittura, Scultura e Architettura Scritte da' più celebri personaggi dei secoli XV, XVI, e XVII pubblicata da M. Gio. Bottari e continuata fino ai nostri giorni da Stefano Ticozzi*, vol. 3 (Milan: Giovanni Silvestri, 1822), no. 12, 39–56, with the passage cited on 41. Reprinted with some changes ("Giorgin mio" becomes "Giorgio mio") by Stefano Audin (Étienne Audin de Rians) *Opere di Giorgio Vasari, pittore e architetto aretino*, Florence: S. Audin, 1823, vol. 6, 339–52, with the passage cited on 340.

17. Robert W. Carden, *Life of Giorgio Vasari: A Study of the Later Renaissance in Italy* (New York: Henry Holt, 1911), 34.

18. An excellent reference for Renaissance currency is found at https://abagond .wordpress.com/2007/05/10/money-in-leonardos-time/.

11. MURDER AND REDEMPTION

1. Benedetto Varchi, *Storia Fiorentina* (Cologne: Pietro Martello, 1721), 588.

2. Ibid.

3. *Vita di Benvenuto Cellini orefice e scultore fiorentino scritta da lui medesimo*, ed. Francesco Tassi (Florence: Guglielmo Piatti, 1829), 352 (bk. 1, chap. 16).

4. "Scoronconcolo" seems to have been a nonsense nickname; the assassin's real name was Michele del Tavolaccino.

5. Varchi, *Storia Fiorentina*, 58891; Eric Cochrane, *Florence in the Forgotten Centuries, 1527–1800: A History of Florence and the Florentines in the Age of the Grand Dukes* (Chicago: University of Chicago Press, 1973), 14–18.

6. Cochrane, *Florence in the Forgotten Centuries*, 18–21.

7. Giorgio Vasari in Florence to Antonio Vasari in Arezzo, 7 Jan. 1537, in *CV*, no. 22.

8. Giorgio Vasari in Arezzo to Bartolommeo Rontini in Arezzo, 31 Jan. 1537, in *CV*, no. 24.

9. Giorgio Vasari in Arezzo to Niccolò Serguidi in Florence, 6 July 1537, in *CV*, no. 28.

10. Ibid.

11. Giorgio Vasari in Arezzo to Bartolommeo Rontini in Arezzo, 31 Jan. 1537, in *CV*, no. 24.

12. Italian text provided by Robert W. Carden, *The Life of Giorgio Vasari: A Study of the Later Renaissance in Italy* (New York: Henry Holt, 1911), 48.

13. Giorgio Vasari in Camaldoli to Giovanni Pollastra in Arezzo, 1 Aug. 1537, in *CV*, no. 30.

14. Ibid.

15. Vasari, *Vita di Paolo Uccello pittor fiorentino*, 3:64–65.

12. THE WANDERING ARTIST

1. Vasari, *Descrizione dell'opera di Giorgio Vasari*, 6:376.

2. Maurice Brock, *Bronzino* (Paris: Taschen, 2002), 66–67, 69.

3. Quoted in Rona Goffen, *Renaissance Rivals: Michelangelo, Leonardo, Raphael, Titian* (New Haven: Yale University Press, 2001), 316.

4. Vasari, *Descrizione dell'opera di Giorgio Vasari*, 6:376.

5. Ingrid D. Rowland, *The Scarith of Scornello: A Tale of Renaissance Forgery* (Chicago: University of Chicago Press, 2004), 115.

6. Vasari, *Descrizione dell'opera di Giorgio Vasari*, 6:377.

7. Giorgio Vasari in Florence to Pietro Aretino in Venice, 1 Nov. 1538, in *CV*, no. 33.

8. Giorgio Vasari in Rome to Ottaviano de' Medici in Florence, 30 Nov. 1539, in *CV*, no. 35.

9. Vasari, *Descrizione dell'opere di Giorgio Vasari*, 6:379.

10. Ibid., 380–81.

11. Ibid., 380.

13. FLORENCE, VENICE, ROME

1. Janet Cox-Rearick, *Bronizno's Chapel of Eleonora in the Palazzo Vecchio* (Berkeley: University of California Press, 1993), 315.

2. Vasari, *Vita di Niccoló detto il Tribolo scultore e architettore*, 5:220.

3. Ibid.

4. Ibid., 221.

5. Vasari, *Descrizione dell'opera di Giorgio Vasari*, 6:381–82.

6. Ibid., 382.

7. Bette Talvacchia, *Taking Positions: On the Erotic in Renaissance Culture* (Princeton: Princeton University Press, 1999).

8. Vasari, *Vita di Giulio Romano*, 5:78–79.

9. Vasari, *Vita di Andrea del Sarto*, 4:379–80.

10. Vasari, *Vita di Giulio Romano*, 5:55–56.

11. Blanca Berasátegui, "El Lazarillo no es anónimo," *El Cultural*, 5 March

2010, Friday supplement to *El Mundo*, accessed 22 Nov. 2014, http://www
.elcultural.es/revista/letras/El-Lazarillo-no-es-anonimo/26742.

12. Antonella Fenech Kroke, "Un théâtre pour *La Talanta*: Giorgio Vasari, Pietro Aretino, et l'*apparato* de 1542," *Révue de l'Art* 168 (2010–12): 53–64.

13. Lionello Venturi, "Le Compagnie della Calza (sec. XV–XVII)," *Nuovo Archivio Veneto*, n.s. 16 (1908), 2:161–221, and n.s. 17 (1909), 1:140–223; Edward Muir, *Civic Ritual in Renaissance Venice* (Princeton: Princeton University Press, 1986), 167–82.

14. Quoted in Robert W. Carden, *The Life of Giorgio Vasari: A Study of the Later Renaissance in Italy* (New York: Henry Holt, 1911), 62.

15. Ibid.

16. Quoted ibid., 63.

17. Vasari, *Descrizione dell'opere di Giorgio Vasari*, 6:382.

18. Rona Goffen, *Renaissance Rivals: Michelangelo, Leonardo, Raphael, Titian* (New Haven: Yale University Press, 2001), 463; Madlyn Kahr, "Titian's Old Testament Cycle," *Journal of the Warburg and Courtauld Institutes* 29 (1966): 193–205.

19. Vasari, *Vita di Cristofano Gherardi detto Doceno da Borgo San Sepolcro pittore*, 5:292–93.

20. Kahr, "Titian's Old Testament Cycle," 193–205.

21. Vasari, *Descrizione dell'opera di Giorgio Vasari*, 6:382.

22. Ibid.

23. Christie's, New York, Sale 9318, Important Old Master Paintings, 27 Jan. 2000. Florian Härb's informative essay is available online at http://www.christies .com/lotfinder/lot/giorgio-vasari-the-pieta-1710633-details.aspx?intObjectID =1710633. See also Donatella Pegazzano, Demetrios Zikos, and Allan Chong, eds., *Raphael, Cellini, and a Renaissance Banker: The Patronage of Bindo Altoviti* (Boston: Isabella Stewart Gardner Museum, 2003).

24. Vasari, *Descrizione dell'opera di Giorgio Vasari*, 6:382.

14. RENAISSANCE MEN

1. William Wallace, "Who Is the Author of Michelangelo's Life?," in David Cast, ed., *The Ashgate Research Companion to Vasari* (Burlington, CT: Ashgate, 2014), 107–20.

2. Vasari, *Vita di Michelangelo*, 6:3–4.

3. Andrew Ladis, *Victims and Villains in Vasari's* Lives (Chapel Hill: University of North Carolina Press, 2015), 93.

4. Vasari, *Vita di Lionardo da Vinci*, 4:18.

5. Ibid., 19.

6. Ibid., 22.

7. Ibid., 24.

8. Ingrid D. Rowland, *The Culture of the High Renaissance: Ancients and Moderns in Sixteenth-Century Rome* (New York: Cambridge University Press, 1998), 257–72.

9. Vasari, *Vita di Lionardo da Vinci*, 4:26.

10. Thanks to Andrew Butterfield for this observation.

11. Vasari, *Vita di Lionardo da Vinci*, 4:36.

12. For the sale of the Mona Lisa to the King of France, see Bertrand Jestaz, "François Ier, Salaì et les tableaux de Léonard," *Revue de l'art*, 126:4 (1999), 68–72.Ruth Webb, *Ekphrasis, Imagination and Persuasion in Ancient Rhetorical Theory and Practice* (Farnham, Surrey: Ashgate, 2009).

13. Vasari, *Vita di Raffaello da Urbino pittore e architetto*, 4:155.

14. Ibid., 186.

15. Ibid., 187.

16. Ibid., 206.

17. Ibid., 200.

18. Ibid., 209.

19. Ibid., 212.

15. SYMBOLS AND SHIFTING TASTES

1. Vasari, *Vita di Michelagnolo Buonarroti fiorentino, pittore, scultore et architetto*, 6:12.

2. Benvenuto Cellini, *Autobiography*, trans. John Addington Symonds (New York: Appleton, 1904), 18–19.

3. Vasari, *Vita di Michelagnolo*, 6:17.

4. Carol F. Lewine, *The Sistine Chapel Walls and the Roman Liturgy* (College Park: Pennsylvania State University Press, 1993).

5. Vasari, *Vita di Michelagnolo*, 6:110.

6. Ibid., 109.

7. In addition, Michelangelo made frescoes for the Pauline Chapel in the Vatican, but these were for private viewing and are difficult to access by the public, even today. He also made several unfinished sculptures, possibly for his own tomb: including Joseph of Arimathea in mourning (with the face a self-portrait), but they were never displayed to the public during his life.

8. *The Canons and Decrees of the Sacred and Œcumentical Council of Trent*, ed. and trans. J. Waterworth (London: Dolman, 1848), 25th decree, pp. 235–36 "Every superstition shall be removed . . . all lasciviousness be avoided; in such wise that figures shall not be painted or adorned with a beauty exciting to lust. . . . there be nothing seen that is disorderly, or that is unbecomingly or confusedly arranged, nothing that is profane, nothing indecorous, seeing that holiness becometh the house of God. And that these things may be the more faithfully

observed, the holy Synod ordains, that no one be allowed to place, or cause to be placed, any unusual image, in any place, or church, howsoever exempted, except that image have been approved of by the bishop." Available online at https://history.hanover.edu/texts/trent/ct25.html.

9. *Iconologia* is probably the earliest text that could establish the study of iconography, which was made famous (if grossly distorted) by Dan Brown's novel *The Da Vinci Code*, wherein the protagonist, Robert Langdon, is called a "symbologist." There is no such word as "symbology," but "iconography" is what the author surely had in mind: the study of symbols. Ripa's work was translated widely, including a 1709 English edition by a man with perhaps the most dynamic and memorable name of the eighteenth century, Pierce Tempest. A Scottish architect, George Richardson, produced the influential *Iconology; or, A Collection of Emblematical Figures; containing four hundred and* twenty-four *remarkable subjects, moral and instructive; in which are displayed the beauty of Virtue and deformity of Vice* in 1779. What it lacked in the prudent use of semicolons, it made up for in influence.

10. Erwin Panofsky, "Reality and Symbol in Early Netherlandish Painting: 'Spiritualia sub Metaphoris Corporalium,'" in *Early Netherlandish Painting: Its Origins and Character* (Cambridge: Harvard University Press, 1964), 131–48.

11. Robert Gaston, "Love's Sweet Poison: A New Reading of Bronzino's London 'Allegory,'" *I Tatti Studies in the Italian Renaissance* 4 (1991): 249–88.

12. See the praise in Vasari, *Degli Accademici del Disegno*, 6:238.

13. Ibid., 234.

14. Gaston, "Love's Sweet Poison," 287–88.

16. TO NAPLES

1. The Renaissance idea of *invenzione* derived from Cicero's early essay *De inventione* and other ancient rhetorical treatises like Aristotle's *De Rhetorica*, Quintilian's *Institutiones Oratoriae*, and Cicero's later rhetorical works. George Kennedy, *A New History of Classical Rhetoric* (Princeton: Princeton University Press, 1994); T. M. Conley, *Rhetoric in the European Tradition* (Chicago: University of Chicago Press, 1990).

2. About this painting, see Stefano Pierguidi, "Sulla fortuna della 'Giustizia' e della 'Pazienza' del Vasari,"*Mitteilungen des Kunsthistorischen Institutes in Florenz* 51, nos. 3–44 (2007): 576–92.

3. Vasari, *Descrizione dell'opera di Giorgio Vasari*, 6:383.

4. Pierguidi, "Sulla fortuna della 'Giustizia,'" 576.

5. Vasari, *Descrizione dell'opere di Giorgio Vasari*, 6:383.

6. Ibid., 384.

7. Ibid., 384–85.

8. Ibid., 385.

9. Ibid., 386.

10. Clare Robertson, *"Il Gran Cardinale": Alessandro Farnese and the Arts* (New Haven: Yale University Press, 1994).

11. Vasari, *Descrizione dell'opere di Giorgio Vasari*, 6:388.

17. THE BIRTH OF *LIVES*

1. Vasari, *Descrizione dell'opere di Giorgio Vasari*, 6:389.

18. RENAISSANCE READING

1. Petrarch, letter to Giovanni Colonna, 21 Dec. 1336, in *Epistolae Familiares*, 2.9.

2. Greek was also still spoken in some areas of southern Italy (as it still is today).

3. Paul Gehl, *A Moral Art: Grammar, Culture, and Society in Trecento Florence* (Ithaca: Cornell University Press, 1993).

4. Here is a short chronology of early printing. 1465: Cicero; circa 1467: Julius Caesar, Livy, Pliny the Elder, Ovid, Lucan, Apuleius, Aulus Gellius, Suetonius, Silius Italicus, Justin's *Epitome*, Donatus, Terence, Strabo, Polybius;1488: Homer; 1495–98: Aristotle; 1501: Virgil; 1502: Sophocles, Thucydides, and Herodotus; 1503: Euripides; 1509: Plutarch's *Moralia*; 1513: Plato.

5. Pietro C. Marani and Marco Versiero, *La biblioteca di Leonardo: Appunti e letture di un artista nella Milano del Rinascimento, Guida alla Mostra* (Milan: Castello Sforzesco and Biblioteca Trivulziana, 2015); F. Frosini, "La biblioteca di Leonardo da Vinci," in Scuola Normale di Pisa/Università di Cagliari, *Biblioteche dei filosofi: Biblioteche filosofiche private in età moderna e contemporanea*, s.v. Leonardo da Vinci, accessed 7 Jan. 2016, http://picus.unica.it/documenti/LdV_biblioteche_dei_filosofi.pdf), pp. 1–13; Romain Descendre, "La biblioteca di Leonardo," in *Atlante della letteratura italiana*, ed. Sergio Luzzatto, Gabriele Pedullà, and Amedeo De Vincentiis, vol. 1 (Turin: Einaudi, 2010), 592–95.

6. https://www.gutenberg.org/files/6400/6400-h/6400-h.htm.

7. 7 Andrew Ladis, *Victims and Villains in Vasari's* Lives (Chapel Hill: University of North Carolina Press, 2015), 31.

8. Vasari, *Vita di Pietro Perugino*, 3:603–4.

19. THE NEW VITRUVIUS

1. For a date of 1542 or 1543, see Marco Ruffini, *Art without an Author: Vasari's Lives and Michelangelo's Death* (New York: Fordham University Press, 2011). For 1546, T. C. Price Zimmerman, *Paolo Giovio: The Historian and the Crisis of Sixteenth-Century Italy* (Princeton: Princeton University Press, 1995), 351, n. 90.

2. He calls him "that locust," "quella cicala," in his letter to Aretino, 6 Oct. 1541 in *CV*, no. 45. See Zimmerman, *Paolo Giovio*, 351, n. 95.

3. Ibid.

4. Vasari, *Descrizione dell'opera di Giorgio Vasari*, 6:390.

5. Vasari, *Vita di Leon Batista Alberti architetto fiorentino*, 3:286.

6. Paolo Giovio in Rome to Giorgio Vasari in Rimini, 10 Dec. 1547, in *CV*, no. 104.

7. Vasari, *Descrizione dell'opere di Giorgio Vasari*, 6:391.

8. Ibid., 392.

9. Ibid., 394.

10. Liana di Girolami Cheney, *The Homes of Giorgio Vasari* (New York: Peter Lang, 2006).

11. The ducal printer was a Fleming, Laurens Leenaertsz van der Beke, who adopted the Italianate name of Lorenzo Torrentino when he was called to Cosimo's service in 1547.

12. These citations are drawn from Lisa Pon, "Rewriting Vasari," in Cast, ed., *Ashgate Research Companion to Giorgio Vasari*, 263.

13. Michel Hochmann, "Les annotations marginales de Federico Zuccari à un exemplaire des 'Vies' de Vasari: La reaction anti-vasarienne à la fin du XVIe siècle," *Revue de l'Art*, no. 80 (1988): 64–71.

14. Vasari, *Descrizione dell'opere di Giorgio Vasari*, 6:396.

20. SEMPRE IN MOTO

1. Ingrid Rowland, "Bramante's Hetruscan Tempietto," *Memoirs of the American Academy in Rome* 51 (2006): 225–38; eadem, "Palladio e le *Tuscanicae dispositiones*," in *Palladio, 1508–2008: Il simposio del cinquecento*, ed. Franco Barbieri et al. (Milan: Marsilio, 2008), 136–39.

2. Vasari, *Descrizione dell'opere di Giorgio Vasari*, 6:396.

3. Ibid., 396–97.

4. Ibid., 397.

5. Ibid.

6. Ibid.

7. Nicole Dacos, *La découverte de la Domus Aura et la formation des grotesques à la Renaissance* (London: Warburg Institute, 1969).

8. Petrarch, letter to Francesco Nelli (Francesco dei Santissimi Apostoli), in *Epistolae Familiares*, 18.8.

9. Dacos, *La découverte de la Domus Aura*.

10. Letter of Francesco da Sangallo, quoted in Leonard Barkan, *Unearthing the Past: Archaeology and Aesthetics in the Making of Renaissance Culture* (Princeton: Princeton University Press, 1999), 3.

11. Ingrid D. Rowland, *The Correspondence of Agostino Chigi in Vatican MS Chigi R.V.c: An Annotated Edition* (Vatican City: Vatican Library, 2001).

21. SHAKE-UP IN FLORENCE

1. Vasari literally writes "as a Christian," but this is what he means.

2. Giorgio Vasari in Arezzo to Vincenzo Borghini in Florence, 4 Jan.1554, in *CV*, no. 210.

3. Gerd Blum, *Giorgio Vasari: Der Erfinder der Renaissance: Eine Biographie* (Munich: C. H. Beck, 2011), 177–78.

4. Vasari would devote his talents to peacetime pursuits. Cosimo had already stationed Gabriele Serbelloni in Cortona with his young Cortonese assistant Vincenzo Laparelli; both would go on to design the fortifications of Malta. In 1557, Cosimo would hired Baldassare Lanci of Urbino as a military architect.

5. Liana De Girolami Cheney, *The Homes of Giorgio Vasari* (New York: Peter Lang, 2006).

6. Roman Vucajnk described these battles to Noah Charney over a series of email interviews, undertaken in 2016.

7. Ibid.

8. Giorgio Vasari in Florence to Michelangelo Buonarroti in Rome, 20 Aug. 1554, in *CV*, no. 215.

9. Lois N. Magner, *A History of Infectious Diseases and the Microbial World* (Westport, CT: Praeger, 2009), 19–25; Sarah Dunant, "Syphilis, Sex and Fear: How the French Disease Conquered the World," *Guardian*, 17 May 2013.

10. Vasari, *Descrizione dell'opere di Giorgio Vasari*, 6.399–400.

11. The border town of Pitigliano became a famous center for these refugees, along with the port of Livorno.

12. David Karmon, *The Ruin of the Eternal City: Antiquity and Preservation in Renaissance Rome* (Oxford: Oxford University Press, 2011).

22. THE ACCADEMIA DEL DISEGNO
AND THE *LIVES* REVISED

1. Vasari, *Descrizione dell'opere di Giorgio Vasari*, 6:402, 403.

2. For the forensic reports on the Medici tombs, see Gino Fornaciari, Angelica Vitiello, Sara Giusiani, Valentina Giuffra, Antonio Fornaciari, and Natale Villari, "The Medici Project: First Anthropological and Paleopathological Results," accessed 17 Aug. 2015, http://www.paleopatologia.it/articoli/aticolo .php?recordID=18.

3. Michael Segre, *Higher Education and the Growth of Knowledge: A Historical Outline of Aims and Tensions* (New York and London: Routledge, 2015).

4. Giorgio Vasari in Arezzo to Vincenzo Borghini in Florence, 1 April 1566, in *CV*, no. 609.

5. Letter of Blosio Palladio (Biagio Pallai), Biblioteca Apostolica Vaticana, MS Vat. Lat. 2847, 175r-v. This passage is translated in Ingrid D. Rowland, *The Roman Garden of Agostino Chigi* (Groningen: The Gerson Lectures Foundation, 2005), 27.

6. Giorgio Vasari in Perugia to Vincenzo Borghini in Florence, 4 April 1566, in *CV*, no. 610.

7. Daniele da Volterra was Michelangelo's star pupil, and the "horse" to which Vasari refers was a bronze equestrian statue he had made for Catherine de' Medici, showing her deceased husband, King Henry II of France, on horseback. "Raccorro qualcosa delle sue fatiche" may mean either collecting some drawings or asking Daniele's studio assistants about his projects, or both.

8. Giorgio Vasari in Perugia to Vincenzo Borghini in Florence, 14 April 1566, in *CV*, no. 611.

9. Giorgio Vasari in Rome to Vincenzo Borghini in Florence, 17 April 1566, in *CV*, no. 613.

10. Beatrice Palma Venetucci, "Pirro Ligorio and the Rediscovery of Antiquity," in *The Rediscovery of Antiquity: The Role of the Artist*, ed. Jane Fejfer, Tobias Fischer-Hansen, and Annette Rathje (Copenhagen: Museum Tusculanum Press, University of Copenhagen, 2003), 74.

11. *The Canons and Decrees of the Sacred and Œcumentical Council of Trent*, ed. and trans. J. Waterworth (London: Dolman, 1848), 25th decree, p. 236.

12. Paleotti wrote him, e.g., on 26 April 1567 as "Molto magnifico come fratello," "Most magnificent Sir, as brother to brother," in *CV*, no. 678.

23. ON THE ROAD

1. Giorgio Vasari in Ancona to Vincenzo Borghini in Florence, 24 April 1566, in *CV*, no. 615.

2. Thomas Coryat, *Coryat's Crudities* (London, 1611), accessed via online edition at http://archive.org/stream/cu31924014589828/cu31924014589828_djvu.txt.

3. Vasari, *Vita di Benvenuto Garofalo e Girolamo da Carpi pittori ferraresi e di altri lombardi*, 5:409.

4. Giorgio Vasari in Milan to Vincenzo Borghini in Poppiano, 9 May 1566, in *CV*, no. 618.

5. Ingrid Rowland, "Vitruvius in Print and in Vernacular Translation: Fra Giocondo, Bramante, Raphael, and Cesare Cesariano," in *Paper Palaces: The Rise of the Renaissance Architectural Treatise*, ed. Peter Hicks and Vaughan Hart (New Haven: Yale University Press, 1998), 105–21.

6. Vasari, *Vita di Benvenuto Garofalo*, 5:424.

7. Ibid., 427.

8. Vasari, *Vita di Madonna Properzia de' Rossi scultrice bolognese*, 4:401.

24. SECOND *LIVES*

1. A classic work on the history of museums is Francis Haskell and Nicholas Penny, *Taste and the Antique: The Lure of Classical Sculpture, 1500–1900* (New Haven and London: Yale University Press, 1982).

2. Giorgio Vasari in Florence to Vincenzo Borghini in Poppiano, 31 July 1566, in *CV*, no. 628.

3. Giorgio Vasari in Florence to Cosimo de' Medici in Florence, 31 Jan. 1567, in *CV*, no. 652.

4. Since the Middle Ages, the Florentine year began on 25 March, so this is our 1567, and each new day began whenever the sun set. Florentine reckoning was not unusual: it would be some time before Europe would agree on a single, universal calendar. The Julian calendar, introduced by Julius Caesar in 45 BC and based on the solar year (with a year being 365.25 days long), was used throughout the Roman Empire, but with the fall of Rome the precise use of this universal calendar was lost. Variations sprang up across the former empire. Until the French shifted programs in 1564, their calendar year began at Easter; until 1522, the Venetian year began on 1 March. The calendar year in England, as in Florence, began on 25 March until 1752. In Oct. 1582, Pope Gregory XIII introduced the Gregorian calendar, which many nations quickly adopted, though some more slowly—Russia used an archaic system until 1918, as did Greece until 1923. Florence switched from its interpretation of the Julian calendar to the new Gregorian

calendar on 4 Oct. 1582. But owing to discrepancies between the new and old calendar systems, the day that followed was officially 15 Oct. 1582.

5. Giorgio Vasari in Rome to Francesco de' Medici in Florence, 13 March 1567, in *CV*, no. 662.

6. Costanza Barbieri, *Le "magnificenze" di Agostino Chigi: Collezioni e passioni antiquarie nella Villa Farnesina* (Rome: Accademia dei Lincei, 2014).

7. Giorgio Vasari in Rome to Bartolomeo Concini in Florence, 15 March 1567, in *CV*, no. 667.

8. Vasari, *Descrizione dell opere di Giorgio Vasari*, 6:406.

9. Vasari, *L'Autore agl'Artefici del Disegno*, 6:409.

10. Giorgio Vasari in Florence to Vincenzo Borghini in Tomerello, 20 Sept. 1567, in *CV*, no. 700.

11. Gabriele Bombaso in Reggio to Giorgio Vasari in Rome, 31 Dec. 1572, in *CV*, no. 1052.

12. Julian Brooks, *Taddeo and Federico Zuccaro:* Artist-Brothers *in Renaissance Rome* (Los Angeles: Getty Publications, 2007), esp. xii, 69; Maddalena Spagnolo, "Considerazioni in margine: Le postille alle Vite di Vasari," in *Arezzo e Vasari, Vite e Postille, Arezzo, 16–17 giugno 2005, atti del convegno*, ed. Antonino Caleca (Foligno: Cartei & Bianchi, 2007); Michel Hochmann, "Les annotations marginales de Federico Zuccaro à un exemplaire des 'Vies' de Vasari: La réaction anti-vasarienne à la fin du XVIe siècle," *Révue de l'Art*, no. 80 (1988): 64–71.

13. Brooks, *Taddeo and Federico Zuccaro*.

14. Hochmann, "Les annotations marginales," 64.

15. Ibid., 64–65.

16. Giovanni Gaetano Bottari, *Raccolta di lettere sulla pittura, scultura ed architettura scritte da' più celebri personaggi dei secoli XV, XVI, e XVII*, vol. 5 (Rome: Niccolò e Marco Pagliarini, 1757), 510–11, appendix 35.

17. Letter of Giorgio Vasari to Ottaviano de' Medici, March [1532], in Giovanni Gaetano Bottari, *Raccolta di Lettere*, vol. 3, no. 7, 21-29, with the passage cited at 21-24. Reprinted with the date 15 June 1540 in Stefano Audin (Étienne Audin de Rians), *Opere di Giorgio Vasari*, vol. 2 (Florence: David Passigli e Soci, 1838), 1422. Not included in *CV*.

25. STILL WANDERING

1. David Cast, ed., *The Ashgate Research Companion to Giorgio Vasari* (Burlington, CT: Ashgate, 2015), 34–35.

2. Ibid., 35.

3. Marco Ruffini, *Art without an Author: Vasari's Lives and Michelangelo's Death* (New York: Fordham University Press, 2011), 2. Ruffini points out that this is

ironic, since Michelangelo developed his own, unique style, one he was never taught, therefore academic, "teachable" technique extends from admiration for someone who was never taught his signature style.
4. Ibid.
5. Giorgio Vasari in Florence to Francesco de' Medici at Poggio a Caiano, 27 Sept. 1569, in *CV*, no. 775.
6. "Progetto Medici: Risultati della ricerca," accessed 26 Sept. 2015, http://www.paleopatologia.it/attivita/pagina.php?recordID=6.
7. Cosimo Bartoli in Venice to Giorgio Vasari in Florence, 22 Sept. 1571,in *CV*, no. 913.
8. Cosimo Bartoli in Venice to Giorgio Vasari in Florence, 8 Sept. 1571, in *CV*, no. 907.
9. See Alessio Celetti, "Autorappresentazione e la Riforma: gli affreschi della Sala Regia vaticana," *Eurostudium*, Jan.–March 2013, accessed 4 Oct. 2013, http://www.eurostudium.uniroma1.it/rivista/monografie/Celletti%20pronto.pdf.

26. BETWEEN THE CUPOLA AND THE SALA REGIA

1. Giorgio Vasari in Rome to Francesco de' Medici in Florence, 7 Dec. 1570, in *CV*, no. 858.
2. Giorgio Vasari in Rome to Francesco de' Medici in Florence, 4 May 1571, in *CV*, no. 884.
3. Roman Vucajnk, email interview with Noah Charney, 2016.

27. A ROYAL HALL

1. Giorgio Vasari in Rome to Vincenzo Borghini in Florence, 5 Dec. 1572, in *CV*, no. 1044.
2. Ibid.
3. Letter from Giorgio Vasari in Rome to Vincenzo Borghini in Florence, 5 Feb. 1573, in *CV*, no. 1064.
4. Filippo Neri's own congregation describes this history on its website: http://www.vallicella.org/giro-visita-sette-chiese/.
5. To demonstrate Vasari's wealth, we might take, for example, an itemized bill from July 1568, made at the suggestion of Duke Cosimo. Letter of Giorgio Vasari to Cosimo de' Medici, 22 July 1568, in *CV*, no. 719: "For each of the four large histories in fresco . . . : 300 ducats. For each of the two smaller frescoes: 200 ducats. For each of the four paintings on stone: 100 ducats. And in total the 10 histories mentioned above add up to 2000 ducats. On the lower wall, twelve

histories remain [to be done] in oil, and these, at 100 ducats each, would add up to 1200 ducats." Thirty-two hundred ducats was a princely sum indeed, equivalent to ten years' good salary—and this was but one of Vasari's bills, and did not include his annual salaries for the positions he held.

6. Borghini supplies the final text in a letter of 2 May 1573: Vincenzo Borghini in Florence to Giorgio Vasari in Rome, in *CV,* no. 1090.

7. Ibid.

8. Jan de Jong, *The Power and the Glorification: Papal Pretensions and the Art of Propaganda in the Fifteenth and Sixteenth Centuries* (College Park: Pennsylvania State University Press, 2013).

9. Giorgio Vasari in Rome to Vincenzo Borghini in Florence, 16 April 1573, in *CV,* no. 1085.

10. Giorgio Vasari in Rome to Vincenzo Borghini in Florence, 29 May 1573, in *CV,* no. 1096.

11. Giorgio Vasari in Florence to Vincenzo Borghini in Pian di Mugnone, 26 June 1573, in *CV,* no. 1099.

12. Giorgio Vasari in Florence to Vincenzo Borghini in Pian di Mugnone (?), 18 July 1573, in *CV,* no. 1110.

13. *Diario Fiorentino di Agostino Lapini dal 252 al 1596,* ed. Giuseppe Odoardo Corazzini (Florence: Sansoni, 1900), 186.

28. THE LEGACY OF *LIVES*

1. Anthony Grafton, Glenn Most, and Salvatore Settis, eds., *The Classical Tradition* (Cambridge: Belknap Press of Harvard University Press, 2013), 78.

2. Ernst M. Gombrich, foreword to Richard Woodfield, ed., *The Essential Gombrich: Selected Writings on Art and Culture* (New York: Phaidon Press, 1996), 7.

3. For more on Denon as a curator, see Andrew McClellan, *Inventing the Louvre: Art, Politics, and the Origins of the Modern Museum in Eighteenth-Century Paris* (Berkeley: University of California Press, 1994). For more on Denon and art looting, see Noah Charney, *Stealing the Mystic Lamb: The True Story of the World's Most Coveted Masterpiece* (New York: PublicAffairs, 2010).

4. Italian editions had been published in 1760, 1811, and 1864, but the 1868 edition brought the text back to life by adding many notes. It was translated into English, only in part, and only in 1846, by a Mrs. Jonathan Foster. Other English editions followed, but until 1912–15, when Gaston C. de Vere published the first complete, ten-volume English-language translation of *Lives,* called the Quattrocentenary edition, all had been abridged.

5. On one occasion Duveen wanted Berenson to certify an *Adoration of the Shepherds* as a work of Giorgione, who died young and therefore left very few extant

paintings, making his work extremely valuable. Berenson, however, thought the work was by Giorgione's contemporary Titian, who lived into his eighties and painted scores of pictures, making a Titian far less valuable. Berenson held his ground and prevailed, inspiring Simon Gray's 2004 play about their argument, *The Old Masters*.

29. CIRCLING BACK TO GIOTTO'S O

1. Ingrid Rowland's translation.

30. CONCLUSION

1. This information comes from several phone interviews with Seracini in 2015. According to him, none of these points have been published in any media reports, although the popularity of the subject matter led to scores of features across the world media.
2. Vasari, *Vita di Lionardo da Vinci*, 4:33.

Bibliography

PRIMARY WORKS

Boccaccio, Giovanni. *Decameron*.

————. *Genealogia Deorum Gentilium*.

Bottari, Giovanni Gaetano, *Raccolta di Lettere sulla Pittura, Scultura e Architettura Scritte da' più celebri personaggi dei secoli XV, XVI, e XVII pubblicata da M. Gio. Bottari e continuata fino ai nostri giorni da Stefano Ticozzi* (Rome: Pagliarini, 1757; Milan: Silvestri, 1822).

Cellini, Benvenuto. *Vita di Benvenuto Cellini orefice e scultore fiorentino scritta da lui medesimo*. Edited by Francesco Tassi. Florence: Guglielmo Piatti, 1829.

————. *Autobiography*. Translated by John Addington Symonds. New York: Appleton, 1904.

Dante Alighieri. *Divina Commedia*.

Gaye, Johann Wilhelm. *Carteggio inedito d'artisti dei secoli XIV, XV, XVI*. Florence: Presso G. Molini, 1840.

Lapini, Agostino. *Diario Fiorentino di Agostino Lapini dal 252 al 1596*. Edited by Giuseppe Odoardo Corazzini. Florence: Sansoni, 1900.

Petrarch. *Epistolae Familiares*.

Scoti-Bertinelli, Ugo. *Giorgio Vasari scrittore*. Nistri, 1905.

Varchi, Benedetto. *Storia fiorentina di Messer Benedetto Varchi*. Cologne: Pietro Martello, 1721.

Vasari, Giorgio. *Giorgio Vasari: Der literarische Nachlass*. Edited by Karl Frey and Herman-Walther Frey. 3 vols. Munich: Georg Müller, 1923–40. Edited and put online by the Fondazione Memofonte, Florence, at http://www.memofonte.it/autori/carteggio-vasariano-1532-1574.html. [Cited as *CV*.]

————. *Le Opere di Giorgio Vasari pittore e architetto aretino.* Edited by Stefano Audin (Étienne Audin de Rians). 9 vols. Florence: David Passigli e Soci, 1838.

————. *Vite dei più eccellenti pittori, scultori, ed architettori.* Edited by Rosanna Bettarini and Paola Barocchi. Florence: Sansoni [later S.P.E.S.], 1966–87. Put online by the Scuola Normale Superiore di Pisa, at http://vasari.sns.it/consultazione/ Vasari/indice.html.

————. *Le Opere di Giorgio Vasari,* ed. Gaetano Milanesi, 9 Vols., Florence: Sansoni, 1881.

SECONDARY SOURCES

Alberti, Leon Battista. *On Painting: A New Translation and Critical Edition.* Edited and translated by Rocco Sinisgalli. Cambridge and New York: Cambridge University Press, 2011.

Alfani, Guido. *Calamities and the Economy in Renaissance Italy: The Grand Tour of the Horsemen of the Apocalypse.* London: Palgrave Macmillan, 2013.

Barbieri, Costanza. *Le "magnificenze" di Agostino Chigi: Collezioni e passioni antiquarie nella Villa Farnesina.* Rome: Accademia dei Lincei, 2014.

Barkan, Leonard. *Unearthing the Past: Archaeology and Aesthetics in the Making of Renaissance Culture.* New Haven: Yale University Press, 1999.

Barolsky, Paul. *Why Mona Lisa Smiles and Other Tales by Vasari.* University Park: Pennsylvania State University Press, 1991.

————. *Giotto's Father and the Family of Vasari's Lives.* University Park: Pennsylvania State University Press, 1992.

————. "The Artist's Hand." In *The Craft of Art: Originality and Industry in the Italian Renaissance and Baroque Workshop.* Edited by Andrew Ladis and Carolyn Wood, 5–24. Athens: University of Georgia Press, 1995.

————. "Vasari and the Historical Imagination." *Word and Image* 15 (1999): 286–91.

————. "What Are We Reading When We Read Vasari?," *Source: Notes in the History of Art* 22, no. 1 (2002): 33–35.

————. *Michelangelo's Nose: A Myth and Its Maker.* University Park: Pennsylvania State University Press, 2007.

————. *A Brief History of the Artist from God to Picasso.* University Park: Pennsylvania State University Press, 2010.

Barzman, Karen-Edis. *The Florentine Academy and the Early Modern State: The Discipline of Disegno.* Cambridge and New York: Cambridge University Press, 2000.

Biringucci, Vannoccio. *The Pirotechnia of Vannoccio Biringuccio.* Translated by Cyril Stanley-Smith and Martha Teach Gnudi. New York: American Institute of Mining and Metallurgical Engineers, 1942.

Blum, Gerd. *Giorgio Vasari: Der Erfinder der Renaissance: Eine Biographie,* Munich: C. H. Beck, 2011.

Brisson, Luc. *How Philosophers Saved Myths: Allegorical Interpretation and Classical Mythology.* Translated by Catherine Tihanyi. Chicago: University of Chicago Press, 2004.

Brock, Maurice. *Bronzino.* Paris: Taschen, 2002.

Brooks, Julian. *Taddeo and Federico Zuccaro: Artist-Brothers in Renaissance Rome.* Los Angeles: Getty Publications, 2007.

Carden, Robert W. *The Life of Giorgio Vasari: A Study of the Later Renaissance in Italy.* New York: Henry Holt, 1911.

Cast, David. *The Delight of Art: Giorgio Vasari and the Traditions of Humanist Discourse.* University Park: Pennsylvania State University Press, 2009.

————, ed. *The Ashgate Research Companion to Giorgio Vasari.* Burlington, CT: Ashgate, 2014.

Celetti, Alessio, "Autorappresentazione e la Riforma: Gli affreschi della Sala Regia vaticana," *Eurostudium,* Jan.–March 2013, accessed 4 Oct. 2015, http://www.eurostudium.uniroma1.it/rivista/monografie/Celletti%20pronto.pdf.

Charney, Noah. *Stealing the Mystic Lamb: The True Story of the World's Most Coveted Masterpiece.* New York: PublicAffairs, 2010.

Cheney, Liana de Girolami. *Vasari's Teachers: Sacred and Profane Art.* London: Peter Lang, 2006.

————. *The Homes of Giorgio Vasari.* London: Peter Lang, 2006.

————. *Giorgio Vasari: Artistic and Emblematic Manifestations.* Washington, DC: New Academia, 2011.

————. "Giorgio Vasari's Portrait of Lorenzo the Magnificent: A Ciceronian

Symbol of Virtue and a Machiavellian Princely Conceit." *Iconocrazia*, Jan. 2012, accessed 4 Oct. 2014, http://www.iconocrazia.it/archivio/00/02.html.

————. *Giorgio Vasari's Prefaces: Art and Theory*. London: Peter Lang, 2012.

Chieppi, Sergio. *I servizi postali dei Medici dal 1500 al 1737*. Fiesole: Servizio Editoriale Fiesolana, 1997.

Cipriani, Giovanni. *Il mito etrusco nel rinascimento fiorentino*. Florence: Olschki, 1980.

Coates, Victoria C. Gardner, "Rivals with a Common Cause: Vasari, Cellini, and the Literary Formulation of the Ideal Renaissance Artist." In David Cast, ed., *The Ashgate Research Companion to Giorgio Vasari*, 215–22.

Cochrane, Eric. *Florence in the Forgotten Centuries, 1527–1800: A History of Florence and the Florentines in the Age of the Grand Dukes*. Chicago: University of Chicago Press, 1973.

Conley, T. M. *Rhetoric in the European Tradition*. Chicago: University of Chicago Press, 1990.

Coryat, Thomas. *Coryat's Crudities*. London, 1611. Accessed via online archival edition at http://archive.org/stream/cu31924014589828/cu31924014589828_djvu.txt.

Cox-Rearick, Janet. *Bronzino's Chapel of Eleonora in the Palazzo Vecchio*. Berkeley: University of California Press, 1993.

Curran, Brian. *The Egyptian Renaissance: The Afterlife of Egypt in Early Modern Italy*. Chicago: University of Chicago Press, 2007.

Dacos, Nicole. *La découverte de la Domus Aura et la formation des grotesques à la Renaissance*. London: Warburg Institute, 1969.

De Jong, Jan. *The Power and the Glorification: Papal Pretensions and the Art of Propaganda in the Fifteenth and Sixteenth Centuries*. College Park: Pennsylvania State University Press, 2013.

DePuma, Richard. *Etruscan and Villanovan Pottery: A Catalogue of Italian Ceramics from Midwestern Collections*. Iowa City: University of Iowa Museum of Art, 1971.

Descendre, Romain. "La biblioteca di Leonardo." In *Atlante della letteratura italiana*, edited by Sergio Luzzatto, Gabriele Pedullà, and Amedeo De Vincentiis, vol. 1, 592–95. Turin: Einaudi, 2010.

Edgerton, Samuel Y. *The Mirror, the Window, and the Telescope: How Renaissance*

Linear Perspective Changed Our Vision of the Universe. Ithaca: Cornell University Press, 2009.

Ekserdjian, David. Introduction to *Lives of the Painters, Sculptors, and Architects*, by Giorgio Vasari. Translated by Gaston du C. de Vere. New York: Knopf, Everymans Library, 1997.

Fletcher, Catherine. *The Black Prince of Florence: The Spectacular Life and Treacherous World of Alessandro de' Medici*. Oxford: Oxford University Press, 2016.

Fornaciari, Ginoi, Angelica Vitiello, Sara Giusiani, Valentina Giuffra, Antonio Fornaciari, and Natale Villari. "The Medici Project: First Anthropological and Paleopathological Results," accessed 17 Aug. 2015, http://www.paleopatologia .it/articoli/aticolo.php?recordID=18.

Frosini, Fabio. "La biblioteca di Leonardo da Vinci." In Scuola Normale di Pisa/Università di Cagliari, *Biblioteche dei filosofi: Biblioteche filosofiche private in età moderna e contemporanea*, s.v. Leonardo da Vinci, accessed 7 Jan. 2016, http:// picus.unica.it/documenti/LdV_biblioteche_dei_filosofi.pdf, pp. 1–13.

Gaisser, Julia Haig. *Pierio Valeriano on the Ill Fortune of Learned Men: A Renaissance Humanist and His World*. Ann Arbor: University of Michigan Press, 1999.

Gaston, Robert. "Love's Sweet Poison: A New Reading of Bronzino's London 'Allegory.'" *I Tatti Studies in the Italian Renaissance* 4 (1991): 249–88.

Gehl, Paul F. *A Moral Art: Grammar, Society, and Culture in Trecento Florence*. Ithaca: Cornell University Press, 1993.

Goffen, Rona. *Renaissance Rivals: Michelangelo, Leonardo, Raphael, Titian*. New Haven: Yale University Press, 2002.

Grafton, Anthony, Glenn Most, and Salvatore Settis, eds. *The Classical Tradition* Cambridge: Belknap Press of Harvard University Press, 2010.

Haskell, Francis, and Nicholas Penny, *Taste and the Antique: The Lure of Classical Sculpture, 1500–1900*, New Haven: Yale University Press, 1982.

Henry, Tom. "Centro e Periferia: Guillaume de Marcillat and the Modernisation of Taste in the Cathedral of Arezzo." *Artibus et Historiae* 15, no. 29 (1994): 55–83.

Hibbert, Christopher. *The Rise and Fall of the House of Medici*. Harmondsworth: Allen Lane (Penguin), 1974.

Higgins, Dick. *Pattern Poetry: Guide to an Unknown Literature*. Albany: State University of New York Press, 1987.

Hochmann, Michel. "Les annotations marginales de Federico Zuccari à un exemplaire des "Vies" de Vasari: La reaction anti-vasarienne à la fin du XVIe siècle." *Revue de l'Art*, no. 80 (1988): 64–71.

Jones, Jonathan. *The Lost Battles: Leonardo, Michelangelo, and the Artistic Duel That Defined the Renaissance.* New York: Knopf, 2012.

Kahr, Madlyn. "Titian's Old Testament Cycle." *Journal of the Warburg and Courtauld Institutes* 29 (1966): 193–205.

Karmon, David. *The Ruin of the Eternal City: Antiquity and Preservation in Renaissance Rome.* Oxford: Oxford University Press, 2011.

Kennedy, George. *A New History of Classical Rhetoric.* Princeton: Princeton University Press, 1994.

Kirshner, Julius. "Family and Marriage." In *Italy in the Age of the Renaissance, 1300–1550*, edited by John Najemy, 82–102. Oxford: Oxford University Press, 2010.

Klapisch-Zuber, Christiane. *Women, Family, and Ritual in Renaissance Italy.* Chicago: University of Chicago Press, 1985

Kroke, Antonella Fenech. "Un théâtre pour *La Talanta*: Giorgio Vasari, Pietro Aretino, et l' *apparato* de 1542." *Rêvue de l'Art* 168 (2010–12): 53–64.

Ladis, Andrew. *Victims and Villains in Vasari's* Lives. Chapel Hill: University of North Carolina Press, 2015.

Ladis, Andrew, and Carolyn Wood, eds. *The Craft of Art: Originality and Industry in the Italian Renaissance and Baroque Workshop.* Athens: University of Georgia Press, 1995.

Land, Norman E. "Giotto as Apelles." *Notes in the History of Art* 24, no. 3 (Spring 2005): 6–9.

Marani, Pietro C., and Marco Versiero. *La biblioteca di Leonardo: Appunti e letture di un artista nella Milano del Rinascimento, Guida alla Mostra.* Milan: Castello Sforzesco and Biblioteca Trivulziana, 2015.

Martines, Lauro. *April Blood: Florence and the Plot against the Medici.* London: Cape, 2003.

McClellan, Andrew. *Inventing the Louvre: Art, Politics, and the Origins of the Modern Museum in Eighteenth-Century Paris.* Berkeley: University of California Press, 1999.

Muir, Edward. *Civic Ritual in Renaissance Venice.* Princeton: Princeton University Press, 1986.

Muratori, Ludovico Antonio. *Annali dell'Italia dal principio dell'era volgare sino all'anno 1750*. Edited by Giuseppe Catalano. Florence: Leonardo Marchini, 1837.

Najemy, John. *A History of Florence, 1200–1575*. Hoboken, NJ: Wiley-Blackwell, 2006.

————, ed. *Italy in the Age of the Renaissance, 1300–1550*. Oxford: Oxford University Press, 2010.

Origo, Iris. *The Merchant of Prato: Francesco di Marco Datini, 1335–1410*. New York: Knopf, 1957.

Panofsky, Erwin. "Reality and Symbol in Early Netherlandish Painting: 'Spiritualia sub Metaphoris Corporalium.'" In *Early Netherlandish Painting: Its Origins and Character*, 131–48. Cambridge: Harvard University Press, 1964.

Paolucci, Antonio. "Angelico l'Intellettuale." *L'Osservatore Romano*, 23 April 2009, http://www.vatican.va/news_services/or/or_quo/cultura/093q05a1.html.

Parenti, Daniela. "Nardo di Cione." In *Dizionario Biografico degli Italiani*, vol. 77 (2012), online at http://www.treccani.it/enciclopedia/nardo-di-cione _(Dizionario-Biografico)/.

Pegazzano, Donatella, Demetrios Zikos, and Allan Chong, eds. *Raphael, Cellini, and a Renaissance Banker: The Patronage of Bindo Altoviti*. Boston: Isabella Stewart Gardner Museum, 2003.

Pierguidi, Stefano. "Sulla fortuna della 'Giustizia' e della 'Pazienza' del Vasari."*Mitteilungen des Kunsthistorischen Institutes in Florenz* 51, nos. 3–4 (2007): 576–92.

Pon, Lisa. "Rewriting Vasari." In David Cast, ed., *The Ashgate Research Companion to Giorgio Vasari*, 261–76.

Pope-Hennessey, John. *The Piero Della Francesca Trail: The Walter Neurath Memorial Lecture*. London: Thames and Hudson, 1991. Reprinted together with Aldous Huxley's "The Best Picture," in *The Piero Della Francesca Trail*. New York: Little Bookroom, 2002.

Price Zimmerman, T. C. *Paolo Giovio: The Historian and the Crisis of Sixteenth-Century Italy*. Princeton: Princeton University Press, 1995.

Quartieri, Franco. *Benvenuto da Imola: Un moderno antico commentatore di Dante*. Ravenna: Longo, 2001.

Rebecchini, Guido. *Un altro Lorenzo: Ippolito de' Medici fra Firenze e Roma (1511–1535)*. Venice: Marsilio, 2010.

Roberts, Paul. "Mass-production of Roman Finewares." In *Pottery in the Making: World Ceramic Traditions*, edited by Ian Freestone and David Gaimster, 188–93. London: British Museum Press, 1997.

Robertson, Clare. *"Il Gran Cardinale": Alessandro Farnese and the Arts.* New Haven: Yale University Press, 1994.

Rowland, Ingrid D. *The Culture of the High Renaissance: Ancients and Moderns in Sixteenth-Century Rome.* New York: Cambridge Unversity Press, 1998.

—————. "Vitruvius in Print and in Vernacular Translation: Fra Giocondo, Bramante, Raphael, and Cesare Cesariano." In *Paper Palaces: The Rise of the Renaissance Architectural Treatise*, edited by Peter Hicks and Vaughan Hart, 105–21. New Haven: Yale University Press, 1998.

—————. *The Correspondence of Agostino Chigi in Vatican MS Chigi R.V.c: An Annotated Edition.* Vatican City: Vatican Library, 2001.

—————. *The Scarith of Scornello: A Tale of Renaissance Forgery.* Chicago: University of Chicago Press, 2004.

—————. *The Roman Garden of Agostino Chigi*, Groningen: The Gerson Lectures Foundation, 2005.

—————. "Bramante's Hetruscan Tempietto." *Memoirs of the American Academy in Rome* 51 (2006): 225–38.

—————. "Palladio e le *Tuscanicae dispositiones*." In *Palladio, 1508–2008: Il simposio del cinquecentenario*, edited by Franco Barbieri et al., 136–39. Milan: Marsilio, 2008.

Rubin, Patricia Lee. *Giorgio Vasari: Art and History.* New Haven: Yale University Press, 1995.

Ruffini, Marco. *Art without an Author: Vasari's Lives and Michelangelo's Death.* New York: Fordham University Press, 2011.

Segre, Michael. *Higher Education and the Growth of Knowledge: A Historical Outline of Aims and Tensions.* New York and London: Routledge, 2015.

Snowden, Frank. *The Conquest of Malaria, 1900–1962.* New Haven: Yale University Press, 2006.

Spagnolo, Maddalena. "La biografia d'artista: Racconto, storia e leggenda." In *Enciclopedia della Cultura Italiana*. Vol. 10. Turin: UTET, 2010. Pp. 375–93.

—————. "Considerazioni in margine: Le postille alle Vite di Vasari." In *Arezzo*

e Vasari: Vite e Postille, Arezzo, 16–17 giugno 2005, atti del convegno, edited by Antonino Caleca. Foligno: Cartei & Bianchi, 2007.

Spicer, Joaneath, ed. *Revealing the African Presence in Renaissance Europe*. Baltimore: Walters Art Museum, 2012. Exhibition catalog.

Talvacchia, Bette. *Taking Positions: On the Erotic in Renaissance Culture*. Princeton: Princeton University Press, 1999.

Taylor, F. H. *The Taste of Angels: A History of Art Collecting from Rameses to Napoleon*. Boston: Little, Brown, 1948.

Tucci, Ugo. "Biringucci, Vannoccio." In *Dizionario Biografico degli Italiani*, vol. 10 (1968), online at http://www.treccani.it/enciclopedia/vannoccio-biringucci_(Dizionario-Biografico)/.

Turner, Nicholas. *Florentine Drawings of the Sixteenth Century*. London: British Museum Press, 1986.

Venturi, Lionello. "Le Compagnie della Calza (sec. XV–XVII)." *Nuovo Archivio Veneto*, n.s. 16 (1908), 2:161–221; and n.s. 17 (1909), 1:140–223.

Wallace, William. "Who Is the Author of Michelangelo's Life?" In David Cast, ed., *The Ashgate Research Companion to Vasari*, 107–20.

Webb, Ruth. *Ekphrasis, Imagination and Persuasion in Ancient Rhetorical Theory and Practice*. Farnham, Surrey: Ashgate, 2009.

Wilde, Johannes. *Michelangelo and His Studio*. London: Britism Museum Press, 1953.

Woolley, Reginard Maxwell. *Coronation Rites*. Cambridge: Cambridge University Press, 1915.

Zerner, Henri. *Renaissance Art in France: The Invention of Classicism*. Paris: Flammarion, 2003.

Illustration Credits

The Sala dei Cinquecento: Scala / Art Resource, NY.

Battle of Anghiari *black chalk and pen sketch by Rubens:* Photo: Michèle Bellot. Louvre [Museum], Paris, France.

A study for the never-executed Battle of Cascina *fresco:* Gabinetto dei Disegni e delle Stampe, Uffizi, Florence, Italy.

Sala dei Cinquecento sketch: Gabinetto dei Disegni e delle Stampe, Uffizi, Florence, Italy.

The fresco by Vasari in which a clue is concealed: Photo: Raffaello Bencini. Salone dei Cinquecento, Palazzo Vecchio, Florence, Italy.

Detail of soldiers in battle with the inscription CERCA TROVA *on a banner:* Photo: Raffaello Bencini. Salone dei Cinquecento, Palazzo Vecchio, Florence, Italy.

A self-portrait by Vasari: Scala / Art Resource, NY.

Vasari's studio at his home in Florence: Casa del Vasari, Florence, Italy.

Vasari portrayed his onetime schoolmate: Uffizi, Florence, Italy.

Vasari's painting of Saint Luke: Scala / Art Resource, NY.

Vasari's posthumous portrait of Lorenzo: Uffizi, Florence, Italy.

Raphael's most famous fresco, School of Athens: Stanza della Segnatura, Stanze di Raffaello, Vatican Palace.

Portrait by Bronzino of Eleonora di Toledo with Giovanni: Uffizi, Florence, Italy.

Cosimo de' Medici, as portrayed by Bronzino: Uffizi, Florence, Italy.

Bronzino's Allegory of Love and Lust: National Gallery, London, Great Britain.

The title page of Lives: Biblioteca B. 2898.1–2. Casa Buonarroti, Florence, Italy.

The frontispiece of the first edition of Vasari's Lives: Photo: Sergio Anelli. Biblioteca Nazionale, Florence, Italy.

Index

Page numbers beginning with 365 refer to endnotes.